D0049235

FULL SPECTRUM

FULL SPECTRUM

HOW THE SCIENCE OF COLOR
MADE US MODERN

ADAM ROGERS

Houghton Mifflin Harcourt
BOSTON NEW YORK
2021

For information about permission to reproduce selections from
this book, write to trade.permissions@hmhco.com or to
Permissions, Houghton Mifflin Harcourt Publishing Company,
3 Park Avenue, 19th Floor, New York, New York 10016.

Portions of this book first appeared, in different form, in *Wired*
in articles titled "The Dress," "Vantablack," and "Colors Are
How Your Brain Makes the World," all by Adam Rogers.

hmhbooks.com

Library of Congress Cataloging-in-Publication Data
Names: Rogers, Adam, 1970– author.
Title: Full spectrum : how the science of color made us modern / Adam Rogers.
Description: Boston : Houghton Mifflin Harcourt, 2021. |
Includes bibliographical references and index.
Identifiers: LCCN 2020039337 (print) | LCCN 2020039338 (ebook) |
ISBN 9781328518903 (hardcover) | ISBN 9780358449379 |
ISBN 9780358449010 | ISBN 9781328519146 (ebook)
Subjects: LCSH: Color — Physiological effect. | Color — Psychological aspects. |
Color vision. | Color (Philosophy)
Classification: LCC QP483 .R64 2021 (print) | LCC QP483 (ebook) |
DDC 152.14/5 — dc23
LC record available at https://lccn.loc.gov/2020039337
LC ebook record available at https://lccn.loc.gov/2020039338

Book design by Kelly Dubeau Smydra

Printed in the United States of America
DOC 10 9 8 7 6 5 4 3 2 1

For Melissa and the kids

CONTENTS

INTRODUCTION

Imagine the island of Britain, its southwestern corner extending a peninsula like a dainty Victorian foot toward the Celtic Sea and the Atlantic beyond. That foot is the southern end of Cornwall, England's beach vacation hub, and its heel is sometimes called "the Lizard" for etymological reasons that have nothing to do with reptiles.

Keep that picture of Cornwall, that tiptoe of England, in your head. Only now rewind the clock 400 million years and move it somewhere near Earth's equator, at the bottom of a small, muddy ocean. That's where Cornwall was in the Devonian period, where it spent maybe 40 million years accreting volcanic rocks, sediment, and gunk until a sly continental plate slid up from the south and slammed into another. The supercontinent of Pangaea was under construction, and the little patch of rock that would become Cornwall was caught in the collision zone. Tectonics were creating the world of tomorrow, which is now today.

Which brings me to a parking lot at the north end of the Lizard, just outside the chain-link fence boundary of Royal Naval Air Station Culdrose. I leave my rental car beneath fighter jets screaming into a bright blue sky so Robin Shail — a geologist at the University of Exeter — can take me for a drive. All that hot tectonic-plate-on-plate action in the Devonian made today's Cornwall one of the most interesting places in the world if you care about rocks.

We do. Just about six miles from the parking lot — half an hour

of tough driving on ancient, sunken single-lane roads — is the spot where, two centuries ago, a priest named William Gregor, who was simply the *most* interested in rocks, discovered an element called titanium and changed the way the world looked forever.

Once under way, Shail apologizes for the smell inside his Volkswagen. Apparently an Oxford geologist who specializes in Lizard-like regions left his wet shoes in the car overnight, and Shail didn't notice until this morning. Shail packed the still-damp offenders into a plastic bag and stuffed the bag into the Golf's trunk, already full of other shoes, gear, and boxes of scientific journal articles. Geology is an outdoorsy science, and Shail, bespectacled and unshaven, tall and lean, has the slightly jagged outline of someone who climbs cliff faces for work. His trunk conveys a vibe of preparedness.

Shail did his PhD on Cornish geology, and now in addition to teaching at the famed Camborne School of Mines, he works with the area's mining companies. "I'm kind of a regional geologist," Shail says. "It's regarded as a little parochial." As we bump along past Cornwall's whitewashed houses with thatched roofs, green fields beyond the hedges, and low stone walls, Shail tells me how it all got this way.

The muck and mud where those continents collided got pushed and pulled, folded and crumpled. The crumpled zone became a new mountain chain that reached across the part of the planet that would eventually become the Atlantic Ocean. This is called the Variscan range.

Meanwhile — well, over the next couple hundred million years, into the Permian period, so more "mean" than "while," I guess — a piece of ocean crust got sliced off, like a thin sheet of cheese curling upward when the grater hits the wedge. It ended up high and dry. In geological parlance this is an "ophiolite," a small plateau on the edge of what became the southwest tip of Britain. It's the Lizard, a name that probably comes from a Cornish word that meant "high land," geologically different from the already geologically weird chunk of Cornwall it's attached to.

Subterranean granite melted into magma, which floated up, solidified, and fractured. Meanwhile a bunch of other minerals, such as cassiterite (tin oxide), chalcopyrite (copper and other stuff), and wolframite (mostly tungsten), remained liquid — a 300-degree-C, watery fluid. The cracks in the granite filled up with the superheated mineral cocktail, forming the "veins" and "lodes" that miners would eventually dig for.

Rain — this is England, after all — would eventually expose areas of granite and filter through it down into local streams. Cornwall has been a mining town since before there were mines, really — two thousand years ago its tin and copper were traded as far away as the Mediterranean. "It was sort of pre-Brexit trade," Shail says wryly. "Tin and copper together make bronze."

By the eighteenth century, Cornwall was producing more tin than anywhere else in the world. Miners dug some of that out of the hills, but nearly half of it came from the mud at the bottom of rivers and creeks. When rain falls on exposed granite and erodes it, it carries denser minerals and ores downhill. Filter the gravel and you get the ore — like panning for gold, except here the ore is cassiterite.

Cornwall became an economic powerhouse and a center for science and technology. Using steam power to pump groundwater out of mines was a Cornish innovation, for example. And another plentiful mineral in Cornwall's dirt, kaolinite, turned out to be the key ingredient in fine Chinese-type porcelain, which ultimately allowed England to break into that industry in the second half of the eighteenth century. (Before that, English factories had imported kaolin from the Blue Ridge Mountains of North Carolina — Cherokee land.) When Josiah Wedgwood made porcelain in the 1770s, he used Cornish clay.

Today Cornwall has more of a reputation as a beach resort and vacation destination, but that mineral history is still there, just beneath the surface. Shail navigates us to the hillside town of Manaccan, a cluster of gray stone buildings along narrow lanes at improbable angles — "quintessential Cornwall," he says with a smile. We drive down the hill toward Gillan Creek, burbling through a green

and shady vale. I wouldn't ordinarily use a word like "vale," but the whole place feels like something out of a Tolkien book.

When we arrive at a little stone bridge barely wide enough for a car, Shail parks. Up the road, the sun sparkles off of a sign that reads MANACCAN, and just past that it is sparkling even harder off of two little rectangular buildings, one built of raw local stone and the other painted a tidy white, with two brick chimneys. These are what is left of the old Tregonwell Mill. One of the buildings — the stonier one — has a metal square bolted to it. "This titanium plaque commemorates the identification of the metal menachanite, later called titanium, by the Reverend William Gregor in the Leat of Tregonwell Mill in the Parish of Manaccan in Meneage in 1791."

This is where it happened: William Gregor found titanium, a metal with at least half a dozen histories and uses. Today you'll find it in artificial hips, supersonic jets, and camping equipment. But for my purposes, its most important identity is as stuff that makes a color.

The mineral Gregor found was black as coal. But if you take a titanium atom and attach two oxygen atoms to it — not as easy as it sounds — you get titanium dioxide, TiO_2. Purified and refined, TiO_2 defines and embodies the color white. In human-made things, titanium dioxide is ubiquitous, a whitener in paints, paper, ceramics, pharmaceuticals, and food. It is the white of the modern world. And thanks to its brightness and opacity, it gets mixed in to other paints and coatings, too. It's the underpinning of almost every other color on almost every surface.

In modern language, titanium dioxide is a pigment, something that gives a paint or material the color we see. Of course, William Gregor had no idea that his new element might have any uses at all, and he certainly didn't recognize it as a technological advance in the creation of color. That wouldn't happen for a century — which is pretty standard in the story of colors and how we humans make them. We learn to see, and then we learn to create, and then we learn more about how we see from what we've created. It's a grand oscillation between seeing and understanding.

The natural world has color, of course, and like a lot of animals

we humans have the sensory apparatus to perceive it. But learning how to capture those colors — to make, improve, and apply them to the world we built — has been nothing less than the millennia-long process of becoming a thinking species with multiple cultures. The material of those colors and the technology that created them has become stitched into our heritage, into the human story of discovery, innovation, and science. Every chapter of that story has been a triple-stranded braid: the light of the universe, the surfaces it bounces off of, the eyes and minds that apprehend them, and the technical skill to mimic and extend the palette.

In a way, that story starts long before humans even existed. But at least one of its multiple once-upon-a-times takes place with the formation of the Lizard, and points to William Gregor mucking around in a stream.

It's possible that the waterwheel churned up the black, fine-grained sand by accident. Whirling away in the leat, a sort of side channel dug to divert stream water for this exact purpose, the wheel would've carried heavy sediment over the top and then left it in the hollow under the downward side. "The thing about a mill leat is, you'd have quite fast-running water, and it acts as a kind of natural sluice box," Shail says. "That's often what's used to try to separate heavy minerals from other materials."

Today, the mill, wheel, and leat are gone. But the creek still runs fast and clear, and Shail offers to clamber down into it and get a sample of what we're talking about.

"That's not necessary," I say.

"No, no," Shail says, pulling a pair of rubber boots from his trunk. "This is what I do for a living."

"You don't have to do that," I say again. But Shail has already drained the last few sips of iced tea from a plastic bottle to use as a sample container, and now he's climbing down through the brambles at the bank. I hear him half shout something from below the bridge about what kind of minerals he expects to find, and then his voice starts coming from the other side of the bridge; he has crossed beneath the road. "I'm looking for fast water moving over a block," Shail says, "so that the grains sort of drop out."

Shail digs his hand into the bed downstream of one of the square blocks that form a base for the bridge. Success! Maybe. "Hang on. I do have my hand lens," Shail says, reaching down the collar of his shirt. Indeed he has a lens on a chain around his neck, worn like an amulet. He looks through it at the mud, nods, dumps it into the bottle.

Climbing back out of the creek, Shail catches his jacket on bramble thorns only once. He's used to it. "Had there not been a plate collision here giving us a little slice of ocean floor from the Devonian, Gregor wouldn't have had ilmenite to sample here," Shail says. He hands me the bottle, a quarter full of black and gray-black sand. Some of it is titanium oxide.

That evening, I dump the mud into the bathtub in my hotel room, hoping it'll dry out, but by the next morning it's still mud, and I need the bathtub to be a bathtub. I gather as much of it as I can into a plastic bag, which I wrap tightly around itself a few times, put into another plastic bag, and shove into my suitcase. With two weeks of travel yet to come, I try not to think about how to explain this to curious Customs agents. ("Imagine the island of Britain, its southwestern corner extending a peninsula like a dainty Victorian foot toward the Celtic Sea" is how I'd probably start.)

Actually, no one asked me what was in my bag of dirt. Back home, I put it in an uncovered glass dish and let it sit in my kitchen, reminding everyone in my family at least twice a day for two or three days not to throw it away. Eventually it was dry as Southern California, and it had a silvery sheen. I poured it into a little glass jar and screwed on a plastic cap. It's sitting on a shelf next to my bed.

Picture a butterfly. Something really exotic and beautiful, iridescent blue and green wings, orange tips, whatever. That's color, right? Out there, in the natural world, glinting in sunlight, a definitional vision of the miracle of life on Earth.

What's it for, though? Well, sex, sometimes. Color, especially the garish butterfly kind of color, gave Charles Darwin the idea that traits that made something better suited to its environment, or better able to get food or avoid becoming food, weren't the only

things that pushed evolution along. Darwin and his pal and fellow scientist Alfred Wallace spent a lot of time talking about this idea — letters about why some male butterflies were more beautiful than female ones and so on. Darwin's idea was that the colors were to look hot.

In Darwin's construction, living things had features that evolved only to compete for mates. That might be stuff like antlers, for fighting, but also ornamentation. That's the idea that would become a follow-up to *On the Origin of Species.* Darwin's 1871 book was called *The Descent of Man, and Selection in Relation to Sex.*

Now, butterflies see color, sure — on each other's wings and out in the world. They do it with very weird eyes. They have that multifaceted, compound bug thing; each one of those facets is the top of a column-like structure called an ommatidium, a lens atop a crystal cone that directs light inward to a long, stemlike crystal called a rhabdom.

That rhabdom is studded with molecular sensors called photoreceptors, which respond to the presence of light. Human eyes have them too — in fact, ours are very much like the ones butterflies have. One of the ways we measure that light is with a value called wavelength, fluctuations in the electrical and magnetic fields all around us. The whole range of possible wavelengths is the electromagnetic spectrum, from radiation to heat; we see a thin slice of that continuum, which we call the visible spectrum.

That's colors.

Human photoreceptors are tuned to the long, middle, and short wavelengths of the visible spectrum — red, green, and blue, basically. Butterflies are different. Some species have receptors for long red wavelengths, but some have receptors tuned to middle, short, and *very* short, or let's say green, blue, and ultraviolet.

That's *also* colors. But not ours.

We never know what the butterfly sees. For that matter, we might not even be able to know what a human sees, really. Normal variation and experience says that whatever happens inside my skull has to be just a little bit different from what happens in yours. And color is one of the best examples of that. Not to get all stoned-

in-a-dorm-room on you, but how can we really *know* whether the red you see is the same as the red I see . . . or if the thing I mean by "red" is the same as the thing you mean by "red"? That butterfly I asked you to imagine a few paragraphs back might look completely different to you than it does to me. Like . . . *whoa.*

Except one thing separates humans from butterflies, and in fact from all the other living things we share the planet with. We're the only ones who habitually, deftly, obsessively make things we find into materials with color. We use science and technology to adapt materials from the natural world and use them to add color to other things — not just for sex, either. Even though lots of other creatures use tools, this adaptive repurposing is one of the defining traits of humanity. And one of the key applications for that skill throughout human history has been the use of natural and synthetic chemicals and careful engineering to recreate the colors we see and to create newer colored materials in ever-increasing numbers.

And then a funny thing happens. Every time humans learn to make new colors, those colors teach us something — about art, or how we see, or how to make even newer colors. Those literal insights inevitably snap back around and teach us how to put new colors on new materials. Like the mind-bendingly fast oscillations between electricity and magnetism that compose light itself, the oscillation between seeing and learning is a steady hum in the background of human history.

Outside your head is a world — an uncountable number of subatomic particles interacting in super-weird ways to make matter, energy, planets, stars, people, buildings, TV shows, light, this book. Everything. All the things.

In your head you have a lump of gelled protein and fat that is everything you are — everything you know and remember and, beyond that, everything you perceive about the world, built moment by moment.

Between the world of everything outside your skull and the thoughtful aspic inside it are sensors, biological marvels studding the outside of your body that, in ways both understood and not so much, take input from that outside world of subatomic particles

and turn it into impulses that your think-meat can use to create a sensible impression of the world.

And at the crossroads of all three are the hands and tools that human beings use to re-forge those subatomic particles into new objects, new impressions for the lump of gelled protein to cogitate on.

If you want to know how all that works, and what we humans do with it all, color is the best way to find out.

Between the years 1495 and 2015, people published more than 3,200 books about color. That tally comes too late to account for the works of the Greek and Roman philosophers, nor does it include the books written by Arab and Chinese scientists and scholars during what Westerners typically call the Middle Ages. So as high a number as 3,200 is, it's a lowball. Yet here I am with another book about color.

This book will roughly follow the back-and-forth of color between — to be reductionist about it — physics and mind. People make colored things, and material that confers color. That's pigments, dyes, paints, cosmetics, whatever. Then they learn about how colors work, their physics and chemistry and neuroscience. Then, with all that knowledge, people make more colors. The wavelength changes, but the oscillation stays the same.

I'll acknowledge, though, that the route we'll take for the next couple hundred pages is less ballistic than circuitous. Idiosyncratic, even.

I start at the beginning of humanity's experiments with making colors that say something about the world, in the protected caves of the Middle Stone Age, 100,000 years ago. That's the age of the oldest paint-making workshop ever found in a cave in South Africa called Blombos. I'm calling this a rough starting point for when people started to convert the natural materials of the world around them into things for making colors — for craft, tools, and art.

We'll take a detour here to ask how (and why) living things see color at all. Making distinctions between different kinds of light must have some kind of evolutionary advantage, or the skill set

wouldn't have stuck around. That probably started with an ancient, microscopic form of life different from any other living thing on Earth, so unlike us humans that either they or us might actually be aliens. Somehow those critters converted an ability to feed on light — like photosynthesis — into an ability to tell by that light's color whether a spot under the ocean was a good place to find food. Light, defined by its color, transformed from power to knowledge.

Color didn't become commerce, though, until humans had trade. The earliest human civilizations had multiple pigments, made colorful art, and argued about its meaning. And when human trade was in full swing in the early centuries of the common era, the color of objects could immeasurably increase their value. The tidal ebb and flow of goods between China and the Abbasid empire (and points along the way, on the Silk Road) was driven by color. Silk got dyed, of course — a dye, basically, is a pigment that gets absorbed into a material rather than sitting atop it. But we're going to focus on a separate revenue line: ceramics, specifically light, strong porcelain, and how the pursuit of the technology to make it and give it pretty colors drove whole civilizations.

In fact, those colors and their origin stories became so important that early scientists were compelled to learn what made them. That story often starts with Aristotle and then jumps, Time Lord–like, to Isaac Newton. But bridging the philosophical and technical gap between the Greeks and the Enlightenment was actually the work of a few centuries of Arab scholarship, of translators and innovators who read the work of people like Aristotle and said, "Well, that's not right." People like Al-Farisi, shining light through water-filled glass spheres to give numerical form to light and physics, made possible the Renaissance and Enlightenment.

And without the Enlightenment and the rise of the scientific method as a way of comprehending the world, we wouldn't have had the rollicking color science of the eighteenth and nineteenth centuries. That's when people started inventing new pigments that made colors never before seen on Earth, and new ways to reproduce images to take advantage of them. They also finally figured

out how the eye perceived color, kicking off modern physics in the process.

Even as people started creating more and more synthetic colors, the color white stood apart, both chemically and symbolically. One pigment, lead white, had been dominant since ancient Egypt and the peak of the Roman empire. It was also hideously toxic.

At the World's Columbian Exposition of 1893, the millennia-old back-and-forth between achromatic all-white and the brightly multicolored cacophony of the coming century came to a head. The so-called White City, designed and built by the leading architects and planners of the day, relied on boring columns, temples, and whiteness — both the physics kind and the racial kind. But one structure, the polychromatic Transportation Building, stood out. Built by Louis Sullivan, one of the fathers of the skyscraper, the building was the product of a color theory powered by a new science of how the mind assembles what it sees.

All the pieces were in place. The science was there, as was the demand. At the height of the Industrial Revolution, an engineer named Auguste Rossi would try to figure out how to use titanium to make a better steel alloy in an electric furnace driven by the power of Niagara Falls — pretty damn American, all that. His efforts would fail, but in the process he'd realize that a side product, a brilliantly white powder of titanium dioxide, could be a white pigment. Within decades, it'd dominate that industry. It still does today.

The postwar world saw a boom in mass-produced color and colorful objects, but a mystery emerged as well: Not everyone sees color the same way. Not everyone uses the same words to mean the same colors — among individuals and across entire cultures. But as color science and new pigments became more and more ubiquitous, it became clear that part of the mystery of how people saw colors and how we felt about them had to do with the words we used to describe them. So in the 1970s, the linguists Paul Kay and Brent Berlin sent investigators around the world to see how people talk about colors, and their work is still a key to understanding the human *Umwelt*. Color was proving to be a tool not only for chang-

ing the technologically powered world, but also to understand the inner worlds of language and cognition.

That work extended even deeper into the brain and mind, as mid-twentieth-century neurophysiologists began the work, still under way, of figuring out just how that blob of goo in the human skull turned light into an impression of color. That science is still exciting, by which I mean, nobody really understands it yet. One of the best pieces of proof that this science isn't finished yet came in 2015, when a single color image of a blue dress — it was blue, not white, OK? — divided the world. With the internet having made its way into every pocket and purse, ubiquitous high-quality screens have given people the ability to recreate a nearly infinite palette. But that chromatic omnipotence — filtered through a polarizing picture of a blue dress taken in late afternoon — shows that everyone has their own version of that infinity. Deconstructing it may also teach scientists exactly how the eye and brain create a consistent world of color even while the colors around us change.

That'll lead to a future of color technology, too. Powered by digital projectors and advanced 3D printers, colorists are making all kinds of old colors look new, and new colors indistinguishable from old. Understanding how the eye takes color in and holds on to an idea of it allowed art conservators to rescue dying canvasses painted by the great Mark Rothko, and print art forgeries nearly indistinguishable from the originals — even if only black-box artificial intelligences understand how it works.

Today, all those screens, all those eyes, and all those brains conspire to create impossible colors and a spectrum not only of light but of emotion. The secret might be luminance, the distance between light and dark, its extremes mimicked by brighter-than-bright beetles and a so-called superblack pigment that ripped apart the contemporary art world. Riding that line between light and dark, the color wizard animators at Pixar, given the highest possible technology, are able to create colors only visible on special screens . . . and maybe, someday, using lasers and code, they'll invoke colors that exist only in the minds of audiences rather than on screens at all.

It'd be a profound achievement, though fundamentally they're still trying to do exactly what the Blombos Cave paint-makers were doing—evoke a state, an emotion, an intimate connection with the world by, to be super reductionist about it, bouncing photons into your eye. Now they're just better at it.

This book leaves a lot out. For one thing, I'm not going to spend much time on the psychology of design and color preference, or ideas on how blue is trustworthy and red is powerful. Mostly that's because little science is behind these ideas. They're—sorry—bollocks. Or, perhaps more diplomatically, those intuitions about what colors mean vary from culture to culture, era to era, and individual to individual.

Likewise, this book isn't a complete history of every color—or, rather, a catalog of lots of pigments and how they came to be. I'll be talking about a little of that where it's appropriate, because the invention of different pigments has been a key to unlocking the history of technology. But this book isn't a list of colors or chemicals. Other writers have written those histories better than I ever could.

A few chapters down the line, there's a car chase. That's fun. It ends with some crooks getting arrested; I don't want to spoil it. But I will say that during opening statements at the eventual trial, an attorney for the defense borrowed from the prosecutor a small sample of bright-white titanium dioxide powder—because that was the MacGuffin in the case—and said, "There have been white things before the iPhone. There were houses painted with white paint a long time ago. There were cars that were white a long time ago . . . Yes, there's a lot of it sold because there's a lot of white things in the world, but in terms of the technology for making this white powder, that's been around forever."

I mean no disrespect to the attorney, but this manages to misunderstand the entire history of technology and the human relationship to color. In a sense, this whole book is basically me pushing up my glasses and suggesting an alternative reading. The story of why it made sense for a would-be Chinese spy to risk (and lose) his freedom for a few million dollars is just one example of the human obsession with color—not just its aesthetics, but the literal stuff of it.

Humans have hungered to know what color is made of, and how to make color and colored things. It was one of our first sciences, and it's still one we get the most emotional about. For millennia philosophers, artists, and scientists have argued about whether form — the shapes of things — is more or less important than color. This is my alternative read: It's a false choice. All those hues and shades on every surface define how we think. They define the world we live in and the one we hope to build. The fight isn't between color and form; color *is* form, giving our universe shape.

FULL SPECTRUM

ONE

EARTH TONES

The wide, low opening of Blombos Cave, about three hundred kilometers from Cape Town, looks out over the shimmering Indian Ocean. The space inside the cave isn't large, maybe the size of a suburban bedroom, but few places on Earth have had more to say about how *Homo sapiens* became human. In the dirt under Blombos's floor, archaeologists found the oldest evidence of people learning to make art — and color.

Blombos is one of a handful of South African caves with evidence of Stone Age habitation — from 110,000 years ago to 75,000 years ago. It has yielded a treasure trove of evidence for how the southern African humans of the Middle Stone Age thought about tools and art. "We call them caves, but often they're actually rock shelters in sandstone cliffs or quartzite. Sometimes they're a little bit of a climb, a few meters up, and they're usually close to a freshwater source," says Tammy Hodgskiss, curator of the Origins Center at the University of Witwatersrand in Johannesburg. "They would have looked quite different then. There's been a lot of sand that's come in and blocked a lot of spaces." Sea levels are different today; when the caves were inhabited, they might have been as much as twenty kilometers from the coast, rather than having the pricy beachfront views they enjoy today.

Think of the ground inside the cave as a sort of vertical timeline. Stuff buried in the uppermost layers is more recent; the deeper you go, the farther back in time you travel.

The top layers of Blombos, the most recent, have yielded narrow, pear-shaped stone tools called bifacial foliate points. The archaeologist Christopher Henshilwood (whose grandfather owned the land around Blombos before it became a protected nature reserve) also found forty-one beads made of the shells of a sea snail — Henshilwood's team knows they're beads because they have holes poked through them, as though someone shoved a pointed object through the snail's natural opening and out the back in preparation for stringing. Diggers have also found engraved bones, another example of early human decorative art.

Those layers also turned up a mineral called ochre. This is where things get interesting. The ochre colors — reds, yellows, oranges, and browns — were among the very first pigments used by humans. Which is to say, the archaeological record contains evidence of human beings gathering these iron-oxide-based minerals, grinding as many of them as possible into particles the size of a single bacterium or a mote of dust (between 0.01 and 1 micron), and then mixing them into some kind of medium that would hold them together and let them stick, mostly permanently, onto something for purposes of giving it a color that it didn't have before. Along with white made from chalk or calcium carbonate, and black derived from charcoal or manganese dioxide, the ochres were the foundational palette of human art.

Things have colors for lots of different reasons, and science, philosophy, and art all have lots of different ways to talk about those reasons. But one way to talk about color is by thinking about light as a wave. It's not exactly like a wave in the ocean, because there's no medium for it to move through like the water, but the principle's the same. In this case, the wave is an oscillation between electrical fields and magnetic fields. Light moves really fast, and these oscillations are really tiny. Between roughly 390 nanometers — that's billionths of a meter — to about 750, our eyes can see those wavelengths. And different wavelengths of light, either ambient or reflected off of a surface, correspond to different colors. The short ones are bluer, and the long ones are redder. If you mix all those different wavelengths of light together, you get white light.

Now, ochre is basically iron bound up with oxygen. Iron by itself reflects almost every wavelength of light equally but not well, which is another way of saying that it is sort of gray but shiny and metallic. That's because a metallic element's color is largely determined by basic physics. Atoms have a nucleus made of neutrons and protons, orbited by charged particles called electrons. Those electrons orbit at specific distances from the nucleus, and each one of those distances, called a shell, is capable of housing a specific number of electrons. If it's full, it'll reflect a lot of light across a wide spectrum—like shiny silver, for example. Iron's outer shell isn't full up, so even though it reflects pretty much across the entire visible spectrum, it does so poorly. Hence the dull gray sheen.

Having room for more electrons also means that iron will join up with other like-minded elements, especially oxygen. When it does, that changes again the wavelengths of light it reflects. The resulting color depends on how the bonds are formed and whether the result has other elemental impurities.

You've seen what iron oxide looks like; it's rust.

Iron oxides also account for the spectacular colors of the American southwestern desert and the red of Martian regolith. The metal is relatively common on Earth and makes up nearly 7 percent of the upper layer of Earth's crust. The most visible part of the geological world is reddish brown. So it's no surprise that humans made use of the stuff. When archaeologists study the Middle Stone Age, they find a lot of stone tools and a lot of red ochre.

They don't just find that ochre as fragments of crumbly rock, though. At Blombos, 10 to 20 meters below present-day sea level —corresponding to 100,000 years ago—amid a layer of dune over a thin dusting of orange sand, Henshilwood's team found two remarkable sets of tools.

Specifically, the researchers found abalone shells fitted with a smaller stone shaped to match the abalones' curves. Both shells had, on their interior, layers of red ochre and signs of crushed "trabecular" bone—the spongy, porous bone that vertebrae are made of. A thousand centuries ago, when it was fresh, trabecular bone would've been full of fat and marrow. The abalone shells also had

signs of powdered hematite — a dark-colored iron oxide — as well as charcoal and quartz grains. A line around the inside of the shells suggested that they'd once held a liquid, a mix of all that mineral and organic sludge. The team also uncovered plate-like slabs of quartzite stained with ochre.

Now, here comes the inference: Traces of powder on the quartzite slabs suggest they were used to crush and grind rock fragments into small particles. Gooey, sticky trabecular fat and marrow would be good for binding small particles into a paste. Hypothetically, these were tools for making paint.

A thousand centuries ago, Blombos was a workshop — by some estimates, the oldest paint-making workshop ever found.

Probably. Researchers are definitely making some guesses here, but they're educated ones. As minerals go, ochres have high pigmenting power, which is to say, they'll stain your clothes and stick to your fingers if you touch them in the wild. Ochre leaves a mark when you rub the rock against just about any surface. Also, a workshop for converting ochre into an even more efficient colorant begs the question of why they were doing it. Maybe it was for decoration — for art. But ochre has other uses too.

Let's say it was for art. Grinding a raw material into a useful pigment and mixing it into a paint is a complicated technology even today; a 100,000-year-old example of the technology is astounding.

To explain why, I have to first talk about a different way of measuring light and color. I mentioned wavelength a few paragraphs back, but scientists also describe light in terms of subatomic particles called photons. The universe's basic operating system says that these little packets of energy are, by definition, the least possible amount of energy you can get. They stream from the star at the center of our solar system, a tsunami of electromagnetic oscillation.

Every second, roughly 1.21 sextillion photons blast every single square meter of the sunlit surface of Earth. As they blast through the atmosphere at the speed of light — again, by definition — they interact with the tiniest stuff in the air. Sometimes they hit a mote of dust or a molecule of water. Sometimes they just catch the edge of one, and because at this scale the edges of things aren't always

well defined with regard to the edges of other things, that glancing blow might catch hold of the photon and fling it in another direction, like losing your grip on your ice-skating partner's arm on the outside of a turn. Photons can have different amounts of energy, and that energy is *also* what determines what color that photon is.

Now we can get back to paints. A paint — a colored coating — is generally a suspension of particles of some colorant in a liquid binder whose job it is to keep the particles the right distance apart and help them adhere to a surface. Particle size is key to how they scatter light. Particles that absorb every kind of photon (usually coughing the energy back out as heat) yield an opaque black coating. Particles that scatter all light in all directions are what we humans see in aggregate as white. If those particles are roughly the size of the wavelength of incoming light or larger, they scatter — a lot. That's called Mie scattering, named for the physicist Gustav Mie, who worked on the problem in the early twentieth century. Mie scattering is why clouds — made of relatively large water droplets surrounded by air — are white. Mie scattering is why a foaming river rapid — made of bubbles of air surrounded by water, the inverse of a cloud — is *also* white.

But as the size of particles decreases, certain wavelengths of light scatter more readily than others, depending on the material of the particle. That's Rayleigh scattering. (Named for John William Strutt, Lord Rayleigh, who figured this out while working on electromagnetism in the 1870s.) It turns out that water vapor — particles of water dispersed in air — preferentially scatters blue light. Rayleigh scattering is why the sky, full of teeny-tiny bits of water, is blue.

Point is, particle size has a huge effect on color — especially in the different kinds of ochre. At 0.1 microns, particles of hematite, Fe_2O_3, are red. But between 1 and 5 microns, they're blue-red or purple. At a diameter of 1 micron, goethite (FeOOH) is a common yellow, but particles smaller than 0.2 microns give you a brown.

Heat changes the game too; it turns yellow ochre red (by tweaking its crystal structure to that of hematite) and red ochre purple. This screws up archaeologists all the time, because if you mistake

intrinsically red ochre for yellow ochre that someone *turned* red, you've missed an important application of technology and all sorts of deductions about where they acquired their raw materials.

So these humans of the Middle Stone Age who'd turned Blombos Cave into an ochre-paint workshop were using the highest technology of the day to turn red, yellow, and orange rocks into powders with particle diameters just right to scatter light in a precise way. In other words, they were manufacturing a more colorful world.

Some of the colors they made might have been more equal than others. Even with, it seems, just six colors to work with — black, white, red, yellow, orange, and purple — red took cultural and technical priority.

Maybe it symbolized blood — something humans would have cared a lot about, presumably. In Qafzeh Cave in Israel, archaeologists found many more samples of hematite, the reddish iron oxide, than goethite, which is yellow, even though both were available nearby. Why? One possible explanation is the "sham menstruation" hypothesis. Blood, specifically menstrual blood, would have had obvious significance in small human groups. A cosmetic that could simulate its presence might have been valuable in a ritual setting.

Other plausible explanations complicate all this storytelling. Early humans could have used ochre for reasons other than its color. "With the Middle Stone Age it's easy to go, 'Well, it's used like that today, so it was used like that then.' We have to be careful and say we don't have evidence they actually did that," Hodgskiss says. "Even though it's pretty much confirmed they had the same cognitive abilities and looked like us, we have to be cautious in how we interpret the data."

Red ochre isn't just red. Mixed with sticky stuff, it can make a strong glue. And in Hodgskiss's work at Sidubu Cave, another South African site, she finds evidence that this chemical property was its more valuable quality. After seeing hints of red ochre on stone tools near where they would've joined with a handle Hodgskiss and her colleagues tried a bunch of different recipes for a useful tool glue

themselves, using combinations of acacia gum (a sticky tree resin, synthetic red ochre, natural red and yellow ochres, and wax. Of fifteen glues, by far the most successful was a simple combination of one particular gum and natural red ochre, which helped keep the resin from drying out, making a less brittle glue — one less likely to shatter when the tool strikes a target. They concluded that this ochre-and-resin concoction was more than just glue. It was a "complex compound adhesive," and the finicky recipe showed that the people who made it weren't just fooling around. They'd have had to experiment with ingredients and use sophisticated "enhanced working memory" to apply the glue to their tools — all necessary conditions for what archaeologists and anthropologists call complex cognition. Using red ochre shows they were thinking. "They could have mixed tree resin with the powder to make a really nice glue," Hodgskiss says. "It seems to be a really good additive in the resin to make it nice and strong."

Or, sure, it could totally be something else. Archaeology is frustrating. For example, the Ovahimba people of northern Namibia today mix red ochre with a clarified butter to make a cosmetic called *otjise*. Women wear it on their bodies and in their hair, and the Ovahimba apply it to corpses before burial. Until the 1960s or so, men applied it to themselves before weddings or journeys. *Otjise* was decoration, but also sunscreen, or maybe mosquito repellent.

The sunscreen part still isn't verified, though it's true that ochres can absorb ultraviolet, the invisible wavelength of light that gives us sunburns. But in 2015 a South African bioarchaeologist named Riaan Rifkin published a paper describing what happened when he tried out the mosquito part. Rifkin made *otjise* with six different kinds of ochre, Ovahimban clarified butter, and antelope fat. Then a person identified only as a "female subject" rubbed each on her arm and presented that potential meal to *Aedes aegypti* mosquitoes. These were pathogen-free, but *A. aegypti* can carry chikungunya, dengue, yellow fever, and Zika, so this experiment was no joke. For comparison, Rifkin and his team also used bare skin, a couple of "organic" repellents, and also DEET, the hiker's companion.

The ochre-and-butter combination did … fine. It's not DEET.

Red ochre does better than other colors, though. Even taking into account Hodgskiss's caution against using present-day applications as an indication of what people did a thousand centuries ago, *otjise* is a bug repellent, a hide-tanning ingredient, sunscreen—and a cosmetic, whose color has symbolic value.

The human eye and the human brain had evolved, tens of thousands of years ago, to understand the world and their place in it well enough to make art. The available palette, however, had not.

You can see a perfect example of this in France, in prehistoric paintings on the walls of the Lascaux Cave. Sort of. Visitors to the Lascaux Cave don't actually get to go to the Lascaux Cave; partway up the hillside with the actual cave inside it, surrounded by parking lots and wide gardens, is an angular concrete building that would be brutalist if it weren't for the big windows and the grass-planted roof. It's the Lascaux IV: International Centre for Parietal Art, overlooking the wide Vézère River valley in the south of France. If the architecture is brutalist, that's in counterpoint to what's inside the museum, which is decidedly postmodern. It's one big ball of simulacra.

Outside, some minutes away, is a cave full of beautifully realized art painted by early humans. No one gets into the cave. Instead, inside the museum, accessible via an elevator big enough for an entire tour group, is a fake cave that perfectly reproduces the real cave full of beautifully realized art painted by early humans.

Fortified with local beer and cheese from a riverside café in the nearby town of Montignac, I didn't mind the discordance so much —especially because the trip into the "cave," while not as cool as going to the actual cave, still manages to convey a sense of wonder. It's a simulation, but a very good one. The display's sheer artifice, its digitally surveyed walls and indirect lighting, brings into literal relief what it must have been like to paint the horses, big cats, and other wild animals of the valley twenty thousand years before (or so), all in motion, with a rough approximation of perspective . . . using blowpipes and rough brushes, and animal-fat lamps to see.

Black-outlined animals with patches of red were placed on the

exact parts of the rock that would make them stand out and give them shape. Darker, thicker black suggests shadow and three-dimensional form. The blowpipes' airbrush effect lets some animals fade into distance, or out of existence, while others almost magically appear. It must have looked amazing by fat lamp.

The difficulty with using art, even art as magnificent as the art in the Lascaux Cave, to try to understand the consciousness of the people who made it is that their available materials couldn't hope to match what they saw. Outside the cave setup in the museum, curators have arranged a line of glass beakers containing powdered pigments, with examples of the source rocks nearby. Two are the usual suspects, yellow goethite and red hematite. The white is "white clay," which could mean calcite, calcium carbonate, or something else. (Identifying Paleolithic white pigment can be tricky; calcium carbonate, for example, can come from chalk, oyster shells, or eggshells, among other sources, and the only way to tell which is what is to mount a dispersion of the pigment on a microscope slide and look.) And the black . . . Well, let me come back to that.

But from the museum's front door, the valley spreads out for miles. Its green, tree-lined hillsides slope down to a winding, sparkling gray-blue river under skies of the azure that, when I first saw it, made me realize that all those paintings of the south of France from the 1800s make some compelling points. The colors of the world weren't reproduced in the colors of the cave art.

Anyway, I bought a plastic package of ground-ochre pigments in the gift shop. It contained four colors—red, yellow, orange, and brown. Presumably some modern-day artists would be able to bind it into useful paint. I just wanted to look at the color gamut.

That's the salient part—the colors available to those early humans. The people who painted Lascaux had roughly the same kind of eyes and brains as you and I. They had retinas that could see three different peak wavelengths, roughly approximating red, green, and blue, and with those and a whole lot of neurons, they could build a vision of the world. But their art—the colors they made—couldn't match it.

———

Even before proto-French people were painting the cave at Lascaux, early Australians were doing much the same. Well, give or take—the only way to date the specific paintings I'm going to talk about, the gwion gwion rock art, is through inference. Many of the images depict the boab tree, which arrived in Australia 70,000 years ago. But they also show animals that went extinct 46,000 years ago. So sometime between those two markers. A wide margin.

Gwion gwion art—also called the Bradshaw rock art by European colonizers—is found on cave walls in the northwest of the continent, spread across a hundred thousand sites in the Kimberley region. Wandjina rock art (from another era but in the same locations) included, the area has more than a hundred thousand paintings; the gwion gwion ones depict, among other things, elongated human figures hunting with spears and ornamented with elaborate headdresses, weapons like boomerangs, clawed hands . . . It's all pretty exciting stuff. And the color gamut is the familiar one: red and yellow ochres, black, and white.

But on at least a few of those paintings, that ain't ochre and that black ain't the usual carbon. Gwion gwion paintings take hundreds of years to weather and fade, and in the late 2000s a team of researchers based at the University of Queensland tried to figure out why. They isolated eighty individual figures easily identifiable as gwion gwion work—so-called Tassel and Sash figures—located along an imaginary line from east to west across the Kimberley. And from 80 percent of them, the team isolated from the red and yellow coloration not iron oxide but DNA. Figures famously described as having a mulberry color turned out to be mostly a fungus from the order *Chaetothyriales,* a black fungus that loves to live on rock faces, alongside a red cyanobacteria the team couldn't identify. Other shades described as "cherry" or "terra-cotta" included more of the cyanobacteria. The biofilm created by the microorganisms was not only coloring the paintings but protecting them from weathering.

That's cool for its own sake, of course—most of the time, microbes like those fungi destroy ancient rock art rather than preserve it. But it's also interesting because of the early role that microbes played

in bringing color to life on Earth. That wasn't these fungi, though, and it happened billions of years before they stuck to a rock face in Australia.

Just thinking evolutionarily, it's hard to figure why microorganisms would have colors at all. It's hard to figure why *anything* has colors. Why, on Earth, do living things have sensors that differentiate among fluctuations in electromagnetic energy? Evolution says every trait that persists across generations must somehow help a species make babies that survive to make babies. So being able to see colors must do . . . that?

Microbes, though, don't even have eyes. They don't see color in each other. So those Australian fungi must derive an evolutionary advantage from being colorful that has nothing to do with actually seeing the colors.

One answer to the question of why Earthlings bother to perceive a thin slice of spectrum as color lives in the guts of some of the oldest microbes on the planet, the genus *Halobacterium*. Despite their name, they're not bacteria at all. Taxonomically, halobacteria are members of the domain Archaea, an entirely different branch of the tree of life than the one leading to you and me and all the other animals, plants, fungi, and slime molds. Ancient and quirky, the Archaea include what scientists have come to call extremophiles, creatures that live in the hottest, driest, most acidic, saltiest, and all-around harshest environments on Earth.

Halobacteria's thing is salt. They live in brine, water with a salinity level so high — 25 percent is ideal — it'd turn cells like ours into dust. Some special biochemistry lets them resist DNA damage from levels of ultraviolet light and ionizing radiation high enough to turn you and me into sunburned cancer blobs. They're oblong, about 6 microns long and half a micron wide, with stubby little flagella on either end that they wave around to swim. They eat amino acids. When a salty body of water like the ponds at the south end of San Francisco Bay, or parts of Utah's Great Salt Lake, get overwhelmed with halobacterium, the water turns red, or even purple.

Maybe it's too dumb even to say, but halobacteria are too small to see color — or anything, really, as they are too small to have eyes

by many orders of magnitude. So you can imagine that it really confused scientists to find out that halobacteria swim toward orange light and away from blue. That's called phototaxis, light-based motion.

In the 1960s, cell biologists learned that halobacteria carry around a bunch of pigments, which are really just specialized chemicals that transmit and absorb specific wavelengths of light, after all. One that you and I might say looks red, bacterioruberin, is an antioxidant that neutralizes the damage caused by UV. A yellow one, they said at the time, came from the membranes around tiny bubbles inside the halobacteria called "gas vacuoles," which help the cell float. And then there was a purple one. Nobody knew what the purple one did.

It was a protein, medium-sized as proteins go, and like all pigments it had at its heart a wee little complex called a chromophore. From the dyes in your clothes to the light-sensing pigments in your eyes, the chromophore is the part that absorbs some kinds of light and reflects the rest. When they're part of animal eyes, where they play a role in vision, those pigments are usually called opsins; one of the most basic ones is a pinkish-purple-looking one called rhodopsin. ("Rhodon" is Greek for "rose-colored," and "opsis" is "sight.") The chromophore at its heart is a molecule called 11-cis-retinal.

Halobacteria avoid blue and near-UV light, and swim toward orangish light. So, guessing that they might accomplish this using the same machinery that humans use to distinguish among wavelengths of light, researchers went hunting for retinal — the same chromophore humans have — in halobacteria's purple photopigment. They found it, and named the bigger molecule that contained the retinal "bacteriorhodopsin," even though halobacteria, again, are not bacteria and this was not rhodopsin.

One thing this molecule was assuredly not doing was seeing color. "They had a number of surprises," says Wouter Hoff, a biochemist at Oklahoma State University who studies rhodopsin evolution. "Maybe the most important was that bacteriorhodopsin is not involved in vision, in detecting light." Instead, the halobacteria bacteriorhodopsin was a battery — well, more of a capacitor, really,

pulling in photons to make energy via something called a proton pump. In other words, halobacteria do a version of photosynthesis, drawing energy directly from the sun, but instead of using the chlorophyll pigment that does that work in modern plants, halobacteria have . . . whatever this was.

How does it work? Yes, well, about that: "I'm a biochemist, my wife is a biophysicist, and if you ask us, we would say we still don't really understand how proton pumping works, not even in bacteriorhodopsin," Hoff says.

Halobacteria got even more confusing upon further dissection. In addition to that proton-pumping photosynthesizer, they actually *do* contain classical rhodopsin. Two different kinds, actually. "Those, the organisms do use for sensing light. For vision," Hoff says. Well, not "vision," exactly, because they don't have eyes, so maybe "perception," except they don't have brains, either, so . . . Hmm. It's a problem.

Either way, halobacteria are using light for both energy and information, and the color of that light is the key. The specific amino acids in an opsin determine what wavelength of light the chromophore will respond to. Halobacteria have at least two sensory pigments sensitive to different peak spectra. In a way, this archaeal setup checks all the boxes for simple color vision.

Now, it'd be great to be able to say, at this point, "A-ha! Here is the evolutionary ancestor of *our* color vision, billions of years old, a living fossil." But that story (like a lot of evolutionary stories) is more just-so than so. Halobacteria sensory rhodopsin doesn't transmit the signal "I caught a photon" the same way animal rhodopsins do. It uses a whole different Rube Goldberg–ian mechanism.

It's true that lots of living things perceive light and color using opsins in some form. It's also true that halobacteria's light-sensing proteins have the same broad structure as ours, the same shape. But they're made of a completely different sequence of amino acids, like using different Legos to make the same spaceship. As Hoff says, it makes sense to suspect that all those proteins — the proton-pumping bacteriorhodopsin and the ones that sense changes in wavelength — arose from the same ancestral protein. But as to

whether that ancestral protein made energy or sensed light, "the field is divided," Hoff says. "It's a question that's really difficult to address."

That could mean ours evolved from them, or that all of them evolved from some super-ancient ur-protein. But it could also be true that evolution solved a problem one way for Archaea, and then billions of years later solved the same problem in much the same way for our ancestors — building the same machine with different Legos. Somewhere along this broken line, life on Earth made an evolutionary deal, adapting the ways they gained power to also gain understanding. Unlike Faust, they lost nothing, yet still gained the light of knowledge.

Today, hundreds of millions of years up the line, lots of animals see color better than we humans do. The garishly colored mantis shrimp has twelve photoreceptor classes, though it's nevertheless unclear how well they distinguish among colors. Chickens — lowly chickens! — have a rhodopsin for low-light conditions, four color-sensing pigments, and a pigment in their pineal glands (uninventively called pinopsin) that uses light to help set their circadian rhythm. That's quite a bit of color, but chickens aren't so lowly, really. They're the evolutionary offspring of dinosaurs, after all.

Compared to all that, animals more closely related to humans can seem sort of blah. Many primates (not to mention horses, dogs, and barracuda) have just two visual pigments for color, and scientists presume they see a world not quite in black-and-white, but very much like the one perceived by a red-green colorblind human. Thanks to evolutionary pressures that scientists still aren't sure about, though, 30 or 40 million years ago some Old World primate in *our* family tree reacquired a different third pigment. Straight-up rhodopsin, the visual purple we humans use for low-light night vision, actually evolved from one of the pigments we inherited from the early mammal-ancestor.

So this is us: four visual pigments. We have a rhodopsin that's really just for seeing in the dark, one for wavelengths less than 500 nanometers (bluish!), and two very similar ones for wavelengths greater than 500 nanometers (greenish and reddish!). That means

we humans have three sensors to differentiate colored light. We live in what a vision researcher might call a trichromatic color-space. But until very recently (on the kinds of timescales that anthropologists and archaeologists care about, anyway), humans had no way of recapitulating that trichromatic space. The universe of color we lived in and the universe of color we could make to depict it barely overlapped.

Early humans lived in the same world of color that we do, but they couldn't replicate it. It must have been frustrating. Their color toolkit had the white-to-black axis — light to dark, "luminance," the opponency that pretty much every living creature understands. But their art had far fewer hues than the natural world — reds, yellows, purples. That's it.

Maybe. That's all archaeologists can be sure of. The evidence is so old that it might be leading everyone astray. Archaeologists worry, rightly, about "taphonomic" effects — the changes in artifacts wrought by time. Assuming that Paleolithic humans were *only* working in red-orange-yellow-purple-black-white just because those are the only colors archaeologists find today . . . well, that assumption is risky, taphonomically speaking.

As early as 1959, the archaeologist Sheldon Judson asked whether the palette of another Dordogne Paleolithic site, Les Eyzies, might have been taphonomically altered. He didn't use those terms, of course. Judson wanted to know, specifically, why researchers found "fist-sized lumps" of white China clay, kaolinite, alongside the hematite one might expect in a cave with a bit of painted surface. That kaolinite had no obvious reason for being there. The technology for turning kaolinite into pottery was thousands of years in the future. Maybe it was a pigment, but Judson noted that European cave art from that time didn't have much white in it. He suggested that the painters were using it as an extender, still a key role for white pigments even today.

That'd be interesting, because while Paleolithic cave art around the world has a lot of black, it doesn't actually have a lot of white *pigment*. Some of those artists deployed white the way modern

comic book artists do—by leaving an area color-free and letting the substrate do the work. Today it's paper; back then it was limestone, which they sometimes scraped so that it would appear even whiter. It's easy to imagine why; as symbolic as red might have been, so too might white have represented bones, skeletons, death, or emptiness.

The problem is, it might be impossible to get an accurate account of *how* symbolic, of *how* important the color white was relative to red or any of the others. Because if you make white out of water and commonly available materials like whitish clay or chalk minerals, they don't stick—or stick around—as well as ochre or manganese. Ochre adheres really well to rock walls, which also creates a kind of statistical survivor bias. Archaeologists see more red, so they think the painters *used* more red. Organic pigments other than carbon black fade quickly—so anything derived from plants or animals would be gone.

Every white pigment available to Paleolithic humans bonded poorly to rock; the paints are "fugitive." They run away. From Africa to India to Australia, researchers infer the presence of white from its absence. (Except in some rock shelters in India, where another microbial infection seems to have turned all the white pigment black.)

All of which means that cave art could have been all sorts of other colors and we'd never know. Delicate blues made from flower petals, greens from mushed-up grasses, river-mud grays—an entire preschooler's outdoor fingerpainting palette could've been up on those limestone and sandstone walls, only to be erased by taphonomy and time.

Still, even if modern humans have misunderstood the early human palette, it's still possible to assert that those Stone Age people first became *us* when they evolved the necessary neural architecture and spread the right memes from person to person—when they started making art. Using natural colors to create designs they imagined was a beginning. Using those colors to represent more accurately what they did see or what they could imagine was the full flourishing of that new intellect.

It'd be just as reasonable to call this artistic lightning bolt a scientific one, as well, as much about the development of chemistry and engineering as painterly attention to detail. Next to manganese-carbon black, these humans were heating yellow goethite until it turned red, mimicking or perhaps improving on the natural color of hematite. That colorant has as much claim, arguably, to being the first "synthetic" pigment as the more famous Egyptian blue or coal tar–based mauveine. Finding these materials, improving them beyond what nature has made, processing them, mixing them with other materials to hold them together and make them stick — this is *technic,* the combination of art, science, philosophy, and culture that has been part of humanity since we started our journey on Earth. Color becomes a symbol when it becomes science.

TWO

—

CERAMICS

Commercial sea traffic steers carefully through the waters around the small island of Belitung, an idyllic, boulder-strewn speck with white-sand beaches between Borneo and Sumatra, because of ship-rending coral reefs. That leaves a safe space for local fishermen to dive the relatively clear shallows for their daily catch. In 1998, one of these men went looking for sea cucumbers and instead found a shipwreck.

It wasn't dramatic, just a low mound on the sea floor, about seventeen meters down. But the diver could see pottery, some of it stuck in concretions of hardened lime, but much of it loose and spread across the bottom. Word traveled — all the way to a German treasure hunter named Tilman Walterfang. The director of a concrete company, Walterfang was an avid diver who had come to Indonesia after a colleague told him about the beautiful, shipwreck-studded waters there. Walterfang never left. He found a villa, started reading up on maritime history, and made friends with the local divers. One of them told him about the cucumber-diver's mound and pottery. They called it Batu Hitam, the Black Rock, though it'd soon come to be known as the Belitung wreck. Walterfang dove the wreck himself on Easter Sunday of 1998.

Belitung is in Indonesian waters, but Indonesia didn't have the resources for a full archaeological recovery. So Walterfang registered the site with the Indonesian government, which eventually licensed his company, Seabed Explorations, to salvage the wreck.

After the first leader of the recovery expedition left under mysterious circumstances, Seabed Explorations hired the maritime archaeologist Michael Flecker for the second season. (Walterfang didn't answer my emailed questions; Flecker, by email, acknowledged to me that his specialty is more marine architecture than ceramics.) The team, Flecker says, laid a grid on the site to properly diagram where every artifact came from — that's standard best practice — and took "perpendicular measurements for important objects or structural features within grid squares." As far as I can tell, the grids and those measurements were never published.

As the salvage progressed, Walterfang's divers began to realize they had something unusual. Unique, even. The boat was small, just about twenty meters long. In form it was more like an Arab or Indian dhow, which would have made it the first dhow found in the waters of Southeast Asia.

The cargo wasn't from the Arab world, though. On board were jars of star anise — a Chinese export, suggesting that country was the ship's last point of departure. Mostly, though, there were ceramics: Over a period of four months, the salvors raised more than 60,000 pieces, the vast majority (57,500 or so) identifiable as products of the famous Changsha kilns, makers of commodity stoneware during the Tang dynasty — 618 to 907 CE (with a bit of a pause in the middle for China's only empress). The oldest known piece of Changsha stoneware had been dated to the year 838 CE, but one of the bowls from the Belitung wreck had Chinese characters painted on the bottom reading: "the sixteenth day of the seventh month in the second year of Baoli era." That's the reign of the emperor Jingzong, so July 16, 826 — the height of the Tang.

That made this the oldest shipwreck that had ever been found in Southeast Asia, and the oldest evidence of the maritime Silk Road — sea routes connecting China to the Arab empires to its west, thousands of miles of trade connections that defined human civilization for the first millennium of the Common Era. As much as it's possible to generalize about millions of lives and several centuries, the years around the Tang and its rough equivalent in the Arab world, the Abbasid caliphate, were marked (again, approximately)

by peace, organized government, art, science, and trade. The bureaucracy worked better, people had more to eat, and the art was good.

It was also an inflection point for how people made and traded colors, or at least colored objects. The cargo of the Belitung wreck redefined the history of colors as commodities, their materiality and technology as valuable as gold, silk, or spices. The way people made and used those colors was the era's highest of high tech. And the delivery mechanism was literally hardware, the killer app of the day: porcelain.

In the centuries running up to the period I'm talking about here, cultures around the world still used the Paleolithic palette. Ancient texts are full of references to iron oxides, the ochres. In fact, they were some of the first pigments humans ever wrote words about, in Assyrian cuneiform and Egyptian hieroglyphics. They're all over Egyptian tombs, Assyrian ruins, Greek ruins, Roman ruins. It's a literal testament to how important they were.

But humans kept adding to that gamut. Some of the first technologies were also the first manufactured colors. The chalky whites of cave walls would be joined in the human palette by a carbonate of lead — lead white — first described in Theophrastus's *History of Stones* from about 300 BCE. That's about when the Chinese started making it too, which means lead white is another candidate for oldest synthetic pigment — found in the ruins of Ur, one of humanity's earliest settlements, and mentioned on tablets in the seventh-century BCE library of Ashurbanipal. In ancient Akkadian it's *hulalu*, likely an etymological relative of a word for vinegar, a key ingredient in its manufacture.

From there we're off to the races, an explosion of color. Pliny the Elder's *Natural History* (which he began writing in 77 CE and didn't quite get finished, owing to his death in the eruption of Mount Vesuvius two years later) extolls the authenticity of painters who worked in Paleolithic white-black-yellow-red. But even Pliny acknowledged the world was changing. There were "somber" material colors, and then there were "florid" pigments, stuff like vermil-

ion, azurite, Tyrian purple, dragon's blood red, and indigo. Pliny says the client whose house or portrait was being painted would be expected to cover the cost of these — implying that they were expensive, imported, and exotic. This was the good stuff. Roman murals have a purple made of Egyptian blue and hematite, and for hundreds of years researchers have been trying to figure out whether a sample of pinkish-purple pigment from Pompeii was Tyrian purple, madder, indigo, or a mix of some or all of those.

These colors were global commercial products at the base of an international trade network. Tang-era China and the Abbasid caliphate both had orpiment, a yellow arsenic-derived mineral. The Abbasids had madder red, an extract from the roots of *Rubia* shrubs — the key colorant is a chemical called alizarin, which binds to metals like aluminum naturally present in plant fibers, making it technically a dye. It's also found in the wraps of Egyptian mummies. The Arabs also had Tyrian purple, the expensive deep-red-to-intense-violet stuff extracted from mollusks such as *Murex brandaris*. Its manufacture dates as far back as the thirteenth century BCE all around the Mediterranean.

The Chinese, for their part, were making pigments from lead as early as the fifth century BCE; during the Han dynasty, white lead was called *hu-fen*, the *hu* meaning "paste," as in ointment or cosmetic. People used it as whitewash for buildings and the ground for murals; it's the background in a depiction of VIPs on the walls of a Han dynasty government office. In later years artists seem to have switched, at least in part, to chalk as a pigment — calcium carbonate.

Red was *ch'ien tan*, "lead cinnabar," and yellow was *ch'ien haung hua*, "yellow flower of lead." Starting in the sixth century CE, the yellow became a sought-after cosmetic. In the Tang dynasty, women of means painted their faces and chests white and their foreheads yellow. They also had red cochineal, derived from South Asian lac insects, and the same stuff that once gave Campari its color. Some historians think vermilion, mercuric sulfide, was a more likely (and no less harmful) candidate for blush than minium, red lead. Fashion also dictated that women, at least rich ones, plucked their

eyebrows and painted in new ones. The au courant shapes and colors varied, but in the late 700s, a dark Persian indigo supplanted a more greenish blue.

Cosmetics weren't the only intensely colored things in eighth-century China, of course. Silks were dyed and painted; walls and statues had pigment. The built world was a vivid one. Those colors added more than aesthetic appeal. They added financial value, and they incited desire.

In terms of the colorful objects on board the Belitung wreck, the most interesting were nine hundred green bowls, many from kilns in Yue, in southern China, and three hundred luminous white bowls and jars from kilns in the northern provinces of Hebei and Henan, often from kilns in Gongxian, Xing, or Ding. But to explain why, we have to jump back in time — to yet another cave.

This cave — Yuchanyan, in the modern county of Dao, just off the Xiarong Expressway — is the site of the oldest pottery ever found, dating back 18,300 years. It was just a couple of handfuls of shards by the time archaeologists got to it in the early 2000s, and technically it was pretty crappy stuff — "low-fired earthenware," meaning its makers heated their clay to temperatures of just 400 or 500 degrees C, and that clay was made of bigger mineral particles. It would have been a porous, crumbly, fragile pot. But still: It was first.

It wasn't until roughly the sixteenth century BCE that cultures along the Yangtze River in China learned to do better, to make a stronger, more watertight material called stoneware. It needs much higher baking temperatures, for one thing, to "vitrify" the clay. Those Yangtze potters painted their work in the familiar red-brown ochre palette.

And in the south, that remained the standard for nearly two thousand years. Northern China didn't even have that technology — no glazed stoneware there until sometime in the sixth century CE. No one knows why.

It's in the sixth century, though, that Chinese potters make two important technical leaps. The northerners learn, or relearn, to make glazed stoneware. And at some point — archaeologists

disagree exactly when — they learn to make something even better. Fired in kilns at temperatures above 1,300 degrees C, it's a lovely white and emits a resonant ding when struck. This, at last, is the grade-A stuff: porcelain. It's lighter than stoneware, almost impossibly thin for its strength, capable of being molded into delicate, evocative shapes.

Part of why Chinese potters were able to create this revolutionary new material came down to engineering. In the north, the center of porcelain innovation, they had the right kind of kiln — the *man-thou*, a thick two-chimneyed dome that could achieve the ultrahigh temperatures necessary.

But the real secret to porcelain was chemistry — in this case, of the clay that was its raw material. So that means geology.

Sometime during the Triassic period, between 250 million and 200 million years ago, the confusing agglomeration of landmasses that comprises northeastern China crashed into and slightly overrode the equally confusing agglomeration of landmasses that makes up southeastern China. Two very different lands became one, belted together by the Qinling mountain range.

Northern China ended up a landscape made of loess, mineral dust that sticks together to form mountains. Below about three hundred meters, that loess mixes with clay — oxides of aluminum and silicon, all stuck together. That mix is the source of terra-cotta — as in, the material of the famous statuary army. When fired in a kiln with low levels of oxygen ("reduction fired"), carbon monoxide and soot in the kiln donate electrons to iron oxide in the terra-cotta. It ends up not the familiar red of iron-oxide ochre, but gray-black. Until you paint it, of course.

Dig even deeper than that, though, and you get something else entirely. It's called China clay, and with it the geology, chemistry, and kiln engineering all come into full flourish together. China clay is full of crystals of aluminum, silicon, and a bit of water, but low in iron. As stoneware, it turns a gray or cream color, and if it's *very* low iron, white. Some of those whites are porcelain. Fired with oxygen available in the kiln — oxidation firing — the whites have warmer tones; reduction firing gives you cool white. The parts of north-

ern China near the porcelain-making center of Xing had China clay remarkably low in any impurities. Cook that at around 1,400 degrees C, and it comes out of the kiln creamy, durable, and white.

Here's a giveaway to how important ceramics are to Chinese history and how important China clay is to ceramics. That high-aluminum, low-silicon clay from northern China was also one of the early Paleolithic white pigments, and today it's alternately called both China clay and kaolin. The name kaolin comes from the Chinese *gaoling*, or "high ridge," referring to the region where people mined it near the northeastern town of Jingdezhen, a center for the porcelain trade as far back as the Song dynasty. It's an etymological legacy that persists even today.

Southern China, meanwhile, was mostly igneous rock, providing an entirely different clay. The ground there was higher in quartz and mica, often with some feldspar thrown in. That mineral is (confusingly) called China *stone*, or porcelain stone. They still had to fire it at high temperatures, but its different elemental recipe results in something colored an elegant green. That's Yue greenware, principal competitor for the affections of well-heeled Chinese connoisseurs of the day. As a matter of durability or functionality, neither was necessarily better — Yue greenware's color simply made it more coveted, another example of color putting rails on culture. In the early 840s the musician Guo Daoyuan filled twelve Yue green and Xing white bowls with slightly different amounts of water and played a symphony on them.

What came out of the kilns at Xing and Ding was unlike anything else on Earth — and not just because of the material. It was "true porcelain" — tough and light. So the designs could be more refined, too. You could almost mistake Xing whiteware, with neither colorful ornament nor the rococo curlicues and animal forms that became popular in later centuries, for something you'd buy in the MOMA gift shop.

You've probably heard of other Chinese inventions — gunpowder, movable type, the needle compass, paper money. Porcelain predated all of that, and was every bit as important, technologically and culturally as significant, as silk and ink. Northern white

and southern celadon were two of China's greatest exports, the products of an almost magical technology. Their unique material properties made it useful, but it was the eye-catching colors those materials produced that made Chinese ceramics objects of desire across civilizations.

Before the Tang, China made *a lot* of pottery, mostly cheap earthenware utensils and statuary. It was garishly colored *sancai,* "three-colored" with red, yellow, and green lead-based glazes. They didn't use it to hold food or drink. Basically it was decoration for funerals. "The reason why they were keen on color then is slightly mysterious," says Nigel Wood, one of the world's experts in Chinese ceramics and glazes (despite his hopes for a retirement consisting of making his own pots). The *sancai* polychromatic funerary wares were, Wood says, "made as bright and spectacular as possible even though they only saw daylight for a short time and then went into the tombs."

But changes in Chinese culture would change those tastes, as well. The Tang era was one of relative internal peace marked by conflict with China's northwestern enemies — the same ones China fights with today, actually, including Tibetans and Uighurs. But that moment of internal peace and a more liberal tax code meant everyone had more food and more leisure time. That's usually a recipe for showy arts and crafts.

The ascent to the throne in 690 of China's only woman emperor, Wu Zeitan, improved things even more. Before her own son deposed her in 705, Wu's efforts to promote qualified commoners to important bureaucratic jobs instead of the usual rich kids made a whole lot of society start working better — including infrastructure such as massive canals and roads marked by secure weigh stations. Merchants could now travel more safely, and kilns — built close to their raw materials but far from cities — had access for the first time to the overland Silk Road to Syria, Iran, and India, and to other trade routes to places as far as northeastern Africa.

All good, in other words. More productivity meant more products, and more access to trade meant more places to sell them.

Except eventually all that military power on the frontiers came back to bite the capital. A military governor of Turkic descent — so, a "barbarian" in the parlance of the day — named An Lushan started to think seriously about his ambitions for the future. An spent a few years on logistics and material, and then in 755 marched an army of 150,000 men south from what's now Beijing toward the then-capital of Changan. The main forces of the various armies protecting the empire were at the borders fighting with Turks and Tibetans, allowing Lushan to cross the Yellow River and seize the Grand Canal, an engine of China's economic power. And when the emperor, Illustrious August, sent forces protecting the capital out to meet him, Lushan crushed them and took over the country.

Just a couple of years later the rebellion was over. An Lushan was dead, and a Tang emperor was back in power. But the cultural turmoil had changed the kind of decorative arts people wanted. Ostentatious displays of wealth and power, presumably like the stuff that got An Lushan in trouble, were out of fashion. The bottom dropped out of the market for outré tricolor funerary ceramics. People still had the money to buy nice things, but priorities shifted from wealth to connoisseurship — to color and design.

Meanwhile, fighting on the borders destabilized the overland Silk Road again, shifting the emphasis to the safer maritime routes — very good for heavy stuff like silk and porcelain. And potters in China, fleeing the chaos and seeking better access to these trade routes, moved south. "Some of them moved to the Changsha area and started using their knowledge of polychrome glazes to produce a new kind," Wood says, though he acknowledges he's speculating. These were the blue-and-white and green-and-white Changsha export ceramics that made up the bulk of the Belitung wreck's cargo.

Meanwhile, well-off people switched their spending habits from colorful objects to rarified experiences. The Chinese had been drinking tea since at least the 300s, but during the Tang, the connoisseurs took over. Tea drinking became a big deal — in large part not because of how delicious the drink was (reasonable people could differ) but because of the ceremony that accompanied it.

Tea didn't come in little bags packed into a cardboard box; it ar-

rived more like an expensive cake of pu-erh, compressed together for transport. When it was time to serve, you cut pieces off of the cake and ground them into powder, frothed that powder with hot water, and ladled it into fine bowls to be mixed with salt or aromatics, spices, and herbs. It was more of a soup than a drink, accompanied by all the pomp and seriousness you'd find today in the formal Japanese tea ceremony, the *cha no yu*.

Squeezing the most intense effect out of the ceremony meant that you had to have the right gear. And that meant porcelain — and not just any porcelain. The popular *Cha Jing* (*The Classic of Tea*) by the poet Lu Yu, written around 761, provided the manual.

Lu in particular prescribed which teas went with which ceramics. Light red tea, for instance, should only be drunk from Xing whiteware, because the yellowish bowls from Shou Chou would make it look rusty brown, "unworthy of tea." None of that makes a difference in any objective sense, but to anyone who has ever wondered whether varietal-specific wineglasses make a difference (they do not), it's familiar rhetoric. This was perhaps the first time a particular material, a particular product available nowhere else on Earth, became equated with quality and with an experience. Thanks to Lu Yu, Xing whiteware now had premium brand awareness.

Until the Belitung wreck the evidence of the spread of Tang porcelain was sparse — a temple in the Japanese city of Nara had a Tang celadon jar in the seventh century, for example, but that was nearly it. That was weird, because historians wondered whether they'd find Tang porcelain in the possession of the dynasty's biggest trading partner, the Abbasid caliphate, centered at Baghdad.

From about 750 to the Mongol capture of Baghdad in 1258, the caliphate's sphere of influence — depending on how you count such stuff — stretched from Samarqand and the southern coast of the Aral Sea all the way to Spain, and covered the entire Arabian peninsula. Baghdad in the west and Changan in the east were the twinned centers of human civilization, the poles of the Silk Road.

Even if you got the same Eurocentric version of world history

in school as I did, you know the Abbasids. Sinbad the Sailor was a maritime Silk Road merchant. *A Thousand and One Nights* is a collection of stories told by and about the Abbasids.

Despite ongoing internecine and external conflicts, the Abbasid was a period of culture and cosmopolitanism. And in general they were gaga for Chinese porcelain. In 851, Suleyman, a merchant and traveler whose records are still vital to historians, marveled at the Chinese ability to create stoneware "as delicate as glass and through which one can see the water, despite that they are of clay." And in the late eighth century, the governor of Khurasan, in northeast Iran, sent the caliph al Rashid a gift of two thousand pieces of stoneware, including twenty pieces of what the Arabs called *chini fanghfuri* — imperial China–ware. The cups and bowls were probably whiteware from Xing and Ding. It was so popular and important, at least one researcher has suggested that the maritime Silk Road should be called the Ceramic Road instead.

The Abbasids didn't have anything like the Chinese products. Abbasid pottery came out of an ancient Mesopotamian tradition that had a plainer aesthetic, off-white with blue or turquoise glaze. This wasn't about preference so much as chemistry. Without kaolin clay and without high-firing kilns, the potters of the caliphate could only produce low-fire stoneware with a sort of yellow body — not good for decoration in itself and certainly of no comparison to the unearthly whiteware from Xing.

Merely knowing that such stuff existed seems to have served as an inspiration for the artisans of ninth-century Iraq. Or maybe it was just that they knew that the market was underserved. "When these wares reach the Middle East, they become very fashionable, and the Middle Eastern potters made great efforts to copy them," Wood says. "That kickstarted the whole tradition of colors in Islamic ceramics."

The bulk of the ceramic bowls pulled up from the Belitung wreck weren't monochrome — luminous whiteware or jade-like greenware. They were whitish or beige with colored glazes. Three dishes were of a specific, classic form called "blue-and-white."

Here's where the white porcelain of northern China had a

distinct advantage over the green, and pretty much over anything else. If you want glazes to show vivid color, the background has to be white. Vivid blue and green glazes work because light actually bounces around inside them, reflects off a white ceramic background and back through the glaze, and then returns to the eye of the beholder. That's what gives the object a glassy, specular-reflecting surface. So, at the time, the only way to make ceramics with vivid blue-green designs on a brilliant white surface — which, as we'll see, was exactly what most of the civilized world wanted — you had to start with whiteware.

That was a problem for the Iraqis, who didn't have kaolin. The material they *did* have for making porcelain didn't have that same luminous glow. In order to model their work after Chinese porcelain, they needed a different way to confer whiteness and opacity.

They found it in a combination of lead and tin oxides. Tin oxide has a high refractive index and small particles — exactly what you need if you want something to be white. And those tin oxide particles remain intact during firing, so the final product is white and opaque.

Nobody really knows how the Abbasids figured that out. The Egyptians used tin-based glazes, so that could be where the Abbasids got the idea. Or, since glazes are kind of like melted colored glass, maybe the Abbasids were able to bring to ceramics their experience with tin-oxide opacification in glassware, another sophisticated technology that dated back to the Roman empire. Nobody has done the comparative chemistry to really be sure.

What gets even more interesting is glaze that both the Chinese and Arab ceramicists started applying over the white. It was blue, rarely used to make so-called blue-and-white porcelain even in Tang-era China and even rarer in the Abbasid sphere until the fourteenth century. And that blue glaze is even more of a mystery than the white. "We've got a big problem with the cobalt blue that was used in the Tang dynasty and also in the Abbasid wares," Wood says. There are only a handful of samples to study, indistinguishable to the eye, but their recipes diverge. Abbasid cobalt blue pigments are actually only cobalt in less than double digit percentages.

They're mostly iron oxides, with between 10 and 20 percent zinc. But the Chinese glaze pigments are up to 65 percent cobalt, with iron oxide and maybe a smidge of copper. No zinc. "They're not the same," Wood says.

So no one knows how. And no one knows *who*. Which is to say, who copied whom? Who invented the blue?

Tang blue-and-white predates Abbasid blue-and-white; maybe the latter developed from the former. Or maybe Abbasid blue-and-white developed independently of Chinese blue-and-white. The shapes of the pots were similar, but the blue decoration (a cobalt-based glaze in both) had local Arabic designs. Given how intertwined the two kinds of ceramic are otherwise, it's hard to imagine that the glazes evolved completely separately from each other.

The Arab world and China have been engaged in a trade in colors for millennia. The ancient world's first bright blue pigment, yet another candidate for the first synthetic pigment, was Egyptian blue — calcium copper silicate, found as far back as pre-dynastic Egypt, like 3600 BCE. Made by heating sand (in Egypt, a combination of quartz, SiO_2, and limestone, $CaCO_3$) with a mineral like azurite or malachite to provide a copper ion for color, it's the blue on Nefertiti's crown. The Chinese had a blue too — Chinese or Han blue, but it doesn't show up in that nation's arts and craft until the Warring States period, like 500 BCE.

Despite a three-millennium difference in birthdays, Han blue and Egyptian blue are essentially the same chemical. Han blue is $BaCuSi_4O_{10}$; the Egyptian version swaps the barium for a calcium. In both, the silicate molecules create repeating crystal units that hold the copper ion, the chromophore. Now, Han blue is a lot harder to make than Egyptian blue, requiring more precise control of temperature and more steps. So the question is, did the Arabs get their blue from Egypt, or from China? Or did the Han Chinese get the idea from the Arab pigment they saw traded on the Silk Road, which they then sold back to the Arabs?

The only way to know is through chemistry. If you want to draw a connection from Chinese whiteware to Chinese blue-and-white to Islamic blue-and-white — and then to Marco Polo bringing a

sample back to Europe and setting off a porcelain craze in the Renaissance — you need evidence that the Abbasids had Tang-era blue-and-white.

Granted, it'd be tough to get. People have only been studying these connections intensively for the last twenty years or so, and the area they'd like to study most closely has been full of soldiers shooting at each other. No one has excavated the kilns of Baghdad, Basra, and Aleppo that might prove the Abbasids got blue first.

But that's not the only place to find artifacts. And that brings us back to Nigel Wood. Like I said, Wood would like to go back to making pots; that's how he started, back in the 1970s, before he got interested in glaze chemistry and ended up writing two-thirds of the thousand-page ceramic technology book in the epic Science and Civilization in China series spearheaded by the researcher Joseph Needham. In his semi-retirement, Wood has opened his own studio and throws his own pots, but he still has doctoral students at Oxford. "There's always a big controversy of some type or other," Wood says. "The Arabist view is that Islamic potters developed their own blue-and-white from scratch. And the thought in China that is developing more now is that they were inspired by the exports from China."

The Chinese government, perhaps sensing a shift in global trends back in China's direction after a few centuries of aberrant Western domination of the globe, wouldn't necessarily mind seeing scientific proof of China's influence on history. "They're very interested in soft power and the impact of China on the rest of the world," Wood says.

The Belitung wreck rewrote the history of the maritime Silk Road, broadening historians' understanding of how Chinese ceramics dominated the ancient world. But more recent research suggests their influence might've been even greater than Belitung suggested. It could be that Chinese blue is in fact the origin of Arab blue-and-white — if you believe the evidence of a three-centimeter triangle of white-glazed, blue-daubed ninth-century pottery.

An archaeologist named David Whitehouse found that tiny piece of ceramic in the ancient port city of Siraf, in present-day

Iran, sometime between 1966 and 1973. Then Whitehouse threw it in a drawer at the British Museum.

Forty years later another researcher, Seth Priestman, took up the thankless task of cataloging some of the thousands of pieces of ceramic, metal, glass, and the other bric-a-brac gravel of fractured history in the British Museum's collection. All the fragments of blue-and-white high-fired ceramic from Siraf had blue, lead-based glaze. On some, it was painted into classic Arab designs — calligraphy, or Arabian motifs like palm trees. But some had patterns of dots and dashes, a convention of Chinese high-fired ceramic. While cataloging, Priestman realized this particular shard — potsherd 2007, 6001.5010 — had blue dots and dashes and was high-fired stoneware. Further analysis showed it was actually Chinese, probably from the kilns at Gongyi, where the potters made both whiteware and lead-glazed polychrome.

Imagine Siraf: a deepwater port that could serve ships that Basra, silted by the rivers, could not. Now, Basran potters were already making pretty good blue-and-white ceramics by this point. The poet al-Adzi described the Basran work as having the "surface of a white pearl" and being shaped "like the contour of the moon."

Siraf's tendrils of commerce stretched all the way to Yangzhou and Guangzhou. It was a destination for high-drafting dhows racing the monsoon winds. Pinched between mountains and the Persian Gulf, Siraf in the ninth and tenth centuries must have been one hell of a town, one of the last stops on what could have been a years-long journey of thousands of miles and a transfer point for converting one empire's exports into another's imports and vice versa — for converting dangerous adventures into money.

Potsherd 2007, 6001.5010 from Siraf indicates that wherever the kilns were that produced Islamic blue-and-white wares in the ninth and tenth centuries, those potters had access to the Chinese version first. Even if they had to come up with their own chemistry, they might have been emulating the aesthetic of the Chinese, who a century later essentially ceded the manufacture of blue-and-white ceramics to the Islamic world. "There's a big surge in

the ninth century, and then the patrons of the Islamic potters get them to copy the Chinese wares. They learn a huge amount from that," Wood says. "And then another wave of imports happens in the thirteenth century from the southern China kilns, and there's a huge effort to copy those."

It's an ebb and flow of color technology, back and forth, between the poles of the Silk Road. More colorfast, brighter glazes on ceramic surfaces that showed off those colors better — that was a market advantage in trade between the ancient world's greatest cultures, engaged in a tug-of-war over technical and economic dominance of the globe.

The eye-popping main exhibit hall of the Asian Civilisations Museum in Singapore displays hundreds of multicolored bowls propped on narrow pedestals, all of slightly varying heights, so that the bowls look like an undulating wave of ceramics, a tsunami of stoneware. That tide is flanked by restrained whiteware. The overall effect is striking, even for someone like me who, until that moment, had not particularly cared about old dishes.

Possibly it's not just the display but the story of it, an epic display of the epic cargo of the Belitung wreck. Unfortunately, that story undulates and twists just like the rows of bowls in the museum hall. If you've been checking my endnotes, you might have seen a bunch of references to a book called *Shipwrecked: Tang Treasures and Monsoon Winds,* a volume that was supposed to accompany an ambitious exhibit of the Belitung treasures at the Sackler Gallery in Washington, DC. That exhibit never happened.

The show didn't go on because of how Walterfang salvaged the wreck. An article in *Der Spiegel* reports that the divers brought up large pieces by hand and sucked up smaller ones with a vacuum hose, sieving the muck on a salvage ship and rinsing them with fresh water ashore. Walterfang feared someone would steal the gold and silver he found; he sent the precious metals to Jakarta and the ceramics to storage in a hangar in New Zealand. Then he started asking for bids from various national representatives to buy

the collection — Doha, Shanghai, and Singapore all registered interest, as did Sotheby's.

Even though it had no strong cultural connection to the find, Singapore's Sentosa Leisure Group made the buy in 2005, for $32 million. The exhibition became the centerpiece of the city-state's prestigious Asian Civilisations Museum. International press reported on the find in the late 2000s, and in 2007 the head of the Freer and Sackler Galleries started working on an exhibit that would travel to the US. That didn't go over well with Western academics, who complained that Flecker, the lead researcher, wasn't trained in their methods and hadn't been academically rigorous in his recovery. "When material came up from the site, it was rinsed in a barrel of fresh water, but that water was never changed, so within ten minutes it was just as salty as the water around it," says Paul Johnston, curator of maritime history at the National Museum of American History. "Apparently the material was never properly desalinated. . . . The salvers just want to clean off the mud. They're not aware of what's needed to properly desalinate something and preserve it. They figure, it's just pottery, so it's probably OK."

(Flecker doesn't confirm or deny this methodological criticism. "I was running the offshore operation and not the onshore [I was on the boat all the time]," he says via email. "I sent the day's finds to shore every evening for cataloguing and desalination. I cannot vouch for the exact technique employed.")

To Johnston's eye, the vastness of the collection is itself proof that the salvagers did a shoddy job. "They recovered forty thousand objects from that wreck," he says. (It was actually more like sixty thousand.) "They were only on it for four months. That's ten thousand objects a month, twenty-five hundred objects recovered per week. On a five-day week, that's five hundred objects a day. On my archaeological site in Hawaii I might recover three or four objects a day. Five years of excavation yielded only twelve hundred and fifty lots of artifacts, because we documented and recorded everything."

Smithsonian memos about the dodgy recovery leaked to the journal *Science,* and in April of 2011, archaeologists and

anthropologists protested. The exhibition catalog came out, but the Sackler Gallery called off the exhibit itself. At the time the Smithsonian made some noise about trying to mount a more proper dig, but it never happened. A 2010 survey of the site revealed scattered ceramic fragments around the remains of the site covering an area of twenty square meters, apparently raised and then thrown back because they were broken. There's no sign of the ship itself, and the site appears "ravaged."

The Asian Civilisations Museum has a hell of a good exhibit, but the loss to science and history isn't calculable.

"If five percent of the cargo is recovered, and it's recovered without any documentation, then you're getting less than five percent of the information that shipwreck can give you," Johnston says. "Even the best archaeology is a destructive science. It destroys the site. All you have is record-keeping to answer questions like 'Why was the ship there?' 'Did they recover any organic things or just things they could raise, rinse, and retail?' The answer is yes. They only recovered things they could raise, rinse, and retail." (To be fair, they also recovered bone, ivory, and that star anise.)

Nobody will ever know what all that gold was doing on the ship. If it was hidden between timbers in the floors, that might mean the captain was a smuggler. If it was part of the cargo, it might have been a diplomatic gift. The location of the artifacts might have even given a clue to the ship's actual destination; the cargo suggests strongly it was headed to the Persian Gulf, but Belitung is on the route to Java. Not being able to answer even those basic questions hints at an incalculable cultural loss. "There was some writing found on some of the Belitung ceramic including some unique poetry from that period, and if you smash ten thousand of those ceramic bowls in order to recover five thousand, who knows how many unique poems from that period were destroyed?" Johnston says. "We'll never know."

The part that I keep thinking about — the part most relevant to the secret history of color along the Silk Road — is in a single sentence in one of Flecker's articles about the Belitung wreck: "A whitish, crumbly, rock-like substance found on the wreck in discrete

scattered lumps has been identified as an aluminum oxide–rich material." Surely there aren't many aluminum oxide–rich, white, crumbly materials that anyone would package alongside valuable ceramic samples. I wonder if it was kaolin—the one thing the Middle East didn't have, the material that gave Chinese whiteware its superior color and durability. Why would a Chinese exporter of ceramics *also* send the raw material for making their product to its principal competitor?

No one will ever know.

THREE

RAINBOWS

As Tang dynasty blue-and-white stoneware flowed toward Siraf and Basra, elsewhere in the Arab world scientists were looking to the work of another cultural powerhouse: Greece, an ancient culture nine hundred and fifty years gone. It's not totally clear to anyone why Persian-, Syriac-, and Arabic-speaking philosophers and scientists were so interested in ancient texts in Greek. Maybe it was that the leaders of the Arab world were starting their own early Enlightenment, and the emerging bureaucracies were finding that they needed to know things like math, and how to mint money.

Historically, everyone sort of assumed that the Greeks were right about everything. But Arab scholars quickly found otherwise. As they translated the work, they included their own corrections and commentaries alongside the original — and wow, did they ever get to it with the Greeks. Their discoveries and corrections in fields spanning the sciences made the European Renaissance possible. Arguably most important were their contributions to the physics of light and color, because it was Arab scholars who were able to explain how the colors people saw in the natural world made sense, had an order. And more than that, the Arab scientists were able to figure out how those colors mixed — how that orderly progression from one color of light to another related to the dyes and pigments people made and used. Those explanations were vital, because the Greek versions didn't make much sense.

Take Aristotle. He was the greatest of the Greek natural philoso-phers, and the translator-scientists of the Arab world used him as a starting place for almost everything. But Aristotle's work on color was a nonstop voyage into perplexity.

He clearly understood the relationship between color and craft — something that the Arabs, masters of global trade in highly col-ored objects such as textiles and ceramics, were thirsty for. Aristo-tle described how people extracted rare, valuable Tyrian purple dye from aquatic mollusks. He talked about textiles and color, and the way that light can change the way a color looks — "embroiderers say that they often make mistakes in their colors when they work by lamplight, and use the wrong ones," he wrote. Aristotle even no-ticed that colors could look different to an observer depending on how weavers juxtaposed them against one another — that purple looked different set next to black than it did when set next to white. These observations still drive color science today.

But just like that purple, Aristotle's ideas on how color worked contrasted weirdly with what he thought color actually *was*. Which is to say that Aristotle's theoretical framework for color didn't match color in practice — not in art and craftwork, and not to a typ-ical observer's eye.

Aristotle's teacher Plato had written that all color, everywhere, derived from just four elemental, fundamental colors: white, black, red, and "bright" or "dazzling." But Aristotle broke from that rudimentary color order. Looking around the world, Aristotle hypothesized that all the colors people see derived from mixing white and black, and from light and dark — what today we'd call luminance. Exactly how many colors that mixing could make ... Well, that was the problem. He chose seven, to match seven basic flavors and the seven notes of the Greek musical scale. Thousands of years of translations of Aristotle's *Sense and Sensibilia,* from about 350 BCE, vary as to what those colors were; he seems to have orbited around a rough scale of subjective brightness — white, yellow, "Phoenician" (probably a reddish brown), violet, green, deep blue, black.

So that was the pure philosophy. But when Aristotle turned to describing actual, real, natural phenomena in his *Meteorologica,* he ran into a problem: rainbows.

Clearly rainbows were a phenomenon of color and light. But which colors? Not the order he laid out for the natural world. Rainbows were red, green, and purple, Aristotle said. That's it.

Well, sometimes orange. But that's it, for real.

What accounted for the difference? That's unclear. "The rainbow," Aristotle writes, "is a reflection of sight to the sun." If you put the sun behind you, he said, invisible mirrors made of water droplets that only reflect color create a rainbow in front of you. "When sight is reflected it is weakened and, as it makes dark look darker, so it makes white look less white, changing it and bringing it nearer to black. When the sight is relatively strong the change is to red; the next stage is green, and a further degree of weakness gives violet," Aristotle wrote.

But that meant that the order of colors in the rainbow differed from Aristotle's initial philosophical color order. So he changed his philosophy. He swapped the green and violet, dropped the blue, and ignored the yellow. The key was that the lines between colors out in the natural world were inviolable. Colors themselves, as, like, *objects,* never mixed. If you, an observer, think you see yellow between the red and green, that's obviously just red being whitened. All the so-called other colors are just reflections and illusions made of the real, actual colors that are really, actually there. Red, green, and purple were the only basic, primary colors available to both craftspeople and the eye.

Without the theoretical structure that comes from knowing about, say, decrements of wavelength or quanta of light, and without any real notion of how the eye and brain work, Aristotle had no way to understand the mechanisms that would allow colors to mix together and form new ones, either as paints on a wall or images in the mind.

Yet Aristotle's vision of the world stuck. Writing four hundred years later, Pliny argued that it was somehow indecent to

introduce new colors and pigments. Plutarch was explicit in his derision for color mixing, suggesting that the Homeric word for dyeing actually meant "tainting" and that mixed pigments were not pure and virginal. And two hundred years after that, the early color theorist Alexander of Aphrodisias also called mixed colors inferior.

But this led to a mystery. If colors couldn't mix, how could they change? Even in Aristotle's day, painters knew that when they mixed two pigments, they got a new, third color (though they tried to avoid the practice, because that new color was also less bright — desaturated, in modern parlance). So how was that possible, scientifically? And how did colors in the natural world fall into an order along a rainbow? What was between two colors there if not a mix of them both?

History used to take a little break right here. The next beat in the eternally swelling rhythm of white-man progress usually falls on Isaac Newton, who blows a rainbow out of a prism, figures out how colored light works, and invents physics. But that isn't the way it happened. Over the next few hundred years, someone had to sort out the mess Aristotle had made of light, pigment, and rainbows. That dawning awareness refracts through Cairo and Baghdad.

In 1009 various Islamic factions went to war on the Iberian peninsula, and the weight of Arab power moved to Baghdad and Cairo. A year later Egypt's caliph, al-Hakim — known for patronage of the sciences but also for being a sadistic jerk who, for example, disliked the sound of barking so much that he had every dog in Cairo killed — invited to Egypt a Basra-born mathematician and civil engineer named Abū Ali al-Ḥasan Ibn al-Haytham al-Baṣrī, also known as Alhazen or Alhacen. Al-Haytham had published an ambitious plan for controlling the waters of the Nile, and al-Hakim wanted him to put it into action.

Al-Haytham and his team took a boat upriver, and as they floated south, al-Haytham realized his plan was not going to work. At all.

His ideas for infrastructure to control the Nile were kaput from the jump. That's not the kind of thing you want to tell a crazy caliph with a reputation for killing creatures that displease him. So, the story goes, al-Haytham went back to the caliph, and, with the greatest of humility and candor, pretended to be crazy and got himself institutionalized. It was literally a crazy plan. And it worked.

The plan had a downside. Al-Haytham spent the next eleven years in a mostly dark cell. All he could do, really, was think long and hard about how light worked. When al-Hakim finally died in 1021, al-Haytham got sprung and built the world's foremost laboratory for studying optics.

He diagrammed human vision from eye to brain, and went on to explain depth perception and peripheral vision. He also was the first person to connect light — stuff out there, in the world — to color, the stuff sticking to the things we see. He showed that light could bend as it moved through a medium, the law of refraction (or "refrangibility") that Willebrord Snell van Royen wouldn't work out until 1621.

With incisive logic, al-Haytham untangled a few knots the Greeks had tied. Like, Plato thought the eye emitted light. "We find that when our sight fixes upon very strong light sources it will suffer intense pain and impairment from them," al-Haytham wrote. "For when an observer looks at the body of the sun, he cannot do so properly because his vision will suffer from its light." In other words, it hurts to look at the sun. So how can light come *from* the eyes? Winner: al-Haytham.

As to the question of whether colors could mix, al-Haytham mounted a classical experiment. Following an idea from Ptolemy, al-Haytham made a top and painted pie piece sections different colors. Someone looking at the spinning top, he said, wouldn't see the colors of the individual pie pieces or the lines that separated them, but an all-new color made from them. Al-Haytham had figured out that colors could in fact mix, and that the sensation of mixing was a function of perception and observation as much as, if not more than, the color of the pigment or light.

For an encore, al-Haytham realized the deeper implication of Aristotle's comment on embroiderers and candlelight. Objects could appear brightly colored in strong light but faded when the light became dim, and the differences in the colors of two objects seemed greater in brighter light. Colored light and colored pigments were related, but different. "The eye observes the colors of colored objects only according to the colors that fall on them," he wrote. Al-Haytham realized that light wasn't the backdrop, but an actor in the play — not *how* we see, but *what* we see.

Two hundred years later, the work of Arab scholars, translating and improving on ancient Greek science, was being translated into Latin. The flow of Arab science to northern Europe became a two-way street as European scientists read it and added their own experiments to the new canon. But no one had cracked the rainbow.

Sometime around the 1220s or 1230s, an influential early European theologian named Robert Grosseteste, who taught at Oxford and in France for the early decades of the century before becoming a bishop in England, wrote three short essays — "On Light," "On Color," and "On the Rainbow." In them, he laid out how the path traveled by explaining how a ray of light bends when it passes through a medium like glass or water, changing how things look, even making them appear bigger or smaller. This "refraction," Grosseteste said, is what somehow caused rainbows. Not bad for a guy writing eighty years before people settled on a Latin word for "lens."

Grosseteste thought that refraction between the sun's rays and humid air in clouds might shape light into a cone, and that the curving "bow" shape was a section of that cone. As for the color, Grosseteste had no idea, but he did suggest that colors might have lots of different qualities that, as they changed, could explain their seeming progression from light to dark, and from color to color. His construction was more than a little abstruse, but at least one set of modern historians thinks he was talking about something very much like our modern ideas of wavelength, brightness, and saturation. Even if that's too kind to Grosseteste, he did come up with the

idea that different kinds of light — different "rays" — had different optical properties. They refracted differently.

Grosseteste's student Roger Bacon went to work on optics and rainbows too. He did the math — if they were right about refraction, a rainbow could never be more than 42 degrees above the horizon. (That's true, it turned out.) A Polish optics researcher named Witelo, in about 1268, took all that and figured out that red rays refracted less and blue rays refracted more, so that the colors of the rainbow were in fact the edges of nested cones.

It wasn't until the 1290s that the details got sorted out. That's when the Persian researcher Kamal al-Din al-Farisi and a German monk named Theodoric of Freiberg both independently started publishing their work on color.

In what must've been a dig at both Aristotle and al-Haytham, al-Farisi called his book *Kitab Tanqih al-Manazir* — the Book of Correcting the Optics. In it, al-Farisi describes his realization that a rainbow couldn't be a mixture of light and dark because, put simply, the colors of the rainbow aren't ordered that way. The brightest, yellow, is between two dark colors. (Under standardized, more scientific conditions, green is twice as bright as yellow, five times as bright as blue, and two hundred times as bright as red. Under a whole other set of similarly well-accepted standards, yellow looks brightest.) And anyway, in the rarer meteorological phenomenon of secondary rainbows, when dual bows appear, the color order is inverted in the second. Doesn't make sense.

Al-Farisi and Theodoric both read the early Arab work, as well as Grosseteste, Bacon, and Witelo. So maybe it's no surprise that they both came up with the same experiment. They closed up all the windows in their labs and opened a tiny hole to the outside, so that a single pinpoint of light could enter — four hundred years before Isaac Newton would do the same thing. They didn't have high-quality prisms yet, so both men interrupted the beam with a glass sphere filled with water. By watching the light play on the walls of the darkened labs, al-Farisi and Theodoric realized that the beam of light entered the sphere, refracted once, reflected off the inside, and then refracted again before bouncing out.

If every individual raindrop in the sky acted like a glass water-sphere, they'd all do the same thing to light. Different kinds of rays would refract to different degrees. Together, they'd make a rainbow.

Why had Arab physicists been able to see more clearly than Aristotle and his classical contemporaries or followers? Maybe it's because of porcelain — and textiles, and painting, and a whole suite of skill sets and technologies that rely on color. The Islamic tradition of elaborately ornamented manuscripts allowed ink-makers to blend and mix colors all the time, and Abbasid painters liked more subtle colors produced by mixing.

Craft expertise with color blossomed into a revolution, parallel with the one in optics and overlapping in subject. So for example, maybe it's occurred to you to ask where all those prism-less guys got their "spherical glass vessels" to fill with water and trace the progress of sunbeams. In Grosseteste's case, they were urine flasks. As early as the twelfth century, physicians used them to collect and assess the color of their patients' urine as a diagnostic aid. To help, they carried diagrams of the possible colors and diagnoses; of five existing versions, all have nearly the same sequence of twenty colors, ranging from white and yellow through grayish brown, dark red, blackish red, blue, green, yellow-gray, and finally black. I think it's safe to say that if your urine is blackish red, you need a better doctor than what twelfth-century Europe might have been able to provide, but regardless, it was an early kind of color order, based in craft.

Color was, broadly, in demand. In the decades and centuries after Theodoric and al-Farisi parsed the rainbow, pigments and colorants for paints, tile, glass, and textiles became major trade products. The visual arts were flourishing, and the same recipes for making colors to put on a wall or a canvas were also used for medicines, and for makeup. The *Compendium Medicinae* of Gilbertus Anglicus, for example, recommended that women mix southern European cyclamen root, a white, with Asian brazilwood soaked in rosewater, a red, to achieve a fashionable pale mien with rosy cheeks. The style reached apotheosis when the ultimate influencer

of her day, Catherine de'Medici, put on her white-and-red game face when she moved from Italy to become queen of France in 1533. Just about a decade later, Agnolo Firenzuola insisted in his *Discourse on the Beauty of Women* that you could tell if a woman was physically healthy if she had a white face with red cheeks — a nominal connection that the English physicians of the era picked up on and continued to advocate. Books that were mash-ups of medical textbooks, cookbooks, and fashion magazines spread throughout society. So did the products they advocated, essentially making these manuals the YouTube makeup tutorials of their day.

Like Chinese women five centuries earlier, European women began painting their faces (and shoulders and chests) white. They used alabaster, alum, talc, and other basic ingredients as pigments but mostly settled on the same ingredient the Chinese had: ceruse, which is to say, white lead. Think of later images of Elizabeth I, going out in public caked in white face paint with vermilion circles for cheeks, as this fashion slightly past its peak. Smearing lead all over your face was a proxy for healthiness, and a good way to achieve the opposite.

Textiles, too, demanded new dyes and colors. Indigo dye, extracted from *Indigofera* plants, had already been around the world — the Egyptians had some kind of indigo in 2400 BCE. Indian indigo was in Venice as early as the 1100s, and it's listed in records from Marseilles in 1228 as "Indigo of Baghdad." One of the main reasons the British opened up trade with India and founded the East India Company in 1602 was to get access to the dye.

As new colors and ways of using those colors entered the culture, craftspeople faced a situation in some respects the inverse of the philosopher-researchers messing around with glass spheres and trigonometry. As the protophysicists had tried to understand how light behaved in the world, painters were trying to represent that world, and that behavior, more accurately on canvasses and walls.

Nobody knew how one color gave way to another, or why some were brighter and some were darker. This posed a practical problem. Artists had already noticed that in draped clothing, for

example, parts of the fabric "closer" to the observer looked brighter, while darker, blacker regions looked "farther away." Painting is, in a literal and dunderheaded way, the art of carefully choosing the colors of adjacent regions on a surface. So something about bright colors and dark colors held the secret of depth—the real-world dimensionality that painters began depicting mid-Renaissance.

In the 1390s (or so; it's a little unclear), Cennino D'Andrea Cennini wrote *Il Libro dell'arte* (*The Craftsman's Handbook* or perhaps *The Professional Manual*). It's primarily a practical guide to turning pigments into paint and applying them to walls covered in wet plaster—frescoes—or dry panels. All the pigments of human experience are there, from the ochres to metals and crushed gemstones. The *Libro dell'arte* evinces no pearl-clutching over mixing pigments together to get new colors; of its no fewer than seven ways to make green, for example, only three are "pure"—terre verte (green earth, a clay generally composed of the minerals glauconite and celadonite), malachite, and the copper-corrosion by-product verdigris. The others are all mixtures of different blues and yellows, from orpiment plus indigo to azurite plus giallorino, which is yellow from tin and lead.

Cennini tells a lovely story about himself that suggests he was more than a merchant and paint-maker, though. He says that on a walk with his father in the hills near his hometown west of Sienna he came across a cave where, scratching at the walls with a hoe, he found "seams of many different pigments: that is, ochre, dark and light sinopia, blue, and white." (The ochre was probably the yellow goethite variety; Cennini might well have called the redder version sienna. The blue was probably azurite, a copper carbonate, and the white a calcium carbonate.) The pigments cut through the landscape, Cennini said, "looked as a scar on the face of a man or of a woman looks."

Like his contemporaries and intellectual descendants, Cennini either didn't understand or didn't distinguish between color as a concept, the thing eyes see and brains make, versus pigments that convey those colors. One thing he does get pretty close to right, though, is how to simulate *volume,* dimensionality. Through the

1300s, Italian painters handled this by using a darker shade of a color for shadow and, next to it but non-mixing, a lighter value for a highlight. But in a chapter called "The Way to Paint a Costume in Fresco," Cennini advised taking whatever color you're working in and splitting it into a dish of the pure color, a dish mixed with a lot of lime white, and a mixture of the two. You had to have a good white pigment to make this work, but if you did, you'd end up with three progressively lighter versions of the same color. The pure color would be where the clothing receded into shadow; the parts close to the viewer would be the intermediate. The lightest would be the highlights . . . and then, where light reflected off the material, Cennini said, pure white should be used.

Good plan; one problem. The saturated color in shadow looked like it was coming forward and the desaturated forward colors looked like they were receding. And since the pigments and paints that artists were using varied in relative brightness, combinations of colors looked even weirder. Yellows stood proud of blues, and so on. The overall effect was almost undulatory, as parts of the image that were clearly supposed to be "closer" to the viewer sort of fluxed backward and forward, trading places with things "farther away."

Another artist of the day, Leon Battista Alberti, had a whole other approach. In his 1435–36 book *Della Pittura,* Alberti told painters to put the pure color in the *intermediate* spot. Highlights, he said, should come from mixing in white, and the shadows from mixing in black. But that had a similar problem to Cennini's system. Mixing white or black desaturates the color in both directions, so that the midground, the parts of the drapery or clothing or whatever meant neither to project forward nor recede, accidentally used color to give an observer the idea they were meant to be out front. But meanwhile, the white-highlighted parts sent the same signal. Alberti's scheme was just as pulsatile as Cennini's, but for different reasons.

To try to understand all this firsthand, I spent an afternoon walking the relevant galleries of the Louvre, standing far back to see entire paintings and then walking as close to them as the

guards would allow to take pictures of the clothes. This had two consequences. One was I got a lot of weird looks from the other tourists, who seemed more interested in using their selfie sticks like épées to achieve a more advantageous angle in front of the *Mona Lisa*. But the other was more pernicious. In the same way that repeating a single word over and over can temporarily disconnect its sound from its meaning, I stopped being able to see the shapes in the paintings altogether. The whole illusory edifice of dimensionality and lighting within the paintings fell apart.

The relatively richer blue capes and robes in, for example, Fra Angelico's 1430–32 *The Coronation of the Virgin* seemed suddenly to hover far closer to me than the rest of the painting, except for the white-blue highlights at the hem of the kneeling saint in the lower right, which now seemed to recede behind the darker shadows. The scattered pink robes turned into black holes, singularities of depth in the canvas. The yellow peaks of the cloak worn by the acolyte on the left in Véronèse's *Supper at Emmaus* (1559) stopped looking like folds of satin or silk and more like 1980s neon. And Fra Bartolomeo's 1511 work *The Mystical Marriage of Saint Catherine of Siena*? Forget it. The glow of a bright orange toga on the left felt simultaneously four miles in front of the rest of the painting but also just a region of color amid other regions of color. Every painting turned, to my brain, into a constructivist's failed attempt to solve the four-color map problem.

Eventually my eyes started to cross. I gave up and went to go look at something that was an actual three-dimensional object, preferably without much color to it. I settled on early-twentieth-century cocktail glasses.

Color theory didn't really offer a solution to the problem of brightness versus perspective until chemistry came through with some help. The answer turned out to be a new kind of paint that allowed colors to mix more controllably. In the fifteenth century, painters and color-makers learned how to bind pigments in oil — linseed, walnut, or poppy, among others. Suspending colored pigments in oil instead of gum Arabic or egg yolk made the paints glossier and more refractive. Their new viscosity allowed artists to

develop a whole new set of techniques to mix them and move them around a surface. Painters could lay down thin, transparent layers, color on top of color, or they could spackle down thick, impasto glops; brushstrokes could be blended or sharp. The paint itself had dimensionality; paintings became three-dimensional objects.

Sometime between 1653 and 1659, a tween in the English town of Grantham bought a small notebook. In it, the young man — an apothecary's apprentice named Isaac Newton — recorded what he was learning about science. He'd built for himself a small workshop, full of tools and equipment, and he used the notebook to describe his work with them as well as memorialize some details from a book he was reading, John Bates's *Mysteries of Nature and Art,* full of instructions on how to make things like kites and mills.

Apparently just as practical and useful to Newton — because he diligently copied them too — were recipes for making ink and paint from pigment. To make a "sea color," steep blue indigo in water and add verditer, which was either bluish azurite or greenish malachite. Caucasian flesh: spots of red lead for the cheeks covered with white lead, shadows in lamp black or umber, unless the person is dead, in which case swap out the white lead with diluted juice of yellow berries, and use blue indigo for shadows. Gray, Newton knew, was black and white together.

It's possible Newton didn't know much more than that about color and light when he arrived at Cambridge for college in 1661. In some parts of Europe, much of that knowledge was secret, or poorly disseminated. But once he became a student, Newton read Descartes, and Robert Boyle's 1664 book *Experiments and Considerations Touching Colors,* which emphasized that at least in dyeing and painting, you could mix all the colors from three primaries. Then, in 1665, the university canceled classes because the bubonic plague was killing thousands of people a week. Newton went back to his mother's house in Woolsthorpe, commandeered a small room for a study, built some bookshelves, and went to work on the experiments that would define modern ideas about color and light.

You're thinking that this is finally going to be the thing with the prisms. But no. Not yet. First Isaac Newton is going to stick a giant needle in his eye.

He wanted to know how eyes worked, physically. So using his finger initially, and then switching to a brass plate inserted between his eyeball and the orbit bone around it — I know! — Newton pressed on the eye and recorded what he saw as a result: "apparations," he wrote. Newton then graduated to a "bodkin," a big needle, and shoved *that* behind his eyeball too. He saw circles, "plainest when I continued to rub my eye with the point of the bodkin," disappearing if he stopped moving the needle. Newton also stared directly at the sun for as long as he could stand it, and realized that afterward light-colored objects looked red to him, and dark ones, bluish. He only let up on the self-experimentation when he feared he might be causing actual damage to his vision, and closed himself off in a dark room for three days until his eyesight healed. In 1726, sixty years later, Newton told an assistant that he could still see the sun's afterimage if he turned his thoughts to it.

The colors and the afterimages made Newton wonder just how much of color was in the mind versus in the world. Conjuring colors with nothing but pressure, seeing them when they weren't "there" in any physical way, had allowed Newton to gather "something of the nature of madnesse & dreames," he wrote. Newton was trying to understand how light made color, but he was also realizing that *perception* of those colors was another critical factor. Light made color in conjunction with chemicals, and with the mind of the observer.

He was also reading Hooke. Robert Hooke was the "curator of experiments" for a bunch of rich guys in London who had started getting together to talk about their mutual interest in "experimental philosophy." In 1662, the Englishmen got a charter for their group, organizing themselves as the Royal Society. Three years later Hooke published *Micrographia,* a detailed account (with drawings) of what he saw through a very good version of a new invention, the microscope.

Hooke's drawings of things like lice and snowflakes made *Micrographia* a hit, but his observations of the iridescent, rainbow-like colors in peacock feathers and thin flakes of glass struck Newton as even more important. These were rainbows too somehow, even though they weren't caused by the refraction of light by water in the atmosphere. Something even more fundamental was at work.

OK, now we get to the prisms.

In his single-windowed study, Newton closed the shutter and like al-Farisi poked a tiny hole to admit a narrow beam of light. He set up a prism so that the light would shine through it and spread into the colors of the rainbow all the way across the room — seven meters — and recorded that the rays that appeared blue were more refracted than the ones that appeared red. The projection distance also gave Newton an oblong spread of color rather than a close-packed circle, enough space to then insert another prism into individual beams of color.

The second prism refracted blue light more than red. But it didn't break the light into any further colors. Blue was blue. Red was red. And bringing yet *another* prism into the line to reintegrate the separate beams had another effect. "Where the Reds, yellows, Greenes, blew, & purples of the several Prismes are blended together there appears a white." The prisms weren't modifying white light to create colors, Newton realized. White light was *already* all those colors, mixed together somehow.

I should say here that this experiment sounds hard, and it is. I bought a couple of good-quality prisms — unlike me, Newton didn't have Amazon — and shut my office up just as he did. I opened the blinds a crack, and managed to cast a rainbow onto the wall. But it was difficult to the point of impossible to align two prisms to break the colors apart. You have to be some kind of genius, I guess.

Newton's big revelation with the prism wasn't that different colors of light refracted differently through the same medium. Theodoric and his contemporaries had already shown that. Newton wasn't even the first to show that monochromatic rays don't change

if you put them through another prism—that was Johann Marcus Marci. Newton's scoop was how all those colors mixed together. Pure sunlight, white light, Newton realized, is actually all the other colors of light mixed together, and a prism separates them by refraction. Or as Newton put it, light "consists of *difform* Rays, some of which are more refrangible than others." The light around us consists of "simple" colors in a fixed order, the thing everyone since Aristotle had been looking for. Newton came up with a really good name for this order. He called it "the spectrum."

And then Newton immediately told no one. Instead he returned to Cambridge. He helped edit an old mentor's work on optics and color but told him nothing of his new results. When that mentor retired, Newton took the guy's old job: Lucasian Professor of Mathematics. Newton, by all accounts a boring lecturer, finally started doling out bits of what he'd learned from the prisms.

Newton's mathematics of refraction was cold and unromantic, but had its suitors nonetheless. A German named Henry Oldenburg, secretary of the Royal Society, had as a major part of his duties the exchange of letters with researchers all over Europe. (Oldenburg was fluent in Dutch, English, French, German, Italian, and Latin.) In 1664 he pitched a moneymaking idea to Boyle, a founding member of the society: Combine all that correspondence into a subscription-only newsletter. The French *Journal des Sçavans* had just started publishing, and its editors had asked Oldenburg to contribute. Oldenburg instead brought an early edition to a society meeting and either a draft or proof of what he wanted to try himself—something similar, "but much more philosophical in nature," he said. Thus began the *Philosophical Transactions,* arguably the first full-on scientific journal in the world. Two or three pages, one shilling a pop.

Oldenburg got wind of what Newton had been up to, and began bugging him about publishing it. Finally, in February 1672, Newton wrote a long letter describing his work with the intention that it be read at a Royal Society meeting. Oldenburg, operating under the assumption that anything anyone mailed to him was on the record,

threw it into that month's *Philosophical Transactions*. Oldenburg had pivoted the journal to a subscription model, and that model lives or dies on exclusive content.

For the seven years of its existence, articles in *Philosophical Transactions* had mostly followed a narrative, chronological model set out by Boyle. The format a journal might follow today — introduction, hypothesis, methods, results of the experiment, conclusions — hadn't yet become a thing. Newton's letter starts out as something of a confection, with his methods and ideas alongside expressions of pleasure at how darn fun the whole thing was, at his joy in discovery.

Then he sort of gave up. About halfway through, Newton stops trying to prove anything with math and just lays out his theory, describing a couple of experiments. This wasn't "my trip to the rainbow." Still, though, for the very first scientific journal in the world, Newton had written the very first scientific paper. And it was about color and light.

Almost right away, the smartest men in the world started trolling him. Hooke wrote Oldenburg within a week of publication, saying Newton was wrong about differential refrangibility, wrong about white light, and wrong about what light was made of. And, anyway, Hooke said, he'd already done these experiments and didn't think they were a big deal. *Philosophical Transactions* spent the next four years publishing criticisms of Newton's work, and then publishing Newton's responses.

Argh.

Eventually Newton bailed. He stopped talking to Oldenburg. Hooke died in 1703, and a year later Newton, clear of his nitpicking, published the book *Opticks*.

In that weighty volume, Newton added a bunch of new wrinkles. He'd already been thinking about primary colors, but now he acknowledged that the spectrum was continuous and included infinite gradations of colors along its continuum — the answer to how colors could change, and how color orders could progress. Yet he also insisted that the spectrum had an Aristotelian (and

alchemical) seven colors — to red, yellow, green, blue, and violet he added orange and indigo, and he wrapped them into a circle, joining the red at one end to the violet at the other via the nonspectral color purple, which he basically just made up. In modern color science terms, he had created a chromaticity diagram, an attempt to quantify ways colors mix and seem to move in an orderly way from one to another.

Newton's ordering was modern, progressing like the rainbow, rooted in natural, physical phenomena. Looping it into a circle, though, might have been Newton's way of tipping his pointy wizard's hat toward the alchemists, with their affinity for the mystical mathematical ratios of Pythagoras. (Historians have not weighed in on whether Newton actually had a pointy wizard's hat, but he was certainly familiar with alchemical ideas on color and its significance — he wrote extensively, though secretly, on alchemy, and his lab at Trinity College included books on alchemy and materials common to its practice.)

Unlike typical alchemists, though, Newton used math. He was able to calculate to great precision the differences in refraction of each color, and his circle apportioned different amounts of circumference — which is to say, larger or smaller pie pieces — proportionately. Those proportions were subjective, to be sure — they had something to do with that mystical musical connection — but perception of how colors relate to each other, as we'll see later, is *always* subjective. That circle was becoming a physical representation of the geometric relationships among colors. It was, in short, a colorspace.

More modern colorimetry has a bunch of problems with Newton's circle. Purple didn't exist on the rainbow, but had to take up space on the circle, and the circle can't show the range of purples people actually see when you mix violet and red. The circle has no way of showing that "spectral orange" would be indistinguishable from a mix of spectral red and spectral yellow. And maybe most troubling for the problem of how colors mix, Newton put colors unmixed with white at the edges of the circle to represent "pure" hues — though he wouldn't use that term — and the center of his

circle white, because combining all those hues gave white light. But the implication was that any two colors opposite each other on the circle would *also* make white, by themselves, if you combined them. Except that was only true for some of the colors as Newton partitioned the spectrum. If the colors weren't "primary," Newton wrote, then they'd combine to form "some faint anonymous Colour." Not a lot of help there. Also, this is all a little confusing, because it only works for colored light — not colored paints or dyes. If you mix those, they get darker, not whiter. More on that in a bit.

From another perspective, though, Newton's circle did offer some help to both physicists and painters. The all-white center of the circle implied that colors could have a quality besides hue. A progression from desaturated white at the center through pastel-like shades to the most intense hue at the circumference is what modern color scientists would call chroma. Newton's circle didn't have the third modern quality, value, or luminance, which is the total amount of light. But nobody's perfect.

Even though the circle was about light and not paint, Newton was almost certainly trying to offer something of use to craftspeople. He peppered his optics-related lectures with color theory from painting, and in later life Newton certainly understood that the business of ceramics was also one of color and pigment. In 1705, by which time Newton was running the Royal Mint, he argued against raising the price of English tin. Why? Well, lots of reasons, but "They cannot glaze earthen ware without Tin & if not Glazed tis nothing worth," Newton wrote. Tin-glazed pottery is glossy, opaque white — the 1700s version of whiteware from Xing.

Pigment-makers and artists showed their appreciation by spending the next century building Newton's color-mixing circle into their own tradition and ideas. And not just Newton's. Since the Middle Ages, craft guilds held their alchemical and practical secrets for making, mixing, and seeing colors under lockdown, hermetic knowledge available only to initiates. (Bates's *The Mysteries of Nature and Art,* the book young Newton copied from, was an exception.) The powerful Royal Academy of Painting and Sculpture in France, founded in 1648, maintained a fierce firewall

around its practical knowledge — students were only allowed to take classes with live models at the school itself, and often lived with teachers in a master-apprentice relationship that would've been familiar to Cennini.

But in 1666 France established the Royal Academy of Sciences, a counterpart to England's Royal Society. These new organizations took over the dissemination of knowledge, and the new crop of scientific publications were as likely to contain new results on textiles, painting, and dyeing as on optics. Joining the *Journal des Sçavans* and Oldenburg's *Philosophical Transactions* was the French *Descriptions des arts et métiers,* which published articles on pigments and materials. There was even a journal called *Observations périodiques sur la physique et les beaux-arts* — a journal of physics and fine arts, a combination hard to imagine on a present-day library shelf.

The massive economic importance of textiles, a principal driver of the Industrial Revolution, turned this publication cycle into a feedback loop. Dyers needed to know more about the new substances they were using to color their products, and the more newly colored products there were on the market, the more demand there was for them, and for making more of them. The first half of the eighteenth century saw the publication of multiple encyclopedias that scraped the old secret craft books for content, which were eventually subsumed in Denis Diderot's thirty-nine-volume *Encyclopédie ou Dictionnaire raisonné des sciences, des arts, et des métiers.* The whole point of these new publications was to get knowledge about practical color and color science to a wider audience.

None of that broadening of knowledge would have happened if Isaac Newton hadn't totally blown his own mind trying to understand light and color. He told the Swedish scientist and mystic Emanuel Swedenborg that his everyday experience of colors was "much brighter and of far greater variety than in the world." Even if Newton was just tripping, certainly his descriptions of those colors — or maybe just the fact that someone had described them — changed how human beings thought about their relationship

to color. In eulogizing his old adversary Hooke, famously short of stature, Newton said that he himself had stood "on the shoulders of giants." But sarcasm aside, those giants were people like al-Haytham, al-Farisi, Grosseteste, Bacon, and Descartes, who'd used their investigations into color and light to literally invent the scientific method that was Newton's capstone. Observation, hypotheses, data, mathematical analyses — these tools were every bit as key to unraveling the rainbow as water-filled glass spheres and prisms. It took the invention of science to turn color into culture.

Aristotle's world of rainbows, colors, and light had seemed almost inscrutable to his translators. The challenge of figuring out what he and his contemporaries were even talking about, much less improving on that, must have seemed an almost unclimbable wall to physicists in Baghdad or Cairo or Paris or Cambridge. But over the course of two thousand years, that wall fell. By staring hard at the sun, at its colors and the colors of the ground on Earth, the first scientists learned that the world was knowable. The rainbow was a bridge between light and material color.

As an aside, the invention and codification of that science would become a source of disappointment for William Gregor, the scientific parson who discovered titanium in Cornwall. Gregor's article was read before the Royal Society in London, but he was in such a rush to publish that he wrote up his experiments and sent them to the German scientific journal *Crell's Annalen* and the French *Journal de Physique* in 1791. By then, *Philosophical Transactions* was the preeminent English-language scientific journal, one of perhaps fifty published worldwide. Journals had supplanted private communication as the main way researchers exchanged results and hypotheses, and while they weren't available to the public (and, arguably, in large measure still aren't), journals had changed how people knew what they knew, and told each other about it.

But alas, the *Transactions,* it turned out, had a rule against printing anything that had appeared in any other journal. Today's scientists might feel Gregor's pain here. They'd recognize that exclusivity as the "Ingelfinger Rule." That is, in 1969, Franz Ingelfinger, editor of the *New England Journal of Medicine,* told researchers that

he wouldn't publish anything in *NEJM* that had been published elsewhere. It was meant, in 1969 as in 1791, as a check on unruly, unreviewed work and a signifier of exclusivity and elite status. *Crell's Annalen* wasn't chopped liver, but it wasn't *Transactions*, either. Gregor missed that particular kind of immortality — something that rankled him for the rest of his life.

THE LEAD WHITE OF COMMERCE

In the early American colonies, paint of any kind was expensive, and you'd get tsked to death for applying it. Colorful clothes and buildings were yet another sinful frivolity. In 1639 Reverend Thomas Allen had to defend himself against the criticism of his neighbors in Charlestown, Massachusetts, for the temerity of having a house with a painted interior; he got his town off his back by proving the previous owner had done the painting. New York, full of Dutch settlers who liked a bit of paint, was less strict, but in general colonial-era homes were made with unfinished wood, maybe whitewashed — that's calcium carbonate, or lime — inside. Supposedly the first church in Boston was never painted, and a 1670 list of laborers in Massachusetts names no painters.

A person might have been able to get away with coloring things straight-out white. And apart from lime, most of the human world got the color white from a pigment that dates back at least to ancient Egypt: lead white.

It was perhaps most familiar as a cosmetic. Xenophon's *Oikonomikos,* written sometime around 362 BCE, talks about makeup made from white lead colored with alkanet. Seven centuries after Xenophon, in 394 CE, Saint Jerome advises a widow to avoid all makeup if she hoped to maintain her religious chastity. "What place have rouge and white lead on the face of a Christian woman? The one simulates the natural red of the cheeks and of the lips; the other the whiteness of the face and of the neck.

They serve only to inflame young men's passions, to stimulate lust, and to indicate an unchaste mind," Jerome wrote. He might've been recapitulating typical mindless sexism; as soon as color became something women did, Western intellectuals wanted to toss it right out. In fact, this dynamic — "masculine" form versus "feminine" color — has threaded through Western thought. Even though (as I'll talk about more later) sculpture and architecture in the Greek world were generally colorful, Plato and Aristotle both argued that form was more important than color. During the early Renaissance, if a contemporary sculpture wasn't colored and ornamented, people figured it was only because its maker or owner didn't have the money to make it look good, but Leonardo Da Vinci and Michelangelo changed all that. They both said that sculpture was supposed to be about pure form, that color was a crutch — a sensibility that the artist and writer David Batchelor argues has held sway throughout the history of Western design and art.

Still, Saint Jerome's injunctions notwithstanding, European ladies generally maintained makeup kits. From at least the sixteenth century, Venetian ceruse — also called "spirits of Saturn," a mix of white lead and vinegar — was a main ingredient. The style for way-pale faces and chests returned in the European Renaissance and stayed in vogue until the end of the eighteenth century. That had consequences — Venetian ceruse caused hair loss, helping perhaps to explain the trend among Elizabethan women of shaving their bangs.

Lead white was also a basic pigment for artists. It's in the budgets for the painting of St. Stephen's Chapel in the Palace of Westminster in 1292 and 1352. Cennini mentions it as a common pigment in *Libro dell'arte,* though he cautions that it can darken when used outdoors. That didn't decrease its popularity.

What made it so great? "It's not just color when you're making a paint," says Barbara Berrie, head of scientific research in the conservation division of the National Gallery of Art who studies historical pigments and wrote a 2011 paper called, delightfully, "Lead White from Venice: A Whiter Shade of Pale?" All kinds of things affect how a paint acts, Berrie tells me — particle size,

homogeneity of particle shape, ratio of pigment to binder, and type of binder, to name a few. Keep the particle size consistent and the shape flattish and you get a paint that remains fluid when you push it with a brush but solid when you don't. (That's called being thixotropic.) The highest-grade lead white paints from Venice had flat, hexagonal crystals that were exactly the right size to include a little bit of ultraviolet refraction — very good for a luminous white — and thixotropic enough to yield precise lines even when used impasto, laid thickly on a canvas. Do you like the ripples of light on the water in Dosso Dossi's *Circe and Her Lovers in a Landscape* (1525), or the highlight on Christ's robe in Tintoretto's *Christ at the Sea of Galilee* (1575–80)? Then you, like most humans throughout time, also like lead white.

As North American colonies got more successful and more liberal, the culture around color changed. Pretty much everyone painted their houses, their barns, their everythings in "Spanish brown," red ochre bound in milk. But if you were rich enough, it was just primer. By 1710, local papers were advertising expensive, imported paints in colors like Indian red, olive green, pumpkin yellow, gray, and blue. "For interiors, blues and greens were favorites, often with the green made olive or the blue grayed by the addition of black. Vivid hues were found on spattered floors, plastered walls, and woodwork. White, gray, pearly tones, and stone shades seemed to have been favored for meeting houses," the color historian Faber Birren wrote in 1941.

More colors soon became available. Vermilion, verdigris, umber. You could get ultramarine, Naples yellow, Dutch pink — if you had the gold to pay for them.

Color had been, in short, industrialized. New pigments were becoming more and more widely available, completely changing how the world looked — on walls, in fabrics, on objects. As a paint and as an opacifier, extender, and brightener in paints of other colors, widely available white lead was a big part of that. And people wanted more of it.

They were about to get their wish. The end of the eighteenth century and most of the nineteenth were about the pursuit of new

colors and new ways to make them. They were also the most fertile time for understanding how people actually saw those colors.

These questions weren't just academic or theoretical. If you want to keep making new pigments, you have to understand their chemical and physical properties, of course. But beyond the recipes, you also have to know how someone will see those colors once applied. Natural and human-made colors were everywhere, but no one had a theoretical construct to explain why.

In the mid-1750s, Venice was still making the purest and most expensive version of lead white—probably for cosmetics. England and Holland made the industrial stuff that was used for paint. And one of their biggest markets was the North American colonies, where white had become the proper color for proper houses, usually with window shutters of green—verdigris, or a mix of indigo and yellow gamboge. "It was new, completely new, as new as a democratic color free from Parliament," writes the historian John Stilgoe. "Against fields brown in spring, green in summer, and yellow in autumn, a white-painted dwelling acquired heightened significance. . . . White emphasized the process of making agricultural land from wilderness. It announced the meaning of every farmhouse to the national polity."

England, specifically, was the main importer of white lead to North America. In fact, it's one of the products taxed in the 1767 Townshend Act, one of the laws that sparked American colonists' anger at taxation without representation and helped cause the Revolutionary War.

Once that war was under way, white lead came to seem like a foreign product, made by the enemy. The supply could have been cut off entirely, had it not been for a Philadelphia carpenter named Samuel Wetherill.

In 1775, Wetherill, a Quaker, joined the fight against the British. He co-founded a company to produce some of the first clothes made commercially by colonists, and when the Revolution was over, Wetherill sold all the weaving and textile equipment in his Philadelphia factory, determined to start creating his own dyes

rather than continuing to buy them from others. Wetherill & Sons added this description to their letterhead: "We are Druggists as well as Oil and Colour Men." The paint they sold would ultimately cover walls across the new country, and spark the creation of one of its main industries.

In 1804, Wetherill built a factory in Philadelphia to make lead white; it burned down, possibly due to arson committed by a worker who was secretly an agent of a European lead white maker. In 1809 he started again, joining with three other Philadelphia firms to build a new factory, giving Pennsylvania the North American monopoly on lead white and its roasted cousin, lead red.

The English white lead makers did more than just (allegedly!) burn down Wetherill's factory. They had the advantage of entrenched factories and a larger customer base, so they waged a price war, undercutting Wetherill to the point that he almost went out of business. Eventually a *war* war — the War of 1812 — saved him by once again cutting off English imports. Except the need for lead for bullets denied the company its most important raw material, so in 1813, the Wetherill family bought a farm known to have a lead deposit and built their own mine and smelter. The company expanded to other lead-based pigments, including litharge and orange mineral, used in dyeing and to make rouge vermilion.

White lead had underpinned the technology of color for centuries. But even so, it wasn't easy to make, especially in industrial quantities.

At the Wetherill factory in Philadelphia, workers would melt pig lead and then pour it onto three-foot-long wooden paddles with raised edges; most of the lead would sluice off and get recycled into the process, and the metal on the wood would cool into a narrow sheet. Other workers would roll it into a loose coil and put it into a clay pot with vinegar in the bottom, cover the pot with wooden boards, and stack it with more and more pots, twenty feet high, each stack ultimately containing twenty to thirty tons of lead. And they'd fill all the spaces around it with fresh manure.

So *that* couldn't have smelled good, especially as the manure decomposed for two months, warming up the pots and vaporizing the

vinegar. This is where the chemistry starts: Vinegar is acetic acid, CH_3COOH. Stewing in the vapor, the lead picks up oxygen and becomes an oxide, and then an acetate as it picks up the carbons and the hydrogens, and then finally a carbonate from the carbonic acid in the manure. The lead carbonate precipitates out as a powdery white deposit on the remnants of the lead coils. When that powder was washed and dried and mixed with linseed oil — as young William Wetherill put it in his 1824 dissertation at the University of Pennsylvania — "it constituted cerusse or the white lead of commerce."

The stuff and the color it made were becoming something of a cultural totem. For example: Even if you've read Herman Melville's 1851 novel *Moby-Dick* — maybe in high school? — you probably don't remember it being great. It is. It's funny, weird, and a deep dive (only kind of sorry) into one of America's biggest industries at the time. One chapter in particular makes my point. In "The Whiteness of the Whale," Melville tries to explain why Moby-Dick is white. It's a pretty color, sure, Melville says, but "there yet lurks an elusive something in the innermost idea of this hue, which strikes more of panic to the soul than that redness which affrights in blood." It's polar bears. Great white sharks. "Even the king of terrors, when personified by the evangelist, rides on his pallid horse."

You think Melville's overstating the case? He knows. "But thou sayest, methinks this white-lead chapter about whiteness is but a white flag hung out from a craven soul; thou surrenderest to a hypo, Ishmael."

White-lead chapter. That's so great! That chapter of *Moby-Dick* is literally led by the color white. It's also heavy and dangerous, like white lead, and the white flag of surrender. All colors were special, but this one was more special than others.

But as for this white-lead chapter right here? Well, the business of white lead still had a couple of problems.

Even the highest-grade lead-white-based paint suffered from the same problem Cennini identified in the 1420s: Exposed to air, it

turned black. By the 1800s, chemists knew why. Sulfur in the air from the burning of coal reacted with the lead and inverted its color; soot settled on the coating's rough surface and made the effect worse.

And then the paint fell off. Somewhere between four months and a year after painting, lead white would come away from the substrate as a fine white powder. No one was sure why it "chalked" like this; hypotheses ranged from the formation of fatty acids within the oil binder to the formation of soaps — yes, the kind you wash with, but more specifically the salt of a fatty acid, in organic chemistry terms. In 1909, Clifford Dyer Holley, chief chemist at the Acme White Lead and Color Works in Detroit, quoted some other expert saying this was not a bug but a feature. "The chalking of white lead while objectionable is not entirely so, since it leaves the surface in an excellent condition to receive a fresh coat of paint," he wrote, finding a silver lining in the black color of his white paint.

Really, though, the business had a much bigger issue. People who made lead white, or indeed came into any kind of prolonged contact with it, got very, very sick. Everyone knew it, and had for a very long time.

The ancient Roman architect Vitruvius knew that making white lead was dangerous, and so was the empire's extensive use of lead for water pipes. (In Latin, lead is *plumbum;* which is why we call people who work with pipes "plumbers.") Pliny warned that wines sweetened with *sapa,* a syrup made by boiling grapes in lead-lined vessels, gave people "dangling . . . paralytic hands," and indeed peripheral nerve damage and weakness in the hands and feet are early symptoms of acute lead poisoning.

But none of those warnings made a dent. In 1994, a team of researchers looked at lead levels in ice cores pulled out of Greenland between 620 and 350 meters deep — strata dating from 500 BCE (about as far back as you can technically see heavy metal deposition) to 300 CE, spanning ancient Greece and Rome. And woof, did they find lead. The entire Northern Hemisphere had lead levels four times as high as the natural background level. In the Greek

and Roman world, levels were 15 percent as high as those achieved by the widespread use of leaded gasoline in the mid-twentieth century.

So people certainly understood the dangers in the late 1700s. In a 1786 letter Benjamin Franklin, arguably America's first scientist, recalled laws passed when he was a boy against the use of lead in the still heads and worms at New England distilleries, and wrote of the warnings he'd heard as a teenager working in a London print shop against warming his lead type in front of a fire, because he could lose the use of his hands—"the Dangles," they called it. He recalled asking why soldiers were included on a list of professions of people treated in 1767 at La Charité, a Paris hospital specializing in lead poisoning. "The Soldiers had been employ'd by Painters as Labourers in Grinding of Colours," Franklin learned. And now houses in the America painted with white lead were leaching "baneful Particles and Qualities" into water shed from their roofs.

Lead's mode of toxicity didn't get fully worked out until the twentieth century, and it is a doozy. Even at minute concentrations in the bloodstream, lead edges calcium out of enzymes that make neurons in the brain work, damaging their ability to send and receive signals. It sticks to proteins and disrupts enzymatic activity. It breaks transfer RNA, a form of genetic material that ferries amino acids to the cellular machinery that assembles them into proteins. It gets inside mitochondria, the powerhouses inside cells, and disrupts metabolic function. Lead breaks the biochemical pathway that synthesizes heme, the oxygen-carrying molecule in blood, and it is especially toxic to developing astrocytes, the cells that protect the central nervous system. It also prevents the body from producing enough myelin, the protective sheath around neurons, and it breaks down the blood-brain barrier. Don't get lead in you, is the lesson here.

But what was the alternative?

In 1780 a French chemist—it was either Bernard Courtois of the Academy of Dijon, or Guyton de Morveau, or maybe both—suggested a possible replacement for lead. Both men proposed

making a white pigment from zinc oxide, a tufty white by-product of the manufacture of brass. Medieval alchemists, always up for mysterious white substances that emerged from other metals as if by magic, called it *nix alba* or *nihilum album* — "white snow" or, if you're into alchemical punnery, "white from nowhere."

Courtois and de Morveau were motivated by the horror show of lead toxicity, and zinc oxide had no apparent health effects. (Inhale too much fresh zinc oxide and you get a Parkinsonian tremor called the oxide shakes or the zinc chills, but, well, omelets, eggs, etc.) Pigments made from the stuff didn't darken when exposed to sulfur fumes the way lead pigments did, but zinc oxide pigments took a long time to dry, and tended to form a thinner, more brittle film. Still, their manufacture didn't cause epilepsy, infertility, and paralysis, so let's call that a win.

Downside: In the late 1700s zinc white cost four times as much as lead white. That was enough to keep it from catching on until the 1830s, when the famed paint manufacturer Winsor and Newton made it into a popular watercolor, "Chinese white," and a French contractor and painter named E. C. LeClaire set out to popularize it even further.

The problem was, LeClaire's clients were still demanding pure white lead. So LeClaire cheated. In 1847, he started painting with zinc white instead, except for small sections of walls that he'd paint with lead white. It's hard to believe this worked; zinc-based whites tend to be warmer and clearer than lead-based ones, which can tend toward yellow.

Apparently he got away with it. Until, that is, the sections painted with lead white started to darken and to chalk. When his clients would complain, LeClaire would say *"Voilà!"* (I assume, because he was French) and reveal that the graying, dusty walls were lead, which was in fact inferior to his zinc. LeClaire won the Legion of Honor and, most important, got the government to shift its contracts to zinc white, which brought the price of manufacture down even further.

American industrialists — including the grandson of Samuel Wetherill, who must've been a black sheep of the family, working

not in the lead business but for New Jersey Zinc — eventually came up with their own competing process. Another transatlantic white-pigment price war began. By 1880, on the strength of the pigment business, zinc was one of the biggest metal commodities in the United States. Zinc wasn't great by itself as a house paint, though when mixed with other white pigments or colors, it worked well.

This was critical, because science was bringing more and more new pigments to market. In 1856, the chemist William Perkin, trying to synthesize a replacement for the antimalarial quinine, accidentally synthesized mauveine, mauve pigment, from coal tar. It was the spark that lit a multicolored explosion. Perkin's trial-and-error approach led to more intentional chemistry — aniline yellow and bismark brown were the first "azo dyes" in the early 1860s, and alizarin opened up the anthraquinone dyes in 1868. Forget the ochres and madders, Prussian blue. Now the world was iodine scarlet, chrome yellow, emerald green, chromium oxide green, manganese violet. In the nineteenth century, the number of available pigments doubled.

And all of those new colors, to a greater or lesser extent, and depending on application, required a white pigment to work. Mauveine was the first synthetic organic pigment. It was a dye, which means that it would stick to other organic substances, like fabric, but also that it combined well with a lead white or zinc white to form a "lake," a dyed pigment that can be an ingredient in paints.

In the arts, painters began experimenting with both lead and zinc, especially in the undergirding "grounds" that Cennini and Alberti argued about. Vincent van Gogh even painted different versions of the same painting with one and then the other. He also complained regularly in letters to his brother Theo about how long zinc white took to dry, and how expensive it was — his letters frequently included orders for more paint, and tubes of zinc white were often on the shopping list.

Artists had plenty of reasons to consider (and reconsider) their choice of white pigment. Even if the health issues of lead didn't

bother them—they were more consequential for the people making the pigments—lead white still tended to turn black. "Zinc oxide didn't, so here was a replacement for an unstable pigment. Or so they thought," Berrie says.

But zinc didn't form films as well as lead, so paint-makers often ended up mixing the two together, especially for exteriors. The problem with that is that zinc white paints do something even worse than chalking. They "spall off," forming an outer layer that peels off like sunburned skin. "They were lauded because of this," Berrie says. "It was as if your house was freshly painted, even though it was just that the top layer was falling off. It works for houses, but doesn't work very well for fine art." Plus the colors were different —not all whites are the same. Lead was much whiter against paper; zinc was softer.

By the late nineteenth century, zinc whites were in demand, but it was the millennia-old white lead that had won the war of the whites and made the built world brighter. One English manufacturer was producing 50,000 tons a year, according to one estimate, and the United States was pushing 70,000 tons. The colorful world came at a toxic cost, and the bill was going to come due.

In 1859, the novelist Charles Dickens decided to use his fortune to make explicit the radical political and economic subtext of his stories. He started a magazine, *All the Year Round,* and made himself a columnist. As a journalist myself, let me say that this is a good scam.

At the newly established East London Hospital for Children and Dispensary for Women, in one of the most Dickensian neighborhoods in Dickensian London—Dickens met a doctor named Nathaniel Heckford, who agreed to show Dickens around. Dickens tells the story of that 1868 tour in the article "A Small Star in the East," reprinted in the book *The Uncommercial Traveler.* He enters a dark, meager tenement apartment, and once his eyes adjust—a small cooking fire is the only light source—Dickens sees "a horrible brown heap on the floor in the corner." This turns out

to be a woman named Mary Hurley, curled up on a bed. There's another woman there, cooking, and Dickens asks her who the person on the bed is.

> "'Tis the poor craythur that stays here, sur; and 'tis very bad she is, and 'tis very bad she's been this long time, and 'tis better she'll never be, and 'tis slape she does all day, and 'tis wake she does all night, and 'tis the lead, sur."
>
> "The what?"
>
> "The lead, sur. Sure 'tis the lead-mills, where the women gets took on at eighteen-pence a day, sur, when they makes application early enough, and is lucky and wanted; and 'tis lead-pisoned she is, sur, and some of them gets lead-pisoned soon, and some of them gets lead-pisoned later, and some, but not many, niver; and 'tis all according to the constitooshun, sur, and some constitooshuns is strong, and some is weak; and her constitooshun is lead-pisoned, bad as can be, sur; and her brain is coming out at her ear, and it hurts her dreadful."

Mary Hurley was a victim of acute lead poisoning. It wasn't a consequence of her constitution, as Dickens's source says, but of chronic exposure to aerosolized lead dust in the course of her duties at a white lead factory. Industrialization had turned it into a scourge — bad enough so that muckrakers like Dickens would write about it, and a do-gooder physician would actually try to stop it.

That was Thomas Oliver, a Scottish doctor who in 1879 moved to Newcastle to become a physiology lecturer at the University of Durham. Newcastle was an industrializing town, and at the Royal Victoria Infirmary, Oliver first encountered patients with lead poisoning — "plumbism" or "saturnine poisoning" — from smelting, pottery (which used lead glazes) and white lead manufacture in the area.

Two decades later, Oliver was part of a government commission on health in the white lead industry. The process of mixing the lead carbonate into binders and pastes that had been done by hand at Wetherill's Philadelphia factory was even more dangerous scaled

up with modern technology. Oliver found that workers—mostly women—were physically carrying open bowls of white lead paste into and out of steam-heated rooms, coming into close contact with dust and vapor. It was the cause of more deadly lead poisoning cases than any other job in the factory, and the women who did the job had a greatly elevated rate of miscarriage and infertility.

Oliver eventually lobbied successfully for laws that banned women from the work, which both helped fix the problem and is exactly the kind of sexism that keeps women from being as well employed and well compensated as men—the invention of occupational health as a practice was aimed more at the health of women's potential babies than the women themselves. "Nearly two decades have passed since I strove for and succeeded in securing the emancipation of female labour from the dangerous processes of lead-making, and, although for years I was the target of abuse of manufacturers and of some of the Labour societies, events have more than justified the recommendations I made," Oliver told the Eugenics Education Society of London in a 1911 lecture. (Yes, I know eugenics is bad, but in the early 1900s it was respected science.)

Oliver did more than just get women kicked out of the factories. He got the English to institute stricter occupational safety requirements throughout the industry, including better ventilation and automated ovens, reducing contact with the raw powder.

The people profiting from that industry fought all those regulations. In his 1909 history *The Lead and Zinc Pigments*, Clifford Dyer Holley pish-poshes occupational health concerns about lead. "While it is true that painters suffer more or less from lead poisoning, it is usually due to lack of even ordinary cleanliness, for the painter who is scrupulously neat is very seldom affected," Holley wrote. Maximilian Toch's 1916 edition of the influential *The Chemistry and Technology of Paints* acknowledges white lead's toxicity but says surfaces painted with it are totally safe. "Its poisonous quality is manifest to the workmen in the factories where white lead is made," Toch wrote, "and also to the painter who is careless in applying it." (That's only true if kids don't get exposed to aerosolized lead dust, play in lead dust–laden dirt, or

eat the lead flakes that peel off old walls — lead still tastes as sweet as it did mixed into Roman *sapa*.) Good factories need only take health precautions, Toch wrote, like putting potassium iodide into their workers' water. It's a testament to how significant Dickens's writing on this was that over forty years later Toch felt the need to tell his readers to ignore as fear-mongering the article Toch either incorrectly or derisively calls "A Bright Star in the East."

Profits were so high, manufacturers were loath to turn away from lead, no matter the human toll; they actually tried to turn lead into a virtue. They asked the government to mandate labeling on paints — to leverage the then-new Pure Food and Drugs Act not to warn people *away* from "adulterated" non-lead paints. The "Dutch Boy" paint logo — now a brand signifier for the Sherwin-Williams Company — started out in 1907 as a guarantee from the National Lead Company of pure, lead-filled goodness. Even though European countries started banning lead in the decade before World War I, the United States wouldn't follow until the late 1970s. In 1907, mines in the US produced 331,000 tons of lead, and nearly a third of that went directly to the production of the white pigment. Everyone knew they needed something better, and no one had it.

Now we have to jump back in time a bit, to bring the scientists up to date with the painters.

In 1704, the same year Newton published *Opticks*, Jacob Christoph Le Blon — also known as James Christopher and Jakob Christoffel — developed a simple way to reproduce the colors in elaborate, full-color oil paintings.

Le Blon wasn't the only person working on what had come to be known as color printing. That history goes back to at least the 1300s, and the idea of making images with multiple plates, each inked with a different color, dates to the first decade of the 1500s. But Le Blon's method was low-impact and elegant. He'd break the painting down into its red, blue, and yellow constituents — something Le Blon had an uncanny knack for. Then he'd ink only those colors onto separate engraved metal plates. The inks didn't physically mix together; just by being adjacent to one another on the

page, those three colors would mimic all the colors anyone saw in the original artwork.

Almost. Le Blon soon realized that they sometimes weren't dark enough, and that his three colors wouldn't mix to convincingly recreate things like dark shadow and night sky. So he added a black-inked plate too; his substrate, paper, provided the white. This process, *mezzotint,* which Le Blon discovered around 1704 and patented in England in 1719, is roughly the same way that color printing happens today. You might have heard of colors described in a CMYK system — that's inks of cyan, magenta, yellow, and black, which in small enough dots on a page mix together, somehow, to form every shade of red, blue, and green — and every other color, too.

That "somehow" is going to get very important. Three colors, mixed "mechanically" or "optically" — which is to say, as dots next to each other generating new colors, rather than as a mixture of pigments — somehow make as many colors as Newton saw in his spectrum. Which is to say, all of them.

Now, Le Blon knew his Newton. In his 1725 book *Coloritto,* Le Blon distinguished — rightly — between the mixing of material colors like pigments to produce, eventually, black, and the mixing of "impalpable" colors, different kinds of light, to produce white. "*White,* is a Concentering, or an *Excess* of Lights. *Black,* is a deep Hiding, or *Privation* of Lights." (The emphases are Le Blon's.)

So that's two categories. On the one hand he has what we'd today call additive or emissive colors, what Newton had fractured from one color of light into (at least) seven. And on the other hand, Le Blon's patent employed subtractive or reflective colors born from pigments, applied to surfaces and bouncing light back at an observer. As craftspeople had done for thousands of years before him, Le Blon was combining just three of those into a complete palette, but one that eventually absorbs so much light through use that it turns black.

In his patent, Le Blon inadvertently laid out the shape of the problems that artists, chemists, physicists, and physiologists are going to be fighting about for the next century and a half. If in

actual practice just three colors can be primary, then what are the spectral colors of the rainbow? Even if you disagree with Newton that there are seven — or eight, counting purple — it's pretty clear that rainbows have more than three. So what, then, is the best way to capture all those colors in reproduction, to build an increasingly colorful world?

Critically: If mixing together the couple of dozen pigments available at the time made a muddier and muddier mess, how can people make something that's white? How can anything people make truly be white?

Not that knowing any of those answers would help Le Blon, particularly. His reproduction-printing business failed shortly after he got his English patent. He couldn't keep up with demand, and he insisted on working in the relatively high-end market of oil painting reproduction rather than the more mass-market clientele of scientific journals and anatomical textbooks.

To be clear, Le Blon didn't solve all — or even many — of the technical challenges of three-color printing. Even with the magazine business in dire straits and the continuing insinuation of electronic screens into every part of daily life, that work continues — with digital controls on the amount of inks and where they land on a page, among other improvements. In fact, the ongoing search for ways to make sure that all three color plates line up to imperceptibly mix together, or stay "on register" in printer-speak, has led to side innovations that don't seem like they have anything to do with color.

In 1902, for example, the Sackett-Wilhelms Printing and Publishing Company in Brooklyn started finding problems with their otherwise high-quality color output. Sackett-Wilhelms typically ran pages through its presses repeatedly, one run per color of ink. But variable heat and humidity meant that the paper itself would change size slightly between runs, resulting in off-register prints that the printers would have to throw away. On the most humid days, the company would have to shut off the presses entirely. So the printers brought in a consulting engineer named William Timmis, who realized the key was — not a giant intellectual leap here —

to control humidity in the printing plant. Timmis had no idea how to do this. So he in turn got in touch with a company called Buffalo Forge, which made fan-blown heaters, and employed a young engineer named Willis Haviland Carrier. It was Carrier who figured out a way to use fans to blow air over coils of pipes filled with refrigerated water. The tech wasn't perfect, but it did reduce relative humidity inside the Sackler-Wilhelms plant by 20 percent. It was also the world's first air-conditioning system. Without color-making technology, we might not have modern climate control.

Of the anatomic plates Le Blon did print, few still exist. Perhaps the most famous is a life-size rendering of a penis. It's 10.5 inches long and about eight inches high (the print, not the penis) and supposedly appeared in a 1721 book called *The Symptoms, Nature, Cause, and Cure of Gonorrhoea,* though the edition you can download from Google Books doesn't seem to have any images. The original illustration is on display on the website of the Rijksmuseum in Amsterdam, but I have to warn you, before you follow the link in the endnotes and look it up, that the depicted penis is fileted wide open. This was for a medical textbook, after all — written by a physician named William Cockburn, no less. (In case you were worried that the history of color would fail to involve a dick pic *and* immature jokes, I have you covered.)

Even in his relative lack of success, Le Blon was trying to answer the same questions everyone who studied and used colors was asking. Why do mixtures of colors sometimes darken, but sometimes make white? If nature makes somewhere between seven and a zillion colors, but a selection of three can reproduce those colors, what's the point of the spectrum? All these questions about how color worked — on surfaces and in nature — were becoming more and more urgent. Scientists were trying to uncover the ways light behaved in the world and how the human body worked at the same time as industrialization and a growing middle class meant demand for reproduced colors and a wider palette was widening. Every time people get a little bit of money, they want more colorful clothes, walls, art, products.

The theory of how to make all that was incomplete. One key element was missing: the eye.

There were hints out there. In 1777, a dyer named George Giros de Gentilly Palmer, himself the inventor of a couple of new colors of dye for textiles, published a book called *Theory of Colours and Vision*. Nobody really noticed.

This pamphlet, written as a dialogue between two men named Palmer and Johnson, has the temerity to contradict Newton and propose a whole new theory of color: White surfaces reflect rays of light and colored surfaces absorb them — a red object absorbs red rays, in Palmer's construction. Red, yellow, and blue were primaries, as artists and artisans also understood them. Purple, green, and orange resulted from mixture. And combining all the primaries gave black, which Palmer proved with an experiment in which he successively dyed white fabric with indigo (dark blue), then cochineal (red), and then weld (intense yellow). The textile went from blue to purple to . . . black.

Putting aside getting reflection and absorption wrong, he's just describing the way adding pigments cuts down the total brightness of the final product. Everybody knew that. But then Palmer has a (quite possibly accidental) stroke of genius. He infers that if you only need three primary colors to make all the colors of the world, maybe you only need to be able to *see* three primary colors to see all the colors of the world. The gross anatomy of the human eye was relatively well understood at this point; Palmer speculated that the retina — the back of the eyeball, heavily enervated and heavily served by blood vessels — was actually made of "particles of three different kinds, analogous to the three rays of light; and each of these particles is moved by its own ray."

He actually got it right. Palmer basically made an informed guess and nailed the mechanism of color vision: trichromacy, a retina with three photoreceptors sensitive to three different kinds of light. It was the first time anyone had connected the physical world of light, the chemical world of color, and the biological world of the eye and brain.

After his book on color theory, Palmer moved on to invent lamps with blue-tinted glass to yield light of better quality. Eventually he retired in Copenhagen, all but forgotten until historians recovered his early, lucky contribution.

So others got the credit for discovering what would come to be called trichromatic vision, starting with a person who, ironically, wasn't trying to understand how people see color. He was trying to understand people who couldn't.

Joseph Huddart was another of those priests who'd rather be doing research, so common in the history of science. In 1777 — the same year Palmer published his pamphlet — Huddart wrote a letter published in the *Philosophical Transactions* about a Cumberland shoemaker named Harris who didn't see the same colors as everyone else. He had seen rainbows, and could tell they were made of different colors, Huddart wrote, but "he could not tell what they were." Neither could two of his brothers. There was something about their vision that meant they saw a different-colored world. But no one knew what that was, or if it was because their brains worked differently or their eyes did.

And they weren't alone. Twenty years later, a decade before introducing the idea of atoms to chemistry, the English chemist John Dalton admitted in the *Memoirs of the Literary and Philosophical Society of Manchester* that something was wrong with the way he saw colors. "I was never convinced of a peculiarity in my vision, till I accidentally observed the colour of the flower of the *Geranium zonale* by candle-light," Dalton wrote. "The flower was pink, but it appeared to me almost an exact sky-blue by day; in candle-light, however, it was astonishingly changed, not having then any blue in it, but being what I called red." Just like the brother of Harris the shoemaker, Dalton's brother saw the flower's color in the same (wrong) way.

Becoming his own research subject, Dalton started comparing what he saw to reports from others. He glued silk threads of different colors into a notebook and noted that the thread called dark green looked blue to him. So-called green wool cloth looked dark brownish red. (It's no surprise that Dalton would refer to

textiles; Manchester was a quintessential industrial revolution mill town, full of automated looms and dyes.) Red, orange, yellow, and green were all "yellow" to him, with the reds having a tinge of brown. Everything else was blue. Dalton realized that most people see six colors in a Newtonian spectrum — nobody really sees the difference between indigo and violet. But him? "I see only two or at most three distinctions."

Dalton even got in touch with one of the Harris brothers from Huddart's letter, who described color vision very much like Dalton's. In the end, Dalton found twenty people, all men, who shared the condition. Dalton suspected that the cause was that some colors contained, as he said, combinations of colors that he couldn't see — crimson contained both red and blue, but Dalton saw only the blue. The implication was that the eye was somehow built to take in specific colors and then combine them.

But how? Remember that Dalton was unaware of Palmer's guess; Dalton thought maybe the gelatinous stuff that fills the eyeball, the vitreous humour, was somehow flawed in his eyes, absorbing the hues he couldn't see. Upon Dalton's death a doctor named Joseph Ransome examined the vitreous of one eye; it was clear. Ransome also cut the back off of the other eye and looked at red and green things through it. They appeared to be normally colored. So if it wasn't vitreous humor, what part of Dalton's eye couldn't see?

Another, different genius would eventually answer that question, even though he wasn't even thinking about vision when he started. Thomas Young — a Cambridge prodigy nicknamed Phaenomenon who'd supposedly read Newton's *Principia* and *Opticks* by age seventeen and spoke multiple languages, and was a member of the Royal Society by twenty-one — was initially interested in sound.

Young came to Emmanuel College at Cambridge in 1797, where he wanted to study acoustics. He knew sound moved through the air in waves, so he started observing waves in media like liquids and smoke.

Young realized that waves could also account for the shimmering,

colored fringes that Newton had seen in the edges of a lens pressed against a glass, and in the iridescence of soap bubbles or oil on water. When waves overlapped, Young saw, they interfered with each other — but in two different ways. *Constructive* interference happened when two crests or two troughs met, adding together, growing higher or deeper. And *destructive* interference occurred when a crest met a trough and they either partially or completely canceled each other out. Young was even able to use the speed of light and Newton's measurements of those refractions to calculate the frequencies of different colors of light in "undulations in a second" — and if you know something's frequency and speed, you have all the numbers you need to calculate its wavelength.

Now, Young had studied three-sided colorspaces made out of artisanal primaries, and now he had a mathematical basis for the Newtonian spectrum. He realized that those numbers, those undulations per second, could correspond not only to primary colors but to all the mixtures of color between them. The eye was the connection between the mathematics of light in the universe and the colors of the surfaces around us.

In a lecture in November of 1801, Young revealed that connection: Light was made of waves, he said, and "the sensation of different colours depends on the different frequency of vibrations." Wavelength is in effect a continuum, producing an essentially infinite number of possible colors. So the number of colors that the retina could perceive could be constrained to three, but the mixture of those wavelengths — more of one, less of the other two, in constantly varying amounts — could let someone see all the possible permutations. Color vision works for essentially the same reason color printing does. You only need three basic receptors: red, yellow, and blue. "Each sensitive filament of the nerve may consist of three portions," Young said, "one for each principal colour."

This theory would also explain the relationship between white and colored light, how the eye perceives color — and it'd explain Dalton's colorblindness as a bonus. Young deduced that, too, and also helped prove that light can act like both a wave and a particle.

After a distinguished scientific career that included helping to translate the Rosetta Stone, he'd die at an unusually early age. Other researchers would pick up the thread.

One of them was James Clerk Maxwell, Cambridge's first professor of experimental physics and the author of an 1864 paper that laid out the equations physicists still use to describe electromagnetism. But before all that, in 1849, Maxwell started messing around with spinning colored disks.

This was the same methodology Ptolemy and al-Haytham had used to understand how colors mixed together, but Maxwell added an innovation. He worked out some clever origami that let pieces of red, green, and blue paper — he called them vermilion, green, and ultramarine, but close enough — slip and slide over and under each other, so he could precisely specify the overall amount of each color that was visible at any given time. The center of his disks had black and white pieces that could do the same thing. Spin the disk and you get a gray in the center and a color around the edge.

Maxwell could then express the quantity of each visible color as a number, and then declare that those three numbers were equivalent to whatever the ultimate color was that the top generated when spun. This was Young's theory by other means — Maxwell could produce a near-infinite gamut of colors just by varying the amounts of any three primary colors. That led Maxwell to agree with Young: The retina had three modes of sensation, three sensors that combined higher and lower amounts of three wavelengths of light to produce all the other colors.

To prove that, Maxwell realized that he needed to quantify not the color observations of people who saw colors normally, but people who did not — which is to say, he'd figured out that colorblind people like Dalton or the Harris brothers must *lack* one of Young's sensors.

Now, Maxwell didn't know that there are a bunch of different kinds of red-green colorblindness (depending on which photoreceptor they're missing, so-called protanopes can't see red, and deuteranopes see red, but as green), but it didn't exactly matter. Maxwell drew a diagram of a colorspace, a triangle with the colors

red, green, and blue at its vertices. This was the equivalent of putting red, green, and blue on his spinning top; the position inside the triangle would be the equivalent of more or less of any one of the primaries. That meant every other color existed in the mixes along its edges, or in its interior. Then he built a machine that shined lights of those colors in different proportions. He picked a color to start with, marked it on his triangle, and showed it to a person with colorblindness.

Then Maxwell showed the person other colors, too. Whenever he found one that his subject couldn't distinguish from that first target color, Maxwell marked that color on his triangle.

He found a pattern. Maxwell could draw a line through those marks, straight to the red corner of the triangle. In fact, no matter how much Maxwell increased or decreased the amount of red light, as long as the ratio of blue to green stayed the same, the subject saw the color as unchanging. "For the normal eye, there are three, and only three, elements of colour," Maxwell wrote. "In the colour-blind one of these is absent." That person was, as Maxwell described him, a "dichromat" where most humans are "trichromats."

This is all important for its basic articulation of how color vision works — the human version of what those archaebacteria were doing back in Chapter 1. The human retina has "elements of colour," as Maxwell said. They're opsins, and they are the biological interface between whatever light and color are made of and the mind that perceives them. Linked to those opsins is a structure called a chromophore — it's what makes those structures pigments, just like the things that give color to paints and dyes.

At about the same time as Maxwell was publishing his conclusions in the *Philosophical Transactions,* a German chemist named Otto Witt was describing the problem from the other direction, making the connection between light and dyes, the physical stuff of color. It had the same solution — Witt was figuring out how chromophores worked in pigments, reflecting color rather than absorbing it.

Witt realized that all the new dyes that had been invented

since Perkin stumbled onto mauve had something in common. They were made of either a ring of six carbon atoms — that's also called benzene — or two of those rings stuck together. And those structures always had specific groups of atoms attached — two nitrogens bonded together, or a carbon and an oxygen, or even just two carbons. The simple functional groups somehow made the dye molecules colorful. Witt called them chromophores, color carriers. The whole structure overall came to be called a chromogen, or color-maker. These were the molecules and fragments of molecules that interacted with light and became a color that an eye could see. The idea of chromophores meant that color-making need never be as accidental as Perkin's luck with mauve had been. It was a theory, and it gave organic chemists a basis for building new dyes and pigments from molecular building blocks. Nobody knew exactly *how* the chromophores in dyes or the whatever-it-was in eyes interacted with light's fluctuating waveforms, and all of this theory would be rewritten, along with everything else in physics, in the early years of the twentieth century. But these connections, between the white pigment that undergirded the onslaught of new colors and the eye that perceived them, promised to drive a new polychrome century.

There was just one niggling problem: Even accounting for color-blindness, not all colors looked the same to everyone. They might even change depending on the context people looked at them, as Aristotle had said happened to embroiderers looking at their work with different sources of light. That fact hinted at a deeply complex interplay between new colors and the culture that demanded them. It wasn't enough to understand the physics of light or the chemistry of color or the physiology of the eye. People saw colors based on the conditions around them, on circumstances and their ideas of the world. Different kinds of colors would have to account for different kinds of people.

FIVE

WORLD'S FAIR

A visitor to the 1889 World's Fair in Paris — one of five world's fairs in that town in the second half of the nineteenth century — would have seen some real steampunk, Jules Verne stuff. There was an industrial metal tower built by the engineer Gustave Eiffel, standing proud of a gas-lamp-illuminated City of Lights. Thomas Alva Edison's new invention, the phonograph, hinted at a future of recorded music available in every home. The broad avenues and modern sewers built by Baron Georges-Eugène Haussmann made most industrial cities look, frankly, disgusting in contrast.

It all made Americans nuts. With the admission of Washington to the union in 1889, the country had put a button on the completion of its manifest destiny, extending across the continent. The four hundredth anniversary of Christopher Columbus's arrival in the New World was just a couple of years away, and so influential rich white men of power decided to stage a coming-out party for the continent they now dominated. Committees assembled, money got raised. Chicago, nearest the geographic center of population and a key railway hub, won the right to host, in 1893, a world's fair to rival the ones in Europe and tout America's ascendency.

This fair, though — the World's Columbian Exposition — would be more than a display of American modernism. Put plainly, it would use design and color to express cultural dominance. A group of white men, backed by the oligarchs of the day, would color the Exposition white literally and metaphorically. They were sending

the message, on purpose, that the fulfilled manifest destiny of the North American continent was more manifest for some people than others. It was the destiny, they were saying, of white men in suits.

As scientists learned more about what made colors and how people saw them, and technologists invented new ways to show those colors, the Exposition would become yet another proxy battle in the two-thousand-year-long war between form and color in which Plato, Aristotle, Da Vinci, and Michelangelo had all been soldiers. This fight mixed on a palette some dangerous ideas about masculinity with some colonial and murderous ideas about race and managed to come up with the color white. (Yes, that is both literally and metaphorically too on the nose.)

I'm going to spoil the ending: Color wins, because of two secret weapons. One was a technology that relied on the way the eye processes color from light, and the other was an emerging understanding of the way the mind assembles color from . . . well, everything.

First, some stage-setting. Chicago in the late 1800s was already famous for industry, protein, Midwestern values, and the biggest chip on (broad) shoulders east of the Mississippi River. If Americans thought Europe was looking down its fine, straight nose at them, then Chicagoans felt that twice as much about the snooty, elite East Coast. Screw 'doze guys, right?

The Exposition's moneymen wanted to keep its design local, and lucky for them, Chicago had some of the best architects in the world. They chose the great Chicago architects Daniel Burnham and John Root, who had built one of the world's first skyscrapers — the Montauk Building, at a then-whopping ten stories. While New York's leading designers were still building in the curlicue Beaux-Arts styles of Europe, the firm of Burnham and Root was the face of architecture's future.

For added oomph, the bosses chose Frederick Law Olmsted and his partner, Henry Codman, to do the site plan. Olmsted had traveled across America, built Boston's "Emerald Necklace" of parks and New York City's Central Park, and had even done some thinking about Chicago's park spaces two decades prior. It was Olmsted who asked that the eventual Chicago fair have a lakeside

location; one of his site recommendations was north of the Loop, but the local railroad bosses refused to build the new lines to get there. With no small amount of grumbling, Olmsted and Burnham turned to a site that Olmsted had already suggested would make a good public space — the marshy dunes of Jackson Park.

Burnham, Root, Olmsted, and Codman's plan for the Exposition would require major regrading and excavation, but all the buildings would be accessible from water and land. The centerpiece of the fair would be an "architectural court," a collection of buildings each containing items or exhibitions on a particular theme. Root hoped they'd employ a variety of styles and colors in the design — in their meetings, Root was the guy who took notes, drawing as the men talked about possibilities — but eventually the four agreed that the buildings on the court and around the main water feature would all be stylistically the same.

The architectural court would be *serious*. None of the frivolity or carnival-like atmosphere of those Parisian glass-and-metal confections. No! Root drew a few sort of Gothic-Moorish red-brown ideas, including a five-hundred-foot-tall octagonal tower and a pink granite Palace of Fine Arts with gabled ends and a mostly glass roof. "The only thing I dread about it is that, like some other things, it may be too good to be true," Root wrote in a letter to his wife in 1890. Olmsted, who like Root knew the value of fun, suggested they include a more variegated entertainment district stretching west from a point midway along the main fairground, something with rides and attractions, dancing, food, and a kind of living museum of other cultures. (Thinking of similar areas of French world's fairs, Olmsted suggested calling this area the Midway Plaisance, and hoped that people would forever more describe similar entertainment districts as plaisances. Today everyone calls them midways.)

If the English and French stuffed their fairs into giant metal-framed and glass-boxed sheds like the Crystal Palace, well, the World's Columbian Exposition would not. The buildings would have facades as rigorously unified as street fronts in Haussmann's Paris, or even London's Regent Street. The fair would be as ephemeral as all the other world's fairs, but it would *look* permanent.

Which, OK. But what did that mean, exactly? Stolidity, perma-
nence, seriousness . . . these are concepts. Architecture has to put
all that into action. What style would the buildings assume? How
would they interact with each other?

What color would they be?

In an 1883 essay, "The Art of Pure Color," Root firmly put himself
on the side of chromatic surfaces. He wrote that visual artists and
architects should learn color theory, optics, and psychology to un-
derstand how colors related to each other and how people saw
them, not just for aesthetic reasons but to make color in archi-
tecture and design more authentic, less of a builder's magic trick.
Constructing with some authentic material — wood or brick, say,
or a local variety of stone — only to cover it up with plaster, paint,
or wallpaper was fundamentally dishonest. Color theory and op-
tics could teach how to incorporate the real, intrinsic colors into a
building; ignoring those colors disrespected the materials and the
users of the structure. "To Science will Art turn, that she may have
her semi-paralyzed optic nerve galvanized into new and truer vi-
sion," Root wrote.

In this protomodern plea for authenticity of materials, Root was
also advocating for what would come to be called polychromy, the
use of material colors, paints, and pigments in a systematic way to
achieve optical and emotional effects. Root believed that the only
way to keep color from being inauthentic and ornamental — from
hiding a building's true materials, construction, and intent — was
with hardcore color science.

Chicago polychromatism was also pragmatic. The city's build-
ings were extraordinarily colorful as early as the 1870s, less out
of a desire to respect the inherent, natural color of a material and
more because of a desire to clean off soot and aerosolized effluent
from the city's burgeoning industry and stockyards, which tended
to turn everything black. Rough-cut gray sandstone doesn't clean,
and it's hell to get pollution gunk out of the turnings, crenella-
tions, and bas-reliefs that Beaux-Arts-trained architects were fond
of. But glazed terra-cotta? You can pretty much just wipe it with

a damp rag. And it doesn't take a brilliant designer to know that white shows stains more than a colored pattern.

Determining the overall color scheme of the Exposition wasn't the first thing on the to-do list. The Exposition had to be huge, national in scope, so Burnham realized that if he wanted that kind of grand sweep (and to get the work done in time), he had to bring in more architects. Out of what might look a little bit like insecurity, he went after those selfsame snooty New Yorkers and Bostonians the Chicago school was trying to beat — it'd help with the Expo's legitimacy, and maybe even bolster his own reputation. After all, he'd be the one giving them orders. The East Coasters were initially a bit reticent, but eventually even that most Beaux-Artsy of them, the prestigious firm McKim, Mead, and White, came on board. The traditionalist, grand old architects were coming to town.

Which they did, literally. In January of 1891, Burnham hosted members of the East Coast architecture teams in Chicago for a planning meeting and tour of the site. Root had already failed to persuade any of them to work in his preferred polychromatic, Eastern-inflected style, and he wasn't feeling well. On a chilly Saturday, the architects took an amble around Jackson Park, and then the next day they all had dinner at Root's house on Chicago's Gold Coast. Root was by then visibly ill; on Monday a doctor diagnosed pneumonia, and Burnham started spending nights at Root's house while the architects waited for news.

Thursday night, Root died.

Burnham spent the night "pacing out the hours and talking to himself at times under the room where his partner lay dead," one biographer wrote. "He seemed to be rebuking supernatural powers: 'I have worked. I have schemed and dreamed to make us the greatest architects in the world. I have made him see it and kept him at it — and now he dies — damn! Damn! Damn!' . . . He shook his fist and cursed the murderous fates."

The meeting with architects went on for another week, but it was a grim affair. With Root gone, things got real normal. Even before they started attending meetings, the East Coast–based architects Burnham recruited had conspired to recommend all the main

buildings should be neoclassical — like banks, or the US Capitol. Roman temples, basically, or at least what they thought Roman temples looked like. That means pillars with curly decorations on top, wide steps leading up to colonnades, and shallow-pitched peaked roofs. The Palace of Fine Arts, the Music Hall, the Women's Building — all would have a monumentality intended to emulate not the wild Jules Verne future of European fairs but the past nominal glory that was nominally Rome. Without Root to be the weird devil on his shoulder, Burnham succumbed to the notion of grand monumentality, and agreed.

Forget the pink granite gables; they decided that every building on the Court of Honor, the main plaza, would not only be the same style but would have a uniform cornice height — that's the decorative line just below the roof. It was the beginning of a rigorously enforced regularity.

But the buildings were also to be temporary. Instead of being built of granite or marble, they'd be made out of the same easy-to-assemble metal and glass frames that European fair construction favored. But they'd have facades of staff, a plaster-and-fiber mix valued for its strength and moldability. The fair was intended to show that Columbus's arrival in America had sparked four grand centuries of progress leading to the Now, and the architects hoped the facades would dignify the buildings, a literal instantiation of empire and industry. It was a whitewashing of history.

And, it turned out, a literal whitewashing as well. "We talked about colors, and finally the thought came, 'Let us make it all perfectly white,'" Burnham later said. "I don't recall who made the suggestion. It might have been one of those things that occurred to all minds at once, as so often happens. At any rate, the decision was mine."

The architects of the Expo thought, or thought they thought, that ancient Rome was white, and wanted to evoke that. And the color white had by the second half of the nineteenth century been clearly linked to the idea of cleanliness, a notion that fed into racial and class bias. A "sanitary movement" was linking public health

efforts, parks, and sunlight to stopping outbreaks of diseases like cholera in cities across the United States and Europe, but it also tended to associate those epidemics with poverty and people of color. Toiletry marketing probably also helped further the imagery—soaps are made of rendered fat, and for most of the nineteenth century, Procter and Gamble's unpopular offerings came only in green and brown. In 1878 when the company started selling a cheap white bar as "99 and 44/100 percent pure," sales took off. In the sense that dog whistles are supposed to be only audible to a receptive audience, this was less of a dog whistle and more of a whistle whistle.

Though none of the designers said anything at the time, at least a couple had concerns. In April of 1892, Olmsted visited the grounds of the Paris Exposition, noting that the surviving buildings were multicolored. (Even the Eiffel Tower was originally a deep red-brown on the bottom, becoming progressively lighter-colored as you went up, to make it look taller.) Olmsted wrote home that he worried that by comparison the US fair would look like "grandiloquent pomp."

The all-white color scheme worried him greatly. "I fear that against the clear blue sky and the blue lake, great towering masses of white, glistening in the clear hot, summer sunlight of Chicago, with the glare of water that we are to have both within and without the Exposition grounds, will be overpowering," Olmsted wrote. He quietly urged his gardener to add more trees and foliage — the classic move of the passive-aggressive landscape architect who doesn't like a building.

A plan of the Exposition from December of 1890 looks extremely Olmstedian — the lagoon and rectilinear parks are cut through with curving, art nouveau paths and bridges. But in the plan from a month later, when Root died, the paths and bridges have all been straightened out. And there's a new building in the southwest corner, displacing the Agriculture Building from its spot adjacent to the train station. It's good siting: The new structure is the Transportation Building.

Every architect got assigned a specific building, and Transportation went to Louis Sullivan, the *other* Chicago-based father of the skyscraper. With his partner, Dankmar Adler, he had designed the Auditorium Building in Chicago, a hive of riotously polychromatic alcoves and passageways behind and around a hotel lobby, done with arabesques in gold painted onto colored backgrounds. Burnham tried to give Adler and Sullivan the fair's Music Hall, but after the Auditorium Building, they worried about being typecast. So Sullivan requested the Transportation Building—more of a challenge and, even better, away from the Court of Honor and so not as subject to the neoclassical hegemony.

If the Auditorium Building had been a riot of color, the Transportation Building would be a full-on revolution against the swords-and-sandals playscape developing in Jackson Park. And Sullivan had just the training to lead it. He was an Orientalist and a bohemian, and, maybe most important, Sullivan adhered to the color rules of a French chemist named Michel-Eugène Chevreul.

The Galerie des Gobelins, a small museum in Paris's leafy thirteenth arrondissement, is a showroom offshoot of the Gobelins Manufactory, founded in 1662 to make furniture for the king of France and reconfigured in 1699 to make the best tapestries in Europe. That's mostly what's on display at the Galerie today—giant tapestries. Many of the twenty-foot-wide hangings, not-quite-great reproductions of famous paintings, were made within the last century—sometimes with the assistance of the original painters.

On my visit, the last thing I see before descending a staircase back to the main entrance is a striking, epically scaled depiction of three birds in vivid crimson. The birds all stand within circles, two brightly colored shading to dark, and one just the opposite. It looks like five hundred square feet of wildfires. The bright red shimmers in a totally different way than the darker, more purple colors.

Until you get close. At a couple of arm's lengths away, there's more going on in *The Night of Gobelins* (sometimes also called *The Celestial Gobelins*). It's a 2016 work by the sculptor Vincent Beaurin,

and it's not just one or two shades of red but in fact thirty-seven different colors of yarn. On close inspection, a darker patch turns out to be magenta and dark red with specks of green; the lighter adjacent patch is pinks and oranges flecked with light gray. The colors you see at a distance have only a little to do with the colors you see a few inches from the surface.

That's true, at least in part, for every tapestry in the gallery. As a craft, tapestry is a little more like designing for a computer screen than applying pigment to canvas. Weaving colored weft through the threads of a warp exposes tiny fragments of one or the other — they're more like pixels, and the dots assemble into an image. Of course, the threads themselves have their own colors thanks to dyes, but weaving doesn't allow for mixing of pigments. Much like a printer, a weaver relies on the way the eye mixes colors. At Gobelins, the chemist Michel-Eugène Chevreul systematized those ideas on color into a theory — in a book from 1839 called *The Laws of Contrast of Colour and Their Application to the Arts of Painting, Decoration of Buildings, Mosaic Work, Tapestry and Carpet Weaving* . . . actually, the title goes on for quite a ways, but you get the idea.

Beaurin, it turns out, was explicitly trying to put Chevreul's theories about weaving colors together back into practice. "When the Gobelins asked me to produce a tapestry, it seemed to me legitimate to wake up the old master of the place, and to give back some nerve to his contrast," he tells me in an email. "I am obviously only speaking about the theory part of *De la Loi du Contraste Simultané des Couleurs et de l'Assortiment des Objets Colorés,* because the rest, i.e. his practical advice, is not to be given to everyone. ;)"

He emoticon-winked at me, I think, because Chevreul's advice wasn't entirely practical. Born in Angers, Chevreul arrived in Paris at seventeen years old, in 1803, with a letter of introduction to an influential chemist at the French Museum of Natural History. Chevreul became his assistant, and over the next decade developed into a star chemist himself — primarily based on his work with fat. Chevreul discovered what chemists now call "fatty acids," figured

out new ways to make candles and soap, and paved the way for the invention of margarine. He managed to get two big-deal books out of it all.

That attracted the attention of King Charles X. Remember, at this point, Thomas Young has only just elucidated how the eye sees color, and synthetic coal tar–derived pigments are still half a century away. Understanding the chemistry of natural, organic dyes that could bind to textiles was essential work. So Charles X made Chevreul head of the department of dyes at the Gobelins Manufactory. The company had brushed up against failure a few times over its previous hundred years because of problems and inconsistencies in its dyeing, but its reputation was a source of pride for the government. Dyeing the textiles Gobelins used required a deep knowledge of degreasing and bleaching raw wool, chemistry, and color classification. It was the kind of job that the most famous chemist in France would plausibly take.

Chevreul barely had time to move into his new office before the Gobelins weavers were waiting outside with grievances. The colors were wrong, they said, in samples of black-dyed wool. Chevreul took the samples back to his workshop and tested their color against black wool from London and Vienna — and couldn't find anything wrong with the dye or how it was absorbed by the wool. It had to be something else.

Chevreul finally hit on a new idea. "I saw the want of vigour complained of in the blacks was owing to the colour next to them," he later wrote, "and was due to the phenomena of contrast of colours." The problem wasn't the color of the dye. It was the color *compared to the color around it*. Colors change, in the eye or brain, according to what colors they're next to — "not a problem of chemistry, but one of psychophysiology," as the art historian Georges Roque writes.

This idea had been kicking around in the philosophical back alleys of color science for millennia. Thomas Young had noticed in his work with colored lights that the colors people saw didn't always correspond to their wavelengths. Shine a colored light onto a surface and that surface's apparent color would change,

objectively, but somehow the observer would still see its original color. That's because of an ability called "color constancy," and Young didn't get it at all.

How could wavelengths and a retina account for these phenomenological properties of color vision? Chevreul realized it was a problem amenable to experiment. He started putting various colors next to each other and observing the effects. Basically, Chevreul found that if you put two different colors next to each other, or even the same color at two different brightnesses, the brain will exaggerate their differences. The eye or brain adds to one color the complement of the other, which is to say that a blue next to a red will look greener, and the red will look yellower. Why those pairs — red-green and blue-yellow? No one really knew.

Chevreul had actually found a way to use complementarity as a tool. He codified his observations into a Law of Simultaneous Contrast of Color, and started deploying its tenets in the real world. Like, at one point, a wealthy man was refusing to pay a wallpaper manufacturer because a gray design amid a green background looked reddish on his walls. The manufacturer was suing the guy. Chevreul stood up as a witness. He cut out a white sheet to cover the green but show the gray, and the gray looked fine. Chevreul's Solomonic solution: Mix a little green into the gray to neutralize the perception of red.

Chevreul put all these new rules into a book — meaning everyone, not just scientists, would get a chance to think about scientific, or at least *almost* scientific, color theory. Since tapestry makers put colors next to other colors all the time, you can imagine that they were very interested in this account of how those colors then behaved. After all, weaving is an art of pattern, but also of color.

A few painters, too, paid attention. The French Romantic painter Eugène Delacroix bought notes from Chevreul's lectures, sketched a complementarity triangle for himself, and used its concepts in his 1840 painting *Entry of the Crusaders into Constantinople*. And in 1880, Camille Pissarro started using stretchers tinted with a color complementary to whatever the dominant color of a painting was, and he showed etchings on yellow mattes with violet frames, and

by 1883 he was showing art in white frames, a suggestion taken almost directly from Chevreul.

The Impressionists, famous for their use of unusual or unexpected colors to evoke what they were actually seeing, were perhaps even more famous for being instinctive and impulsive. Claude Monet knew about complementary colors; he just didn't particularly care. It's possible that Impressionist painters such as Claude Monet knew about Chevreul's work, but it's more likely that if they encountered ideas about complementarity it was in the writing of the critic Charles Blanc (nominative determinism at work here), who wasn't a scientist, but apparently was a jerk — and another soldier in the war between form and color. The most famous opinion ascribed to Blanc's pen is that drawing is "absolute," which is an advantage over "relative" color. "Drawing is the masculine side of art, color the feminine," Blanc wrote.

More likely, though, if any development in the science of color gave Impressionists a push toward flexes like Monet's lurid studies of the Rouen Cathedral at different times of day, it might have been the simple availability of more pigments, and the fact that new tin and lead tubes made oil paints portable, so they could take their kits outside and paint light and colors as they happened. Though maybe it's evidence of color winning the broader form-versus-color war that Impressionists largely abandoned the chiaroscuro technique of modeling form in light and shadow and *then* applying color in favor of *peinture claire,* making forms from colors first, highlighted with white.

The slightly later clade of neo-Impressionists, though, were total Chevreul-heads. Paul Signac visited Chevreul at Gobelins in 1884, and may have taken Georges Seurat there to see Chevreul's assistant a year later. It makes sense. The idea that tiny dots of color combine in a viewer's eye, the "optical mixture" so important to the divisionism of Signac and Seurat — popularly called pointillism — does seem like a reasonable inference from Chevreul's ideas. And it's essentially how halftone printing works, at a microscopic scale — the modern version of Le Blon's trichromatic printed plates. All

the pictures you see in a magazine that seem to run the full gamut of visible colors are usually made of mixtures of dots very, very close together.

Chevreul pointed out that one color adjacent to a primary color might take on some of the character of that primary's complementary color. He even had colored plates in his book that exaggerated the effect, showing halos of complementary colors around circles of the primaries. But Chevreul didn't mean that painters should actually try to do that on purpose. In fact, he thought it looked pretty bad. Whatever influence Chevreul had on painting, his book was aimed at the decorative arts — especially textiles, his specialty. So fashion designers picked up his ideas on color, which led to more attention via science articles in general-interest magazines aimed at women. English translations of his books in the 1850s turned him into a scientific celebrity in publications like *Godey's Lady's Book and Magazine,* the women's magazine with the biggest circulation in the United States. An April 1855 *Lady's Book* article explicitly advised readers to use Chevreul's ideas in choosing clothes and home decorations.

Critics and art theorists, too, were reading those translations. And their incorporation of Chevreul's ideas was helping to create the opposition to lily-white Beaux-Arts neoclassicism in American architecture and design. The war of form versus color was coming to an endgame.

The World's Columbian Exposition opened on May 1, 1893, and had between 12 million and 16 million visitors. In 1890 the population of the United States was about 63 million, so even after trying to account for foreign visitors, that means something like one in six Americans saw the Exposition. What they got was "object lessons," a term coined by George B. Goode, assistant secretary of the Smithsonian Institution, who created a way to codify and display every object that would be seen at the fair and in which building — a Dewey Decimal–like system for physical things in physical space. The material objects would teach things about the world, whether

they were in the cultural displays of the Midway or in the buildings on the Court of Honor.

Sullivan's Transportation Building was filled with Goode-coded objects, but it didn't look anything like the buildings on the Court of Honor. Lined with a row of arches colored in forty different reds, mixed with blue, yellow, orange, and dark green, in zigzags, rosettes, diamonds, medallions, and winged and rising angels, the building was a finger in the eye of the École des Beaux-Arts. It all centered on its main entrance, the Golden Doorway — surmounted by six concentric arches set into a vast rectangle, itself a flux of red, yellow, and orange against a flashing yellow-lacquered aluminum. Sullivan hoped it would all come together in the eye of an onlooker, becoming "not so much many colors as a single, beautiful painting."

The fair made Burnham famous. His embrace of what came to be called the City Beautiful style of urbanism showed up in his later plans for Chicago, San Francisco, Washington, D.C., Cleveland, and Denver. You see his neoclassical monumentalism in Washington's Union Station and in the lamented Pennsylvania Station in Manhattan.

Sullivan wanted none of that. Burnham had essentially thrown Root's mysticism away and embraced the Beaux-Arts approach, using achromatic whites and beiges as symbols of imperial power. But Sullivan wanted to create an indigenous art form like his transcendentalist intellectual forebears. He saw the togas-and-sandals Court of Honor as being just as bad as the inauthentic use of materials Root railed against. To Sullivan, all that glory-of-Rome stuff was ahistorical facadism — literally a false front, fundamentally dishonest and kind of stupid.

As early as 1896, only three years after the fair, Sullivan was telling people just that. In an article in *Lippincott's Magazine* (in which he coined the alpha modernist aphorism "form follows function" — as "form ever follows function"), Sullivan accused the other Expo architects of "strutting and prattling handcuffed and vainglorious in the asylum of a foreign school."

In his 1922 autobiography, written when his career was perhaps on the skids and he was struggling with alcohol addiction, Sullivan

went even further. He claimed Burnham had intentionally dumbed down their work. "'Hustle' was the word. Make it big, make it stunning, knock 'em down!" Sullivan wrote. Visitors to the exposition "departed joyously, carriers of contagion, unaware that what they had beheld and believed to be truth was to prove, in historic fact, an appalling calamity. . . . A naked exhibitionism of charlatanry in the higher feudal and domineering culture, conjoined with expert salesmanship of the materials of decay."

All was not lost. He had kind words for the landscape work. But this is what scholars usually take to be Sullivan's money quote: "The damage wrought by the World's Fair will last for half a century from its date, if not longer. It has penetrated deep into the constitution of the American mind, effecting there lesions significant of dementia."

The architecture critic Lewis Mumford blamed the fair for everything chintzy and poseur-like about the first fifth of the twentieth century — "that very noncommittal quality in its massive forms which permitted the basilica to become a church, or the temple to become a modern bank," Mumford wrote. The attempt to convey trust and permanence was essentially a grift. Design in a local vernacular, adapted to local conditions and using local materials would have produced buildings that were more functional, that had genuine relationships with their surroundings. They would have been representative of the people who used them. Instead, the neoclassicism at the fair and beyond was, as Mumford said, merely veneer. "Correct in proportion, elegant in detail, courteous in relation to each other, the buildings of the World's Fair were, nevertheless, only the simulacra of a living architecture."

That grift, by the way, got color totally wrong. Tethering whiteness to neoclassicism was an unforced error. Root probably knew that. In choosing the Exposition's all-white colorway, Burnham either intentionally or accidentally traded accuracy for convenience.

Roman and Greek architecture and sculpture look white today, yes. But just as archaeologists worry about in their studies of Paleolithic red ochre, that whiteness is a taphonomic artifact, a result of time and age rather than what the artists and builders

actually did. In 1748, archaeological excavations began around Mount Vesuvius, uncovering objects and surfaces slathered in color. Soon after, the British classicist architects James Stuart and Nicholas Revett found colored walls up in the forgotten high corners of the Athenian Acropolis.

The same École des Beaux-Arts that trained the neoclassicists who built the World's Columbian Exposition had, earlier in the nineteenth century, not only allowed but *required* architecture students to draw and reconstruct Etruscan, Greek, and Roman buildings — colors included. Starting in the mid-1800s, artists and architects started traveling to Greece to draw and paint depictions of the ruins of the great temples of Athens and elsewhere. The architects displayed their art in Paris, and included vivid colors on buildings and sculptures — in the ochre brown-yellow-red palette, yes, but also red from the mercury-sulfur compound cinnabar and from arsenic sulfide, also called realgar. The ancient Greeks also used orpiment for yellow and blues including azurite and Egyptian blue. These discoveries were robust enough by the early nineteenth century that the archaeologist Antoine Chrysostôme Quatremère de Quincy first used the term "polychromy" to describe the style.

Even in the face of two hundred years of archaeological and historical evidence, die-hard classicists sometimes refused to believe in the original color of Greek art. In 1805, the artist Edward Dodwell wrote that the reddish yellow he saw on the west side of the Parthenon in Athens was just an artifact of age, an "ochreous patina." But when the painter Lawrence Alma-Tadema depicted the Parthenon as multicolored in his 1868 work *Phidias Showing the Frieze of the Parthenon to His Friends,* it created as much of a scandal as a painting could. Alma-Tadema, famous for painting scenes of everyday life in ancient Greece, had depicted the fifth-century sculptor Phidias displaying for friends his relief-work for the Parthenon. Now, the actual frieze is (and was, at the time of Alma-Tadema's work) on display at the British Museum. It's one of the "Elgin marbles," and it's very white. But in the painting, it's vibrantly colored. This is all kind of meta, but supposedly when Alma-Tadema showed his work depicting Phidias showing his

work, the sculptor Auguste Rodin put his hand to his heart and declared, "I feel here that these were never colored." The historically verifiable truth that real classical architecture and sculpture were colorful was an existential threat to Rodin's understanding of his antecedents. Perhaps he should have spent more time Thinkering about it.

Still, by the time of the Chicago exposition, art historians were laboring mightily to keep those facts in play. An article in *Harper's New Monthly* reviewed "that complete polychromy with which a former generation had been familiar," insisting that present-day Athens was covered with fragments either showing hints of their old colors, or patterns in the marble that could only have been caused by an earlier layer of pigment protecting it from weathering. There were whole museum shows on the subject — including one in Chicago in 1892, when Burnham and his crew would've been there to see it. The architects who'd rebuilt Paris along City Beautiful lines were literally studying colored ancient sculpture and architecture at the same time. Burnham and his team had to have known that the latest scholarship showed that the ancient world was vividly colored. Yet still they decided to go with all white.

This blindness was as much political and metaphorical as it was aesthetic. The fair was all about industrial and cultural dominance — a Ferris wheel, Tesla and Edison gadgets, Krupp cannons, automated walkways, turnstiles, and Frederick Jackson Turner lectures about the end of the American frontier. The message of the fair was clear: In the twentieth century, destiny would be manifest, Darwinism would be social, and monochromatic cities were beautiful, literally and in the sense of denigrating the diverse backgrounds of the people who actually lived there.

Olmsted's Midway Plaisance stood in partial contrast to that; it was as polychromatic as real life. It was also something of a cultural gulag, to which Burnham's crew had exiled the street of Cairo, the Moorish Palace, the Native Americans on display, and Little Egypt dancing burlesque. But that was hardly enough to counterbalance the messaging — symbolic and literal — of the rest of the fair. The pop-up village built by people from Dahomey became a source of

anti-African propaganda, and even though the famous abolitionist Frederick Douglass spoke at the fair, exhibits dealing with African Americans had to be approved by all-white screening committees before they were accepted. A pamphlet called *The Reason Why the Colored American Is Not in the World's Columbian Exposition* made political noise in 1893; African Americans worked on the excavation of Jackson Park and were the majority of the Pullman car workers on the railroads that brought attendees, but were prohibited from joining the ranks of the "Columbian Guard," the police force that secured the fair itself. The "object lesson" of the multiethnic, multigendered, chaotic Midway versus the buttoned down, all but segregated Court of Honor was that America's future was male and white.

At least, that was probably the intent. But all that futuristic technology and its meticulous and celebratory display ended up projecting a much more complicated message.

As the archaeologists looking for the hints and implications of color on cave walls and ancient Greek buildings and statuary will tell you, color is fleeting. Most of the World's Columbian Exposition's buildings are gone. What didn't get disassembled after the fair burned in a fire. The Palace of Fine Arts is now Chicago's beloved Museum of Science and Industry, but other than that and a small bathroom, nothing beside remains.

But if anyone knows what it might have been like to be at the World's Columbian Exposition, it's Lisa Snyder, an architectural historian at UCLA. While the fair may be very dead and mostly buried, its digital doppelganger lives on inside Snyder's laptop— as a three-dimensional model she's been building for more than twenty years.

When Snyder was a doctoral student, she came to believe that the sections, plans, and elevations that architects use to communicate ideas to each other were lousy for teaching the history of the field. Snyder thought that a better approach would be an interactive environment, somewhere people could visit virtually even

if the actual place didn't exist yet, or didn't exist anymore. "The Columbian Exposition has so many different scales, buildings, and experiences," Snyder says. "It was also a compelling choice for me because it came at a time right before moving images, so we don't have any video footage. We have static images and other materials, but there's also a lot we don't have. So it was kind of perfect." Snyder had written her master's thesis on Sullivan, and the Transportation Building is one of her favorites.

So she fired up her Silicon Graphics Onyx 2 — this would really impress you if you were a computer-graphics-head in 1997 — and launched software originally intended to create flight simulators. The reconstruction would take more than computation, though. How do you get information about color when any accounts are necessarily subjective, or may have faded or changed over time?

The starting point was a map, precise latitudes and longitudes in Jackson Park triangulated against a coordinate system of the fair. Daniel Burnham's report on the project was useful; its eighth and final volume was an atlas of the fair. Academic journals from back then provided elevation and section drawings. But color was a real challenge. Photographs of the action are, of course, black-and-white, and the painters who recorded the fair — among them Winslow Homer, Charles C. Curran, and Thomas Moran — primarily focused on the neoclassical scenery. (Ironically, among the art on display at the Columbian Exposition were works by Degas, Monet, and other Impressionists.) "There were lots of watercolors, lots of tinted black-and-white images, tinted lantern slides. Of course, you have to take it with a grain of salt, because everybody was making judgments," Snyder says.

The most useful data came from more obscure places. Banister Fletcher, an English architect, hung out with the Exposition's designers for months, and he kept a journal. "He had an amazing description of Sullivan and the colors of the Transportation Building," Snyder says. The entry, the so-called Golden Doorway, was set in a surround of green-silver with blue washes. Oh, and a physicist who visited the fair as a tourist self-published his

photographs — not big, architectural hero shots but close-ups of ornaments and staff.

Snyder tried a few experimental approaches. She studied contemporary color images of Sullivan's extant, post-Expo polychromatic work — the trading floor of the Chicago Stock Exchange — and then dropped out the color information. Then she tried to compare the resulting black-and-white images to black-and-white information on the Transportation Building, to see if that would tell her anything. "I gotta say, it didn't," Snyder says.

Snyder's virtual Exposition was always supposed to be a teaching tool, and the fact is, people love it. It's especially easy to love when an actual physical fragment of the fair, a living example of what it looked like, turns up. It's a direct connection to an all-but-invisible history. And Snyder has funding from the National Endowment for the Humanities to turn the virtual Exposition into something downloadable, with a better interface, so classrooms can take her models and fly through them, annotate them, even create presentations right in a shared 3D space.

"At some point maybe someone's going to want to put in AI people and let you interact as a person in the crowds, but that's someone else's research agenda," Snyder says. "In terms of the buildings and their accuracy, I think I'm there."

As close as her many sources have gotten her to an accurate depiction of the buildings, the visual chroniclers of the fair also help address one facet critical to the colors of the otherwise-White City: the lights.

By the time of the Exposition, bright electrical illumination had already become a fundamental part of the urban experience. New York City installed its first electric lighting on a building in 1880; Los Angeles came second, in 1881. After remaining stable for three hundred years, the price of artificial light dropped off a cliff in 1800, and it hasn't stopped falling since.

While the Columbian Exposition wasn't the first world's fair to be open at night and lit for guests, it did feature a massive display of electrical illumination — a battle to show dominance in the fight between Thomas Edison and General Electric, and Nikola Tesla

and Westinghouse. The first city lights were flickery, high-voltage things. After them came an electrified tungsten filament in a bulb full of nitrogen called a Mazda, named for the Persian god of light. But the Chicago fair used a fourteen-year-old technology that would change everything: incandescence.

This was the tech that Edison popularized, a metal filament heated inside a vacuum until it emitted a peculiarly vivid light. (Westinghouse, the company that actually did the Exposition's illuminations, came up with its own version; it didn't have access to the ones made by General Electric, which had the Edison tech.) While daylight contains every wavelength of visible light in roughly equal amounts, as Newton found, artificial lights don't. Most tend toward the reddish side of the spectrum — less in the ultraviolet and violet, more in the infrared. That's especially true of incandescent bulbs, which is why they get hot. But their lack of cool early-morning blues gives the lights a warmer tone, almost the flame of a hearth without the flicker.

At the World's Columbian Exposition, artificial illumination repainted the stark neoclassicism into something almost comforting. "Innumerable incandescent lights sparkle along the cornices and pediments," one visitor wrote. "The top of the wall enclosing the grand basin is outlined in fire; search-lights from the top of the Liberal Arts building cut their wide swaths of light in gigantic circles." Lights glowed from within the buildings, and illumination inside the basin's three giant fountains glowed white, then rose, then azure. The Ferris wheel gleamed. The Manufactures Building was studded with lights. On the fountains, said one guidebook, "thirty-eight 90-ampere projector lamps, with burnished silver parabolic reflectors, by their concentrated effort, illuminate in the most pleasing manner the ever varying streams of water."

Visitors to the World's Columbian Exposition didn't experience it solely as a White City. Its surfaces may have been mostly white, but the light shining on them and reflecting into people's eyeballs was colorful and exuberant. This was how the electrified, brightly lit twentieth century began. In Chicago, hundreds of thousands of people learned a lesson about cities, nights, lights, and colors.

In the war between form and color, the strange effects of color contrast were a force multiplier on the color side, but light was the secret weapon that ended the conflict. Because no matter what color buildings were in cities, the color of artificial light would be what defined them.

Just a few years later, the 1901 Pan-American Exposition in Buffalo, New York — a part of the world we'll return to in the next chapter — featured polychromatic architecture in part to be the focus, literally, of a nighttime light show. Visitors called it the Rainbow City.

That was going to be the mark of color in the twentieth century — as fashion, as design, and as science. Surfaces and light, light and surfaces. Theatrical performances had been using colored lights possibly as early as the 1600s, and in the 1890s the popular dancer Loie Fuller mounted performances where the dancers, clad in multicolored, gauzy costumes, spun around amid color-changing spotlights that shined from below. The use of colored light eventually migrated from small theaters to Broadway, bringing with it a new generation of theatrical designers. Norman Bel Geddes, for example, was an off-Broadway designer who embraced colored lights — and it was Bel Geddes's coterie of production designers who'd become the first industrial designers. They soon discovered that markets were always hungry for new products, and companies always wanted to sell them — from the locomotives that dominated continental transit to relatively newfangled automobiles to the gadgets of convenience in a home. As the design writer Reyner Banham observed in 1965, worship of "the great gizmo" is an essential American trait. Engineering, though, doesn't always cooperate. In general, this year's locomotive doesn't work appreciably better than last year's; as long as the old refrigerator or radio works, no one has much reason to buy a new one. Unless! Designers learned to re-skin all those gadgets, at first in form — that was "streamlining" in the 1920s — and then, of course, in color. Bel Geddes could teach corporations how to make next year's line of gizmos look different even if the engineers were still building them with last year's guts.

Colored lights, architectural materials like terra-cotta and brick, bright new dyes for textiles, vivid paints for walls, and colorfast moldable materials like Bakelite and eventually plastic led to what the *Saturday Evening Post* in 1928 called a "chromatic revolution." "We must thank the chemists for liberating scores of new hues from the gummy darkness of coal tar and other plentiful substances," the *Post* said rhapsodically. "We must pay homage to their success in elaborating new bases and solvents for the modern lacquer paints which carry the novel hues so effectively and help brighten a dingy world." The *Wizard of Oz* transition from Dorothy's grayscale Kansas to technicolor Oz in movie theaters a decade later wasn't just fantasy; it *actually happened*. To *everyone*.

But the other side of the equation, the thing that would make those bright electric lights of the future shine most brightly and make new paints and coatings possible was still to come. All revolutions need a Year Zero — here, that meant a new kind of white.

TITANIUM WHITE

Walter Liew was screwed, and he knew it. He was sitting on his couch, next to his wife, Christina, and their son, and the house was swarming with FBI agents. They had a warrant — lots of them — to search Liew's home in Orinda (a suburb of San Francisco), his nearby office, and the home of one of his business associates in Delaware. It must have been one hell of a way to start a summer morning.

The agents had been preparing for the search for months, and they knew just what to look for: anything related to the manufacture of a chemical called titanium dioxide, one titanium atom stuck to two oxygen atoms — that a handful of companies around the world dig out of the ground and turn into the whitest pigment on Earth. Walter Liew had told a massive mining company in China that he knew how to build a factory that could make that pigment, helping China fulfill a long-term goal for global industrial dominance.

There were two problems. First, Liew and his company, USAPTI, had no idea how to build such a factory. And second, to fill that manifestly critical gap in his knowledge, Liew had stolen the plans for that factory from the people who *did* know how. That would be the DuPont Corporation, a massive chemical company in America. This is not the sort of thing chemical companies let slide. DuPont called the FBI.

It's safe to say that in 2010, when the FBI took that call, nobody there knew what titanium dioxide was, much less the key role it

played in color science and technology. They did know, however, that the Chinese government had a large, well-funded program to acquire US technical knowledge. They'd known it for fifteen years, since Congress had passed the Economic Espionage Act. That's when the bureau opened a small branch office in Palo Alto with the mandate to focus on the highly technical intellectual property of nerd-dom that China coveted. "So much R and D is developed within twenty square miles," says Kevin Phelan, who ran the office at the time of the Liew case. (He has since transferred.) "We started that office just to see, how do we work these cases? Are there any cases?" It was a small group, but unusually diverse. If your image of an FBI agent is a burly white dude in a suit with a military buzz cut — well, you're picturing Phelan. But his office was split nearly evenly across genders, and his half dozen agents had expertises ranging from structural engineering to judo. They were an elite team of high-tech investigators. That's why, when the competitive intelligence group at DuPont found out that Liew might be selling trade secrets to a company affiliated with the Chinese government, the request for help made its way to Phelan's Palo Alto office.

Liew was, in retrospect, a pretty good candidate for recruitment. He grew up poor in Malaysia and got a degree in electrical engineering from the University of Oklahoma. In the late 1990s he found his way to China, his wife's birth country, and at a dinner nominally in his honor, representatives of the government gave Liew a list of technologies that, gosh, they'd really, awfully love to be able to industrialize in China. Liew said that he had the know-how to build TiO_2 factories.

When those representatives took the bait, Liew came home and tried to build a fishing pole. He needed someone who could do what he'd promised, and eventually he found a couple of unhappy former DuPont engineers, one of whom had, no kidding, kept plans for a TiO_2 plant he'd helped build. Both were unhappy enough about their exits from DuPont to buy into Liew's plan, even though they knew it wouldn't be easy. According to notes that Liew took after a phone call with one of them, Liew was given fair warning. "Even with the best technology with stolen prints, but without startup

people and maintenance expertise, the plant won't be successful,"
Liew wrote, literally doing the thing you are never supposed to do,
which is take notes on a criminal conspiracy.

Which brings us back to the Liews' living room. With the help
of the Asian Organized Crime squad in the Bay Area and a team in
Delaware, Phelan's agents had figured out who Liew's ex-DuPont
engineer accomplices were, and where they were. They'd figured
out when representatives of the Chinese chemical company were
coming to the US to receive the stolen plans. They had enough ev-
idence to get search warrants. And now, at six a.m. Pacific time,
nine a.m. in the East, they were ready to spring on the entire orga-
nization, top to bottom, coast to coast. "Cast of thousands, surveil-
lance teams, tons of agents," Phelan says. "When something like
that comes up, everybody surges to it."

On site in Orinda was Cynthia Ho, a ten-year veteran of the
agency who'd participated in, by her own account, more than thirty
searches. Of Chinese descent and fluent in Mandarin and Canton-
ese, Ho had spent a long time working on Asian organized crime,
and she knew that the two things you always find in a search are
safe-deposit box keys and pornography. In this case, at least, she
found — in Christina's purse, on the floor of the kitchen — a set of
keys that looked like the former. Ho held them up so the Liews
could see them and asked whether there was a safe-deposit box.

Walter and Christina gave each other a long look. Christina got
up and walked over toward Ho, and Walter said something, quietly,
in Mandarin.

Only Agent Eric Bozman, nearest to the Liews, heard it. Bozman
is Caucasian, and until that moment had only spoken English to
the Liews. But he'd also spent years in China as a student and a law
clerk, and is fluent in Mandarin. He told another agent what Walter
had said: "You don't know. Don't know."

Then, at some point, Christina asked if she could leave and
go get some breakfast. The agents on scene looked at each other
and quickly agreed that this seemed like a really good idea. After
Christina left, Ho called Phelan to tell him what they'd found.
Phelan tasked a surveillance team to follow her. "Unfortunately, it's

the Bay Area and it's rush hour," Phelan says. "They lose her, they find her, they lose her. Then they get her into downtown Oakland, which is just a surveillance nightmare."

Phelan had Chris White, the agent on the surveillance squad, on cell phone. They figured Christina was heading for a bank. But which one? Agents in the Liew house found paperwork referring to no fewer than fifty-six different bank accounts. An analyst quickly assembled a list of all the bank branches within twenty blocks of where the surveillance team lost Liew, and built a kind of matrix ranking the ones where she was mostly likely to have an account. The list was too long to check them all, but White decided to give it a shot. Phelan emailed him a picture of Christina Liew, and White started going into the banks on the list and asking if anyone had seen her.

After a few misses, White walked into a bank and a teller told him that she had indeed been there, asking if it was possible to get into her safe-deposit box. She'd lost the key, you see. The teller told her it was, but she'd have to come back later.

White called Phelan, and the crew got a new warrant, which another agent managed to drive across the Bay Bridge from downtown San Francisco to the Oakland bank, where Ho was waiting. The bank revealed that Liew did have a box there, number 006. Using the key from Liew's purse, Ho opened the box and found "approximately ten external computer storage devices, approximately $11,600 in US currency, approximately $10,000 in Singapore currency; portions of what appear to be contracts between USAPTI and one or more Chinese entities for contracts valued at more than $17 million; and a USAPTI invoice dated January 6, 2011, to the Pangang Group Titanium Industry Co., Ltd. In the amount of USD $1,780,000 for engineering design work on a TiO_2 chloride process project."

That seems bad, right?

For her part in the theft, Christina got three years of probation; Walter got fifteen in prison. He and another accomplice were the first convictions by a federal jury under the Economic Espionage Act. Most of the millions Walter had made on the deal disappeared.

China now has a thriving industry turning low-quality titanium-bearing ore into high-quality titanium dioxide pigment via an advanced chloride process. Probably not a coincidence.

All that crime, all those millions, not for computer chip design or software or biotechnology, but for technology for making a color. A *boring* color, you might even think. But titanium dioxide pigment (according to longtime industry-watcher Reg Adams, the keeper of these numbers) is an $18 billion business worldwide; in 2019, worldwide production was 6.1 million metric tons. It's in almost every paint on every wall. It's in paper, ceramics, plastics, pills, cosmetics, and candy. It makes other colors cover surfaces better, and it makes them look brighter. You own things made with it, you've eaten it, and you think your world is better for it. It took a long time for people to figure out how to mass-produce the stuff, but once they did, it changed the world.

The Reverend William Gregor did twenty-one different chemistry experiments in a vain attempt to identify the weird black sand from under the waterwheel in Cornwall. He wrote up his results for *Crell's Annalen,* got it published . . . and no one noticed. It fell into a memory hole like so many other papers that earn a glance and a shrug from scientists deluged with new results. Spellings and translations do Gregor no favors here. In 1791 Manaccan (as on the sign near the old mill leat) was also spelled "Manaccan" and "Menachan," and across the German and French versions of his paper and his own personal writing, the actual stuff Gregor discovered is called menaccanite, menakanite, manacanite, menackanite, and menachanite. Others had also called it menachine. And it's not totally clear whether he meant that name to refer to the black sand, or to the unknown mineral or element within it. Even Gregor admitted that his research was inconclusive, and he didn't actually travel to the mill himself until 1794.

In 1795, there was a breakthrough — but it wasn't Gregor's. The esteemed chemist Martin Klaproth, arguably the inventor of quantitative analytical chemistry and the guy who discovered uranium, took a good, hard look at a Hungarian sample of a mineral

called red schörl. He realized that whatever was in red schörl was actually the oxide of yet another new element — "a peculiar, distinct, metallic substance," he wrote. "As I did in the case of uranium, I shall borrow the name for this metallic substance from mythology, and in particular from the *Titans,* the first sons of the earth. I therefore call this new metallic genus TITANIUM." The italics and capitals are his.

And then, in 1797, Klaproth found out about menachanite from Cornwall. So he got a sample from a friend of Gregor's, did the comparative analysis, and admitted that he'd been preempted. Klaproth graciously acknowledged that Gregor's "menachanite" was his "oxyd of titanium"; in another essay he also misspelled the name "McGregor," which had to sting a little.

So something shy of a century later, when the engineer Auguste J. Rossi first came into contact with this odd element, at least it had a name.

Actually, that's probably not right — titanium is the ninth most common element in Earth's crust. Human muscle is 0.0325 percent titanium, if you really want to get into it. So in that embodied sense, Rossi had certainly come into contact with titanium before then. But he probably hadn't noticed.

The first time Rossi *paid attention* to titanium, then, was in front of a blast furnace in Boonton, New Jersey. He was French, a college graduate at sixteen years old and an engineer at twenty, which is when he left Europe for New York. He ended up in Boonton around 1864, first as a surveyor of a plot of land to be turned into a park and then working on a railroad headed for the Boonton Iron Works. When the Iron Works' managers heard he knew chemistry and metallurgy, they hired him for their laboratory instead.

The Iron Works had a problem. The best steel is made from not much more than carbon and iron, but Boonton's feedstock came from Morris County, New Jersey, and it was doped with titanium — anywhere from 1 to 2.5 percent. At the time, not everyone thought you could make steel out of titanium-bearing ore at all, much less good steel. So Rossi's situation wasn't either-ore.

New Jersey's state geologist at the time, George Cook, had

written extensively about the local titaniferous iron ore — ilmenite, the same stuff that William Gregor found in that creek bed in Cornwall. Rossi turned it into something of a hobby, reading everything he could on the ubiquitous, seemingly useless element. He managed to get the blast furnaces producing perfectly salable steel with an unusually high titanium content.

Rossi eventually went on to other gigs, but in the 1880s, an entrepreneur named Eckert got a contract to rent the by-now-closed Boonton Iron Works smelters to make "stove iron" from the leftover melted stuff still in the bottoms of the blast furnaces. Eckert planned to add to these "puddled cinders" additional iron ore with a 2 percent titanium content. Except he couldn't make it work. So he sued the estate of the former owner of the Iron Works to get out of his contract — blaming the titanium.

The estate brought in Rossi, who still had his notes from those days. Boonton had been able to make perfectly good iron out of that 2 percent ore, Rossi said. The testimony won the case, and earned Rossi enough money and cred to set up shop as a consulting engineer in New York. His special expertise was the smelting of titaniferous ore, and he wasn't short of business; the Industrial Revolution was in full swing, demand for iron was high, and the ore in that part of North America was titanically titaniferous, as much as 25 percent in some places. It'd be useful if someone could figure out how to deal with it.

Others had tried. From 1840 to 1858 Archibald McIntyre ran a couple of blast furnaces in the Adirondacks, trying to turn the titaniferous ore up there into iron. When his grandson James MacNaughton inherited the furnaces, the land, and the mining rights, he decided to try again. So in 1890, MacNaughton went to see Rossi.

Was it possible? Sure. Furnaces in Stockton-on-Tyne, in England, had been using 35 percent titanium ore to make award-winning iron. But they were wasteful, too — four tons of slag for every ton of usable metal. Rossi thought he could improve that number by tuning the ingredients in the furnace. He convinced MacNaughton to let him go up to the Adirondacks and have a look at the old

facility, where he found not only the furnaces but also an old iron chest full of records describing how the furnaces worked. With those in hand, he built a small blast furnace himself in Buffalo.

MacNaughton died soon after, but Rossi was able to convince the man's nephews that his experience had given him another idea. Titanium wasn't just a nuisance in the furnace; Rossi had come to think that it actually helped produce better steel. He just needed a hotter, more powerful, and more controllable furnace. Rossi needed more power. In the 1890s, that meant electricity.

Not to be too hand-wavey about it, but molecules hold together because of electricity — or rather, electrons, the subatomic carriers of charge. They orbit atomic nuclei in specific numbers and at specific distances, and when atoms that have room for more electrons in their outer orbitals get close enough to atoms with a surfeit of electrons, they bond. The electronic orbits merge, and separate atoms become a molecule. Different atoms have affinities for different kinds of atoms — iron loves oxygen, for example, and all kinds of stuff likes to stick to carbon, which waves four available bonds wantonly. Carbon's ability to stick to all kinds of other atoms in all kinds of ways is what makes "organic chemistry" organic. Be grateful for carbon's profligacy; that's life, as the saying goes.

Running electricity through something requires a circuit, a loop for electrons to run through, with an entrance and an exit. Just as in the simplest battery, electrons flow outward from a structure called a cathode and back into one called an anode. In electrochemistry, adding electrons to an atom "reduces" its charge, since electrons are said to have negative charge by convention; taking away electrons, on the other hand, "oxidizes" the material, generally because it often involves oxygen sticking on as well.

Manipulate that electronic flow and you can make all kinds of atoms that'd rarely stick together adhere to one another, or rip apart molecules that time and physics would have said were permanently attached. *Zap!* Peel sticky oxygen off of aluminum and you get the light, superstrong metal. *Zap!* Silica and carbon become silicon carbide, carborundum, the first synthetic abrasive. *Zap!*

Salt turns into sodium and chlorine, enabling the manufacture of bleach for clothes and chlorine to clean the water in the growing nation's urban water systems.

The best place in the world to buy those zaps on the cheap was Niagara Falls. People started using the force of water dropping 176 feet to power mills and other factories in 1759, but it wasn't until the 1870s that they started using it to spin electricity-producing turbines and run generators. Coming up on the turn of the century, a handful of companies on both the Canadian and American sides were pumping out hundreds of thousands of horsepower — perhaps two hundred ninety megawatts. That ready access to power made Niagara a sort of industrial age Silicon Valley, a highly charged crucible for start-ups making the seemingly miraculous metals and chemicals that'd grease the new century's wheels. Niagara's electricity-making abilities made possible "fancies which were undreamed of by the alchemists," as the then-president of the American Electrochemical Society put it.

So in 1899, Rossi went to Niagara Falls.

Nobody was quite sure what he was doing there, holed up in a little barn, with his little electrical furnace. The community heard stories, of course, and they gossiped. Rossi wasn't necessarily against having visitors, who'd see him stoking the furnace, his wife doing analytical metallurgy on the products. But he was trying something new, and a little bit odd.

He built a furnace out of graphite-containing bricks. That graphite — which is to say, carbon — was his cathode. It gave Rossi a furnace hot enough and controllable enough to make a steel that was at least one-fourth titanium. He called it "ferro-titanium," and as late as 1912 he was still trying to sell it, with little success, as a "wonder-working alloy."

But in 1908, Rossi noticed something else. The manufacturing process had, as a by-product, a brilliant white powder made when two atoms of oxygen hooked on to an atom of titanium. That gave him an idea. According to *Titanium*, Jelks Barksdale's 1949 standard reference, Rossi experimented with "mixing the material with salad oil and brushing out the resulting composition. This was

probably the first instance of the use of chemically prepared titanium dioxide as a white pigment."

It was a big moment. Rossi knew about the toxic hegemony of the lead conglomerates in the pigment business. Over the next decade, Rossi and his partner Louis Barton continued to refine the pigment-making process alongside the ferrotitanium business. Their pigment still tended toward yellow, but adding calcium sulfate or barium sulfate to the titanium liquid yielded an even better pigment, very opaque, though the calcium one had a sort of creamy color. They developed and patented a new method for getting titanium dioxide out of one of its common mineral ores, ilmenite, and in 1916, the men built a factory to produce titanium dioxide pigment at scale — a beat-up wooden barn next to a railroad siding, with a crumbling brick chimney and multiple new ones poking through the roof, hinting at the new industry developing inside.

In 1918, Rossi won the Perkin Medal — named for William Henry Perkin, discoverer of the first synthetic pigment, mauveine. So it was fitting, in a way, that in his acceptance speech, Rossi announced that he was pivoting to pigments. Titanium dioxide was a white, smooth powder that "finds a direct application in the production of a white titanic pigment," Rossi said. That pigment, bound into oil, covered better than white lead and zinc white, and neither blackened nor chalked. And, Rossi announced, he had patented the whole process.

Given enough feedstock, they could even produce titanium dioxide pigment directly. All they needed was a source.

That's when they found out about Florida.

The world's largest titanium mine is in Mozambique, square across the channel that separates mainland Africa from Madagascar. In 2011 the mine, called Moma, then owned by Kenmare Resources, shipped almost a million tons of the ores that contain TiO_2 — concentrated ilmenite, rutile, and zircon. Ships dredged that precious dirt from the bottom of artificial ponds fifty feet deep and as big as four football fields, tearing apart coastal forests and leaving behind wastelands. Moma's current owner, the minerals giant Rio

Tinto, seems to be reneging on promises to clean it all up. Similar mines — ponds plied by dredges — operate in coastal Australia and across China.

Compared to Moma, the works of the mines in Florida seem small. But it's here that this whole business got started. The ore deposits in the Adirondacks were OK for steel, but they weren't titaniferous enough for Rossi to get into the pigment business. In 1913, a couple of engineers told him and his partner about their surveys of the sands of northeastern Florida, full of the minerals they'd need. The beaches near Jacksonville supplied Rossi's Niagara furnaces until 1922, when the company that by then owned the business flipped them to a resort developer.

Just because mining operations stopped on the beach, though, didn't mean there wasn't any ore left. A 1989 US Bureau of Mines survey described Trail Ridge as the most valuable source of titanium-bearing minerals in the United States.

The sprawling machinery of the mine there today is essentially invisible from the road, hidden behind walls of stick-straight slash pine. The trees are forty feet high with trunks about half a foot wide, perfect for making into paper, another big local industry.

Turn into the right driveway, though, and off in the distance the mine's signature machine appears: Next to what looks like a four-story factory under construction — no walls, just black girders and machinery designed for the production of steampunk metaphors — two huge pipes jut out at about forty-five degrees. Each is spewing thick black mud in ballistic trajectories, twin arcs of pure liquid goth. If Mordor has a McDonald's, this is what it looks like.

The mine is just about four thousand miles away from that wee stream in Cornwall where William Gregor realized the dirt carried a new element, about a thousand miles from the electric furnaces where Auguste Rossi learned to turn that element into pure white pigment. This isn't a tunnel into a mountainside or a topped-off mountain. It's more of a moving lake. Atop a pond of opaque brown-black water float two massive, tethered machines. There's a dredge, a sort of tugboat-looking thing, connected by a thick umbilical cord to the wet mill, the Mordor McDonald's visible from the gate.

The short version: The dredge sucks up mud — technically this is called "sand slurry," I'm told, but come on — from the pond's bottom and feeds it to the mill. The mill extracts 3 percent of that mud; just a third of that is titanium-bearing minerals. The rest, mostly quartz sand, stays in the mud and gets spit out the back. Move forward. Repeat.

I'm making it sound simple. It's not simple. But it is clever.

"We're dredging fifteen hundred tons an hour of sand. In a good hour, with good feed, you'll make forty-five tons of concentrate," says Phil Pombier, the unit manager of the mine, which is owned by Chemours, which used to be DuPont's titanium business. He's big, wide of middle, with a beard. A chemical engineer, Pombier has been with the company for thirty-seven years, and since I visited he's been promoted. Pombier is also steadier over the dirt and metal-grid walkways than I am, possibly because he is more used to his composite-toed work boots and possibly because he is a cyborg. "I've got two titanium hips, and they're both cast in Florida zircon," Pombier says. (He walked that back later, admitting that he didn't really know where the zircon that cast his cyborg hips came from, but it did make for a badass quip at the time.)

When everything is going as planned, the land looks pretty much the same before and after the dredging. Whoever owns the land clears away the timber and sells it. Chemours clears what's left and scrapes off the topsoil, pushing it into berms that'll surround the pond. The dredge and the mill do their thing and then move on to the next grid area, bulldozers push the topsoil back into place, and the landowner might well plant more slash pine. It's the circle of life, if you define "life" as "commercially productive land."

Pombier explains all this to me as we climb up onto the berm, making deep tracks in the soft, bulldozer-aerated soil, the thrum of the dredge loud even through my earplugs. We watch fountains of mud stream out of the pipes on the back of the mill, splash down, and then ooze back into the pond. If geology can be said to have a gory component, this is like watching the guts spew.

Sometime in the early or middle Pleistocene, the middle of what people now call Florida and Georgia was a wetland, a swamp,

separated from the ocean on the east by a sand dune running from present-day Jesup, Georgia, past today's Okefenokee (probably a lagoon back then) and Jacksonville, and into the heart of the modern Florida peninsula. The dune ran right across the weird sideways curve that the Florida–Georgia border makes before it hits the Atlantic.

Not much of that long sand spit is left today, except for about a hundred miles of hillock about a mile wide and just about two hundred feet high, running from the Okefenokee to Starke, Florida. That doesn't seem tall, but the rest of the terrain around there is pancake-flat and sea level. The Trail Ridge, as the onetime dune is now known, is one of the area's few pieces of topography.

It's mostly made of what geologists call Eolian sand over a layer of solid-ish peat, squished prehistoric vegetation. "Eolian" means that the Pleistocene wind and ocean pushed the dune on top of the swamp and then eroded away the topmost layers. The peat is what's left of the plants that populated the swamp.

These kinds of deposits of heavy-mineral sands are economic drivers on coastlines all over the world — Australia, India, Madagascar. Weathering and erosion bring minerals down to the coast via streams and rivers, where they sort by density. The heaviest stuff goes down to the bottom at the beach, in the swash (where pirates used to fight, or "buckle"). Waves do more mixing, backwashing the lighter detritus to the wave zone while the heavier minerals settle on the upper beach face. What's left, thousands or millions of years later, might look like a dune or even a forest, but cut into the ground and you'll see fine strata, alternating dark and light in a grayscale mineral mille-feuille. Some little bit of that is zircon, ilmenite, and rutile. Those last two are mineral forms of titanium dioxide.

We tromp up over the berm and down to a serpentine bridge of toothed-metal ovals loosely bolted to pontoons. The walkway rocks up and down as we step on each segment, and the water looks almost gelatinous, the surface covered in floating sticks about

eight inches long. They're the remains of tree roots that the dredge pulled up, sucked through its innards, and spat out the back.

It's hot, but there's a breeze, and I feel a dappling of moisture on my cheek like a spring rain shower. The wind has picked up the muck spewing out of the back of the wet mill and thrown it our way in tiny droplets. "Oh, yeah, it got us," Pombier says, pointing at my right arm. I look down and see that it's freckled with mud — or, sorry, "sand slurry." The right lens of my safety glasses gets similarly dappled. My entire right side is covered with a pointillist depiction of the mineral content of eastern Florida.

Even though the wet mill is just thirty feet or so from the edge of the pond, the walkway takes a few long minutes to navigate as it curves this way and that, a Disneyland ride's worth of switchbacks before we step up onto the mill itself. That flexibility's important because the dredge and the mill move, and this path will stretch to stay in contact. "Six hundred and fifty feet of walkway," Pombier says. "It don't matter if you're ten feet from the edge or seven hundred."

The inside of the mill itself contains what I took to be tanks of some kind, about the size of basement hot-water heaters. But they turn out to be coiled fiberglass spirals, nearly a thousand of them, nestled together and offset so that two can occupy the same cylindrical space, like opposing spiral staircases or DNA. The trick here is that the minerals the company wants have different sets of properties: particle size, specific gravity (weight, essentially), conductivity, and magnetism. That's what it takes to separate mineral wheat from mineral chaff.

The first pass works by simple gravity. Thanks to giant spinning drums that filter out the big rocks, only smallish particles get pumped up to the top of the mill. They get sent down the coils, each like a mini spiral waterslide. The lighter particles of silica slide to the outside; peering into one of the spirals, I can actually see the color differences in the "lanes." What they don't want goes out the back.

The coils on the mill have progressively narrower and nar-

rower curves moving from the front to the back and top to bottom, successively cutting the heavier particles from the lighter — from "rougher" spirals to "cleaner" to "finisher," from "1 percent TiO_2, then it's 3 percent, then 9, then 27," Pombier says. That's what he calls "wet mill concentrate," which is to say, as good as the wet mill can do. That goes into a six-inch-wide flexible pipe that runs as far as thirteen miles to the next step in the process — forty tons per hour, five hundred gallons per minute, ten feet per second. An overhead power line runs alongside the pipe to keep the booster pumps moving; each one of those, the size of a refrigerator, sits in a little hut topped by four round metal brushes, like miniature chimney sweeps, which are supposed to disperse some of the electricity from the area's regular thunderstorms rather than letting it short out the whole operation.

The dredging runs twenty-four hours a day, every day of the year. Every two weeks the half dozen men running it shut it all down and disconnect everything — the outflow pipe, the electrical cables, the pipe bringing fresh water — because the dredge has moved forward five hundred feet. So everything on the land side has to move too, to catch up. And the dredge keeps doing that, moving up along the Trail Ridge some ways, then turning around and moving back, again and again. The bulldozers prep the next area to become a pond, flattening it out, pushing aside the topsoil, prepping the power and water connections. And behind it, more bulldozers push topsoil back into place to await replanting.

But the mineral sand moves on. Its next stop: a mostly automated facility that cleans it with a solution of 20 percent sodium hydroxide — lye — to remove whatever organic matter remains from that layer of prehistoric swamp. That gunk would reduce the minerals' electromagnetic properties, the key to the next step in the process. At a twenty-foot-high gantry of pumps and ramps, eventually this cleaned version plops off the end. No kidding, blobs fall onto the ground with a resonant plopping sound, like stamping onto a beach right after a wave recedes. All those blobs form a giant conical pile.

Next we drive to an entirely other fifty-foot-high steampunk

factory, the "dry mineral processing mill." It's surrounded by looming railcars on train tracks. At the top of the mill, the dirt gets sent through two sets of massive screening tables, like the flour sieves of Brobdingnag, which separate out even finer-grained impurities. They call that "rice rock," because the grains look just like rice, a total waste product that piles up in artificial dunes behind the dry mill. They might start selling it, if they can figure out a market.

Here's where another clever bit starts. What comes off the screens is a ground-pepper-looking powder that contains a mix of minerals. The titanium-bearing ones conduct electricity; the others don't.

So the fine-grained combination of all of them gets dumped through hoppers into V-shaped bins, dozens of them, sitting atop rollers five inches wide. The rollers are connected to a DC power source and have a brush on one side; running along the other is a wire connected to AC. Sparks arc between the wire and the roller, and the titanium-bearing minerals literally jump off the roller toward the wire and then fall onto a conveyor belt below. The other stuff sticks to the roller and gets brushed off onto another conveyor.

They run that process a few times just to make sure everything comes off, and then they run those powders past similar magnetic rollers, too. The result, down on the bottom floor of the mill, is two streams of powder. Pombier opens a gate around the magnets and grabs a handful. He extends his gloved hand toward me. It's full of sparkly gray powder as fine as baker's sugar. "What you've got there is titanium mineral, all by itself," Pombier says.

It's quite lovely, actually.

The discovery that an oxide of the little-known element titanium could be a brilliant white pigment was a surprise, but the idea that a new material could make a new color wasn't. Rossi smeared his white-coated finger across a piece of paper at the end of more than a century of new science racing to new colors. The discovery of new elements led to new chemistry, and much of that was colorful. The element chromium, identified in 1797, led to the pigments

chrome yellow and chromium oxide green. Cadmium in 1817 led to cadmium yellow and its variants in the 1840s. The first synthesis of cobalt blue — long a colorant in glass — led to its increased use in pigment. Through the Victorian era, brilliant designers like William Morris met the demand for vividly colored wallpapers and textiles with pigments based on arsenic — toxic to mine and toxic to manufacture. That's where you get colors like "arsenic green."

Perkin's discovery of mauve in the middle of the nineteenth century accelerated the race even further. The palette of available pigments blew up. The discovery of copper phthalocyanine blue in 1927 led to a whole new gamut of colors with wild chemistry adjectives — indanthrone blue, quinacridone violet, dinitraniline orange. These "synthetic organic" pigments became dominant; by one count, somewhere between half and 70 percent of the artists' pigments sold today come from this family.

The beginning of the next century changed things even more, with an all-new understanding of physics and of color. In 1900, physicists were a little panicked that the frequency of light emitted from an object as it was heated wasn't following the curve they predicted at ultraviolet wavelengths. This was bad enough news to earn the name "the ultraviolet catastrophe." The German physicist Max Planck averted that catastrophe by figuring out that these theoretical objects were absorbing or reflecting electromagnetic energy at specific, discontinuous increments related to the size of the wavelength. Planck named these increments "quanta." It was the beginning of quantum physics, and five years later Albert Einstein said light came in quanta, too. Those came to be called "photons." Three years after that, 1908, was the year Gustav Mie came up with his equations for how individual particles scatter light.

It was also the year Rossi mixed a little TiO_2 into salad oil. Though scientists at the time were only just then figuring this out, what his new white had was an absolutely killer refractive index. In a vacuum, photons travel at the universe's speed limit, just shy of 300,000 kilometers per second. But put matter in the way of those photons, any matter at all, and its atoms will screw things up. They catch onto the photons like socks to burrs, changing the

time it takes to flux between electrical and magnetic fields. The speed of light slows down. A material's refractive index is the ratio of speed of light in a vacuum to speed of light as it moves through that material.

A material that reflected all light perfectly would be a mirror, but surfaces can also bounce back specific colors and bright white highlights. Those are called specular effects — think of glossy cars, sparkly gems, varnished wood, or velvet. A reflection isn't just about the kind of light, though. It's also about angle. Light hits at one angle, it reflects off at the same angle in the opposite direction. A thirty-degree angle in means a thirty-degree angle out. When a material sends light back at a different angle, though, that's called refraction.

If the particles in a medium scatter all wavelengths efficiently, that medium will appear white. As Mie figured out, clouds are very good at this — suspended water droplets are all about the same size, larger than visible wavelengths, and they refract and diffract light. This is also the source of my biggest disappointment about real-world science, which is that almost every chemical is a boring white powder, like sugar or salt. Very few labs ever have multicolored liquids giving off ominous vapor. That only happens in movies.

Lead white has a pretty high refractive index. Zinc white is higher, but it's also chemically reactive in paints. Titanium dioxide, though? Almost literally off the chart. TiO_2 is very bright, and very opaque, even when applied thinly — because so much of the light gets scattered back toward an observer instead of passing through to the surface below. That means paints made with the pigment — even other colors, not just white — can be made more cheaply, and can cover with fewer coats. And the colors end up brighter, livelier, and longer-lived. It's not an exaggeration to say that paints and surface coatings made with TiO_2 changed the way the human-built environment looked.

But just because TiO_2 was technically a good pigment didn't ensure it would be a successful one. Opaque paints — white ones in particular — were very much in demand, no doubt, but figuring out the best way to produce them wasn't a sure bet.

Rossi and Barton needed sulfuric acid to convert titanium-bearing ore into TiO_2 pigment, but so did the weaponeers making explosives for World War I. That slowed Rossi and Barton down. They had a few other problems, too—makers of the pigment hadn't yet learned that without the proper chemical coatings, TiO_2 particles are photoreactive. Live by electrochemical oxidation and reduction; die by electrochemical oxidation and reduction. It turned out that if the binding medium in a paint containing TiO_2 is an oxidizable chemical, then ambient ultraviolet in sunlight will reduce TiO_2. In action, that means excess, unpaired electrons swing around on the outside of the molecule like wrecking balls, annihilating the paint. Despite Rossi's later assurances to the contrary, it chalked—titanium white and the pigments around it would turn powdery and flake off the surface.

Despite those technical issues, public recognition of the peril of lead paints gave TiO_2 an unmistakable advantage. Since the 1880s, the National Lead Company had been by far the main provider of white lead in the United States. But seeing the tide shifting away from their product, in 1920 the company acquired Rossi and Barton's Titanium Pigment, and four years later, it bought a similarly large share of their main European competitor. Those investments were on point. In 1920, the global market for titanium dioxide was 100 tons; by 1944 it was 133,000, and National Lead was the dominant player.

Rossi consulted at the company he started, Titanium Alloy Manufacturing, until just a few days before his death in 1926, three days short of his eighty-seventh birthday. His obituary in the Niagara Falls paper described him as the discoverer of titanium—screwing William Gregor out of the credit yet again.

Titanium dioxide's bright opacity is the result of some hard math. The person who figured that out—not just for TiO_2 but for any pigment, really—was a chemist named Paul Kubelka. Working in parallel with another chemist named Franz Munk, Kubelka developed a set of differential equations that went way beyond

Mie's ideas about photons bouncing around among particles. Kubelka and Munk realized that the wee quanta of light weren't moving through an idealized space of evenly distributed particles, but were better understood as if they were bouncing through and among infinitesimally thin layers — coats of paint, basically. Photons would reflect off one layer, refract through another, hit the substrate, bounce back upward, and bounce around through layers again . . . It wasn't straightforward.

The color of a layer, Kubelka and Munk figured out, related to that layer's ability to both absorb and scatter light. In an opaque layer — like the ones TiO_2 could give you — those two qualities were related. Scattering the inbound photons actually disrupted absorption. But in a translucent layer, scattering and absorption didn't affect each other. That may not seem like that big a deal, but the math behind it allowed color scientists to predict how a given paint, loaded with a given pigment, would behave on a given surface. For the first time they could predict a paint's "hiding power" — it's ability to be opaque, to cover a surface with no show-through.

That's cool, but it's not Kubelka's biggest move in this story. Two years after he and Munk published what came to be called the Kubelka-Munk equations, Kubelka made an even more important discovery. The process that Rossi developed to make TiO_2 needed sulfuric acid, and sulfuric acid is nasty, polluting stuff. Now, chemists and metallurgists also knew how to take titanium-bearing ore and make another compound, titanium tetrachloride ($TiCl_4$, or "tickle"). It wasn't necessarily cleaner — it required highly toxic chlorine gas — but it was cheap. Kubelka figured out the industrial chemistry to turn $TiCl_4$ into refined titanium dioxide.

DuPont made the chloride process a lynchpin of their paint business. It's the process that Walter Liew said he could steal for the Chinese, and it's still how the half dozen or so major TiO_2 companies make pigment.

That's what brings me to Ashtabula County, Ohio, to a factory built by DuPont for Sherwin Williams in the 1960s. It has changed

hands a bunch of times since then — indeed, it got new owners again after I visited — but the factory is still one of the largest producers of titanium dioxide pigment anywhere on the planet, putting out 245,000 metric tons a year.

"Have you ever been to a chemical plant?" Malcolm Goodman asks me as we drive toward that very thing. When I was there, Goodman was vice president of technology and innovation at Cristal, which owned the place.

"Well, breweries and distilleries," I say.

Goodman half snorts. "Not much dangerous in a distillery," he says. "I guess the ethanol can explode." He's right; that doesn't really compare to the possibility of exposure to chlorine gas.

Joe Ferrari, principal analyst in Cristal's Risk and Insurance Group, insists there's nothing to worry about, though — neither for a rube like me nor the 520 people who work at the plant. "I've proved that by working for this company for forty-two years. I've been making TiO_2 since 1976," says Ferrari. "There's nothing wrong with me other than I'm old and overweight." Ferrari speaks a bunch of languages and has lived in Brazil and England, where he built TiO_2 sites. After we're done here he's headed to France, to one of the oldest chemical plants in the world, which these days makes TiO_2. Ferrari has a salt-and-pepper mustache and a mid-Atlantic working-class accent that renders "that" as "dat." "I'm focused on making the product, getting it right, getting it in the bag, and not having problems with the EPA," Ferrari says, and our escort from the public relations office winces so hard, I can almost hear her facial muscles contract. Ferrari, since this visit, has retired.

When we meet, Ferrari has a copy of Barksdale's *Titanium* on the table in front of him. Seventy years after publication, it remains the bible for what this factory does: turn black sand into white powder.

In a dingy conference room, I get my PPE: a hard hat, goggles, earplugs, leather gloves, steel-toed shoes, and a white Tyvek coat. On a nylon mesh belt at my waist is a yellow leather pouch with a respirator inside. I do not look cool in all this but, again: chlorine.

The factory goes through roughly ninety tons of chlorine every day and a half or so, and as a rule, none of it ever escapes containment, because that would be very, very bad. But Ferrari assures me he'll be able to tell me if it's time to put on my PPE. Well, either him or the screaming alarms.

We pile into a company SUV and drive into an airplane-hanger-sized metal shed, Ferrari weaving us past a semitrailer and a mighty bulldozer to thread between mountains of what looks like dirt. This is the ore. "I'll go get you a sample," Ferrari says, jumping out of the driver's seat, returning with a handful of the dirt. What looked like reddish-brown earth turns out to be a mix of reddish brown and black, a consistency somewhere between beach sand and talc. The reddish brown is all on the exterior of the pile. It's oxidation where the air has gotten to the iron in the ore — rust, or rather, ochre.

Outside we pull up near a six-story-high superstructure of I-beams protecting a big cube of a building; inside are tanks that combine the ore — mostly iron, titanium, and oxygen — with chlorine gas at 1,000 degrees C. That cooks into a new mixture as all those atoms recombine, and then the whole stew moves to cooling tanks; as the temperature falls, freshly created iron chloride condenses out, leaving titanium tetrachloride. A whole new set of coolers chills that $TiCl_4$ down to ten degrees below zero, which also frees up a bunch of the gases used or created in the process — nitrogen, oxygen, carbon dioxide.

From there, the tickle moves to a simple column still very much like the ones at those distilleries Goodman poked fun at me about, a tall cylinder with steam coming up from the bottom and tickle pouring down from the top. The steam carries away pure tickle and leaves behind any remaining impurities. "Burn that and you get a nice, white pigment," Ferrari says.

What's remarkable about the process up to this point is that it is essentially invisible. Sure, I can see the machinery — the pipes and plumbing. But the raw materials are so Lovecraftian in their toxicity that if you can see them, you're probably about to die.

But once that nice white pigment comes out of a tank called an oxidizer, it becomes very, very visible.

We step out of the SUV and head into a building just beyond huge fiberglass tanks full of hydrochloric acid, past the still and the oxidizer. Inside is a forest of pipes, valves, and ducts, all connected by metal gridwork floors and stairs, and everything — *everything* — is bright, bright white, every surface covered with white particles so fine that they almost turn to paste when you touch them, like icing sugar. The air seems clean — I'm not coughing, though I detect a taste so similar to flour that I suspect it's psychosomatic, some artifact of my brain trying to decode the achromatic world around me.

We climb up a few flights of metal stairs, Ferrari reminding me to keep my hands on the railings. Earplugs in, because the whole building seems to be thrumming and shuddering. At the top of the climb, Ferrari walks over to what looks like an eruption of industrial plumbing through the floor. We're about four stories up, I reckon, and this is the top of some clot of boilers and motors. It's literally shaking, and the top has a wheel mounted on a bolted-down port like the airlock entrance to a submarine. Ferrari stops, turns, and puts his foot on top of it.

He's standing atop a 25,000-gallon tank of chemicals and particles of titanium dioxide just 280 nanometers in diameter, all getting mixed together by a 100-horsepower motor. The particles want to flocculate — to stick together. For them to become pigment, they have to stay apart. That's what the chemicals do. "All I'm trying to do in that tank is keep the titanium dioxide in suspension in water and mix it with chemicals," Ferrari says. The exact recipe for the coatings is a secret.

Eventually the slurry gets pushed into huge screened, revolving drums, each one the size of a municipal trash-collecting truck. Thanks to some clever ventilation, the top of the drums stays at vacuum but air blows into the bottom. White TiO_2 slurry gets pulled into the bottom of the drum and sprays against the sides. As I watch one of the drums rotate slowly, its sides seem to thicken and grow somehow indistinct, as if they're losing focus, and then when

they turn far enough, white crud that has subtly accrued there falls off. The rime drops into a channel where a forever-spiraling piece of metal carries it off for drying and collection. It's impossible to get very close without getting splashed. I take a picture.

As I walk away, a familiar shape in a corner flickers into my view, white against an all-white background, barely perceptible. It's conical, about as high as my waist, with a square flange at the base . . . and I realize, this is an orange cone — what construction workers use to caution people way. Or rather, it's the shape of an orange cone, turned completely white against an equally white background. With its fundamental orange-ness gone, against a background the exact same shade, in the exact same lighting . . . I almost couldn't identify it. I felt like I was on the front lines of the war between form and color. And war is always foggy. It wasn't just that I couldn't see the cone. It was like I couldn't see anything.

In the late 1500s or early 1600s the Japanese artist Hasegawa Tohaku painted *Pine Trees,* a set of two six-panel screens five feet tall. In just black on a white background, now yellowed with time, the screens depict a pine grove on a misty mountain, some nearer trees more solid and black than faint ones in the distance. A white mountain painted on the white screen disappears into the forever, and while the black trees in the foreground are stalwart and highly detailed, the ones in the distance blur into indistinct smudges. Maybe it's actually a painting about the experience of boundless empty infinity, where you can barely see both past and future.

Anyway, that's what it was like trying to look at that no-longer-orange construction cone.

In the first half of the twentieth century, as titanium dioxide became common and then ubiquitous, popular culture again took up the battle between form and color, and what each revealed. Titanium dioxide was a sort of fulcrum here, because as I've mentioned, it does more than just make white. It also makes things colorful. If you're making paint, some pigments that you might use as ingredients don't need any help — a high

refractive index, like cadmium yellow at 2.4 or vermilion at a whopping 3.0, means that they'll bounce back an intense color at an observer and do a good job at covering up whatever's beneath them, as long as you don't grind the particles down too small — ten microns or even higher. But other pigments need a little boost. Ultramarine, with a relatively pallid refractive index of 1.5, gets ground finer so more particles will reflect more light. But to then also be opaque and bright, it has to be mixed with a white pigment with a refractive index of 2.0 or higher. Today, that's almost always TiO_2.

Design and architecture started embracing all the new pigments and colors they allowed. The World's Columbian Exposition reveled in whiteness in the 1890s; the cubist, colorful decorative-arts pavilions at the 1925 fair in Paris were, one visitor said, kaleidoscopic. Chicago's Century of Progress exposition in 1933 had polychromatic buildings lit by 150,000 incandescent lamps, 41 searchlights, 3,200 floodlights, and 277 underwater floodlights — not to mention all the neon and mercury vapor. During the closing ceremony at the Great Atlantic and Pacific Tea Company exhibit, a designer suggested that people should paint their kitchens to match the company's colorful packaging.

Paint consumption rises with wealth and quality of life. I heard a story from one of the TiO_2 industry people, possibly apocryphal, that the reason the Russian Bloc countries always seemed a little dimmer, a little less colorful, during the cold war was that they didn't have titanium dioxide–based paints. Crossing from West Berlin to East Berlin was a journey into desaturation. Even today, analysts predict spiking demand for paints and coatings in countries with developing or improving economies. And you need TiO_2 for almost all of it.

Houses and buildings in colonial America showed their patriotism and optimism by being achromatic, but the modernists (in Europe, at least) embraced a more colorful future. The German architect and urban planner Bruno Taut splashed color all over the suburb of Falkenberg in 1913, painting the houses red, olive, blue,

and yellow-brown. Taut hoped that brightly colored garden towns would give the people who lived there an emotional bond with their homes. In 1921 Taut designed an entire town, Magdeburg, according to polychromatic principles, and the famous Bauhaus architect Walter Gropius helped with the aesthetics of the facades. (Sure, by spring they were all fading and peeling, but that doesn't make the idea bad.)

Even the defining consumer product of the twentieth century, the automobile, was a (literal) vehicle for adding color. Henry Ford probably didn't say of his Model T, "You can have any color as long as its black" — that would've been weird, because the Model T came in a bunch of different colors for the first seven model years. But from 1914 to 1925, black was the only choice. Black became the new black because assembly-line Fordism depends on speed. All the other colors of paints tough enough for automotive use took too long to dry, and Ford was having trouble keeping up with demand. But in 1922 DuPont introduced a fast-drying lacquer perfect for cars that could also contain lots of different pigments. Thanks to a monopolistic purchase of 23 percent of General Motors in 1917, DuPont's colors became standard at GM. In 1924, the carmaker introduced the first widely available automotive color, True Blue, for a car called an Oakland.

Three years later, Ford came around. You could have a 1928 Fordor in any color you wanted, as long as it was black. Or Andalusite Blue, Balsam Green, or Rose Beige, among others.

Colors spilled all over everything. The mid-twentieth century brought with it a spate of new products, but it wasn't enough for them just to be new. They had to *look* new. That was a trick of design — sometimes of form, often of color. A sampling, from the historian Stephen Eskilson:

Lifebuoy Soap, Bokar Coffee, Kotex, and Packer's Shampoo all had begun to use colored packaging to secure larger shares of the consumer marketplace. In 1928, Macy's introduced the Red Star iron, which sold tremendously on the basis of its red

molded plastic handle. The late 1920s also saw the introduction of dyed petroleum products (gasoline), such as red Socony Special and Pure Oil's blue motor oil. Not only automobiles and their associated products, but trains (New York's Blue Comet, Chicago's Red Bird), Pullman cars, and planes were employing new color schemes.

New pigments and titanium-based paints made many of those product-defining colors possible. They looked like the future.

At the same time, though, artists working in less commercial, more philosophical realms saw the modernist future as more achromatic and all-white than ever. The modernists, suprematists, Bauhaus adherents, surrealists, Dadaists, and so on all used blank spaces, which were really sort of whitish spaces, to make points about the emptiness and isolation of the Industrial Revolution and World War I. All the world's new machines were making them think new thoughts about time and space, and big swaths of the white seemed to help evoke or concentrate those ideas.

So, for example, Kazimir Malevich's 1918 painting *Suprematist Composition: White on White* — a suprematist abstraction, a slightly akimbo bluish-white square floating on a pinkish-white field — became one of the definitional images of a new aesthetic. Malevich primarily used the pigment zinc white, sometimes with lead white mixed in. *White on White* picked up and perpetuated the sense that the color white had something to say about modernism by being a surface off of which all of its other colors could reflect. Over in Holland, the de Stijl artists, led by Piet Mondrian, were using white as a field for primary colors. (Unlike Malevich, Mondrian was actually using titanium white; the first work of fine art to use the pigment seems to be Jean Arp's *Shirt Front and Fork* from 1924.)

What's important about all of these all-white or mostly white projects isn't actually the white, though. *White on White*'s white isn't the end of the story. The Bauhaus thinker László Moholy-Nagy wrote in his 1928 book, *The New Vision,* that despite being

"merely a white canvas with an equally white small square surface painted on it," Malevich's painting was actually the avatar of something even bigger. "One cannot deny that this constituted the ideal screen for the light and shadow effects which, originating in the surroundings, would fall upon it," Moholy-Nagy wrote.

As a matter of theory, this open emptiness waiting to be filled by the viewer's experience is something big fields of monochrome are supposed to be very good at. Malevich's *White on White* (and Robert Rauschenberg's 1951 *White Painting,* executed in layers of white housepaint to be even more depth-free than Malevich's work) were supposed to be the "degree zero" of modernism. The critic Branden Joseph writes that only white, a non-color color, could be, as Rauschenberg said, both "nothing" and "silence." Joseph could have said the same about Malevich, too, of course. In pigments, white is a silent nothing, but white is also a noisy everything — the full spectrum, if you'll pardon the eponym here — when executed in light.

This dual-use capacity to be both everything and nothing, light and pigment, additive and subtractive, was the color white's actual superpower. As Moholy-Nagy said of *White on White,* its ability to reflect the world around meant the painting had the same function as the *other* defining technology of the twentieth and twenty-first centuries — "its big brother: the cinema screen."

Actually, let me revise that.

Yes, William Gregor discovered a weird new element in Cornwall. Martin Klaproth named it. Auguste Rossi learned how to make it into a brilliant white pigment that transformed synthetic color in the modern age.

But they weren't first. To get to *first* — or at least, scientists' current best guess at first — I have to jump backward again, to Peru in the time of the Inka, from the 1400s until about 1532 CE. Then, as now, the people who lived in the Andes drank a kind of beer called *chicha,* made from corn. It was ceremonial booze, consumed via ritual toasts from elaborately carved wooden cups

called *qeros,* generally around twenty centimeters tall, wider at the top than the bottom with a graceful wasp waist. The Inka who made them carved geometric, nonrepresentational designs into the qeros' surfaces. They almost never decorated the qeros with color. Like a lot of people who lived in Central and South America, their language was full of color words, indicating a high level of cultural importance. They used organic pigments to dye textiles, and worked with gold, silver, copper, and bronze (the things that attracted the conquistadores). They just didn't apply any of that to the qeros.

At or just before the arrival of the Spanish conquistadores in 1532, when Francisco Pizarro met the Inka emperor Atahualpa, something changed.

A set of qeros found in a tomb that dates to 1537–39 have the usual incised geometries — a rippling zigzag across the bottom, and sets of rectangles within rectangles. But on this set of cups, the so-called Ollantaytambo qeros, those rectangles frame images that look like jaguars, bright red-orange with black spots, six on each cup. From that moment, qeros got wild colors.

The color isn't paint. It's an inlay, made by mixing a pigment with a rubbery resin called mopa mopa, made from the sap of *Eleaegia* trees native to western South America. Mopa mopa is insoluble, gooey stuff that only gets workable when you heat or chew it — which the Inka did, getting it to a taffy-like consistency so they could knead pigments into it and cut it into pieces, then press those pieces of colorful gum into the carved-out parts. "In the colonial period, all of a sudden everything gets really figural and narrative, with lots of people and flora and fauna," says Emily Kaplan, a conservator at the Smithsonian who has been working on qeros for decades. "You get men wearing European clothing, you get horses, you get fantastical creatures from medieval bestiaries like mermaids and crazy animal-human figures, and things like coats-of-arms."

Kaplan's mother was an anthropologist, and her father was an archaeobotanist. She grew up watching them teach and do research

and fieldwork in Mexico, and combined that family interest with her own specialty in analyzing the materials and meaning of historic artifacts from Latin America.

To Kaplan and her colleagues, most of the pigments in these new designs were familiar: indigo blues, cochineal and cinnabar reds, copper-based greens, orpiment yellows. And of course the Inka had white. On the wall paintings of the time, they used calcium carbonates. But those pigments don't cover well. They don't hide the color of the surface behind them, and they'd show the slight greenish-yellow tinge of the mopa mopa.

So instead, somehow, the Inka used titanium dioxide — three hundred years before its nominal discovery and four hundred years before anyone thought of it as a pigment.

In the early 2000s, Kaplan and her colleagues turned their analytical attention to samples of mopa mopa–impregnated color in sixteen qeros now in collections around the world, including one excavated at Ollyantaytambos, and found TiO_2 in twelve of them.

Nobody had any idea where the stuff could have come from. Kaplan literally Googled it, and struck paydirt. In present-day southern Peru, she learned, someone was trying to sell mineral rights to a place called the Giacomo deposit, a wide-open pit of fine, brilliant white mineral sand, open to the skies, readily accessible.

The curious mud that Gregor worked on was the mineral ilmenite, titanium, oxygen, and an iron atom. It's black. Titanium dioxide deposits around the world might also be a mineral called anatase — its crystal structure makes it look black too. That's why both have to go through all the refining steps I've talked about to become a white, opaque pigment. But at the Giacomo deposit, the TiO_2 is yet another crystal form, anatase, mixed together with the quartz and cristobalite you'd find on a white-sand beach. And it is pure, sparkling white — piles and piles of it, a mountain of white titanium dioxide pigment.

At first, Kaplan's fellow conservators didn't believe it. Titanium dioxide is a modern pigment, after all. In fact, its presence in the ink on the Vinland Map, a putative fifteenth-century Viking map

showing North America, makes most historians think the map is a modern-day forgery. But the titanium white on the qeros was mixed into mapo mapo of the right age, and its chemical makeup matches the Giacomo minerals. (Kaplan's team eventually bought a sample from the mine to do the analytical comparison. "We could never get to it, but we did get an ore sample from it and compared it to the white from the qeros, and it was super similar," Kaplan says. "It's just remarkably pure titanium and silica. It's an extraordinary deposit.")

Titanium white didn't have much of a run among the Inka. The Spanish saw to that. "One thing the Spanish did do was send over a lot of European artists to teach the indigenous people to make Christian art, paintings, and polychrome sculpture. They brought some pigments with them, and they brought lead white," Kaplan says. "People in the Andes were such good metallurgists, and there's tons of lead there, but only a handful of lead objects. So we think they could have figured out how to make lead white, but just didn't want to — a cultural choice."

The Europeans obviously had no such compunctions, and probably had no interest in what might've been good about the Inka white or bad about their lead. By the end of the early colonial period, about 1570, all the extant polychromatic qeros use lead white.

Kaplan doesn't know why the Inka started coloring their qeros. She's convinced that the white came from the Giacomo deposit, but nobody knows why the Inka started using it, or why they stopped. None of the contemporary Spanish accounts of Inka cultural or craft-making practices mention the deposit or the odd white pigment. It's a mystery, an alternate timeline where Inka color technology could've changed the world's colors half a millennium before Auguste Rossi came to Niagara Falls. The conquistadores ensured that didn't happen. But maybe somewhere out in the quantum foam of the multiverse, the Inka developed titanium-based pigments into a more colorful empire free of Spanish rule. Or maybe the conquistadores on some other timeline recognized

the pigment for what it was and brought it back to Europe like so many other natural treasures from the New World, obviating five hundred years of lead poisoning and changing the infrastructure of Renaissance art. It's an alternate universe so bright, you can almost see it — if you squint.

COLOR WORDS

Paul Kay didn't expect graduate work in Tahiti to be easy, exactly. Nice, maybe, because: Tahiti. But "easy" is exactly how it seemed to him when he did fieldwork there in 1959, because learning the local language turned out to be relatively low-impact. That was in part because Tahitian had so few words that Kay had to learn for different colors. It had words for "white," "black," "red," and "yellow," and one word—*ninamu*—covered all the greens and the blues, the "grue" region of colorspace. That was it. Simple.

But Kay didn't know why this should be so. That's where things went from easy to complicated.

Soon Kay got in touch with his fellow anthro grad student Brent Berlin, who'd been studying in Chiapas, Mexico, learning the Mayan language of Tzeltal. Berlin had noticed the same thing—learning the colors had been easy. And when Kay compared notes with Berlin, they realized that Tzeltal in fact had the exact same color categories as Tahitian. The words were different, obviously, but the color categories that those words covered were the same.

Tzeltal and Tahitian couldn't be farther apart on the linguistic family tree. So when Berlin and Kay found themselves working together at UC Berkeley in the mid-1960s, they resolved to figure out this cross-cultural coincidence. Their work would become one of the most significant pieces of research in linguistics and color science.

Berlin set up interviews with forty native speakers of Tzeltal in Chiapas. He, Kay, and their students added to the group native speakers of nineteen other languages back in the Bay Area, ranging from Arabic to Cantonese to Tagalog to Urdu to Ibibio.

To each of their informants, the team presented a kind of poster, cardboard coated in acetate, on which they'd mounted 320 color chips — an array of forty colors at eight levels of brightness, all fully saturated, plus white, black, and some grays. Then they asked their informants to say what their native language's basic color terms were.

These are the irreducible quanta of color psychophysiology, words that describe a color without calling it by the name of something else. "Blue" is in, but "turquoise" is not. "Yellow," yes; "lemon," no. Then Berlin and Kay gave the informants grease pencils and asked them to indicate, on the array, the *best* exemplar of a given basic color term, and then all the other chips that they would say also represented that term.

The tests hid a disquieting, massive question, a problem that, by the middle of the twentieth century, was vexing not only color science, but also linguistics, anthropology, and neuroscience: Do people who call colors by different names literally see different colors? Language is the way we explain what our brain is doing. So to ask that another way, is seeing a color the same as talking about it?

In a way, all of those attempts to put colors in some kind of order, from Plato's construction of a continuum running from white to black and red to something sort of like "dazzling" through Newton's spectrum and beyond, had been leading to this. They were inchoate attempts to corral the science of color with language. As that science improved and complexified, the need for language to talk about those colors — to measure them and understand how people saw them — became more and more acute. Color, the ways we see it and make it, had become so crazy that scientists realized they needed a better language to handle it all.

And once they could figure that out, they realized, they could also do the reverse. They could use color to understand language,

which would in turn reveal something about how the human brain really works.

The words people use to describe colors are just as important as the wavelength of light or the physiology of the retina. The way we *talk* about color is as critical to its manufacture as how we physically make or see it.

Here's the physics: Scientists can measure light — the length of waves and the energy of photons. The light that human eyes see as "violet" isn't actually violet until some meat-based computational systems behind the back of your eyes convert it to a neuroelectrical signal. Prior to that, it's just a wavelength of about 400 nanometers. Oh, but, sorry, it's *also* photons — with about three electron-volts of energy. If I tell you about light with a wavelength of 540 nanometers, "yellowish-green," I can also say those are photons with an energy of 222 kilojoules per mole, a different metric for counting the same thing.

Waves are made of photons, but photons are also made of waves. It's messed up, but that's just how things are. The difference isn't in the math or the science. It's in the method — and the language.

When people measure the color of artificial light, they use a whole different system of measurement and another vocabulary. It's "color temperature," as in, the temperature to which you'd have to heat a theoretical "black body" to get that color, measured in degrees Kelvin. So this is also energy, but by another name. As with a flame or molten metal, blue-white is the hottest, so ghostly electronic flash bulbs come in at 6000 K — yet people describe that light as cool. Incandescent bulbs like the ones that lit the World's Columbian Exposition and, until very recently, most people's houses, land between 2700 K and 3000 K, a cool yellowish-white that people counterintuitively call "warm."

Light and the colors we perceive — or that our technologies can see — can be described in other ways, too, using other terms. The interactions of photons and electrons described by quantum electrodynamics has its own jargon for talking about color;

scientists who scrutinize how light interacts with particles and surfaces have their own special terms. They're all talking about the same thing.

One of the people who kickstarted that idea was the British politician William Ewart Gladstone, who wanted to talk about the colors people don't talk about. In 1858, ten years before he became prime minister for the first of four terms, Gladstone wrote a three-volume analysis of *The Iliad*, *The Odyssey*, and beyond called *Studies on Homer and the Homeric Age*. In it, he famously pointed out that Homer never uses words that might correspond to "orange," "green," or "blue" in English. (Homer being blind might've had something to do with all this, though Gladstone dismisses that — he's not even sure "blind" is the right word, and anyway, "blindness did not maim Bards, who neither wrote nor read their compositions," Gladstone writes.)

In fact, lots of Homeric color is weird. Homer uses a word Gladstone translated as "purple" — *purpura* — to refer to things as disparate as blood, a dark cloud, ocean waves, clothes, and a rainbow. He describes dawn as "rosy-fingered" even though fingers are never rosy. And don't get Gladstone started on that "wine-dark sea" that Homer is always going on about. Of the words Homer uses for "wine" when he means a color, Gladstone wrote, one means "dark, but probably without a determinate hue," and the other "fluctuates between the ideas of flame and smoke, either means tawny, or else refers to light, and not to colour, and bears the sense of sparkling."

Gladstone concludes that it's a mess, "hardly reconcilable with the supposition that Homer possessed accurate ideas of colour." In other words, maybe the ancient Greeks didn't merely lack the language to describe blue and green. Maybe they didn't have those words because they literally couldn't conceive of those colors as Gladstone could.

There's no physiological reason to think this. Very few humans lack the gene that enables a person to see blue. It doesn't seem

likely that every ancient Greek, man and woman, had this genetic deficiency. And why would the Greeks use blue pigments in their arts and crafts if they couldn't see them?

More likely, Homer was using Greek color words for things that were meaningful to the Greeks. This is what professors like to call "salience," which means something like "cultural and personal significance." The Homeric color term *porphureos* derives etymologically from the expensive, royal purple dye called Tyrian purple — *porphura* in Greek — extracted from a certain type of Mediterranean sea snail. It was highly prized in part because it took ten thousand snails to make a gram of dye. Chemically a relative of indigo, it probably ranged from a dark red to a deep blue, with some anoxic blood tones along the way. To the Greeks it was a signifier of wealth, of trade, of empire.

And hey, who's to say that the ocean Odysseus was looking at was actually blue, anyway? Most people think the color of water reflects the ambient color around it, generally the sky. But the most important thing about the color of water is that its molecular structure — two hydrogen atoms and an oxygen atom, H_2O — allows it to form bonds with other water molecules. Each hydrogen atom in a body of water can be bound to two oxygens, not just one, and those hydrogen bonds vibrate at a frequency just specific enough to absorb infrared and red light — reflecting blue. When whitecaps and foam form in the wind or a storm, they scatter ambient light (appearing white) and prevent much of it from penetrating deep enough to make the water blue. It ends up white, gray, black. Wine-dark, even.

What the Greeks really valued about water — about lots of things, possibly — was its quality of "brilliance," of "shine," the ability of *porphura* to make a textile shimmer like silk or velour. That's why one of Plato's primary colors was "brilliant and shining." The Greeks could see the blue; they just didn't care about it.

In 1879, a novelist and philosopher named Grant Allen tried to put Gladstone's hypothesis to rest. Allen would go on to pioneer both detective fiction and science fiction, but before that, as part of his early book *The Colour-Sense,* Allen sent letters to "missionaries,

government officials, and other persons working among the most uncivilized races." Put aside Allen's racism; the point is, he gave people a list of color questions to ask or answer. How many colors do they distinguish, or have names for? Can they distinguish between blue and green, or between blue and violet? Do they have "mixed" colors like mauve or purple? How many colors do they say are in a rainbow? How many pigments do they use? Do they have names for all of them? Do they have any color names for which they don't have a pigment?

These are *very* good questions. And it might only be because of the haphazard, anecdotal way Allen gathered his data that his answers aren't more famous. In the end, Allen asserted that all the peoples of Europe and Asia saw and spoke of colors pretty much the same way. So too did the indigenous people of North and South America. People from southern Africa could see all the same colors, but often lacked a word for violet. "In one case, a Mozambique had no native word for purple, which is wanting in his own language, but had learnt the name in Dutch, and applied it correctly," Allen wrote. And then a few pages later: "Even the wretched Andaman Islanders, probably the lowest known specimens of the human race, daub their faces with red and white."

Gladstone's hypothesis, in other words, was wrong. People could see colors for which they didn't have words. The absence of words — "negative evidence of language," in Allen's construction — wasn't evidence of the absence of a concept.

A more recent translation of the Odyssey solves the epic's negative-language problem by simply making it go away. In her new version, Emily Wilson, a classicist at the University of Pennsylvania, fills Homer's world with colors. Dawn is still rosy-fingered, but the sky is sometimes bronze, particularly when the Pylians bring black bulls to the beach for sacrifice to blue Poseidon. Ships have red painted prows. The sea is sometimes wine-dark, but also occasionally grayish and sometimes whitening.

That's because Wilson knows that very few words in ancient Greek have one-to-one modern equivalents. The culture was just too different. Ancient Greek has a word that's kind of like "wife-

woman," but doesn't mean spouse or servant, Wilson says. *Dmoos,* often translated as "slave," doesn't have the same connotations of forced lifetime servitude. The same goes for color. "That's an insoluble problem with translation in general, and it's a gesture of theoretical naivety to pretend we can get closer to authenticity by using weird English," Wilson tells me in an email. "I tried on occasion to flag the to-us-surprising ways Homeric Greek deals with color by using some surprising words—making the sea 'purple' and 'indigo' as well as blue, because of course the Greek term covers them all."

Allen's work on color was obscure and ignored by philosophers such as Friedrich Nietzsche and Johann Wolfgang von Goethe, who came to think much the same way as Gladstone. The idea that a person who didn't have a word for something couldn't conceive of that something proved to be extraordinarily sticky. In large measure that's due to the work of an autodidactic linguist and fire safety inspector named Benjamin Whorf.

Fascinated by the attempts of an early 1800s French mystic named Antoine Fabre d'Olivet to find hidden meanings in the Bible, Whorf picked up the idea that Hebrew letters have deeper, hidden significance than just sounds. In looking for evidence of d'Olivet's "root-signs" in Hebrew, Whorf prefigured what linguists call the phoneme, a basic sound element of language—the Lego-block atomic particles that unify all languages and describe their structures.

Whorf went on to look for root-signs in Aztec, Hopi, and Maya —a polymath polyglot. Even while keeping his day job, Whorf published in academic journals at a pace that a university professor would envy, working late, writing first drafts in elegant pencil and taking breaks to listen to classical music tinkled out on his mechanical grand piano. And when he started taking classes at Yale from a linguist named Edward Sapir in the early 1930s, the two developed an even bolder theory. All languages were related, but their differences weren't the outcome of culture—they were

its driving force. Languages themselves guided and restricted how their speakers thought about the world.

In a series of articles for *Technology Review* in the 1940s, Whorf laid the groundwork for what would become known as the Sapir-Whorf Hypothesis, or "linguistic relativism." What you can say, they argued, puts rails on what you can think. Grammar was "not merely a reproducing instrument for voicing ideas but rather is itself the shaper of ideas," Whorf wrote. "No individual is free to describe nature with absolute impartiality but is constrained to certain modes of interpretation even while he thinks himself most free."

"Language dictates thought" is the Sapir-Whorf Hypothesis in a nutshell. And this dictum has kept linguists, anthropologists, psychologists, and cognitive scientists riled up for decades. In part that's because it's *very* difficult to test. At the very least, coming up with an experiment to disambiguate language from thought requires finding some objectively measurable thing, a thing that exists apart from perception with its own verifiable, quantifiable reality, but that also exists as something entirely made up, a cognitive construct that languages invent words for.

In other words: color.

Measuring the color of light — wavelength or photons or color temperature, whatever — is easy. But determining what color people *see* is a whole other problem. Making some kind of chart, reliably and reproducibly, that everyone — all of us — could put a finger anywhere on or in and agree that we were pointing at a specific color that we'd all have the same name for? That turns out to be damn near impossible.

This is the problem of a field called psychophysics, and it's a doozy. Some spectral colors inherently appear brighter than others, even when seen under the same objective amounts of light. People see the dividing lines between colors in different places. People don't even agree on what the basic colors are. Should the axes of the colorspace flow through the Newtonian spectrum, or

the trichromatic red-blue-yellow? Red-green-blue? And what the hell is up with the extraspectral purple Newton invented, or any of the other colors nobody sees in a rainbow? Pink? Brown?

Those difficulties have never stopped people from trying. Even on the fundamental shape of colorspace, they disagreed. There was Tobias Mayer's double pyramid of 1758. Philip Otto Runge painted it as spheres in 1810; Chevreul proposed a hemisphere in 1839. Christian Doppler (of the eponymous Effect) sketched one that was shaped like an eighth of a sphere — an octant. In the 1850s, attempting to reconcile Newton's color circle with experimental evidence ended up with a sort of upside-down, off-center horseshoe, a "barycentric arch" with violet at the lower left and red at the lower right, and white an off-center eye in the upper right. It's preposterous, but the math works, so it's the basis for official color charts people still use today.

You can see how language and color naming might trip people up in all this. As the number of pigments people could make, artificially, blew up in the nineteenth century, being able to have a common language for those colors has gotten more and more critical. I've never forgotten the color of paint my mom chose for our living room in the 1980s — it was Apricot Ice, a name that can conjure up precisely no actual color in your mind upon reading it. (It was sort of pastel pinkish orange.) I have no idea where to locate it in an international colorspace, but it's somewhere out there, coordinates on all the various maps that international color industry groups and TV screen makers and textile dyers use so assiduously.

Albert Munsell was another of those poor saps who tried to build a rigorous colorspace. His was more successful than most. As an art student in Europe in 1879, Munsell was merely a competent painter, but the fact that he couldn't find a colorspace that'd make his color theory work easier bugged him. By 1900 he'd constructed a topology that contained a color gamut with colors evenly spaced according to hue and brightness, which he called "value." Over the next few years Munsell incorporated the saturation or pastel-ness of the color, a quality that he named "chroma." That gave every

color three mappable coordinates in a branching, treelike Munsell space.

The first book explaining all this came out in 1905, and by 1918, just before Munsell himself died, the Munsell Color Company was issuing chips and other samples organized according to Munsell's system. Munsell's system is still a reference standard for any field that uses or analyzes colors, from car paint to fashion. And since it comes in a kit, on calibrated chips like the paint samples you buy at the hardware store, it's portable — very appealing to field researchers like Brent Berlin and Paul Kay.

Sitting there in front of seven dozen speakers of various languages, pointing at spots on a modified Munsell poster and asking what they saw, Berlin and Kay knew that they were playing, virtually, with high rollers. Their results would unlock a centuries-long mystery. The eyes were finally going to be actual windows on the soul.

If Gladstone and Sapir-Whorf were right, their results should have been chaos, a different set of colors for every language and every mind.

If Allen was right, everybody's color-sense should be the same. Even if people used different words, those vocabularies would add up to the same basic color gamut.

The result: neither.

Berlin and Kay found, instead, a pattern. Not all languages have words for the same colors, but all languages, it seemed, acquire new words for colors in the same order.

On its face, there is no reason that should happen. Yet time and again, in language after language, this is what they found:

1. All languages contain terms for white and black.
2. If a language contains three color terms, then it contains a term for red.
3. If a language contains four color terms, then it contains a term for either green or yellow (but not both).

4. If a language contains five terms, then it contains terms for both green and yellow.
5. If a language contains six terms, then it contains a term for blue.
6. If a language contains seven terms, then it contains a term for brown.
7. If a language contains eight or more terms, then it contains a term for purple, pink, orange, gray, or some combination of these.

Allen had proposed in 1879 that languages might acquire new color terms as the cultures that used them learned to use or make new pigments — "red is the earliest colour used in decoration, and accordingly it is the earliest colour which receives a special name." That's in keeping with what anthropologists today think about red ochre. But Berlin and Kay were after something more fundamental. This wasn't about ornament or synthetic color; it went deeper than smearing ochre onto a face or a cave wall.

Berlin and Kay had no idea why this should be so. They hypothesized that maybe cultures without technology like "dyed fabrics or color-coded electrical wires" wouldn't have lots of color terms because they didn't need them. Their world wasn't complicated enough, perhaps, though this notion does seem to conflate sophistication with gadgetry.

Anyway, that didn't seem grand enough. Berlin and Kay published *Basic Color Terms* in 1969, about the same time as the linguist Noam Chomsky was working on his controversial theories of a "deep structure" for grammar in the human brain, and that gave them an idea. They decided that their eleven basic color categories were in fact "pan-human perceptual universals." Berlin and Kay suspected they had found "deep color."

Alas, no one else agreed. In fact, the pushback was immediate, and critics found a lot to bite down on. English could have leaked into the native tongues of the bilingual speakers, they said. Correlating color terms to an abstract pseudometric of "development" struck critics as arbitrary at best and racist at worst. Why would red be

more important to a pre-technological culture than the green of trees or the blue of sky and water? The fight raged.

Berlin and Kay decided to defend the terrain. In the late 1970s, they hooked up with an organization now called SIL International, at the time known as the Summer Institute of Linguistics. It was a controversial group; SIL International's stated mission is ethnolinguistic development, which involves anthropology, cataloging languages for preservation, and NGO-style aid. As one might expect for an organization that shares a founder with a group called Wycliffe Bible Translators, however, those efforts seem in practice to involve handing out copies of the Bible in local vernaculars. Also it's been accused of being a front for the CIA (which its representatives deny). You take what you can get, right?

The Berlin-Kay team trained the Summer Institute's linguist-missionaries to administer an even more laborious version of their color panel. This time they went to native speakers of 110 different languages from 45 different language families, on their home turf, with the quiz administered in their own language. The linguist-missionaries showed each one of the 330 Munsell chips to the speaker, one at a time, asking what color it was. Then they showed the speakers the entire board and asked them to point out the best exemplar of each of their basic color terms. It was exhaustive and exhausting, and they did it with 2,616 people.

So what did they find? Well, the original pattern didn't bear out. The Stage I, "two-term" systems that only had words for "black" and "white" weren't that at all. Two-term systems actually had a word for black, green, blue, and the "cool" colors, and the other word covered white, red, yellow, and the rest of the "warm" colors. Like, "white" is actually a "so-called *extended white;* i.e. it is WHITE," they wrote. In the new system, shouty white includes a whole gamut of colors. So does shouty black.

Most apparent to Kay and the rest of the group was that just six colors — white, black, red, green, blue, and yellow — formed what they called "perceptual landmarks." Most of the languages in the world in fact had the same basic color terms. If white and black stand in for light and dark, these are in fact an entirely separate

set of primary colors, ones that psychophysicists had been arguing about since the mid-1800s as being fundamental to how the brain processes color. (They were also, you might notice, the complementary pairs Chevreul identified.) Kay's group seemed to have found a deep structure of color — it just wasn't the one they expected.

Aristotle, Gladstone, and even Whorf all had something in common. They all knew that the perception of color had something to do with the way people talk about colors, and that the way people talk had something to do with their minds. They also all suspected, to varying degrees, that the most important action happened in one specific region in colorspace: the blue and green part. That's not a coincidence. Grue is a monster.

They weren't alone in this suspicion. In 1739 the Scottish philosopher David Hume published *A Treatise of Human Nature,* in which he tried to identify where ideas came from. In almost every case, Hume argued, people had to experience a concept before they could really understand it. If you want someone to know what pineapple tastes like, you give them a bite of pineapple. The sensory impression becomes a metaphor for the thing. But not colors, Hume said. They were an exception.

Because people see all colors in the spectrum of everyday light, Hume thought they might be able to formulate the *ideas* of colors they'd never seen. Take a person with normal color vision, he said, and show them a bunch of shades of blue ordered from darkest to lightest. Now show that person a new shade of blue, one they'd never seen before, and our hypothetical person should be able to slot that shade into the right place along the continuum. So, Hume asked, could someone *imagine* what that missing color would look like without having seen it, to develop "the idea of that particular shade, though it had never been conveyed to him by his senses?" If so, it'd be an exception to all of Hume's other rules, a "contradictory phenomenon." Nevertheless, Hume thought the answer was yes. People could imagine the "missing shade of blue." Philosophers have been arguing about whether he was right ever since.

Gladstone, Allen, Whorf, Berlin, and Kay all wanted to know if

people could see colors they didn't have words for; Hume wanted to know if people could have words for colors they'd never seen. Grue is the part of colorspace where everyone goes to find out.

Just look at the linguistic variation: English has a basic color term for blue and one for green. As Berlin and Kay learned, Tahitian and Tzeltal both have a single word that covers both. The Old French color term *bloi* covered blue and yellow; *sinople* in Old French was "red" but in the language of heraldry was green, and before 1800, people usually said the complement to red was blue-green, not blue. Greek has two basic color words for blue, and so does Russian — in Russian, *siniy* is dark blue and *goluboy* is light. And Japanese! When I studied the language, I was taught that the color at the bottom of traffic lights was *aoi*, blue. The language didn't have a basic color term for green. They used *midori*, "melon," to suffice.

So is there something special about grue?

"Yes. Absolutely," says Delwin Lindsey, a color researcher at Ohio State University who, with his wife and research partner, Angela Brown, has followed up on some of Berlin and Kay's conclusions. "Grue is primarily where most of the variation is, and we don't understand that. We don't."

See, it's not just linguistic. It's also physiological, Lindsey says. Of all the photoreceptors in the human retina, just five to ten percent are the short-wavelength, bluish-sensing ones. They're wired to nearby cells with higher visual acuity, even though human spatial resolution is worse for short-wave light. And the blue receptors are concentrated in the part of the retina called the fovea, the photoreceptor-dense center of attention. People with lighter-colored irises tend to see a shorter-wavelength unique green, as do people with a greater density of macular pigment, the yellowish pulp of carotenoids in the center of the retina that helps keep vision clearer by absorbing stray blue light. Also, confirming your priors here: Men and women almost certainly perceive the colors in the grue region the same, but they *describe* them differently. This is the region of colorspace that launched a million arguments over whether this shirt goes with these pants.

Let's get this straight: People who speak languages with just

one word that covers blue and green — grue languages — have the same kinds of retinas and the same kinds of brains as people who speak languages with multiple terms in grue space. So why the differences? "We even wrote a paper that speculated that this was related to the tint of the ocular lens," Brown says. "That's probably not true, but proving it not true was a trick."

The scientific term for what Lindsey, Brown, and others are trying to figure out is "categorical perception," the ability to tell the difference quickly, or accurately, between things. In color, one of the biggest questions about how people see is whether they distinguish better between colors from different categories (a blue and a red) than colors from the same category (two greens).

The more interesting question than "why have just the one word," then, is whether having a bigger vocabulary literally changes the colors people see. That's sort of the opposite of what Gladstone hypothesized, and there's some evidence for it. Like, remember the Russians with their light-blue and dark-blue words? In 2007, a team of researchers showed Russian-speaking and English-speaking volunteers three square color chips selected from twenty shades of blue, presented in a triangle formation. Then the researchers asked the volunteers which of the two squares on the bottom was the same as the square at the top. Sometimes the non-matching square, the "distracter," was from the same category as the match — either all *goluboy* or all *siniy* — and sometimes it wasn't. Sure enough, if the colors corresponded to different linguistic categories, the Russian speakers were faster at picking the match than English speakers.

Having access to more color terms led to better categorical perception. And when the researchers then asked their volunteers to do the same test while simultaneously trying to remember a long string of digits — to mess up their verbal processing — the Russian speakers lost their advantage.

No researchers have ever really been able to get their hands around the throat of this thing. That's partially because people literally see colors differently — but not all colors. Even within a specific language, some people will talk about and identify blues, greens, and grues differently. Brown and Lindsey did a variation of

the Berlin-and-Kay-style test of color names on Somali speakers, some of whom had different words for blue and green and some of whom used a "grue" for both. Some of them even called all the blue samples by the Somali word for "gray."

They all had normal color vision, were from the same culture, and spoke the same language. "We're talking about people who live next door to each other," Brown says. That makes it hard to accept the idea that the perception of color and choice of basic color terms is determined by words. In fact, according to Brown and Lindsey's work, whatever diversity you might find in color names across cultures, you find roughly the same amount within cultures, as well.

To prove it, Lindsey has me play a little game. He sets up his laptop with an image of what looks sort of like a pinwheel, with black fin-like shapes swirling atop a circular colored field. Moving my finger on the trackpad of the laptop shifts the color — cycling from very green to very orange. (The rotating black means that the stimulation changes, so the subject — me, in this case — doesn't get competing afterimages in his eye. Oh, and the cells in the primary visual cortex that they might be studying if I was stuffed into an fMRI right now deal with color and also spatial resolution, and the spiral stimulates that optimally.)

"Set a color that you would say is your killer yellow," Lindsey says.

I play with the track pad a bit. Go too far one way, and it's obviously green. But bringing it back from the verdant cliff and not too far into sunset? Not easy. I finally settle on something and hand him back the computer. Lindsey makes a note, then hands the machine to Brown, who does the same. Then it's Lindsey's turn.

"Now let's see what you got," he says, and shows me my choice. Then Lindsey says, "Here's mine." He caresses the trackpad, and boom, it's yellow.

"I like yours better than mine," I say.

"There's huge variation in what people say," Lindsey says.

But Brown disagrees with me. "That looks very clearly greenish to me," she says.

Then we try the same thing, only finding a green between blue

and yellow. This time I move more slowly. And indeed this time my green is right in the center of what most people, including Brown and Lindsey, might agree with.

Out in the world of larger research, though, things usually go in the opposite direction. Ask a bunch of people to identify a colored light as "yellow" and most of them will pick very close to the same wavelength, even though the ratios of middle-wavelength and long-wavelength photoreceptors in people's eyes — you need both of them to see yellow — vary widely from person to person. Ask about green, holding all other things equal, and people will vary by as much as 60 nanometers.

Let's try this from the other direction. So far, all these research- ers have tried to find out how much a person's language influences the colors they see by messing with the colors. The other way is to mess with the language.

So all researchers had to do was find some humans who don't have any language at all, and ask them about colors. This is a slightly trickier methodological approach, because it's hard to ask someone anything if they don't have a language. Science required humans with eyes and brains but no language. Science found babies.

Developmental psychologists take as canonical the idea that before they can talk, human infants will stare longer at something they've never seen before — a novel stimulus — than at something they're familiar with. So hypothetically, if babies recognized differences between colors, they'd stare longer at the new ones, and a patient researcher would be able to tell if they had categorical perception without language. If they did, and if they could distinguish the categories Berlin and Kay identified, that would suggest they were right about deep color.

This actually worked. In 1976, a team of researchers showed groups of four-month-olds lights at specific wavelengths — blue, green, yellow, and red — and found that the babies looked for longer at the ones that were more different. The effect was bigger if the colors were from different categories. But nobody could seem to replicate the results. (Imagine wrangling dozens of four-month-

olds in a lab. Yeesh.) Some people thought that using colored lights was the problem, that in the real world, people see colors reflected off of objects.

But wait. How would the difference between pure monochromatic light and light reflected off an object skew that experiment? "It wouldn't, really," says Anna Franklin, a psychologist at the University of Sussex, head of the Sussex Colour Group and Sussex Baby Lab. "It just provides a useful way of brushing it under the carpet when it's not convenient for your theoretical position."

In the early 2000s, Franklin did a series of experiments that confirmed that baby data. "But over the next decade, there was quite a lot of resistance," she says. "People were saying that maybe infants are just looking at the color they prefer."

The problem might be that psychophysicists and linguists don't really understand behavioral psychology. To be fair, Franklin's methods are hilarious, involving a viewing chamber centered on an infant car seat mounted 40 centimeters from a screen with two little windows in it for Munsell chips, and a place to hide a video camera. Then you just strap in some babies. "Pop in a new color, and you can see the babies' eyes kind of pop out," Franklin says. "That means they've caught something has changed."

Babies aren't the easiest subjects. The car seat helps keep babies from being influenced by their parents. "We just find that if babies are well fed and have slept, then as soon as you turn the light off, if they're in their comfy car seat, they just settle down," Franklin says. "You also have to make sure the experiment is quick. You've got about five minutes really to get any data. Ten minutes, max, if you've got a really good looker." Franklin even tried it on her own son. It was fine.

Her lab has been refining the setup ever since, and the results are pretty clear. Babies can distinguish among the categories red-yellow, green-yellow, blue-green, and blue-purple. But they have a much harder time distinguishing hues within the categories. Which is to say, even without being able to put names to them, babies see the following colors: red, green, blue, yellow, and . . . purple? The rest of the colors on the Newtonian spectrum give them more

trouble. So something mysterious is happening there. "It's our basic biology providing us with the fault lines of how infants categorize color," Franklin says. "Cultures as they learn color terms obviously develop lexicons that suit their own culture and environment, and we end up with radically different color lexicons. But there is a common pattern that relates back to our biology."

So how do those lexicons — the color words — evolve to account for that biology? Research going on right now is trying to answer that question. Some of this work would look familiar to Benjamin Whorf, with his fascination with the symbols hidden in language, and to fieldworkers like Paul Kay.

For example, if you want to hear some interesting things about how people see colors out in the world, good people to ask are the Tsimane' (pronounced chee-MAH-nay) people of the Amazon — hunters and farmers, mostly. They have words for white, black, and red. But show them just about any other color, and all of a sudden their vocabulary gets different from person to person. "There's a huge amount of variability," says Ted Gibson, a language researcher at MIT who works with the Tsimane'. "Different people use different terms for what we would call blue and yellow and orange. They really divide up the space differently, depending on the person."

Gibson took this finding to the neurobiologist Bevil Conway, a color researcher now at the NIH. I first met Conway when he was a PhD student in the lab of the Harvard neuroscientist Margaret Livingstone, an icon in understanding the way human brains process vision. Somewhat unusually for color scientists, Conway's also an artist. He plays a big part in the next chapter, too.

Conway studies color and vision; Gibson studies language and information theory. Together, they cooked up a new research project to figure out why the Tsimane' have such an unusual color language.

The team did Berlin-and-Kay-style Munsell-chip interviews with the Tsimane', as well as native Spanish speakers in a nearby town in Bolivia and English speakers in North America. But they

played a whole new game. "We asked people to describe color chips in a way that would make sense to someone else who spoke their language," Conway says. "Instead of saying, 'You have to use a basic color term' — and telling them what that is — we just asked people to describe these chips with whatever terms they thought were useful."

That's where Gibson's information theory expertise came in. The team first did a statistical analysis on those conversations to pick out the main color word, the "modal term," for each chip. And then, step two: "You just go through, for every chip, how effective people are at communicating those labels," Conway says. "If you have the complete color array sitting in front of you and I have it in front me, and I pick a chip without showing it to you and use a word to describe that chip, how many guesses does it take you to home in on which chip I'm talking about?"

Some colors turned out to be "highly communicative"; that is, people needed fewer words and fewer guesses to get them right. Some took more. In terms of information theory, some chips required more bits. Now, North American English and Bolivian Spanish are pretty sophisticated about communicating color. Tsimane' doesn't have as many color words and doesn't use them as precisely. "But these three languages, even though they're totally different, have pretty much the same pattern when you rank-order the chips by their communicative efficiency," Conway says.

In other words: Regardless of the differences between their cultures and their languages, an English speaker and a Tsimane' speaker have roughly the same difficulty conveying the idea of the same colors. And in both, colors in the "warm," longer-wavelength, red-orange-yellow space were easier to communicate about than colors in the cool grue space. Which is weird. "That's none of the Western ideas about color," Conway says. "That's a much more primitive, fundamental, backbone universal color categorization."

Still, it was familiar to Conway-as-artist. "This is the main, first-order terminology we use to talk about pigments and their importance in painting," he says. "But painters are sort of pooh-poohed in science."

But why should this be so? Why would the human mind be better at talking (and presumably thinking) about red or orange than blue or green? We see and perceive them all the same way. They're just waves. Or photons. Whatever.

Conway and Gibson have a hypothesis about that. The answer lies not with the colors, but within ourselves. To understand their idea, think about the colors we see in the everyday world — the colors of all the things. They might vary by region or time of day or year, but from pole to equator, rain forest to desert, the overall gamut of possible colors things might have stays the same, right?

Well, not quite. Conway and Gibson acquired a database of twenty thousand images, pictures of all kinds of everyday things that, as it happens, the giant computer company Microsoft was using to train machine learning systems. These kinds of "artificial intelligences" are, ironically, not very intelligent. They have to be shown patterns over and over again before they can start picking them out on their own. This set of pictures specifically was meant to teach machines the difference between *object* and *background,* between a target and the nothing-to-see-here around and behind it. So human beings had gone through each one of the twenty thousand digital pictures and hand-coded every single pixel according to whether it was something or nothing, object or background, in a way a machine would understand.

And, yes, there was a pattern. The same pattern. "Objects are systematically biased for — drumroll — warm colors," Conway says. People's brains, he says, are tuned to talk about and understand not the vast, overwhelming Rayleigh-scattered blue of sky or the roiling wine-dark sea, not the green of a forest, but the rainbow of bright hot spikes that stands out from it all. That's what our minds care about. "Greens and blues are typically things we don't want to label. These are not 'objects,'" Gibson says. "Warm things are the humans and other animals, the berries and the fruits, flowers and stuff."

This explains the linguistic development that Berlin and Kay found in a whole new way. The colors that are more important to

daily life enter the lexicon sooner. And what's important changes as humans start to synthesize new ways to make colors.

The most important part: This change is still happening. Industry, new science, new technology, all create new ways to show colors to people, and our languages and minds change as a result. "The earliest cave artists had two kinds of ochres and charcoal. This radical change to our environments that we brought about is the addition of synthetic pigments," Conway says. "We're now at the point where we have high-definition color televisions capable of producing many more saturated colors than we've ever been able to produce."

It's a good hypothesis; now it's up to the rest of the vision science world to try to prop it up or knock it down. It won't be easy. People study color not just because it's a fascinating way to get into someone else's head — is your red the same as my red? — but because it digs into the machinery of human perception and cognition. "We just don't understand enough about how high-level color vision is done by the brain," Lindsey says. What we talk about when we talk about color is nothing less than the human brain making the cognitive world.

Or as Brown puts it: "The spectrum is continuous. But our understanding of the spectrum is not."

EIGHT

THE DRESS

Cecilia Bleasdale spent the afternoon of February 7, 2015, shopping for a dress to wear to the wedding of her daughter, Grace. At 3:30 p.m., at a shop in Cheshire, England, Bleasdale found a blue dress with black lace trim, and took a picture of it with her phone. She texted the picture to Grace and asked her opinion of it.

Grace thought the dress was white with gold trim. Her mother told her it wasn't. That was weird — so weird, in fact, that Grace posted the picture to Facebook, asking why she and her mother had seen different colors. Grace's friend Caitlin McNeil, equally puzzled, reposted the same image to her page on the social network Tumblr after the wedding.

Soon after, McNeil sent this message to the Tumblr account of the digital news outlet *BuzzFeed*: "buzzfeed please help — i posted a picture of this dress (it's my last post on my tumblr) ok and some people see it blue and some people see it white can you explain because we are goING CRAZY."

The person running the *BuzzFeed* Tumblr, Cates Holderness, basically shrugged and went about her day. But by about five p.m. on the US East Coast, where Holderness was based, that Tumblr post had more than five thousand comments beneath it. Holderness called a few coworkers over to look, asking them what color the dress was. The group immediately underwent a consensus-shattering perceptual mitosis, like a single yeast cell dividing into two. Holderness found herself flanked by two angry

mobs, screaming angels and devils on her shoulders: white-and-gold versus blue-and-black.

With a preternatural sense of the kinds of things the internet likes, Holderness made a poll and posted it to *BuzzFeed*. "There's a lot of debate on Tumblr about this right now, and we need to settle it. This is important because I think I'm going insane," she wrote. It posted at 6:14 p.m. Then Holderness left to catch the subway home.

She emerged from underground to find that her phone notifications had been nuked. Her text messages were a tsunami. Her poll's traffic had hockey-sticked into the digital stratosphere. She couldn't get onto Twitter; it kept crashing, maybe because the microblogging network was itself seeing a global spike in traffic, 11,000 tweets per minute, with people evenly divided between seeing white-and-gold and blue-and-black. Tumblr was seeing the same kind of numbers. The dress had become The Dress.

At the time I was the science editor at *Wired*. Without Holderness's keen feel for the internet, I didn't think much of the meme when I first saw it. It was a blue dress. Whatever. It was the end of our day on the West Coast, then typically a time digital news traffic trended downward and our day slowed down. One of my bosses, the executive editor, plopped down in the chair next to mine to kibbitz. I said something like, Can you believe this Dress thing? Like, people can't tell what color it is.

He said, I know, right? Ridiculous.

Like, it's obviously blue, I said.

He looked at me with a worried frown and said, "It's white."

Now, at last, I grasped what I'd missed. That Dress — or rather, that Picture of a Dress (*ceci n'est pas une robe,* as the surrealist painter René Magritte might have said) — didn't merely divide people into two camps. It ossified their positions. It wasn't just that you saw blue and black. It was that anyone who saw white and gold was crazy, or lying. And vice versa. The way people see color, with their eyes and with their mind, was the biggest news story of the day.

More than that, it was a massive science story, and I was an hour late to it. We were in trouble.

Before I started at *Wired* I had a journalism fellowship at the

Massachusetts Institute of Technology. I spent those nine months talking to people about color and human visual perception—work that would become this book. Almost twelve years to the day before the Dress, I met Bevil Conway—the artist-neuroscientist who worked on the Tsimane' language in the last chapter—and I remembered liking his multidisciplinary approach. I looked Conway up—he was by then at Wellesley College—and sent him an email with a link to the original *BuzzFeed* post, without much hope. He emailed me back. I called him.

"So some people think it's blue and black?" Conway said. "Really?"

I told him I was one of those people.

"Well, that's good," he said. "At least we don't agree. It's definitely blue and gold. Blue and orange on my Photoshop."

Even on Conway's carefully calibrated screen, the "gold" or "brown" parts were actually orange. The RGB coordinates of the individual pixels—their location in the red-green-blue colorspace of computer monitors—were of no help. Their objective, independently quantifiable color had nothing to do with the color (colors) people saw when they looked at the overall image. Now, we've already seen that colors can seem to change next to other colors—that's what Michel-Eugène Chevreul catalogued. But why was it happening here, on a picture of a dress on a computer screen? And why did different people see different colors?

"The white-and-gold is easy to understand," Conway said. "My strong hunch is that it's because we have a very strong bias for the daylight axis."

He explained: If you put a white sheet of paper outside on a sunny day and took spectral readings from it, objective measurements of what wavelengths of light it was reflecting, its actual color would change along a predictable curve through colorspace—reddish, then blue, and then white (with reddish again at the end of the day). But to our human brains, that paper would look white all day long. The colors would change in the eye but remain stable in the mind. "These are the chromatic conditions under which we evolved," Conway said. "What's happening here is, your visual system is

looking at this thing and you're trying to discount the chromatic bias of the daylight axis."

Centuries before, Thomas Young had realized that the colors people saw didn't always correspond to their objective wavelengths. Shine a colored light onto a surface and that surface's color would change, objectively, but depending on the context, the observer might still say it was the same, original, authentic color. The ability to see something's "true" color — well, true-ish, as we'll see — is called color constancy.

Surfaces are tricky; the objectively measured color of an illuminated object may change under a different color of light, but our brain makes sure we see it as the same. Take an egg from daylight and put it under red, and you'll still see it as white. The machinery of the brain somehow subtracts the color of light reflecting off of an object, the *illumination,* to yield a consistent picture of the color of the object's surface, its *reflectance.*

Some people saw that picture of a dress and subtracted the blue; they saw white and gold. Other people interpreted the gold as yellow-orange illumination. They saw blue and black. Now, like I said, the dress was dark blue — another researcher I talked to, Jay Neitz of the University of Washington, had tracked down other pictures Cecilia Bleasdale had taken. In those, the dress's color wasn't a question. Something about this specific picture had induced a cataclysmic, population-scale failure in color constancy.

I wrote a story saying all that; it posted at 7:28 p.m. West Coast time. I hung around the office for a while, drinking wine and watching the numbers roll over on the software we used to monitor traffic. In the end I think 38 million people read it. They *still* read it. It's still the most-read story *Wired* ever posted. It's certainly my record — by millions and millions.

That wasn't the end of the story, though. The Dress registered as a seismic shock to the field of color science. Research in the years after the Dress showed that the dividing line wasn't as clean as the neat white-and-gold/blue-and-black grouping that made the initial meme so virulent, but the whole episode was an object lesson in a scary fact: In determining the colors of things, the physics of light

and the chemistry of pigments get transduced and reinterpreted by an intricate architecture of calculating neurology, from the wired-together photoreceptors of the eye to the labyrinthine synaptic connections of the brain's visual cortex. And that brain is like an old house remodeled by a do-it-yourselfer. The wiring isn't exactly up to code, and sometimes it shorts out.

The single most important thing that determined how you saw the Dress was how your brain identified, unconsciously, the color of the light illuminating the image — maybe even, as Conway first guessed, what time of day you thought the picture was taken. The Dress undermined or outright broke almost every assumption scientists had about color constancy and the daylight bias of human vision. In a time of ubiquitous, high-quality screens, many people have constant access to a nearly infinite palette. But that chromatic omnipotence also shows that everyone has their own personal infinity — color perception isn't just cultural, but highly individualized. We all see color differently, in billions of individual palettes. So the technological capacity to emit as many colors as nature would now force science to grapple, yet again, with how people actually manufacture color — in the world and in their minds.

Impressionist painters intuited color constancy in the nineteenth century. The radical idea that artists such as Claude Monet had — powered by the wide range of newly available pigments — was to paint things the colors they *were* so, that viewers could see how they *looked*. Monet painted the Rouen Cathedral from the same spot on different days, at different times of day, creating a series of paintings with wildly different color gamuts that any viewer can tell are the same place. It's a depiction of color constancy along the daylight axis.

Looking at the paintings in series, as I did at the Musée d'Orsay in Paris, makes it possible to build a mental image of the cathedral in time and space. But seen independently, the Rouen effect almost falls apart. One of the paintings, banded in daubs of peach, taupe, and aqua with deep greens and indigos for shadows, is almost clownish, a visual punch line that only makes you laugh if you don't

know the gag in advance. The cathedral actively does not possess any of those colors as intrinsic surface qualities. If you're unaware of Monet's project, it looks silly.

Color-thinkers in the nineteenth century like Chevreul recognized that contrast effects could cause the same spectra to appear different depending on context, on what colors they were adjacent to. They also recognized the obverse — different spectra can appear the same in different contexts. But the question of *why* that happened had vexed scientists for centuries. It was one of a category of tricks that the color-seeing brain could play, as when varying levels of brightness change the colors people see or the complementary-colored after-images that people see after looking away from a bright light. (This phenomenon was the scientific preoccupation, in the late 1700s, of Robert Waring Darwin, father of Charles.) In all those cases the brain seems to be generating colors that aren't there.

It's possible to imagine a few ways that might work for color constancy. One hypothesis is that over a lifetime of experience of looking at a colorful world, we store memories of what objects or classes of objects look like, and then we use that as a reference. We see an object — let's say an egg — under, like, orangish-yellow light. But we recall what color eggs are supposed to be, and then mentally subtract the orangish-yellow to get back to eggshell white. That's called "color memory."

Another hypothesis is the inverse. Maybe we look at reference objects familiar to us under a current illumination — like that orangish-yellow egg — see what color they *seem* to be, and then use that information to infer the color of the illumination. ("The scene must be suffused with orangish-yellow light," we say to ourselves.) Then we subtract that illumination from the entire scene we're looking at to get to the "authentic" hue (the eggshell-white egg, and the colors of everything around it, too. That's "memory color." The reference object would have to be portable and intensely familiar, though. Some eggs are brown, after all. One version of the theory says it might be the color of our own skin.

If you've ever messed around with cameras, especially video

or digital, this might sound familiar. It's "white balance." Either the user or software will choose a particular surface to represent "white," and the camera balances all the other colors against this. If the sheet of paper or whatever you hold up as reference white has a slight greenish tone, let's say, the camera knows to subtract that green light from everything else. In the early days of color photography, the output from film often looked nothing like the way the photographer had perceived it in real life. The photographer's eyes and brain had used color constancy to ignore the yellow tinge of a streetlight or the blue of a fluorescent. But the photographer's color film was not color-constant and so could not.

In fact, that problem with color film is what got the founder of Polaroid interested in vision. Edwin Land, the inventor of instant photography, had a complicated theory as to how the brain did the computation necessary for color constancy. He called it Retinex, and it turned out to be mostly wrong, but Land still made an important contribution to the field. To test people's ability to be color-constant under different lighting conditions, he built large boards covered in different-size and different colored squares and rectangles, all matte so they wouldn't kick off any complexifying reflections, illuminated by projectors tuned to the absorption peaks of photoreceptors in the human eye. Because of whose art these collages looked like, Land called them Mondrians, a beautiful coinage. They're going to matter again in a bit.

Land wasn't the only one coming up with ideas as to how color constancy works. Through the 1980s, they spread like bamboo. Maybe the visual system accounts for the color of surfaces near the object ("local surround"). Maybe it focuses on the areas of greatest difference ("maximum flux"). But a psychologist named David Brainard didn't believe any of it. As a graduate student in 1984, he resolved to figure it out. "I thought, Great. I'm going to go and, in the next couple of years, make some measurements of human color constancy," says Brainard, now at the University of Pennsylvania. "That's going to be my thesis."

It took somewhat longer than a couple of years. In 2006, Brainard published a paper that at last solved the problem. Or so it

seemed. Brainard showed volunteer subjects a three-dimensional, digitally rendered scene, a "room" with dark gray walls, furnished with equally dark gray shapes — a cylinder, a sphere, and a triangle — and a big, polychrome Mondrian. Under different kinds of digitally engineered lighting, ranging from normal daylight to a kind of Martian pinkish, the observers twiddled the computer they were using to change the lighting and make a dark-colored square on the back wall look gray. Brainard then used the actual lighting, perceived lighting, and colors of surfaces to teach a computer algorithm how to be color-constant. "If you can estimate the illumination of a scene, that's the hard part of color constancy," Brainard says. "Once you know what that is, if you've got the raw colors, correcting those to appear correct under illumination is rather easy."

The paper introducing the algorithm seemed to sew up a lot of the remaining questions. "I was really excited about that," Brainard says. "I felt it was the culmination of a lot of hard work." It was really only accurate in nonreflective worlds, like the ones the Mondrians were meant to represent, but it was conceptually right. And for more complicated real-world examples, like shiny or textured surfaces? "I'd say we're more in an exploratory phase," Brainard says, deadpanning the science-ese for "We have no idea."

The Dress screwed all of that up. "I don't think there's even agreement that in 2006 I solved the matte, flat Mondrian world problem. But I don't think anyone thinks anyone has solved the three-dimensional, natural scenes version of the problem," Brainard says. And his model certainly didn't account for a case where different people saw two distinct versions of the colors in the same scene. But that's what was happening with the Dress. "Nobody had a model that had that property," Brainard says. "And nobody could say, 'I can go produce twenty more images that have this feature.' The fact that nobody could do either of those things means we don't have a theory."

You might have seen optical illusions that look like one thing, and then flip to looking like another — two people in profile that also look like a vase, or a drawing of a rabbit going one direction and also

a duck in the other. These kinds of images are "bistable," meaning they have two different versions, and your eye and brain flit from one to the other.

The Dress, though, is different. For one thing, most familiar bistable illusions are about form; the Dress deals with color. But also, the Dress doesn't flipflop. People tend to adhere immovably to their first knee-jerk reaction. It's not bistable so much as bimodal. You see it, pick a side, and stay there, utterly certain that your perception of the Dress's color is correct — is true.

Actually, it's even more complicated than that. Remember how Brent Berlin and Paul Kay started asking people for the names of colors in their native languages? One of the things that shakes up that sort of research is variation even among speakers of the same language, like the Somali speakers that Lindsey and Brown talked to, or the Tsimane'. The Dress induced the same phenomenon in English speakers. The original *BuzzFeed* poll constrained the choices to white or blue. But asked to simply look at the dress and pick the best color to describe it, some people call it lavender, lilac, or periwinkle, and name combinations including lime green and white, purple and blue, and green/pale blue and yellow. Maybe it was just social media that pushed people into the two seemingly unshakable groups — forcing their choices like a close-up magician with a deck of cards.

A few months after the Dress hit the internet, Conway and a few other researchers dug even further in. They surveyed 1,400 people, some familiar with the image and some not, on what colors they saw in it. Most picked the two familiar sides, though fully 11 percent said they saw blue and brown — like Conway, who insisted to me, you might remember, that he saw the unusual combination of blue and gold. ("Gold" is what people call yellow with specular highlights, and "brown" is really just dark yellow. So I think he was in the 11 percent — he was seeing blue and shiny brown.)

And why do people see it the way they do? Maybe, one researcher said, people who were naturally night owls get exposed to more longer-wavelength, reddish-yellow incandescent lighting. So in cases where the illumination is hard to discern —

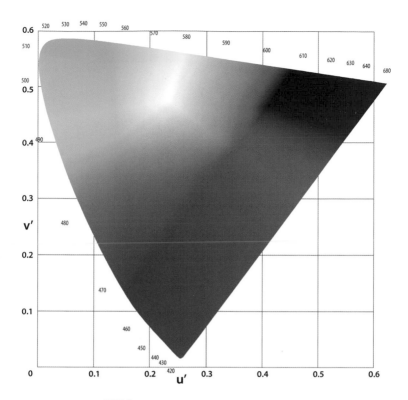

THE 1976 CIELUV CHROMATICITY DIAGRAM

In this diagram of all the possible colors in the world — it comes from the International Commission on Illumination — the distances between colors represent idealized perceptual differences in human observers. The *u'* and *v'* coordinates are the results of complicated equations that take into account hue (the wavelength, essentially the color) and chroma (how much or how little of that color there is, or saturation). *Adoniscik/Wikipedia Commons*

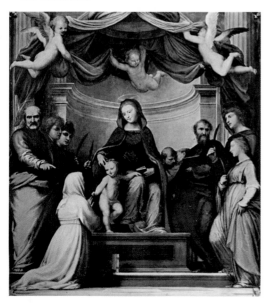

THE MYSTIC MARRIAGE OF SAINT CATHERINE OF SIENA BY FRA BARTOLOMEO. 1511

Fra Bartolomeo takes a good crack here at using brightness to convey dimensionality, an innovation of Renaissance painters. It *almost* works. The shadows under Saint Catherine's robe are clearly meant to be farther away, but the white of her knee and the pale orange of the draping in the lower left of the painting end up looking specular rather than forward-projecting, as if the cloth was cheap satin, or lit with neon. *Print Collector/Getty Images*

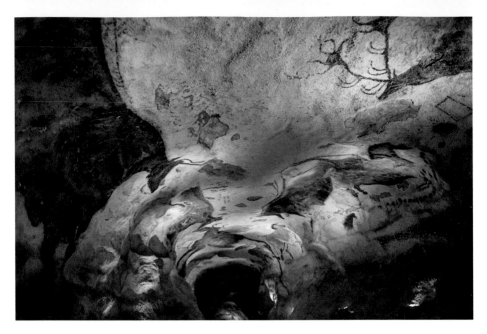

LASCAUX CAVE PAINTINGS

The paintings on the walls of the Paleolithic cave at Lascaux in the south of France have some perfect examples of the Paleolithic palette — yellow-orange-red ochre, black magnesium and charcoal, and white calcium carbonate. These may have been the only colors with which early humans could express themselves. Of course, it's hard to tell if that's true, since if they *had* blues or greens derived from, say, flowers or bugs, those colors would have faded long ago. *Ugo Amez/Sipa/AP Images*

WHITEWARE FROM XING

This seventh- or eighth-century vase from the kilns of Xing, in northern China, looks as modern as anything on a shelf in *Architectural Digest*. Part of that is due to the shape, of course — the Xing whiteware's heyday was a time of design restraint and elegance. But the color, a deep and luminous white, was a must-have for the sophisticates of its day. *agefotostock/Alamy Stock Photo*

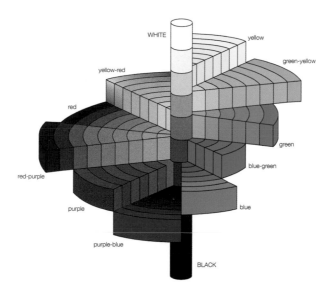

Albert Munsell wasn't the first person to try to create a three-dimensional colorspace that'd show geometric relationships among colors—like the CIE space on page 1 of the insert. That was probably Tobias Mayer, in 1758. But Munsell arguably made the biggest impact. He started work on his system, diagrammed here, in the late 1800s, and eventually created what became a reference guide to color, and a standard for scientists and artists alike. As with CIELUV, the vertical axis is light-to-dark, and what most people call colors—the wavelength-defined hues—are around the outside edges. Saturation, or chroma, moves from the inside to the outside. *Encyclopaedia Britannica/Getty Images*

Michel-Eugène Chevreul became famous for working on dyes at the Gobelins Manufactory. It was there, working with weavers, that he rediscovered what philosophers as early as Aristotle had known, but failed to understand—that colored surfaces look different when placed next to different colors. Chevreul's codification of these seemingly impossible changes into a set of rules of color contrast helped define the modern study of color and human perception, as well as influencing a generation of painters and designers. *From* Principles of Harmony and Contrast of Colours, and Their Applications to the Arts *by Michel Eugène Chevreul, first published 1839.*

Fine Art/Getty Images

Heritage Images/Getty Images

Photo Josse/Leemage /Getty Images

It's not really clear how much influence Chevreul had on the use of color by the Impressionist artists who were his contemporaries. Impressionists such as Claude Monet, who painted these multiple views of the cathedral at Rouen at different times of day, were probably better at using their gut than Chevreul's rule book. Monet and his frenemy artists had the further advantage of the first truly portable oil paints, which let them go on-scene and reproduce the colors of the world as they saw them, and capture how they changed in the light of the waning day. The magic here isn't contrast so much as another phenomenon of the eye and brain: color constancy, the human ability to perceive an object as having a stable color even when, objectively, the light reflecting off of its surface changes.

The French Romantic painter Eugène Delacroix bought notes from one of Chevreul's lectures and used them to sketch a triangle of complementary colors that would eventually form the basic palette for his 1840 painting *Entry of the Crusaders into Constantinople.* Hey, maybe it even works — the blue-green of the water in the distance and on the dress of the woman on the left do seem to play off the flickers of red of the crusaders' uniforms, right? Sure they do. *Heritage Images/Getty Images*

EVENING CALM, CONCARNEAU, OPUS 220 (ALLEGRO MAESTOSO).
PAUL SIGNAC, 1891

If Monet and the Impressionists were unimpressed by Chevreul, consider neo-Impressionists like Georges Seurat and Paul Signac a bit more smitten. In *Evening Calm,* as in so many paintings, Signac wants the dots to let the viewer create colors in the mind's eye without losing any brightness, as mixing the actual pigments might have. It doesn't actually work, but the effect does have a certain shimmer. *agefotostock/Alamy Stock Photo*

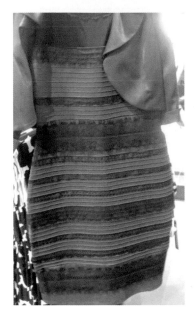

Is it blue and black, or white and gold? It's blue, but if you can't tell, don't blame yourself. This casual shot of a dress made its way to the upper echelons of meme-dom in a gentler era of the internet. The alternate colors are an illusion, but unlike most of the ones people are familiar with, this illusion is about color, not form — and it sent scientists scrambling back to their labs to understand color constancy better. *Swiked, Tumblr*

A B

LOCAL
SURROUND

Test
Patch →

SPATIAL
MEAN

EARLY COLOR CONSTANCY WORK

One of the first people to come up with a solid hypothesis for how color constancy worked was a researcher named David Brainard. This is the setup he and his team created in 1999 — a computer-generated scene that research subjects could tune the colors of. The colors in the background changed, of course, but with different lighting, you might see each image as being the same "color." *Figures from "Mechanisms of Color Constancy under Nearly Natural Viewing," first published in* Proceedings of the National Academy of Sciences *Vol. 96, No. 1. Copyright © 1999 by National Academy of Sciences. Reprinted by permission of PNAS.*

The actual building has been gone for more than a century, but architectural historian Lisa Snyder, of UCLA's Office of Information Technology and Institute for Digital Research and Education, rebuilt this version of Louis Sullivan's Transportation Building as part of a computer-generated simulation of the entire World's Columbian Exposition. So it still exists — in her laptop. *Image copyright © 2020 by Regents of the University of California*

This is a titanium mine near Jacksonville, Florida. The goth-punk boat is a floating ore processor that suctions in mud from the bottom of an artificial lake. The titanium-bearing stuff gets piped away for more processing; everything else gets spewed out the back. *Photo courtesy of Tronox Holdings plc*

MAKING TITANIUM DIOXIDE

This is one of the last steps in a long process of multiple chemical baths and cooking steps: taking titanium oxide ore, cleaning out all the other atoms, and coating what's left, so that it eventually becomes a watery, white slurry. Here, a dewatering filter rotates through a tank full of that slurry while a vacuum pulls titanium dioxide cake onto a filter cloth. The vacuum pulls out the water and then releases the still slightly damp pigment to a drying room — covering most of this part of the factory with dust so bright and white that it obscures the outlines of everyday objects. Walking through these rooms is like walking through the pencil sketches of a comic book, before ink and color get added. *Photo courtesy of the author*

THE NIGHT OF GOBELINS (OR THE CELESTIAL GOBELINS),
VINCENT BEAURIN, 2016

Today part of the Gobelins Manufactory is a gallery, mostly showing epic tapestries. From a distance, this hanging looks like a fiery mix of just a few shades of red, but closer inspection reveals that it's actually made with thirty-seven different colors of yarn — gray, green, magenta, red, pink, orange, and so on. The colors you see at a distance have only a little to do with the colors you see a few inches from the surface. Weaving colored weft through the threads of a warp exposes tiny fragments of one or the other — the threads are more like pixels, and the dots assemble into an image. Beaurin, the sculptor who made this tapestry for Gobelins, was explicitly trying to put Chevreul's contrast theories into action. It's beautiful. *Photo by the author*

like the Dress image — they assume it's longer-wavelength and mentally subtract that, yielding a dress that must be blue-black. But if they're day people, or "larks" as the researcher had it, their ambient illumination prior is the shorter-wavelength blue light of day. So they subtract that from the image and come up with white. Conway's group argues that the choice comes from a viewers "priors," which is to say, assumptions based on experience — like what you know about fashion. The most important assumptions people were making, unconsciously, had to do with the material they thought the dress was made of (and therefore its textural and surface effects), and what kind of lighting they thought it was under.

So for example, showing people a blown-up image of the dress with better resolution and more detail on the fabric — higher "spatial frequency" — led to more people identifying it white-gold reflecting bluish, late-afternoon light. And when the team went the other direction, blurring the image, more people thought the dress was blue, seen in whitish midday sun.

Tweaking the illumination cues in the image also pushed people in the direction you'd expect. Conway's team clipped the dress out of the original image and overlaid it on a stock shot of a model, as if she were wearing the outfit. Then they added in a background tinted toward bluishness (and blued the model's face a little). Pretty much everyone said the dress was white and gold. When they moved the background illumination effects toward yellowish, the dress turned blue and black. As I type this, I'm looking at the two images, side by side, on a calibrated UHD monitor, and the difference is striking. I was committed to blue and black, but the dress on the bluish background is definitely looking sky blue and gold.

It's all very troubling.

In a perfect world where neuroscientists actually understood how the human brain worked, you might propose cutting out the middleman of language and subjective perception and drilling right into the brain. Why not just shove some people into an fMRI tube, show them the dress, and see what their brains do? And indeed a team of researchers in Germany did just that in the spring of 2015.

They found twenty-eight people split evenly along blue-and-black and white-and-gold lines, put them into the machine, and showed them two squares of colors matched to two colors from the original image, and then they showed them the dress.

What they found — while broadly inexplicable — was also kind of crazy-pants. The group of people who saw white and gold had significantly more activation in a bunch of areas of the brain — not just the regions neuroscientists have come to expect for color perception, but across the entire cortex. The blue-and-black group had no such activation. Blue-and-black was some kind of resting state; white-and-gold was using more energy. That doesn't explain whether the illusion of white-and-goldness — remember, the Dress is actually, for real, blue and black — was the result of more brain activation, or the brain activation happened because of the illusion. Further studies necessary, etc.

In the years after the Dress, when researchers had more time to mount bigger studies, they tried hypothesis after hypothesis. Again, they found possibilities, but nothing entirely convincing.

This is all so strange that some researchers suspect it might be a clue to the entire mystery of how people see color — maybe even a new framework for making colors and showing them to people. That'd be a relief, honestly, because no one really understands how the brain turns signals about the outside world into a perception of color.

The retina at the back of the eye has three kinds of photoreceptors that absorb light of different wavelengths. But that's the end of simplicity. The retina actually has multiple layers — optic nerve fibers, then ganglion cells, then a mesh of different kinds of neurons hooking it all together. Light entering the eye has to pass *through* all that before it can reach the rod and cone cells, the photoreceptors, that turn that light into neural signals. The actual rods and cones project backward, smooshed up against the back of the eyeball.

In the center of the retina, the cones, the photoreceptors that detect color, are packed really densely. But out toward the edges of the retina, the cones are more spread out, and multiple cones

are wired together to a single neuron sensitive to everything those photoreceptors pick up collectively. That's called a receptive field. Some neurons only activate if the center of their receptive field gets stimulated. Others might do the same if it's the edges ... or they might get inhibited if the edges get stimulated. And they all signal to other neurons up the line, summing their own signals into *that* neuron's receptive field, on up the line.

All of those neurons collect into a neural cable coming out of the back of the eye and projecting into the brain. But even by the time the neural signals reach the first junction box, a synaptic connection in a region called the lateral geniculate nucleus, the brain isn't mixing three colors like printers. It's manufacturing color out of balances among what are sometimes called *opponent* colors. You'll recognize those as the basic colors that Berlin and Kay settled on: blue and yellow, red and green, and a white and black (which is also luminance, the overall amount of light). So some of the neurons fire excitedly at red wavelengths but not at all at green; or they fire at green but not red; or they fire when green turns off but not when red turns on. And some of the receptive fields have different firing patterns depending on what color appears in their center versus their edges.

Upstream even further, in the deep recesses of the visual cortex, the situation is even more confusing. Some of those regions — in nonhuman animals, at least — have clusters of neurons that light up for different colors. Some might just be light sensitive, and color's just an accidental outcome. As Soumya Chatterjee, a neuroscientist at the Allen Institute for Brain Science, puts it, "Color, which one would argue is fundamental to trichromatic primates like you and me, has a stimulus map that has resisted scientific consensus."

So researchers hope that understanding the differences in Dress perception can give some clues as to what that mess of kludged-together neural wiring actually does. "It tells us something about not just the way the human brain works in general, but the way human beings are different," says Anya Hurlbert, director of the Centre for Translational Systems Neuroscience at Newcastle University. "And about the fundamental characteristic of color,

which is that it is purely subjective." Hurlbert wrote one of the core explainers of color constancy in 2007, and a decade later, she became one of the key researchers trying to understand what the hell was going on with the Dress.

Philosophers have killed a lot of trees wrangling over whether color exists is an intrinsic characteristic of an object, or whether it's assembled somehow post-hoc — by the interactions of sub-atomic particles, by the workings of the eye, by consciousness it-self. And now here's Hurlbert, one of the world's preeminent color vision scientists, saying, Yeah, it's pretty much all in your head, and the Dress is proof. "The whole thing of people saying, 'What's the real color of the dress?' means that people think it *has* a real color, and that's what we're trying to get away from," Hurlbert says. Peo-ple describe colors in a context, their own *Umwelt,* their own life experience, and the experience of the moment. And color vision is pretty easy to trick, suggesting some fundamental instability. "You can make somebody change the name they give to a light from 'blue' to 'yellow' just by showing them a series of twenty-five dif-ferent lights before they name it," she says.

"The dress has a color, though," I say. "It's blue. It's a real thing."

"We say, 'What would the dress look like if you put it under bright, equal-colored white light?'" Hurlbert answers. "If you want to call that 'real color,' OK."

You'd be a dope, though. And Hurlbert proved it.

Her first step was acquiring the actual, real-live dress. "It's a pretty foul material, I have to say," she says. "It's not glossy. It has a lot of Lycra in it, stretchy, and a fairly matte cloth. It's probably polyester and elastane, something like that. It's thick and not highly reflective." (Score another one for Conway's ideas about priors and textiles; if someone thinks the dress looks reflective in the picture, they might mistake brighter areas for specular highlights like the ones Plato and the Greeks thought were so important.)

Then she put it on display, in London's Wellcome Collection museum. "We put it on a mannequin and stuck it under special lights that we can tune in real time to produce any spectrum," Hurlbert says. So: darkened room, dress illuminated with what

looks like white light but is actually equal amounts blue and yellow mixing together to make white. Then people come in, look at the dress, and say what color it is.

If you do what the internet did and give them only two choices, "half of them say it's white and gold, and half of them say it's blue and black," Hurlbert says.

But if you unconstrain their responses? "I've got data from nine hundred people who saw the real dress," Hurlbert says. "The responses I got were hugely variable. People said 'mauve and khaki.' There was a big, big range of color responses."

"So does that mean," I say, "that you could take any object, put it under the right lights —"

"— and you could get people to change their color name for it. Yeah. Absolutely, you could," Hurlbert says.

She knows because she has done it — at the National Gallery, using paintings by Gauguin, Degas, Cézanne, Seurat, and Monet. Hurlbert's team asked people to name the color of objects in the paintings, while the researchers controlled the color of the lighting. Some people would call one thing orange, others red, others brown. Then they changed the lights, and the proportions of people picking each color changed. Same art, different light, different percepts. It was like imposing Monet's experiments with the haystacks, or the Rouen Cathedral, with illumination instead of reflectance.

The same thing can happen with the same image under the same light — with different people. "The reason the Dress is particularly interesting is not just a smudging of color category boundaries. It really does seem to be a difference in the way people's intrinsic mechanisms for color constancy operate," Hurlbert says.

That might begin to explain why nobody knows how color constancy works. It may operate differently for different people, an emergent property of all of the individual variations in the way we see color. Colors don't have to be constant, really, in the sense that they have to match some objective standard. They have to be internally constant, maybe — so that an egg always looks like an egg, in case we might want to eat it. But colors don't have to be externally

constant. It doesn't matter whether my blue is your blue ... until we want to have a shared culture and mutual language. But even then, we just have to tacitly agree that when I say "blue" you know what I mean — that's the endpoint of the information-theory patterns Conway and Gibson found with the Tsimane'. Colors may be less about cognition and more about communication.

A few decades ago, no one would have even seen the dress — it was transmitted via phone and computer screens, a brand-new technology, relatively speaking. The image itself wouldn't have even existed; it was a product of the algorithms that govern how the camera embedded in a mobile phone calibrates color and light, not the eye of an artist. Just a few years earlier, people seeing that image on their screens wouldn't have seen those colors, because the screens weren't of high enough quality to display them.

The dress was the right material, of the right color, photographed at the right time of day, seen under the right lighting, imaged with the right camera, seen on accidentally calibrated screens — a combination of conditions impossible to imagine until the moment it happened. And when it did, it proved some of what the most spiritual color-philosophers had long thought. Color is always constructed in the mind, illuminating dark, indistinct corners of human perceptual and psychological colorspace. The Dress was either an exception to rules no one yet fully knows or the Rosetta Stone that may allow scientists to decrypt them. I'm inclined to think the latter.

The future that the phenomenon of the Dress promises is one where people construct color in the mind not accidentally, but with intention — not as illusions, mistakes, or curiosities but as a material that artists and scientists can actually use. Colors in the mind are the way this story has to end. Maybe they'll be used for mere entertainment, the virtual realities of the future. But if color, perception, cognition, and communication really are all different facets of the same jewel, then these science-fictional colors-in-mind could offer whole new ways to understand information — and each other.

FAKE COLORS AND COLOR FAKES

Color constancy probably helps people move through a colored world with more confidence. We recognize the fruit we like even if it's in shadow; we aren't startled by discord between our memories of objects and their colors when we reencounter them. Or, to put it another way: Imagine what the world would be like if people *didn't* have color constancy. You'd park a car in a lot in the morning and then return after sunset, when all the yellow-tinted mercury vapor lights are lit, and the car would be all but unrecognizable — except for its shape, license plate, and the crap in the back seat, of course.

But if color vision really is the mind making sense of illumination and radiance, well, that could actually solve some complicated problems. You wouldn't even have to know how it worked, exactly — just *that* it works. You could fool the human eye into seeing a color that didn't really exist.

Why would anyone want to run that scam? One possibility: rescuing art. In 1960, Harvard University commissioned the artist Mark Rothko, famous for painting monumentally scaled blocks of intense color, to create a site-specific work for the university. Rothko signed on to paint another in his series of "rooms," massive canvasses sized to fit specific spaces, as he'd done for the Four Seasons restaurant in New York's Seagram Building. At Harvard, the dons gave him a dining room on the top floor of what was then called the Holyoke Center, a modern building in Harvard Square,

across the street from the Yard. The room had floor-to-ceiling windows, and Rothko agreed to paint a triptych to fill an alcove on the room's west wall, and two more paintings to face them from the east.

An abstract expressionist, Rothko worked in fields of color, something of a hallmark of late-twentieth-century modernism. The color, either on a canvass or on the wall, would encompass the viewer's entire field of view, an emotional experience that relied as much on how the viewer's perception of that color changed over time as it did on whatever the painting actually looked like.

For Harvard, Rothko painted six canvasses and then chose which five to use on-site. He installed them there in 1963 and 1964. They all seem to represent doors or portals of some kind — dark, monumental, and foreboding. A couple curve inward slightly, conveying either a sense of decay and collapse or maybe something more organic. They're all predominantly a plummy, luminous purple color that Rothko, a skilled technician who often hand-mixed his own pigments, made from animal glue, ultramarine blue, and the synthetic pigment Lithol Red. That's an "azo dye," a synthetic substitute for the bluish-red alizarin, derived from the roots of the madder plant. (A dye, remember, is technically a pigment that bonds to some organic substrate, like wool or silk; if you add aluminum to alizarin, it'll stick to that and become a "lake" — which is when you use a dye to color a pigment.)

Rothko often asked people who installed his "rooms" to keep the lighting low and use no furniture besides a bench, right in the middle, for people to contemplate the work. To that request Harvard said, Welp, this is a dining room, my friend. And so it was. Over the next two decades, people ate, drank, and smoked under those uninviting gateways. Thanks to the tenth-floor penthouse's lovely view, it became a "party function room." The paintings started showing tears and dents, and even some graffiti. Worst of all, the facility managers left the curtains open. Boston's not the sunniest town in America, but the sun does come out, and that light, visible and ultraviolet, streamed into the party space.

That vivid Lithol Red screwed Rothko. The pigment books of

his era insisted that it was a lightfast, colorfast pigment, but they were wrong. Dispersed into a binder and exposed to ultraviolet light, it faded. Mixed with ultramarine, it faded even faster. And Rothko had used titanium dioxide white to lighten his ground. In an organic binder like animal glue, and used with azo dyes, TiO_2 turns into a photoreactive destroyer of all things colorful.

In 1979, the Rothkos — faded, damaged, sad — went into storage. People who saw the Harvard Rothkos at a 1988 exhibit described them as "irretrievably lost."

Today the Holyoke is called the Smith Campus Center, and it is about five minutes' walk across Harvard Yard from the Fogg Museum. Since 1895, the Fogg has been a center for conservation and research into paints and pigments. In 1928 its director, Edward Forbes, started the Conservation and Technical Research Department, hoping to turn fine art conservation into a more rigorous discipline. That meant scientific analysis of pigments, and to that end Forbes started collecting samples from all over the world. Today that department and collection occupy the upper floors of the building that houses the Fogg, around a skylit atrium, with two stories and a glass roof added to the building during a remodel by the architect Renzo Piano. This is now the Straus Center for Conservation and Technical Studies, and its conservators subscribe to the same prime directive as their colleagues all over the world: Do as little as possible to a work of art to preserve it, and whatever you do, make sure you can undo it. If conservators could get away with it, they wouldn't touch an artwork at all.

The centerpiece of the Straus is also one of its reasons for existing. A set of tall gray cabinets with glass doors runs the length of one side of the building, overlooking the atrium. It houses the pigment collection that Edward Forbes started.

The cabinets are a living infographic. Time runs along the Y axis, from the floor to the ceiling — raw materials are on the lower shelves, with pigments ascending upward, variations of the same color. And the X, the length of the hall, unwinds new color after new color, each one in its place. As we walk along that X axis, I remark on this to Narayan Khandekar, the director of the Straus,

and he nods. "It's like a color wheel that has been opened out," Khandekar says. We're walking in a literal colorspace.

I keep seeing old favorites, samples of things that up until then I'd only read about, and I can't resist stopping Khandekar so I can snap pictures. Above white lead buckles like you would've found in Samuel Wetherill's barrels are jars, phials, and flasks of all the other would-be white pigments, from powdered alabaster to calcined bone to TiO_2. They have dragon's blood, a once-mysterious red from China, and Japanese agate that was ground into a pigment called memo. Next to parchment bladders once used to contain paint are examples of the first tin tubes that replaced them, the portability technology that made Impressionism possible. They have a real murex — the critter that got turned into Tyrian purple — from Phoenicia. A bag of beetle bodies that could be ground into cochineal. Madder root from Edward Forbes's own garden. Sepia from a cuttlefish.

"Do you paint?" I ask Khandekar. He says he does — tiny streetscapes, little three-dimensional sculptural things.

"You're steeped in it," I say.

"It's a whole different thing," he says. "What I know professionally doesn't inform how I do stuff with that."

"No way. Really?"

"I mean, I know where to go when I need to solve a problem, but it's not like I'm going, What's the most stable, long-lasting pigment?"

"But," I say, and gesture lamely at the cabinets.

"It's not a collection of colors," Khandekar says. "It's a collection of pigments."

I get what he means. There's a difference between the idea of color and the technology of color, and Khandekar's lab is one of the places that bridges the gap. Artists only use pigments because they're playing with color, and pigments are the tools.

When the Rothkos were due to come out of dark storage once again in 2014, it was clear that nothing in the cabinet-timeline-colorwheel would help. Adding pigments to replace what the

Rothkos had lost would fundamentally alter them, in color and in spirit. Cleaning or adding a glaze or varnish would, too. Conservators typically *start* by cleaning off old varnish, selectively removing it where it makes sense to lighten the colors behind it, replacing the smallest amounts they can get away with. Old paintings acquire a patina that's part of their heritage. You don't want to mess with that. But in order to create his subtle light effects, Rothko hadn't varnished the paintings at all. That left them essentially unprotected; adding glaze now would darken the overall paintings and screw up the gloss/matte effects Rothko wanted.

So Khandekar knew that to save the Rothkos, he'd need a new approach — something so noninvasive it'd seem spartan, Zen-like in its hypothetical non-ness. "The Rothko project was a chance to do something for the first time," Khandekar says. "Can you restore a work of art without touching it? As it turns out, you can."

He got in touch with a physicist named Jens Stenger, and together they turned the problem on its head. They wanted to change a color. They weren't allowed to change the pigment. So they would have to change the light.

The Harvard team planned to create an illusion — to put the "con" in color constancy. To be fair, this was all before the Dress, so they had no idea that a color constancy violation could cause a memetic frenzy. They were really more worried about art critics.

The plan was to use colored light to restore the paintings to their original appearance. A conservator named Raymond Lafontaine had first tried it in the 1980s, beaming blue and white light at J.M.W. Turner's *Mercury and Argus* and Lucas Cranach the Elder's *Venus* to compensate for yellowed glazes added to both paintings. Lafontaine had come up with the idea as an aid to conservators, to show them what a work might look like after they cleaned it. But in the 2000s, museums and historical sites began to use the trick for objects on display, such as a damaged Renaissance mural in Germany and a Henry VIII tapestry outside London.

If the trick is going to work, you have to know what the art

looked like when it was still mint. The conservators of the Henry VIII tapestry, for example, relied on the color of unfaded threads from its back.

Khandekar and Stenger didn't have any hidden threads to pull on, but they did have Ektachrome transparencies, five-by-seven-inch pictures taken of the original Rothkos. But these were the wrong color too. Ektachrome was intended primarily for portraiture, so it has a bias toward warmer hues. Even if the transparencies had been in perfect condition, the colors they showed wouldn't have been the ones Rothko had painted. And they weren't in perfect condition. The printing process for Ektachrome, like any other color photography, involves dyes or ink in the primary colors cyan, magenta, and yellow, and the cyan in Ektachrome from the 1960s turned out to be unstable. It fades over time, shifting colors of the prints toward the other two colors. So the transparencies were as untrustworthy as the paintings themselves.

Except unlike the paintings, Ektachrome has a predictable, objective degradation curve. At the Imaging and Media Lab at Basel University, researchers scanned each transparency with red, green, and blue LEDs with peak wavelengths matching those absorbed by the dyes. Then they color-corrected these digital images according to a model based on the actual dye concentrations on the original transparencies and how their appearance had changed.

Khandekar and Stenger also had a backup. Rothko had painted six pictures but only installed five at Harvard; his heirs still had access to the sixth panel, which he'd taken back to New York. Some of it had faded; some had not.

So the Harvard team had multiple points of reference. Now came the tricky part. They couldn't just project the color-corrected images of the Rothkos onto the Rothkos. That'd be a slideshow, not an art exhibition, but more than that, the surfaces of the Rothkos already had faded Rothko on them; adding more Rothko wouldn't work. The colors would interact and form all-new colors with nothing to do with the originals or the faded contemporary versions.

The researchers took another picture of the paintings, starting with neutral gray light made of red, green, and blue LED

illumination. Then they compared that with the reconstructed digital images of the transparencies, creating a new, antimatter picture they called a "compensation image." This became a guide to recalibrating the red, green, and blue output of each pixel on their projectors. Basically, they'd cast the exact right color of light at the exact right place on the painting to bounce off the aged, faded pigment and into people's eyeballs, screwing up their color constancy and tricking their minds into seeing the original colors. "If you look at those projection maps, the maps of the missing color, they're kind of crazy," Khandekar says. "You have no idea how that color plus what's on the painting is going to combine."

It's a Frankensteinian mash-up — the additive color of a digital projector and the subtractive color of pigments on a surface. The pigments had lightened, but "you can't make something darker by shining more light onto it. And when you are painting, you often want to put more paint on to try to make it darker," Khandekar says. "What we were doing was combining a map of the missing color and shining that onto the painting, which still had color. And so that combined reflection of the projected color and what was still existing on the surface produced an image of what the painting looked like." In other words, the paintings didn't look like themselves anymore, and the compensation image didn't look like the paintings, but when they shined the latter on the former, they had a 1964 Rothko.

Almost. They had to defocus the projectors a little, because each pixel has a thin black outline, usually invisible, but just slightly apparent at the wide scale of the mural. And despite all the mathematics they did to get the projections to register exactly with the paintings, they still had to tweak some of them manually, because the paintings themselves had changed shape a little bit, having been unstretched and restretched. Oh, and despite all this effort to replicate Rothko's finicky matte/gloss action, the matte surfaces of the canvasses didn't scatter light equally. That disrupted the match between the projection and paintings, especially when seen from an angle.

The paintings went on display, and were quite popular, but maybe

not for the reasons Rothko would have hoped. People liked to show up around four p.m., when the museum would turn the projectors off, so they could see the transition from augmented to original. The altered work reflected its original appearance, but not the hand of its maker or the history of the canvas. It was, fundamentally, a constancy illusion — like the Dress, the new Rothkos were color-inconstant. Well, *ceci n'est pas un Rothko.*

One artist reportedly expressed disappointment at the whole project — light reflecting from a canvas was intrinsically different from the light that supposedly emanates from a Rothko. That's probably artsy-fartsy pretension; paintings don't emit light. I will allow, though, that some pigments, including alizarin — what Lithol Red simulates — reflect ultraviolet light as well as visible. While the human short-wavelength-sensing photoreceptor has a peak absorption at 426 nanometers, it has a long tail that reaches a bit into the almost ultraviolet, and individual human variation does allow some people to perceive blue light more intensely than others. Maybe — *maybe* — some people might have seen a fluorescent luminosity in the original pigments. *Maybe.* And it wasn't there in the re-lit restorations.

Or maybe art critics are like audiophiles who hear nonexistent "warmth" in vinyl records and "clarity" from expensive cables. "Mark Rothko's kids really liked it," Khandekar says. "It works for some people. It doesn't work for others. And, you know, I think that's OK. We weren't saying it's the only way of doing it. In the end, you know, you turn off the projectors and the paintings haven't changed at all."

As with Khandekar and the Rothkos, Liang Shi and Michael Foshey didn't set out to break color constancy. Their goal was much more commercial — to build what would be, by some standards, the greatest color printer on Earth. That's what you'd expect of two bright young researchers at MIT's prestigious Computer Science and Artificial Intelligence Laboratory. But Shi and Foshey also had a loftier, yet somewhat larcenous goal: They wanted to teach an artificial intelligence to forge paintings.

That isn't how they phrased it, of course. Forgery would be wrong. Shi and Foshey's lab, the Computational Fabrication and Design Group, is in the Frank Gehry–designed Stata Center, a silver-clad cluster of curving and leaning geometry with multiple incompatible internal levels, floors that fail to connect across the entire building, and offices with no bookshelves. So I have no way to describe to you what floor the lab is on, or even how to get there, really.

The space they work in has an outer room full of desks, computers, and bicycles, and the actual lab is a narrower, windowless room lined with chugging 3D printers the size of refrigerators, connected to tangled arrays of tubes that deliver fluid colors. It's a hub of the highest of high tech, so it seems a little weird to put Shi and Foshey into the same grand tradition as Joseph Christoph Le Blon and the three-color dick pic. Yet here we are. Like Le Blon, they were looking for a better way to make copies of paintings, the kinds of things you could sell in the first-floor home décor labyrinth at an Ikea, maybe stick up on a dorm wall. Klimt's *The Kiss*. Some *Water Lilies*. That kind of thing.

You can see the problem here. If color really is a mix of a surface and the light bouncing off it, then a painting should change its appearance under different lighting. That's why museums and galleries are so careful about that. And a copy of that painting, on a different surface, made with different pigments, will look *different* under different lighting. A bad copy, in other words. Modern four-color printing, a process called halftoning, has its imperfections. It's bad at reflections and shine, the "specularity" that even blacks show in the real world. Sometimes the dots that compose an image, even at the microscale of modern printers, spread and diffuse through the paper, smearing the edges of the colors. (That's "physical dot gain.") Sometimes light penetrates the ink, moves through the paper substrate, and exits somewhere else, yielding the wrong color ("optical dot gain").

Foshey was part of a team that in 2017 came up with an alternative to fix all that. They called it "contoning." Instead of mixing different dots of color on a paper surface, as in traditional halftone printing,

they mixed layers of inks in a volume — a solid, three-dimensional layering of color. Printing with the four classic colors and a fifth, white (based on titanium dioxide of course), to provide an opaque substrate in the absence of paper, the team was able to print objects all but indistinguishable, visually, from deeply chromatic materials like marble and wood.

But the process had a flaw. The equations that Kubelka and Munk derived for how light moves through colored layers, the ones aimed at figuring out how well given pigments would cover a given surface, aren't perfect. They're really just approximations, because the actual math and physics of how all those photons interact with all those particles are hideously complicated — that's part of what Kubelka and Munk tried to simplify by looking at layers in the first place. When Foshey's team tried to scan 3D objects and then use the Kubelka-Munk equations to make precise copies, the math wasn't good enough to calculate how the pigments would absorb and scatter light throughout the solid replica. It didn't look right.

So they switched tactics. If the physics of how light moved through colored solids wasn't good enough, they needed new physics. Instead of trying to use Kubelka and Munk's math, they built a huge database of colors and the layers of 3D-printed pigments it took to generate them. Then they showed that database to a machine-learning algorithm, software designed to learn by examples and generate its own sets of rules to reproduce what it sees.

The algorithm started complaining right away. Not literally — machine learning AIs don't whine — but Shi and Foshey quickly realized that their computer vision system was seeing colors that their 3D printer couldn't replicate. The contoning ink palette was too small, which limited the gamut of colors they could create because of the very same problem that Aristotle and Newton had grappled with: the way colors mix. In this new world of 3D printing, the print heads were too small to extrude more than one material at a time, and mixes anywhere except in the volume they were printing would screw up the computer model.

There was a simple answer: more inks. Magazines occasionally pay more for an additional ink to join the CMYK palette — often

a fluorescent or a metallic. And painters add to their palettes pigments beyond the so-called primaries for much the same reason, to expand their gamut on the canvas without darkening the colors from mixing. To CMYK, Shi and Foshey added red, green, and blue. Then they put in a violet and an orange (more reflective at longer wavelengths than the red, and with a narrower absorption band). They also included a transparent white with a lower concentration of pigment to lay over the tops of ink stacks and desaturate them, and a high-concentration opaque white—because unlike traditional printing, they didn't have a substrate of white paper. The white pigment, Foshey says, is "basically our structure."

To train the AI, they showed it more than a hundred colored grids, each with more than two hundred dots of color that were just one square millimeter each, but made of thirty layers of color and twenty layers of white (yet a scant 1.1 microns thick). The computer figures out what layers of pigment make what color.

Then they set up a scanner, a $70,000 multispectral digital camera mounted above a table, illuminated by two LED panels. The camera, they tell me, is capable of discerning every wavelength from 420 to 720 nanometers, pretty much the entire visible spectrum, at increments of ten. That's a finer scale than humans can distinguish. In other words, their scanner sees colors better than a human. But a camera doesn't "see" the way people do—cameras have lenses like our eyes, but instead of the proteins in the back of our eyes that respond to photons, digital cameras have sensors. And rather than triggering a cascade of neural signals and neurotransmitter proteins flowing across synapses, photons hitting those sensors trigger an electronic flow of ones and zeroes. The eye transduces light to biology; a digital camera transduces light to math.

"What we capture is a 3D vector of spectral reflectance at each pixel," Shi says. Every individual "dot" that'll make up their final printout has a numerical value, a mathematical code for where it should sit in the printer's expanded colorspace—what color it should reflect, regardless of what light is shining on it. "A better setup would surround it with lights," Shi admits. "But the paintings we reproduce are mostly flat."

That hints at a limitation of the process. Part of the point of oil painting is three-dimensionality and layering to achieve subtle lighting effects. Some painters, especially modern ones, slather their paint on almost sculpturally. Rothko painted flat canvasses that played with color and reflection; Jackson Pollock's spattered paintings had thick, raised surfaces that sometimes even incorporated cigarette butts. A 3D printer could theoretically replicate that, too — but not this printer. Not yet, anyway. "So it'd be fine with Rothko, but not great with Pollock?" I say. Shi and Foshey smile and nod noncommittally, which makes me suspect that maybe they don't know.

Here's where another limitation showed up. Even thirty-layer stacks of eleven pigments didn't result in a wide enough gamut. Contoning gave them hundreds of thousands of primary colors, but that still couldn't capture the chromatics of a human-made painting. They had to get tricky again — by going back to basics. "We use the primaries to do halftoning," Foshey says. They use their new 3D printing technique to lay down dots next to each other — "a way to perceptually create more color," Shi says, as proud of his discovery as the comic book artists, weavers, and post-Impressionists who used it too.

Foshey disappears for a moment and then returns with a small panel, perhaps half the size of a playing card, painted with abstract smears of color. It's almost like looking very, very closely at a segment of an Impressionist take on late sunset reflecting off, perhaps, the Charles River — flecked golden yellow at the top, spreading through green and blues, with diffuse red at the left edge and across the bottom, where it's smeared with a heavy stroke of deep black. It's not a famous image — they don't have access to the Rothkos just up the road at Harvard. But the wife of one of their co-authors is an artist, and they prevailed upon her for something original they could forge. Or rather, reproduce.

Then Foshey shows me what the computer came up with. And I have to say, it's damn close. The black brushstroke's dimensionality and specular reflections are missing, and there's slightly less detail in the red, but other than that . . . it's very good.

The most remarkable thing about their reproduction technology, though, isn't how good the printouts look. It's how good they always look. This is the breakthrough. Under multiple different kinds of illumination, an original and a contoned, halftoned, 3D-printed reproduction stay almost indistinguishable from the original.

The ink palette still has trouble accurately reproducing some pigments, such as cobalt blue and cadmium yellow. Lithopone, another white, also doesn't copy well. Shi and Foshey think a further customization of the printer and the addition of more inks might fix the problem. I saw other variations, though, that made it obvious, every time, which one was the reproduction. Surface effects, either from the dimensionality of an oil painting or the gloss of a glaze, can't be reproduced by the printer. "We think in addition to the color layers, we can also print varnish," Foshey says.

That's not all they might improve on. Light doesn't just bounce off the tippy-top surface of a material — those photons penetrate some distance in, bounce around, and then fling back out. That's called subsurface scattering, or in the mathematics of computer vision, "bidirectional reflectance distribution." The team didn't build any of that math into the models they trained the AI on. The result? "It causes some blur in our reproduction," Foshey says.

A European team has already done some work using traditional 3D printing to recreate textures typical of Renaissance paintings, incorporating a varnish into the inks available to the printer. They were able to use a scanner to pick up gloss effects — tricky business, since they change depending on the angle that the viewer looks at the image. It almost worked; their printouts show variations like those you'd find in gloss and in the actual varnish layers. A work in progress.

Of course, none of this jibes with the way scientists think color constancy should work. The same surface under different illumination should look the same . . . and different surfaces under the same illumination should reflect differently. But here, an algorithm has figured out how to make a copy of a surface that reflects any color of light indistinguishably from the original.

In a scientifically perfect world, that should tell color scientists

more about how color constancy works in the mind — and how different materials interact with light to create color. For a reproduction made with some other technology — old-fashioned CMYK printing, let's say — a change in illumination would be a major tell. A viewer looking at both side by side would, perhaps, be able to tell which was fake if the lighting changed. Here, though, the different materials are color-constant in the exact same directions. Halogen lights, fluorescent lights, sunlight, weird combinations of LEDs — the spectra of any illuminant changes the paintings and the printings in what seem to be the exact same ways, thanks to equations that the machine came up with all by itself. This is the nature of machine learning — it's just algorithms, a black box of differential equations that the machine never outputs. Nobody really cares, as long as it works.

Consider the implications here, though: The most advanced physics of light and color, the math of light moving through thin layers, didn't work. So Foshey and Shi built a computer that could end-run all of that. "We previously used a physics-based analytical model, but it only works as well as we define the physics," Foshey says. "This system doesn't know anything about physics."

That's not true, though. It has to know physics, or else it wouldn't be able to generate colors. It's just that the physics it knows is *different* than the physics humans know. It understands how light moves through surfaces better than Kubelka and Munk in their wildest aspirations. Yet Shi and Foshey don't seem particularly interested in finding out anything about it. "It basically learns its own physics," Shi says with a shrug.

Their black box knows something important about color and constancy, about the way the mind creates color and maybe the way we humans could create new colors, too. But the black box won't tell.

TEN

—

SCREENS

The brightest, whitest white in the world — whiter than new printer paper, whiter than a baby's teeth — is the armor of the *Cyphochilus* beetle, native to southeast Asia. They're about an inch long, squat, cute as insects go, and they're ghostly, almost luminous. *Cyphochilus* eat sugarcane, and might be white because they're hiding from predators amid a white fungus that also lives on sugarcane. That's a guess.

But if you unmixed the ingredients of a *Cyphochilus* beetle's exoskeleton, you wouldn't find anything white-colored. Its armor contains no white pigment, no titanium dioxide or kaolin. The scales that make up the beetle's carapace, each just a twentieth of the thickness of a human hair, are made of chitin — the same stuff as in lobster shells and the mushroom cell walls. And those scales are transparent, not white.

So where does *Cyphochilus* get its color? Figuring that out required shooting them with lasers.

In 2006 a team of researchers from Exeter University painstakingly peeled individual scales off of beetles — probably more painstaking for the beetle, to be honest — and mounted them on the ends of needles. Then: *pew pew*. Focused beams of light went into the scales, and the scientists measured that light as it bounced around, refracted, and then reemerged onto spherical screens surrounding the beetle scale, like shimmers on the walls of a room with a crystal chandelier.

The ghosts of that ghostly armor revealed the secret to this unbearable whiteness of beetle: *Cyphochilus* chitin is a mess. "The key property required to make white is disorder, randomness," says Pete Vukusic, the Exeter photonics researcher who led the work. It's chaos at the scale of wavelengths, in the size and placement of the reflecting structures.

Nothing else works. Same-sized particles positioned randomly give you a different color. Different sized particles arranged in a periodic array give you a pastel color. To get a really bright white—a snow white, a milk white—you need multiple, randomly oriented edges (very much like the water crystals in snow and the proteins and fats in milk, in fact).

In those beetles, the white comes not from chromophores or other light-absorbing molecules as it would in a dye or pigment, but from infinitesimally small structures whose shape guides the reflection and refraction of light. That's a "structural color." They're not uncommon in the natural world—the blue of bird feathers and the iridescence of butterfly wings are both structural.

But the beetles did actually yield a sort of nanopigment. A team of textile researchers in Hong Kong figured out how to replicate the structure of chitin in *Cyphochilus* scales using a process called electrospinning, extruding a fine web of polymer from an electrically charged syringe. Squirted onto a rotating drum, the polymer became a synthetic textile as brilliantly white as the beetle. And it didn't turn yellow under ultraviolet light the way lots of synthetic whites do. This, too, is still experimental.

So that's all one more example of the ways that learning how colors are made can turn into new colors people use. But it's only one side of the equation.

In the computation that eyes and brains perform to make color in the mind, black and white serve dual roles. Learning what those roles are has an impact not only on theoretical, science-y stuff like beetle armor but on everything we see.

Black and white are, in color language, "achromatic," which is to say, *not* colors. But don't make the mistake of thinking that puts

them in some other category of vision or art. Thinkers from Aristotle to Goethe argued that the opposition between light and dark was vital to the colored world. And they may not have been far off, after all. Van Gogh said it; it must be true. "Black and white are colours too, or rather, in many cases may be considered colours, since their simultaneous contrast is as sharp as that of green and red," he wrote in an 1888 letter.

Light and dark, white and black, are the ends of the axis. Well, one axis, anyway — almost every way that artists and scientists have invented to put colors in order, every colorspace, includes a light-dark dimension. I've talked about this axis a few times already; it's luminance, and in some colorspaces it's hidden, or merely implied. That's a shame, because when it comes to the kinds of colors people now look at every day, the ones on the screens we carry in our pockets or mount on our walls, luminance may actually be the most important quality of color. Aristotle might have been right.

If you ask someone to describe or identify their "perfect white," you'll get a lot of different answers for something the eminent color scientist John Mollon once called the "mother of all unique hues." They'll sometimes define it as a color that is neither reddish, greenish, bluish, nor yellowish, the multiple opposite of all the colors that the brain computes color with. But in reality, different people have different "perfect" whites. They'll be a little reddish or a little bluish, perhaps, but they mostly line up on the same daylight axis of colors that was so important to figuring out the Dress, the so-called cerulean line. In fact, there's so much variation in how people see white that some researchers think it's a bad placeholder for the light end of official, research-grade colorspaces. Maybe white is not light — or rather, maybe white is not merely the absence of dark.

"Black," though, almost certainly equals the absence of light. One piece of evidence: The color black and darkness are both really just the state of no photons hitting the retina. The cones of the retina, the photoreceptors responsible for sensing color, are by themselves colorblind. Even though stimulating a single cone is enough to induce a color response, they're really just transmitting a signal

most of the time that says "Yes, I caught some photons" or "No, I didn't." They just see light in different wavelength ranges; it takes the neural armature around and behind them to assemble the perception of a color. And when they don't see light? Nothing.

The retina has another kind of photoreceptor, called a rod. Utterly insensitive to color, the rod functions exclusively at low levels of light, when just a few photons are ranging around. This high-resolution vision, well designed for seeing fast-moving objects, is called "scotopic," and it's just what you want if you're a nocturnal hunter, as so many early mammals were.

(Side note, when your eyes dark-adapt and you switch over to scotopic vision, you also see what looks like static. Rods can sense just a single photon, so they're subject to a little bit of quantum leakage, of statistical not-there but also there-ness. That gives rise to a flicker, subatomic "noise" you can see if you look at a blank wall in the dark. Don't. Don't do this. Don't even think about it. We're not really meant to stare at quantum worlds. You won't be able to get back to sleep. I'm telling you this from experience.)

Trying to turn black into a pigment, though, is tricky. The main thing you want from a black is absorption of all wavelengths across the spectrum, slurping up stray photons instead of sending them back toward some observer's eye. That ability, the scale from "Yeah, that's blackish, I guess" to "Hotblack Desiato's sundiving spaceship," is measured in terms of "jetness."

For most of human history, the best way to make jetness has been to burn some organic material like ivory, bone, wood, or coal down to soot — carbon — and then grind and mix the resulting powder. All had slightly different qualities in use, but they were all just burnt carbon. (Yes, yes, black Egyptian kohl was lead sulfide. Still.)

These days, makers of carbon black — that's the pigment — usually just burn some petrochemical as a feedstock. That's it. It's pretty jet. Worldwide, the market for carbon black is 13 million metric tons a year — but less than a million tonnes of that is pigment. A bit more is "toner," used to add opacity and depth to other coatings. Another category is called "tread," because it goes to tires, which without it

would be the off-white of rubber. The carbon lends strength to the treads and a soft, bouncy flexibility to the sidewalls.

In terms of making paints for things like cars or pigments for makeup and other products, carbon black is the beginning, not the end. Finely ground carbon is refractive, so it has some of the same sheen as coal or oil even when suspended in a medium. And the opacifiers and extenders that give any paint or ink the ability to cover well and stick to a surface can reflect light, too — making the pigment less black.

"Also, black is cool," says Bevil Conway. "Like, black is independently a really neat thing, and the asymmetry between black and white is fascinating."

The proof? Well, I've talked about the whitest white. Now let's talk about the blackest black.

The year after Pete Vukusic shot lasers at beetle armor, chemists and engineers started learning how to synthesize structural colors into "superblacks." This is more nanotechnology — based, a little ironically, on carbon. Here, though, it's not carbon's ability to absorb light as a pigment that matters, but the fact that it forms a particular kind of molecule, a tiny soccer ball made of carbon atoms, that can form new shapes — balls, sheets, and tubes. But making them with the level of control you need to redirect light the way nature does isn't easy. So it wasn't until 2013 that an English company called Surrey NanoSystems finally came up with a low-temperature manufacturing method that worked.

Using a technology very much like the one that produces computer chips, Surrey engineers figured out how to deposit carbon nanotubules, teeny tiny pylons, onto a surface so that they'd stick up like blades of grass, a billion or so per square centimeter. Made like that, the nanotubules capture photons like golf balls in the rough. "Light comes in as photons, enters the top of the structure, and then the photons bounce around between the carbon nanotubes and get absorbed and converted to heat," Ben Jensen, founder and CTO of Surrey NanoSystems explained to me back when the new

material started getting famous. "And then the heat is dissipated through the substrate."

In other words, visible light hits that nanoscale shag carpet, gets redshifted to invisible, longer wavelengths, and then shuffled out the back. The barest fraction of that light reflects back toward an observer. Surrey named the stuff Vantablack, for "vertically aligned nanotubules, black."

When you look at something coated in Vantablack, or take a picture of it, you see only a void. Vantablack is so black that it makes reality look Photoshopped. Perception of depth and dimensionality disappears into a scotoma of darkness, as if God has redacted something. You look at Vantablack, but nothing looks back at you. "It's a nuts material," Jensen says.

Surrey introduced the stuff to the public at the 2014 Farnborough Air Show, and calls quickly started coming in. "We were just inundated with requests, because it opened up a lot of new technologies," Jensen says. It turns out that if you want to calibrate the kind of spectrometer that might someday go into space on board a surveillance or scientific satellite, you need a material that does not reflect light. But not everyone interested was a spy or a rocket scientist. Lots of the calls came from artists looking for a way-new thing. And one of those artists was Anish Kapoor.

A dominant contemporary artist for the last three decades, Kapoor is known for working negative space and voids into his work, through literal holes in materials such as stone and red wax. One of his installation pieces, *Descent into Limbo,* consists of a small stucco room, about twenty square feet, with an eight-foot-deep hole in the middle — its inner surface is spherical and painted black, so it looks infinite, bottomless. It's so impossibly unreal-looking that a guy fell into it once. Kapoor also designed *Cloud Gate,* the reflective "Bean" in Chicago's Millennium Park. He is a knight.

You can imagine that an artist obsessed with the chromatic properties of surfaces might aggressively pursue this material. Now, Kapoor's interest didn't matter right away, because Vantablack was too technical and finicky to use anywhere outside space telescopes. So the Surrey engineers went back to their labs. They developed

another Vantablack, designated S-VIS, that doesn't cover as much of the infrared spectrum as the original, but to the human eye it is still the unnerving black of a portable hole like one Bugs Bunny might use to vex Elmer Fudd. More important, it's easier to make. The strands don't have to align in finicky bundles. "It's more like spaghetti. So you can spray it down rather than grow it," Jensen says. "That was a huge breakthrough. No one thought you could do that at a commercial scale." It still doesn't come in a can — basically a robot arm dispenses it inside a closed box — but it can spray onto any object that fits inside the box.

Surrey decided to work with Kapoor. "His life's work had revolved around light reflection and voids," Jensen says. "Because we didn't have the bandwidth to work with more than one — we're an engineering company — we decided Anish would be perfect."

They signed a contract. Kapoor got exclusive rights to use Vantablack in art.

Through his gallery representative, Kapoor declined to answer questions about Vantablack, but he has talked about the stuff elsewhere. "It's the blackest material in the universe after black holes. I've worked with an idea of non-material objects since my void works from the mid-'80s, and Vantablack seems to me to be a proper non-material," Kapoor told *Artforum* in 2015. "It exists between materiality and illusion."

To be clear, Vantablack is not the blackest material in the universe, just the blackest synthetic material on Earth. But hey, art! To be clearer, Kapoor is very famous and very divisive. Curators from New York's Museum of Modern Art, San Francisco's Museum of Modern Art, and the Tate Modern all declined to talk to me about him or Vantablack. David Anfam, a consulting curator and co-author of one of the many, many coffee table books about Kapoor, says he is "a nice chap and very affable," but another artist I spoke to says he "has a major ego and is a narcissistic maniac."

That reputation, combined with some misunderstandings about the nature of the Surrey-Kapoor deal, led to people getting the (wholly incorrect) idea that Kapoor had asserted not only the sole rights to use Vantablack but to use the *color* black. To

be clear, that's impossible. Some colors have gotten trademark protection, like a particular pink for insulation, but the standard is unattainably high. The artist Yves Klein developed and patented his own International Klein Blue. Then he filmed naked women rolling around in it and rubbing themselves against a white canvas, which is creepy. But his patent was on the pigment, not . . . *blue.*

Other artists beat Kapoor up on social media and in the press, griping about "artistic freedom" and name-checking other famous users of deep blacks such as Goya and even Malevich, who, three years before painting *White on White,* had spent some quality time down at the bottom of the luminance axis by painting its opposite, *Black Square.* The contemporary artists wanted to be able to use black freely! (Which, of course, they could.) And they wanted to use Vantablack. (Which, of course, they couldn't.) So they took all that out on Kapoor.

The British artist Stuart Semple found out about Vantablack from his mom. He's twenty-five years younger than Kapoor, primarily a painter, and less famous. Semple works in large formats, but he also sells art on iTunes and via his own website. He has mixed his own pigments since his university days, including a garish fluorescent pink, and when his mom told him about a blacker-than-Nixon's-heart paint — she thought it was a paint — he wanted to try it.

"The thing with artists is, we make stuff out of other stuff. So when we see something like that, our minds automatically run through all the possibilities," Semple says. He found out that Kapoor had exclusive claim. "An artist acquiring the rights to a process was, like, completely unheard of. There's no other substance on the planet that artists are the only people banned from using."

(Again, not a "ban." It's an exclusive license to a proprietary process. Surrey NanoSystems will sell the stuff to spectroscope makers or anyone else with the cash. They just won't sell it to any other artists. And artists are actually banned from plenty of things, when you think about it — they're not allowed to acquire the specialty inks the US Bureau of Engraving and Printing uses to print their own cash, for example.)

During a talk Semple gave at the Denver Art Museum, an audience member asked what his favorite color was. "Vantablack," Semple said. "And I can't use it." The questioner followed up: What are you going to do about it?

With little forethought and a lot of tongue shoved into his cheek, Semple answered: "I'm going to release my pink, but not allow Anish Kapoor to use it." In November 2016 Semple put "The World's Pinkest Pink" up for sale on his website Culturehustle. Three pounds ninety-nine (about five dollars) for 1.8 ounces. He included a legalistic warning:

> By adding this product to your cart you confirm that you are not Anish Kapoor, you are in no way affiliated to Anish Kapoor, you are not purchasing this item on behalf of Anish Kapoor or an associate of Anish Kapoor. To the best of your knowledge, information and belief this paint will not make its way into the hands of Anish Kapoor.

Semple didn't expect to sell any paint. "That was it. That was the point," he says. "I thought I might sell one or two, but the website itself would be almost like a piece of performance art, and the pink jar would be like an artwork."

It didn't go that way, though. The orders started coming in, first a few, and then a rush, and then a flood. Five thousand jars. Semple had to enlist his family to grind ingredients and fill orders. The house got very pink. The pinkest pink. Artists who bought it started making art with it and posting it online, under the hashtag #sharetheblack. The performance art piece Semple intended had become no less artistic, but much more interactive.

At which point Anish Kapoor took to Instagram to issue, thus far, his only comment on this whole situation. He posted a picture of a middle finger, presumably his own, dipped in a pot of Pinkest Pink.

No one can tell whether Kapoor meant his Insta as a good-natured "Back atcha" or a bad-natured "Fuck you." Either way, social media does not deal well with subtlety or irony. "The comments

kind of say it all, but basically thousands of artists were pissed off," Semple says. "That kind of upped the ante. At that point, everybody started writing in and asking me to make a black."

Semple spent Christmas and New Year's working, and in early 2017 brought out what he calls "an OK black," Black 1.0. But the collective performance art project was about to get even bigger. Semple separated the black pigment from the acrylic base he used in all his paints — his "superbase," he calls it — and sent a thousand samples of each to artists all over the world, people who'd gotten in touch via the #sharetheblack hashtag and others. And he asked them for help: Make this black more black. Jetter. Blackerer.

The other artists sent back ideas for new pigments and different, better binders. Superbase used silica as a "mattifier," an ingredient to keep the pigment evenly reflective. But silica is itself white. "It was making the black less black," Semple says. His new allies told him about new transparent mattifiers that reduce gloss in some cosmetics, so he started adding those to the mix instead. "I also didn't understand some of the differences in some of the black pigments available," Semple says. Just upping the proportion of pigment helped, too. "You just put a bucketload more pigment in and it makes a big difference." The result: Black 2.0.

It's not quite the void, but it does disrupt shape recognition, just like Vantablack. "You can paint with this stuff, and it's nontoxic, and it's affordable," Semple says. It even — no kidding — smells like black cherry. And down in the fine print you'll find another legal-ish admonition: "Not available to Anish Kapoor."

After his Instagram pic, Kapoor didn't reengage. He released one piece of work using Vantablack, a watch from the Swiss company MCT called the Sequential One S110 Evo Vantablack, which uses the material on its face. It was a limited edition run and costs $95,000, so don't get your hopes up. The 2021 Venice Biennale has scheduled a display of Kapoor's work with Vantablack, though — the first public showing.

Surrey, for its part, seems to have loosened up at least a little. The architect Asif Khan covered an entire pavilion at the PyeongChang

Olympics in a new version of the material, apparently both portable and weather resistant, called Vantablack Vbx2. Then he studded it with tiny lights that looked like stars. This might not be a reference that'll work for everyone, but to me it looked like a real-life version of a superhero costume trope called a starfield suit, black with sparkling stars that shift like the night sky. It's the kind of thing that could have only existed in comic books — before Vantablack.

Semple's hope for a fun little conceptual art piece turned into a big, giant conceptual art piece — the one we all deserved, maybe. New technologies are supposed to turn into new art. That's how culture processes and understands them. In the 1990s, the medium was video. Today, art takes place on social media, with all of us as participants and audience at once. "In many ways, the conversation you and I are having is the piece of art that Anish Kapoor is creating, and that's kind of cool," Bevil Conway says. "The important thing about color is that it is ultimately an abstract concept. Kapoor has distilled the pigment out to its most abstract conception, the thing you can never actually make that is just an idea."

Semple told me when we first spoke that he might try for a Black 3.0, but then he wanted to move on, get back to painting. So a couple of years after I wrote about his Pinkest Pink snark-fight with Kapoor, I called Semple back to check in.

It turned out he did indeed move on to Black 3.0. "We collaborated with a lab in Dallas that made a custom pigment for us, a nanopigment that doesn't reflect any light," he says. "And we made our own acrylic polymer, and it can hold loads more pigment." He put it on Kickstarter. He thought he'd raise £25,000, and instead he has gotten £480,000 so far.

"It's taken a year and a half to crack it. It's been really tough," Semple says. But now they're going to sell it for twenty-one dollars and ninety-nine cents a bottle. "It's just mind-blowing, really. It's weird. Totally weird," Semple says. "I honestly see the materials as part of the art. For me, it's still a piece of conceptual art."

He'd stumbled on the same truth about colors that everyone who uses them, studies them, or tries to understand them eventually stumbles on — the same one that I have. Nobody makes colors

alone. Nobody sees them without a context, without a contrast or a constant, without geology and biology and history and chemistry and physics. We all make colors together.

People love to watch colors move and change. Think of the *ooh, aah* of fireworks, a centuries-old art form. And by the late nineteenth century, people were finding that thrill at the movies. The motion picture pioneer Georges Mèliés sometimes hand-painted the frames of his films. In 1917 *The Gulf Between* used an early version of Technicolor, which itself evoked the old three-dye-type process that color printers and photographers had pioneered. Technicolor stayed on the forefront through the late 1930s with *Snow White and the Seven Dwarfs*. But that old philosophical divide between the perceived frivolity of color versus the seriousness of form meant that movies with serious themes, aimed at adults, were produced in black-and-white well into the 1960s.

Because television transmits to screens via a broadcast signal rather than projecting light through a film, switching TV to color was more of a challenge. The nascent Columbia Broadcasting System had a rotating-filter method for turning its black-and-white signal into a rough color image by 1940, and over the next decade the Radio Corporation of America and the inventors Philo Farnsworth and Vladimir Zworykin waged a long fight with each other over ways to do that electronically, entirely within the signal and the hardware. At issue was how to transmit a high-enough quality color signal while still also transmitting a black-and-white one, the standard at the time, so people wouldn't be forced to buy a new set. Hard to imagine in our times of Thou Shalt Upgrade Thy Phone, but that's the way it was.

Eventually they figured out a way to transmit a color signal between the luminance lines. It condemned US television to lower resolution (because bandwidth didn't change, and the transmission was essentially carrying two versions of itself, one black-and-white and one color), but also ensured the signal would be forward compatible. In 1953, that became the color-TV standard in the United States.

As revelatory as it must have been to find out that the Lone Ranger's shirt had been blue this whole time, early color television was a desaturated mess with a limited gamut. TV, as the saying goes, is not real life. The colors a camera could pick up were far fewer than those perceivable by a human eye, and still fewer could be transmitted, broadcast, and displayed on people's TVs. Screens simply weren't capable of showing the range of colors in the world, much less what the human eye could perceive.

In the 1970s, a color scientist named Michael Pointer set out to show just how big the difference really was. First he needed the real-world colors, for the sake of comparison—a database of the colors of the world. He started with the Munsell catalog, and then added data from a bunch of paint and pigment companies about what colors they sold. He also threw in color charts from the Royal Horticultural Society, because flowers are famous for having highly saturated colors.

Then Pointer white-balanced his colorimeter, stabilized his light source, and spent two days measuring his exemplars.

His results formed a map not of all the possible colors, but a map of all the *actual* colors—the colors of the real world. Today scientists call this "Pointer's Gamut," and when Pointer laid that map over the range of colors that photography and video technologies were capable of in 1980, the news was not good. Color screen technology covered just about half of what people saw in the real world. Television of the time missed out on much of the grue region, and also the far reaches of red and purple.

Pointer's gap sparked a race among video technologists to improve. "We had to squeeze a color signal into black-and-white so we didn't notice the color we were missing," says Andy Quested, chair of the International Telecommunication Union subcommittee that deals with colorimetry. "But displays got better. We're digital. Bandwidth has gone up and compression has gotten better."

And then one invention broke the bottleneck. In 1992, Japanese engineers invented a diode that emitted blue light. There were already red and green LEDs; blue—the shortest wavelength—was a tough enough problem that its discovery earned its three inventors

the Nobel Prize in 2014. Shorter-wavelength lasers ballooned the capacity and quality of compact discs — which read and write data optically — and then made possible the modern flat-screen TV, with pixels that emitted three colors of light. They could finally match what color printing and color film could do. And some more recent iterations of those TV sets also add a white-only pixel, or a way to let through all-white backlight, to make screens bright enough to see in a well-lit living room.

Those are the pieces TV makers have to play with when they're trying to improve digital screens. One approach to the problem would be just to add more, smaller pixels. That makes the picture sharper. And it's getting better all the time. Newer ultra high definition 4K has 3,840 pixels horizontally and 2,160 along the vertical. That's a lot.

More important than pixels and resolution, though, are two other measures. The first is the number of colors in the signal — that's the gamut, the ability of all those LEDs to subtly adjust.

The other one, though, is what we've been talking about. It covers the whiteness of the whites and the blackness of the blacks, and the smoothness of the continuum between very bright and very dark. That's called dynamic range.

The challenge for screens, then, is the same as the one Thomas Young tried to figure out — desaturation in mixed colors. When you increase the white light on those TVs for brightness, you lose colorfulness. And since the whole setup is emitting light all the time across the entire screen, it's also nearly impossible to get a really good, deep black.

The newest color standard, the one the international standards associations have adopted and the TV makers are building screens with, actually covers all of Pointer's gamut, and then some — a smattering of reds and purples and a pie slice of greens not found in nature can now be displayed on a TV. And the *next* standard technology, the one that only a few places in the world have so far, does it at higher resolution, with greater dynamic range.

All that means that color technology has finally outpaced the eye and the brain. Those new screen technologies actually let

filmmakers produce impossible colors, ones never seen in the real world. And the masters of this new color magic work are movie visual effects experts — specifically, the ones at Pixar.

Danielle Feinberg was watching a scene from *Coco,* and it wasn't working. It was the moment when the family of Miguel, the main character, finds out he's been hiding a guitar and collection of music memorabilia, against family rules. The scene takes place at twilight, or just after — a pink-and-purple-tinged time of day everywhere, but even more so in fictional Pixarian Mexico — and Feinberg, the movie's lighting director, pressed pause with a frown. She'd gone on multiple research trips to Mexico and taken pictures and notes on lights and color all over — in marketplaces, even in houses. And while this critical moment in Miguel's house looked lovely, it didn't look right. "We had finished lighting. We were at the point where we were going to show it to the director," Feinberg says. "And I asked the lighter to put a green fluorescent light in the kitchen."

It was an unusual request. Greenish-tinged fluorescence usually means a movie is about to turn eerie, even ominous. But Feinberg wanted to see the kinds of lights she remembered from the warm, homey kitchens they'd seen in Mexico. "I wasn't sure the director was going to be happy with me putting green fluorescent light in the background," Feinberg says. "It was a little bit of a risk."

When she took the scene to the director, Lee Unkrich, he agreed. It looked like Mexico, Unkrich said. He remembered those lights from their travels too. The green glow, which usually had one narrative meaning, assumed another.

In a way, every filmmaker is really just playing with moving light and color on surfaces. That's the whole shtick. But Pixar's emotionally weighty, computer-generated animated films are all about intention. Pixar trains its storytellers to use color and light with precision to convey narrative and emotion alike — from the near-total absence of the color green in *Wall-E* (until postapocalyptic robots find the last plant on Earth) to the orange marigolds that symbolize Miguel's trip to the magical Land of the Dead in *Coco.*

Almost every Pixar movie works within a defined color palette, a story-specific gamut that filmmakers like Feinberg map, scene by scene. But *Coco* complicated that process. When its story moves to the magical Land of the Dead, it cranks up all the dials, color-wise. The director told the team to use every color they had, at the highest saturation. The Land of the Dead looks made out of neon, like a bio-organic version of Tokyo's Shinjuku District at night. "So when it came time to do the color script, it was like, 'The Land of the Dead has every color. All of it takes place at night, so we can't use time-of-day to elicit emotion. There is no weather in the Land of the Dead, so we can't use weather to elicit emotion.' Those are three pretty typical things we use to support the story," Feinberg says.

So instead of using colors to code for emotions, Feinberg's team did it with light — with luminance. Take the scene where the old ghost Chicharrón dies unremembered in the Land of the Dead. It's a tear-jerking moment, but the color palette is still just as wide (though it does dial hard into moonlit blue for this moment). Instead of taking away color, the scene is less bright, lit not by the virtual neon or glowing-orange *cempasúchil* flowers but by just a couple of lanterns. "That was the way we had to do it on *Coco*," Feinberg says, "just because it was a colorful, lively world and we didn't want to sacrifice that, but we still needed to elicit that emotion."

Control the lighting, control the colors, control the feelings. That's filmmaking. As of this writing, Pixar's last twenty-two movies — going back to 1995's *Toy Story* — have made a combined $6 billion, adjusted for inflation. Kids like them; adults like them. But I'll tell you a secret: When it comes to wringing emotion from color, Pixar cheats.

In a screening room at Pixar's Emeryville, California, headquarters is a very special screen. It's not huge, perhaps just ten feet across, and it's at the front of a room dominated by a huge control panel studded with five smaller monitors and at least two keyboards, not to mention sundry buttons and switches of unclear function. The

ceiling is covered in felt and the carpet squares are black instead of the gray that's standard at Pixar, to keep light contamination to a minimum.

The big screen doesn't have a typical projector. The light it shines comes from a custom-built Dolby Cinema projector head. In a movie theater, this tech would involve two laser guns, each firing red, green, and blue light with their actual wavelengths offset from each other slightly. That's so that 3D glasses can see one output with one lens and the other output with the other, and then combine them to create the illusion of dimensionality. At Pixar, all six lasers stream from one source, which means this projector has six primary colors. And this projector is more than ten times brighter than one in a civilian-class Dolby Cinema.

The standard unit for measuring "luminous intensity," the amount of light coming from a source over a given angle of view, is the candela—as in one candle's worth. But if you're talking about "luminosity," the amount of light emitted by something like a TV screen, what you want is candelas per square meter, a unit also known somewhat delightfully as a "nit." The standard-issue Dolby Cinema output is 108 nits, but Pixar cranks the dial harder. "We've goosed this projector with an extra six hundred percent laser power or something like that. We can get well above a thousand nits on this screen," says Dominic Glynn, a senior scientist at Pixar, as he sits at the control panel. "It's one of the most linear, perfect reference color-grading displays you can conceive of."

Pixar makes its movies on virtual "sets," digitally generating the environment, its colors, and the light bouncing off of them. They're just ones and zeroes; the worlds contained therein obey only the physical laws they're programmed to. That includes the physics of light and motion. Cameras and lenses have chromatic aberration, sensitivities or insensitivities to specific wavelengths, limits to the possible color gamut. At Pixar, the only limit is the screen that will display the final product. "We could light the whole set with a green laser," Glynn says. "That's kind of hard to do in the real world."

When *Inside Out* was in production, Dolby was working on its

in-house version of the new standards for high dynamic range. The color triangle was bigger and the "grayscale ramp" between darkest black and brightest white got some new math too. A theater equipped with these lasers can turn its light output so low that the screen becomes a black indistinguishable from the walls ("exit signs notwithstanding," Glynn says). It was an entirely new standard of color, and even though only half a dozen theaters in the world had it at launch, Pixar's directors of photography decided to try to expand their own envelope anyway. Digital cinema already had good colors, but not compared to the real world. "The specific hues at the red, green, and blue corners of that triangle are not really what you'd experience under, say, ultraviolet illumination," Glynn says. "We said, Hey, what would happen if we tickled all the portions outside a traditional cinema gamut?"

Glynn taps on the control panel keyboard and calls up — in a resolution color gamut and dynamic range akin to what I'd see on a home TV — the scene from *Inside Out* where the characters Joy and Sadness walk into the Realm of the Subconscious. Glynn hits play; Joy and Sadness walk into a dark room and see a forest of giant broccoli, lit from the side so it seems outlined in a bright green. They walk to a red staircase headed down into infinity, and then meet another character, the clownish imaginary friend Bing Bong, imprisoned in a cage of candy-colored balloons. "These are all basically as saturated a color as one can achieve in digital cinema today," Glynn says.

Then he cues it up again, in super-high-end digital cinema fireworks, using everything the screen can give us. "They go through the doors, and you see the little long shot of them in the distance, then all of a sudden we kind of have everything." The shot widens and the camera heads toward the broccoli forest, but now the broccoli is laser-pointer green, glowing against the blackness. The red archway around the staircase is the most vivid red I have ever seen, and when Joy and Sadness start walking down the stairs, the edges of the screen disappear. The room, the world, is nothing but black except for the stairs. The balloons of Bing Bong's prison look unearthly, like a Jeff Koons dog with eldritch powers.

"I want to say sixty percent of this frame is outside the gamut of traditional digital cinema," Glynn says. "We have a version of this film that has been creatively approved and built for exhibition on televisions that don't exist yet." Pixar does have a prototype of what that television might be like, though. It's in the next room. I convince Glynn to show it to me in action, and when he fires it up to maximum brightness, it's actually painful to look at. I'm left with an afterimage, as if I've stared at the sun.

Once these technologies are in every movie theater and every living room, maybe even on every phone, things are going to get really weird. The Dolby screen has given Glynn some pretty out-there notions. He asks if I know how color receptors in the human eye can "bleach," which is to say that they essentially use up the molecules that absorb specific wavelength-ranges of light and transmit color signals from retina to brain. Deplete them selectively, Glynn says — like, blast the middle-wavelength greenish receptor with that color of light, for example — and "you can actually heighten the sensitivity or perceived sensitivity to other colors in compliment to that."

This is the same thing that vexed Charles Darwin's dad and so many other color-in-mind scientists. "You're talking about contrast effects and afterimages," I say.

"For sure," Glynn answers. So what if, he proposes, a scene in a movie added, subtly, light in a very specific wavelength of green? And then just kept ramping up, more and more green, in one specific wavelength designed to bleach that green receptor — and then, at a key moment, drop all the green out at once. This is straight out of Chevreul. The movie would induce the complementary color as an afterimage.

"In essence, you can control viewer sensitivity to certain chromatic stimuli," Glynn says. And if you pick the precise wavelength, "you could actually cause someone to perceive a color that they could never otherwise see. Like, there's no natural way for you to have the perception of that color."

That color wouldn't be on-screen. It wouldn't be anything a projector could cast or a computer could generate. It'd be a function of pure cognition, different for every viewer, existing only in the

mind. You could induce an "impossible" reddish green, or Hume's missing shade of blue.

As far as I can tell, this color inception has only ever happened once in real life, and it was a lot more invasive than going to a movie theater.

In the mid-2000s, a thirty-eight-year-old man with severe complex partial seizures — disorganized, massive activation in the brain, like epilepsy — went to Baylor College of Medicine for help. A team of neuroscientists and surgeons decided to implant a strip of electrodes in his brain, to try to locate the part of his brain that was freaking out and perhaps fix it.

It was an invaluable opportunity, because one of the spots the surgeons were aiming for with the electrodes was near the fusiform gyrus, one of the many parts of the brain that deal with color. Once the electrode array was implanted, the Baylor team could pulse electricity through it — the language of the brain — and see what happened. What they got was pure mental action. "The subject reported that stimulation of the electrode produced a percept of a 'blue, purple color, like aluminum foil when it burns,'" they wrote. The neurosurgeons had induced color — no light source, no pigment for light to reflect from, no retinal response necessary. It was literally all in their patient's head.

Scientists have decades of experience using electrodes and imaging to watch a person's brain while it processes color. This was the first time anyone actually induced a color directly, and it hints at a future where a computer interface could send colorful images directly into the vision centers of the brain. You wouldn't need to look at something to *see*. The hard, numeric calculations of colorspaces inside a computer would translate into something neurophysiological that people could share as easily as they share text today. That'd have to be objective color. Wouldn't it?

Now, Pixar's obviously not plugging anyone into a brain–machine interface. But the animators there have already been able to apply the new color gamut and luminance range to the movies in new ways, to generate new colors and induce new effects. Yet you

might never have seen them. Pixar's people have been rendering their work in the newest digital color format, which means that those images really only look the way their creators intended in Dolby Vision theaters with the hardware to display the new standard, the "Wide Color Gamut," an even bigger triangle of possible colors that comes from high dynamic range and 4K resolution, a whole new depth of information about color. In *Inside Out*, the "real world" of preteen Riley's San Francisco was created in the old standard. But Riley's inner world of personified emotions — where each emotion is literally color-coded (Sadness is blue; Anger is red) — was in the new wider gamut. If you didn't see *Inside Out* in a topline digital movie theater, you didn't see the colors its animators intended.

Are you turning Angry Red yet? What does that even look like, really? Can you imagine it?

Around 2015, Poppy Crum found herself watching one of her company's super-high-end research monitors. If you're the chief scientist at Dolby — which she is — you get to do that. The screen pushed 20,000 candelas per square meter — 20,000 nits at peak luminance, the whitest white — and went down to 0.004 candelas per square meter at the bottom, in the blackest blacks.

"One of the pieces of content we'd show was a fire dancer, because fire has deep black levels as well as really good specular highlights," Crum says. "And watching this, I felt my face react." She was flushing, responding to real heat as if she were standing in front of an actual open flame.

"I asked the developer who'd built it if the display was giving off heat when there's a big specular highlight, and he said, 'No, it should be constant,'" Crum says. "I had someone else there, and they also felt their face react. So I went and got a thermal camera and measured the screen. It was completely constant."

Crum, a neuroscientist by training, experienced the other kind of flash — one of insight. The phantom sensation of heat she was experiencing as a function of luminance alone would have to have a physical analog. "I realized we could track regions on people's

cheeks in response to the flame," she says. With a wide enough dynamic range, a screen could make people feel things as though they were real, with physiological responses she could test.

Crum's lab at Dolby now aims at extending not only the colors visible on a screen but the physiological responses of the audience. She thinks that the ratio between the brightest and darkest parts of the image determines the magnitude of that response.

To figure out exactly how, Crum built what she calls a "sensory immersion lab." It's as near to virtual reality as anyone could get without strapping on a headset — wraparound screens eight and a half feet high, driven by three 4K laser projectors. High-fidelity microphones and fifty-five speakers can change the acoustics of the room in real time to simulate real spaces, from a concert hall to a beach. That means the soundtrack and the acoustics don't have to match what's on-screen. Crum can decouple what her subjects hear from what they see, and use cameras to track their gaze and figure out what they attend to most.

But the physiological responses? Crum has a lab for that, too. Together we walk into a darkened room, walls lined with sound-dampening foam. High-quality speakers are on towers in corners. In the front are three giant screens, the middle one a sixty-five-inch (I'm guessing; it was real big) latest model from the TV maker LG. Dolby Vision UHD, OLED, the works. "The black level is unprecedented," Crum says. And indeed, watching demo images play across it — honey dripping from a spoon in close-up, condensation on the outside of a cold drink, a clear teapot filled with water at a rolling boil, an effervescent soda pop — the blacks are none more black, and the specular highlights reflect with a crispness I'm not sure I've ever seen in real life, much less on a screen. It's that ratio of gleam to black that Crum is most taken with.

But I've left out the weird part. Seated on a couch in front of that screen is another neuroscientist named Nathan, who is watching those highlights go by while wearing a thing on his head like a shower cap studded with sensors for reading the electrical activity of his brain — an electroencephalograph, or EEG.

EEG is a blunt instrument, neurophysiologically speaking. It's

good at picking up fleeting, vast changes, but without much ability to tell where, exactly, in the brain that activity is happening. One of the kinds of activity that skullcap electrodes can measure — without needing to shave Nathan's head and apply electrically conductive gel — is called P300. It's a good indicator of changes in overall attention, and Nathan's P300 readout is displayed on a screen to his right.

The screen on Nathan's left shows . . . Nathan, in the infrared. So Nathan-left is a psychedelic, shifting apparition, registering heightened emotions like fear or arousal as the tiny capillaries in his face dilate and bring more warm blood to his cheeks and forehead — the blush response. In a full lab setup, Crum would also be recording the volume of exhaled carbon dioxide (as a proxy for respiration), the amounts of molecules like acetone and isoprene in those exhalations (because under conditions of arousal, people tighten their muscles, and their metabolisms kick out more of those molecules as a result), galvanic skin response (sweaty palms, basically), and heart rate.

Basically, Crum has turned her lab into the Voight-Kampff replicant detector from *Blade Runner*. But even though she could, Crum isn't trying to catch artificial people lacking empathy; she's trying to build tools that let real people experience *more* empathy. "This is about how we non-overtly communicate and have richer experiences together," Crum says. In fact, she continues, when people watch highly emotive, impactful scenes together, all their Voight-Kampff measurements start to synchronize.

The greater the range from light to dark, the more intense those feelings are. Show an audience one of those BBC *Planet Earth* documentaries without a high-dynamic-range TV, and they'll talk about how well made the program was. Show it to them on a state-of-the-art set, Crum tells me, "and all they talk about is climate change. It's a completely transformational impact on storytelling."

It might be true. You'd have to test people's empathic responses to normal video content, too, as a control. But even that might not be the right data set. I wonder what would happen if I could use Crum's screens to compare people's physiological and neural

responses to the colored plastic products of the 1940s and 1950s versus high-dynamic-range, saturated imagery of *sancai* glazed porcelain, and the blue-and-white glazes of Abbasid and Chinese ceramic from before that. I'd like to fly through Lisa Snyder's virtual model of the Chicago World's Columbian Exposition, color corrected into some next-generation Ultra Super Mega High Def, and maybe re-rendered by Pixar to reproduce what the polychromatic Transportation Building looked like during the nighttime light show. For that matter, I'd like to roll through all of Bevil Conway and Anya Hurlbert's experiments with the Dress, or (if I could get it past an ethics review) find someone with a strip of electrodes in their brain, near some color-processing node, and see what kind of electrical spikes happen at the moment Dorothy crosses the threshold into Oz. Crum may have found a way to do more than recreate colors. She might be able to explain why people care about them.

CONCLUSION

Once, after a morning at the Museé d'Orsay in Paris spent looking deep into neo-Impressionist optical mixtures and Monet's color-constant churches, my wife and I went walking in search of lunch on the Île de la Cité. On that wander, a display in a pharmacy window caught my eye. Pharmacies in France are overstuffed with high-end cosmetics and unguents, and they don't mind a bit of homeopathy. Here, as an enticement to enter, was a multicolored sign for something called a Bioptron.

It was a sleek black-and-white handheld thing that looked like a 1960s ray gun, and the display partially encircled the gun with rings of different colors — roughly following the spectral hues. Next to it was another sign. LA CHROMOTHÉRAPIE BIOPTRON UNE SYNERGIE UNIQUE DE LUMIÈRE ET COULEUR POUR RÉVEILLER LES SENS. My French is crap, but what I couldn't parse, I could Google. The Bioptron is basically a flashlight that shines different colors at you. Why? Well, red, the sign promised, would "reactivate and revitalize." Green would "balance and relax." Indigo "purifies and concentrates," though it was unclear exactly *what* it purified and concentrated. Next to these assurances, a chartreuse-tinted picture of a very happy woman with a very low-cut shirt peered downward, eyes closed. She seemed happy. Balanced, even.

I looked it up later. The Bioptron is a Swiss device that shines polychromatic light via a patented polarizing mirror, and its makers claim it'll do everything from make skin look younger to treat

chronic pain. The Bioptron has no side effects, the website claims, which doesn't surprise me, because it seems unlikely that it has any effect effects, either.

Except, in a way, my skepticism here is utterly wrong. Even if the Bioptron isn't a miraculous route to younger skin (it isn't), color and light *do* affect us. The colors we look at change us in ways both prosaic and profound. The problem is, nobody really knows why. Color isn't even what our brains are best at; the human eye and brain are, objectively, much better at resolution and object identification than at seeing colors. Compared to all that, one titan of psychophysics described color vision as "just a hobby." Considering all the tricks the brain has to play to create a cogent, consistently colored picture of the world, in a way it's all — pardon my French — bullshit.

After thousands of years of just a few dozen pigments to play with, and then a couple hundred years of new ones flooding out of labs and factories, the future is starting to look a little dull. The flood of synthetic organic dyes synthesized from coal tar — mauve, alizarin — has subsided. The discoveries of new elements fueled new pigments — chromium leading to chrome yellow, cadmium leading to artificial ultramarine — but the periodic table doesn't seem likely to accommodate much more of that sort of thing. Today, when a new pigment shows up, it's a cause for celebration, controversy, or both.

That's what happened with yttrium-indium-manganese blue, YInMn. When the chemist Mas Subramanian stumbled onto it in 2009, it was the first new blue in two hundred years, which sparked all sorts of excitement in the color world. The use of indium, a rare-earth metal, makes it quite expensive, but slightly viral coverage in the art press did finally score YInMn blue sales to actual paint companies and a Crayola crayon "inspired" by it (that contains no actual YInMn blue).

Subramanian kept tweaking YInMn blue's chromophore — the part that actually makes the color — and produced a lineup of hues covering most of the rest of the spectrum. But he couldn't figure out a red. That was disappointing; a new red could be, as one busi-

ness magazine put it, a "billion-dollar color." Car paint–makers are desperate for one; the most popular Ferrari red is bright and beautiful, but rain and heat fade it after a while. That doesn't happen with the iron oxide pigments that neolithic painters ground down from rocks and smeared on cave walls, but ochre just doesn't have the bright sportscar sheen to be a category killer.

Reaching for those colors of tomorrow, though, won't be as easy as the stumbling accidents of mauve or YInMn blue. They might not be anything like the ochres of early humanity, or the plant-based blues or mineral greens. Their actual chemistry might not matter at all.

The future of one pigment I've spent a lot of time on in this book — titanium dioxide — might not even be as a pigment at all.

It still dominates the world of paints and coatings, of course, and it's critical to papermaking — primarily in decorative laminates and glossy, coated packing boxes. (Paper still relies on the neolithic white of calcium carbonate and the kaolin that was the key to porcelain, too.) TiO_2 is ubiquitous in consumer goods — candy, toothpaste, shaving cream, pills, cosmetics from mascara to lipsticks to blush and concealer to nail polish. Makeup aimed at people with darker skin colors tend to just leave out the TiO_2, it turns out, making explicit the connection between whiteness and Whiteness.

I mentioned a while back that the worldwide market for titanium in 2019 was 6.17 million metric tons. That's nearly 70,000 railroad cars full to the brim with brilliant white powder, a bulk commodity traded across continents for use in just about every sector you can name. Which is why the industry is more than a little worried about the sign that every country in the European Union will soon require on every product with a certain proportion of the teensiest nanoscale TiO_2 in it: Global Harmonisation Symbol GHS-08, a bold red diamond featuring the head and shoulders of a human, colored black, amid a white five-armed star decorated with black dots, like the comic-book signifier for fearsome cosmic energy. Here, it indicates the possibility that a product contains an inhalable carcinogen. They're saying TiO_2 might cause cancer.

The science is uncertain, as is so often the case in matters of public health; the nanoscale form of TiO_2 used in sunblock, with particle sizes below 100 nanometers, might be riskier than the size of particles found in pigment, between 200 and 400 nanometers. But the pigmentary version always has some amount of the nanoscale version in the mix. The new rules attempt to distinguish between products with the maybe-harmful nanodust and products without. TiO_2 is so common, almost ubiquitous, that multiple industries would have to learn all-new chemistry even as scientists try to understand whether there's anything actually to worry about.

Plus, canceling TiO_2 might foreclose on a whole other, brighter future, because TiO_2 does more than just make things white. It's also a semiconductor, like the silicon that makes computers possible. If a photon without a lot of energy hits the outside of a TiO_2 crystal, not much happens; it bounces right off. That's part of why it's a beautiful white.

But if that photon does have enough energy — about three electron-volts, at the material's so-called band gap — it'll knock an electron loose from one of the oxygen atoms. That process is called charge separation, and it leaves behind a sort of space called a hole that another electron can fall into. In titanium dioxide, the electron-hole pair — it's called an exciton — is highly reactive, the hub of the chemistry that causes chalking. On the wall of a house or in a painting, that's a real problem. The National Lead Company had researchers trying to keep this from happening as early as the 1940s, trying to find coatings and stabilizers that would hold their paint together.

In a chemistry lab, though, charge separation turns out to be awesome. In 1972, Akira Fujishima and Kenichi Honda realized that they could make an electrode out of TiO_2, submerge it in water, and hit it with ultraviolet light, and those excitons would break the water into its constituent hydrogen and oxygen. The Fujishima-Honda Effect turned titanium dioxide into the laboratory standard for studying photoelectric surface chemistry.

If you can learn to harness these quirks of titanium dioxide, you can do all sorts of tricks. "How does the electron conduct? How

does it hop from one side to the other? Does it move through the solid like a wave, which is what happens in metals? Or does it really physically hop from titanium to titanium to titanium, because it doesn't want to stick to the oxygen?" asks Ulrike Diebold, a physicist who studies it at the Technical University of Vienna.

Answer these questions, and TiO_2 starts to look a little magical. It'll goose a solar panel, or generate hydrogen — unlimited, clean, non-climate-change-causing fuel. Those reactive excitons will even make a surface coated in titanium dioxide effectively self-cleaning — it'll destroy dirt and the kind of pollutants that city air drops onto everything. It even works on germs. It doesn't just kill bacteria and viruses dead. It disintegrates them with the finality of a *Star Trek* phaser set to kill. Keep the UV on long enough, and the microbes are completely mineralized, converted to their constituent carbon dioxide, water, and other mineral molecules. Add a little copper to the surface and it'll work in normal indoor illumination. Toto, the Japanese company known for its excellent toilets, makes a self-cleaning TiO_2 tile for building exteriors. Thousands of buildings in Japan are clad in it.

There's some irony here. People tend to discover pigments or other colored stuff when they're looking for something else — Perkin was looking for synthetic quinine to treat malaria when he found mauve; Subramanian was working on new materials for electronics when YInMn turned blue. And now here's a whole, potentially world-changing function discovered in a pigment. The substance arguably most responsible for making the built world as bright and colorful as it is might also have a role in saving that world from pollution and climate change.

Color does something, or we wouldn't be able to see it. Color means something, or we wouldn't care. Every advance in our ability to make colored things has advanced our understanding of what color is and how it works.

There's a trap built into that realization, though. You can start to think of color as just surfaces, as decoration. After all, people can do pretty much everything important without color at all, right?

You can recognize objects without color. Most machine-vision algorithms don't bother with color at all; to computers (and to a not insignificant number of human philosophers), color is literally immaterial. From this mechanistic perspective, the war between form and color is over, and form won.

This isn't correct. For one thing, color is more than just photons bouncing off of objects and into our eyes, triggering a neurochemical blip of recognition. Those photons interpenetrate those surfaces, even if only a few atoms deep. When we see color, our brains are doing their level, meaty best to process a quantum interaction. When we see colors, our brains are processing nothing less than the invisible subatomic world in action. Color is the way the deep mysteries of matter and energy say hello.

The other half of the mistake is underplaying how our minds turn those mysteries into colors we can talk about. "When I teach about the cones and optics of the eye and basic properties of retinal ganglion cells, I'm reasonably confident that most of what I'm telling the students . . . somebody teaching this course in fifty years will regard that information as still fundamental," says David Brainard. "Whether our way of thinking about computation in the visual cortex in fifty years bears any resemblance to ours now . . . I wouldn't bet big bucks on that."

In fact, the part of the brain that humans use to tell one thing from another — the "object cortex" — has regions triggered by colors. No one knows why. "Now I know what the unknown is. It's about the role of color in perception and cognition. I don't know what it is, but I know it's there," Bevil Conway says. He doesn't think it has anything to do with recognition or identification of objects, in the end. You can do that without color, after all. "There are two separate processes: What is that, and do you give a shit?" Conway says. "Color is doing the second."

The story of colors and how we make them is not over. Best guess: New colors and color technologies will keep coming at about the same rate as they have since the nineteenth century. Every new pigment or dye moves science forward a little, and that science

pushes forward how people see or make colors, so people want more of them. It's the color circle of life.

The next turn of that wheel probably won't come from pigment chemistry or the physics of light-emitting diodes at all. Most likely, it'll come from specialized engineering—from structural colors like Vantablack that people construct atom by atom, nanoscale geometries that bend light to human will.

Nature beat us there, of course, and not just in the crazed, chitinous colors of beetle carapaces. Human skin color has a surprisingly limited range, really just from reddish to brownish. That comes from a pigment called melanin. You'll find it all over nature, even in bird features—where it's both structure *and* pigment. Like a lot of other animals, birds package melanin into tiny structures called melanosomes, between 200 and 500 nanometers wide. But the birds then embed those melanosomes into an architecture of keratin—the same stuff your hair and fingernails are made of.

At the keenest, finest edges of bird feathers, keratin forms a minuscule thorn-on-a-thorn-on-a-thorn shape called a barbule. To the human eye, melanosomes by themselves are a lustrous black; their placement inside the barbules changes that. Disorganized, haphazardly tossed in, they can assume the inky black of a crow's feather. But in, say, a bronzewing, the melanosomes' repeating patterns make the wings flash from red to blue, depending on the angle at which you see them. In mallards, the melanosomes form into hexagons. In peacocks, they organize into squares. Butterfly wings are even more complicated, arrays of fairy-tale-castle architecture at the photonic scale that produce iridescent blues and greens. A materials scientist would call all these structures "photonic crystals."

It isn't easy to make a photonic crystal into a pigment. You can't just crush ten thousand butterfly wings into powder and stir it into acrylic to make butterfly-blue paint. First of all, what kind of monster would do that? But also, the size, shape, and orientation of the photonic crystals that make up that structure are what create the color. Disrupt that and all you have is butterfly soup.

So with all that in mind, humans are trying to build their own photonic crystals to create structural colors. Some researchers are trying to mimic those complex melanin patterns; at Harvard, a materials scientist named Vinothan Manoharan is trying to build synthetic versions out of polystyrene — Styrofoam, basically.

Manoharan started by looking at birds. He realized that some birds' feathers seem to change color because the crystal patterns inside their barbules aren't homogenous. Seen from one direction, they form one pattern — and reflect one color — but seen from another direction, a different pattern dominates, and so you get a different color. The photonic crystals in there are packed in such a way that the gaps between them repeat different patterns along different axes.

It turned out that the different colors were essentially due to the length of the particle along that axis — to particle size, basically. The wavelength of the color is about twice the length of the particle.

That seems like good news for would-be color-makers. If you're synthesizing your own particles, you can make that length anything you want. But once you put those into a binding medium and try to paint a layer or multiple layers of them, some old problems come back to bite you. Classical Mie scattering says particle size determines color. But in a medium, the thickness of the layers can also have an effect. That's the Kubelka–Munk equations at work.

Initially Manoharan's teeny-tiny particles wouldn't give back much of any color at all — they'd get the size right for a specific wavelength, but the binders and coatings would reflect and refract all kinds of other wavelengths that'd swamp the effect. The team eventually created what they call a "core-shell particle," basically a nanoscale Tootsie Roll pop — a nonrefractive gel coating around a candy center of very refractive polystyrene. It almost worked; changing the size of the core gave them colors from green to light blue to indigo.

Which really isn't everything, is it? Like Subramanian after YInMn blue, they couldn't get red. It wasn't that the particles weren't reflecting red wavelengths. They were, but they were re-

flecting way more blue. In nature, melanin reflects the red and *ab-sorbs* the blue, but Manoharan wasn't working with melanin. And he couldn't use a material that absorbed any light at all, because it'd just reemit it in the infrared — Manoharan wanted his particles to work in screens, like the e-ink in a Kindle, and if they emitted infrared, that future gadget would get too hot to hold.

Manoharan and a now-international team of collaborators set out to make a new kind of particle. They started with polystyrene beads, grew a silica shell around them, and then burned away the polystyrene and filled the now-hollow silica shells with a resin that had the same refractive index. The new critter had two reflective peaks — one red and one still over on the other side of the spectrum, pushed all the way into the ultraviolet so it was invisible to human eyes. The result wasn't a brilliant red, but it was a red nonetheless. It's not a process likely to show up in a Kindle anytime soon, but it does hint at a post-pigment future.

Once, I attempted to paint a picture of a tangerine.

Now, we could disagree on my abilities as a wordsmith, but I am, objectively, highly trained and experienced — technically skilled. In the visual arts, though? Not so much.

So in the course of reporting this book, in the interests of getting in touch with that side of my cognition, I signed up for a watercolor class. At a long table in a sunny converted loft in Oakland, the teacher — Amanda Hinton, an artist and paint-maker — took the class through a dizzying series of exercises in the properties of various kinds of brushes and paper. Only after getting through all that did we get to mess around with colors.

A mess is indeed what I made. The same two paints, mixed together in different volumes, could somehow combine to be a brown, an olive, a darker brown, or a . . . No, that's still brown. Yellow and blue didn't make green for me; they made some other blue. Or at least it looked blue to me. Magenta and blue made . . . maybe a purple? Maybe that's what purple means. I even tried to paint a color circle, a basic colorspace of the kind I've been yammering on about for the last two hundred pages — blue, yellow, and red at the

primaries, with a white hole in the middle. It was terrible. If I ever see a donut frosted like that color circle, I will not eat it.

The tangerine was the final test—to look at a color printout of a photo and see it not as "a tangerine with a leaf attached" but as a map of variously colored countries adjacent to one another, to break those into plausibly paintable regions on a lightly penciled drawing, and then to paint it.

I thought hard. I looked at the printout upside down. I sketched. I picked a palette, just three or four colors—a brown, a green, others I can't remember. It doesn't matter. You couldn't tell from looking at the result, because it was, predictably, terrible. You could recognize it as a mostly failed attempt to copy the printout, especially if you were also looking at the printout. But nothing realistic even sniffed at the outside edges of my painting. It was just, you know, some colors.

Obviously a single watercolor class wasn't going to give me some transcendent capacity to make sense out of colors. But I did think I could get closer. A few weeks later I meet Hinton at her studio, a ten-foot-by-twenty-foot space in a Berkeley building full of similar ones, with a west-facing window through which sunlight streams the day I visit. Shelves along the walls look like an alchemist's makeup counter, row upon row of small glass vials filled with colorful, vivid pigments. Indanthrone Blue. Dioxazine Violet. Vivianite. Magnetite. Caput Mortuum.

On a workbench made of tempered glass opposite the shelves, Hinton has poured a pool of vivid yellow goop—benzimida yellow, she tells me. "It's a really good primary yellow," Hinton says.

She starts with a pure powder, a pigment, that she mixes with water while wearing a respirator, so as not to inhale the dust. Some of them are more toxic than others. After mixing that into a color paste with a palette knife, she adds a binder—gum arabic, vegetable glycerine, sometimes even honey or clove oil. "Then you mull it out," Hinton says.

Ah. We are going to mull this over. But it won't involve chin-stroking. A muller is a heavy glass mushroom with a flat head,

turned downward onto the glass, onto the mix of yellow matter and binder. "Mulling is the process of creating a dispersion, when every pigment particle is wrapped in the binder," Hinton says. She starts making circular passes through the yellow, a widening gyre, flattening and spreading the pool of color. "The goal is to create a tiny, thin layer of paint in between the glass," she says. I try: The muller won't come up off the surface without a struggle; there's a little suction. "You just sort of feel when the paint is done. It feels like paint. One smooth, even mixture."

This action, this grinding-down, is as deeply connected to the human act of coloring things as any behavior I can think of. This is what the tools were for in the prehistoric workshop in the Blombos Cave in South Africa. The color providers of Renaissance Venice valued the slabs of porphyry on which they ground out their pigments enough that they itemized them in workshop inventories. And now here we are, at Hinton's heavy glass table, about the size of the flat-screen TVs that Poppy Crum has her research subjects stare at. I didn't feel any more in control of colors than I had in class, fighting with that tangerine, but I did feel like I was riding the line of light and color that connects ochre to blue LEDs, white beetles to Vantablack, photons to neurons. "It's taking raw materials and turning them into something that you can make something beautiful with," Hinton says.

In the end, we make colors for each other. "All art, decorative or imitative, retains to the last somewhat of its original character, as a direct stimulant of simple chromatic pleasure," wrote Grant Allen in *The Colour-Sense,* way back in 1879. "The highest aesthetic products of humanity form only the last link in a chain whose first link began with the insect's selection of bright-hued blossoms." Color helps us understand how the universe works at a basic level of code — even though all of us see color in slightly different ways, it unites us.

Whatever multispectral structural-color gadget that Manoharan eventually invents — no doubt with the most dynamic of high dynamic ranges, and a color gamut tuned to cover every shade or

hue that Michael Pointer found in the "real world" — it won't be much different than a limestone cave wall lit by flickering tallow-light, colored with charcoal black, calcium carbonate white, and red and yellow ochre. Light bounces off a surface and into electrified meat and jelly mounted in the bony skull of our great-to-the-nth-grandparents, and they see what we would've seen: glorious color that lets the human mind observe and become a part of the universe at play.

ACKNOWLEDGMENTS

The book you are holding has been folded up inside me like an alien embryo for two decades, pulsing obscenely and assembling itself from the weirdest and most complicated tidbits of information, biding its time before uncoiling for a dramatic emergence.

BOOM. Hi.

But unlike Athena or a xenomorph with acid for blood, *Full Spectrum* didn't burst out fully formed. I needed a lot of help to set it loose.

My partner, Melissa Bottrell, has shared me with this book. During its long creation, the preponderance of the burden of maintaining our household fell unfairly on her. Yet she has shown nothing less than total support, and contributed her keen intellect and a faith in the book's completion that even I didn't always share. Our children, too, showed preternatural patience with my not-all-thereness during the most intense parts of the book's reporting and writing. I love them all, thank them for their forbearance, and ask their forgiveness.

Many friends and colleagues provided material and psychological support. Sunny Bains and Stuart Arnott opened their home in London to me while I reported from there. Daniel McGinn and his wife, Amy, did the same for me in Boston. Dan and I started in this game together, along with a group of pals—Brad Stone, T. Trent Gegax, Paul O'Donnell, and Matt Bai—whose friendship forms the arches on which this all stands.

Patricia Thomas, Mark McClusky, and Clive Thompson all read portions while I was working on the text and offered lifesaving criticism and encouragement. Clive also pointed me to at least two of the stories I tell here, including the tale of the blackest black.

Other journalists were openhearted and helpful. Andrew Curry, Olivier Knox, and Thomas Hayden offered critical sourcing; Carl Zimmer had kind words, good advice, and helpful tips. Emily Willingham tracked down the most important picture of a penis in the history of color science. I got platinum-tier advice about writing, reporting, and organizing from Maryn McKenna, Terence Samuel, and Christian Thompson. Deborah Blum, ace science journalist and head of the Knight Science Journalism Fellowship Program at MIT, gave me astute guidance and, with her program's administrator Bettina Urcuioli, material aid in reporting and access.

Colleagues at *Wired* not only listened to my gripes and boasts through years of work on *Full Spectrum,* but also picked up my slack when I occasionally flittered off to write it. Mark Robinson, Sarah Fallon, Megan Molteni, Scott Dadich, Rob Capps, and Scott Thurm, mensches and brilliant journalists, were all nicer about my absences than I deserved, and their thoughts about the book helped it get done smarter. *Wired*'s editor in chief Nicholas Thompson, executive editor Maria Streshinsky, website editors Andrea Valdez and Megan Greenwell, and science editors Sandra Upson and Kara Platoni were all authoritative slack-cutters, and I'm grateful.

Many, many sources contributed time and thoughts to this book—even beyond those whom I quote by name. I'm particularly grateful to Robin Shail, Anya Hurlbert, Delwin Lindsey, Angela Brown, Jay Neitz, Maureen Neitz, Greg Horwitz, and Reg Adams. Lisa Snyder, David Brainard, Michael Foshey, and Lin Shi all talked to me about their work and then, months later, dug back into their files to provide images for me to use here. They provided color for this book both metaphorically and literally.

Bevil Conway of the National Institutes of Health has been a sort of guru for me in the world of color since the beginning. I met him when he was a postdoc and I was just starting to think there was a book in all of this, and he has been a patient teacher ever since.

My stalwart agent, Eric Lupfer, contributed both his sharp editor's eye and his steadying hand on every puzzle piece, including his author. (Me. That is me.) My editor, Naomi Gibbs, made sure every single word was as good as it could be, and that all of them were in the right places. She and her colleague Jenny Xu kept many balls in the air, especially when I'd forgotten which balls were what and how to juggle. And Glyn Peterson's research and fact-checking went way beyond accuracy and precision to encompass truth and beauty.

Nevertheless, if anything is wrong in this book, the fault is mine. Allllllll mine.

Finally: I've come to think that it is at minimum churlish to go without acknowledging my readers. (You. That is you.) I wouldn't have a career if you weren't willing to come along on this trip into colorspace. I'm glad you're with me.

NOTES

INTRODUCTION

CHAPTER 1: EARTH TONES

2 *forty-one beads:* d'Errico et al., "*Nassarius Kraussianus* Shell Beads from Blombos Cave: Evidence for Symbolic Behaviour in the Middle Stone Age," 3.

 The ochre colors: Delamare and Guineau, *Colors: The Story of Dyes and Pigments,* 16.

3 *dull gray sheen:* Nassau, *The Physics and Chemistry of Color: The Fifteen Causes of Color,* 165–66.

 southwestern desert: Nassau, 331.

 Martian regolith: Sherman et al., "Spectral Characteristics of the Iron Oxides with Application to the Martian Bright Region Mineralogy," 10169.

 relatively common: Nassau, 331.

 nearly 7 percent: Wood, *Chinese Glazes: Their Origins, Chemistry, and Recreation,* 159.

 20 meters below: Henshilwood et al., "Engraved Ochres from the Middle Stone Age Levels at Blombos Cave, South Africa," 29.

 "trabecular" bone: Henshilwood et al., "A 100,000-Year-Old Ochre-Processing Workshop at Blombos Cave, South Africa," 220.

 vertebrae are made of: Oftadeh et al., "Biomechanics and Mechanobiology of Trabecular Bone: A Review," 1.

4 *high pigmenting power:* Helwig, "Iron Oxide Pigments: Natural and Synthetic," 40.

 Ochre leaves a mark: Hodgskiss and Wadley, "How People Used Ochre at Rose Cottage Cave, South Africa: Sixty Thousand Years of Evidence from the Middle Stone Age," 1.

 for decoration: Henshilwood, "A 100,000-Year-Old Ochre-Processing Workshop," 222.

 Every second: Kiang et al., "Spectral Signatures of Photosynthesis. I. Review of Earth Organisms," 233.

5 *A paint:* Diebold, *Application of Light Scattering to Coatings: A User's Guide,* 6.

 Mie scattering: Diebold, 7.

 foaming river rapid: Lynch and Livingston, *Color and Light in Nature,* 99.

 Heat changes: Helwig, 53, 69.

6 *In Qafzeh Cave:* Hovers et al., "An Early Case of Color Symbolism," 502.

7　*Of fifteen glues:* Wadley et al., "Implications for Complex Cognition from the Hafting of Tools with Compound Adhesives in the Middle Stone Age, South Africa," Table 1, 9591.

　　"complex compound adhesive": Wadley, "Compound-Adhesive Manufacture as a Behavioral Proxy for Complex Cognition in the Middle Stone Age," S116.

　　the Ovahimba people: Rifkin, "Ethnographic and Experimental Perspectives on the Efficacy of Ochre as a Mosquito Repellent," 65.

　　ochres can absorb ultraviolet: Helwig, 53.

　　But in 2015: Rifkin, 67.

　　A. aegypti *can carry chikungunya:* "Aedes aegypti — Factsheet for Experts."

　　The ochre-and-butter combination: Rifkin, 71.

9　*Identifying Paleolithic white:* Siddall, "Mineral Pigments in Archaeology: Their Analysis and the Range of Available Materials," 203.

10　*early Australians:* Pettigrew et al., "Living Pigments in Australian Bradshaw Rock Art."

　　Gwion gwion art: "The Australian Rock Art Archive."

11　*Halobacteria's thing:* Henderson, "The Purple Membrane from Halobacterium Halobium," 88.

　　They're oblong: Spudich and Bogomolni, "Sensory Rhodopsins of Halobacteria," 195.

12　*halobacteria swim:* Spudich, "The Multitalented Microbial Sensory Rhodopsins," 480–81.

　　In the 1960s: Stoeckenius, "The Purple Membrane of Salt-Loving Bacteria," 38.

　　Halobacteria avoid: Pichaud et al., "Evolution of Color Vision," 622.

13　*Halobacteria have:* Nathans, "The Evolution and Physiology of Human Color Vision: Insights from Molecular Genetic Studies of Visual Pigments," 299.

　　But they're made: Sudo and Spudich, "Three Strategically Placed Hydrogen-Bonding Residues Convert a Proton Pump into a Sensory Receptor," 16130.

14　*hundreds of millions:* Nathans, 299.

　　garishly colored mantis shrimp: Cuthill et al., "The Biology of Color," 2.

that uses light: Okano et al., "Pinopsin Is a Chicken Pineal Photo-receptive Molecule," 94.

Many primates: Marshall and Arikawa, "Unconventional Colour Vision," R1150.

Thanks to evolutionary: Nathans, 299.

Straight-up rhodopsin: Goldsmith, "What Birds See," 71.

We have a rhodopsin: Nathans, 299.

15 *As early as 1959:* Judson, "Paleolithic Paint," 708.

16 *It's easy to imagine:* Alexander Marshack, "Comment," in Hovers et al., 514–16.

Because if you make: Marshack in Hovers et al., 515.

Organic pigments: Petru, "Red, Black or White? The Dawn of Colour Symbolism," 204.

Every white pigment: Bednarik, "A Taphonomy of Palaeoart," 70.

17 *Next to manganese-carbon:* Siddall, "Mineral Pigments in Archaeology," 202.

Egyptian blue: Nassau, *The Physics and Chemistry of Color: The Fifteen Causes of Color,* 113.

CHAPTER 2: CERAMICS

18 *In 1998:* Flecker, "A Ninth-Century Arab or Indian Shipwreck in Indonesian Waters," 199.

It wasn't dramatic: Sudaryadi, "The Belitung Wreck Site After Commercial Salvage in 1998," 2.

They called it Batu Hitam: Patterson, "The 1,200-Year-Old Sunken Treasure That Revealed an Undiscovered China."

Belitung is in Indonesian Waters: Kremb, "Find on the Black Rock."

Seabed Explorations: Lambert, "Belitung Shipwreck."

19 *After the first leader:* Lambert.

The boat was small: Flecker, "A Ninth-Century AD Arab or Indian Shipwreck in Indonesia: First Evidence for Direct Trade with China," 339.

like an Arab or Indian dhow: Guy, "Rare and Strange Goods: International Trade in Ninth-Century Asia," 20; Flecker, "A Ninth-Century Arab or Indian Shipwreck in Indonesian Waters: Addendum," 385.

the salvors raised: Yang, "Tang Dynasty Changsha Ceramics," 145.

The oldest known piece: Guy, 19–20.

reign of the emperor: Flecker, "A Ninth-Century Arab or Indian Shipwreck in Indonesian Waters," 210.

20 *Ancient texts:* Helwig, "Iron Oxide Pigments: Natural and Synthetic," 41.

They're all over Egyptian tombs: Linton, *Ancient and Modern Colours, from the Earliest Periods to the Present Time: With Their Chemical and Artistical Properties,* 9.

The chalky whites: Pulsifer, *Notes for a History of Lead and an Inquiry into the Development of the Manufacture of White Lead and Lead Oxides,* 205.

Chinese started making it: Gettens et al., "Lead White," 68.

found in the ruins of Ur: Nriagu, *Lead and Lead Poisoning in Antiquity,* 294.

extolls the authenticity: Pliny, *Natural History,* Book XXXV, ch. 32.

"somber": Pliny, Book XXXV, ch. 12.

"florid" pigments: Pliny, Book XXXV, ch. 32; Siddall, "Not a Day Without a Line Drawn: Pigments and Painting Techniques of Roman Artists," 21.

21 *pigment from Pompeii:* Clarke et al., "Pompeii Purpurissum Pigment Problems," 13.

Tang-era China: Linton, 4.

The Abbasids had: Christie, *Colour Chemistry,* 4.

wraps of Egyptian mummies: Linton, 11.

deep red-to-intense-violet: Linton, 12–16.

Murex brandaris: Christie, 4.

Its manufacture: Cooksey, "Tyrian Purple: 6,6'-Dibromoindigo and Related Compounds," 736.

during the Han dynasty: Schafer, "The Early History of Lead Pigments and Cosmetics in China," 428.

People used it: Schafer, 431–32.

Red was ch'ien tan: Schafer, 417.

yellow was ch'ien haung hua: Schafer, 418.

derived from South Asian lac: Nassau, 131.

mercuric sulfide: Benn, *China's Golden Age: Everyday Life in the Tang Dynasty,* 107.

22 *dark Persian indigo:* Benn, 108.

nine hundred green bowls: Krahl, "Green Wares of Southern China," 185.

the oldest pottery: Boaretto et al., "Radiocarbon Dating of Charcoal and Bone Collagen Associated with Early Pottery at Yuchanyan Cave, Hunan Province, China," 9595.

cultures along the Yangtze: Kerr and Wood, *Science and Civilization in China,* 134.

23 *they learn:* Krahl, "White Wares of Northern China," 202.

the man-thou: Kerr and Wood, 320.

the Triassic: Vermeesch, "A Second Look at the Geologic Map of China: The 'Sloss Approach,'" 128.

Two very different lands: Sensabaugh, Foreword, i.

Northern China ended up: Kerr and Wood, 95.

24 *low in any impurities:* Wood, *Chinese Glazes: Their Origins, Chemistry, and Recreation,* 98–99.

creamy, durable, and white: Sensabaugh, i.

Here's a giveaway: Sensabaugh, ii.

Southern China, meanwhile: Kerr and Wood, 133.

The ground there: Yanyi, "Raw Materials for Making Porcelain and the Characteristics of Porcelain Wares in North and South China in Ancient Times," 4.

That mineral is: Yanyi, 4.

played a symphony on them: Li, "Ceramics of the Sui, Tang, and Five Dynasties," 240.

Porcelain predated: Kerr and Wood, 152.

Northern white: Li, Introduction in Li et al., *Chinese Ceramics: From the Paleolithic Period Through the Qing Dynasty,* 6.

25 *Their unique material:* Kerr and Wood, 29.

internal peace: Li, "Ceramics of the Sui, Tang, and Five Dynasties," 200–201.

ascent to the throne: Li, 203.

son deposed her: Dash, "The Demonization of Empress Wu."

26 *Just a couple of:* Krahl, "Chinese Ceramics in the Late Tang Dynasty," 45–46.

Meanwhile, fighting on the borders: Benn, 9–15.

safer maritime routes: Lewis, *China's Cosmopolitan Empire: The Tang Dynasty,* 147.

drinking tea since: Kerr and Wood, 271.

Tea didn't come: Krahl, "Chinese Ceramics in the Late Tang Dynasty," 46.

27 *Lu in particular:* Yu, *The Classic of Tea: Origins and Ritual,* 90–93.

None of that: Rogers, *Proof: The Science of Booze,* Loc 2481 in Kindle. Yes, I have always wanted to cite myself.

Tang celadon jar: Yoh, "The Export and Trade of Chinese Ceramics: An Overview of the History and Scholarship to Date," 537.

28 *"as delicate as glass":* Krahl, "Chinese Ceramics in the Late Tang Dynasty," 49.

imperial China–ware: Hallett, "Pearl Cups Like the Moon: The Abbasid Reception of Chinese Ceramics," 75–84.

Ceramic Road: Yoh, 538–40.

Abbasid pottery: Hallett, "Pearl Cups Like the Moon," 75.

Without kaolin clay: Hallett, "Pearl Cups Like the Moon," 76.

29 *Vivid blue:* Mason and Tite, "The Beginnings of Tin-Opacification of Pottery Glazes," 46.

the Iraqis, who didn't: Mason and Tite, 43–46.

The Egyptians: Hallett, "Imitation and Inspiration: The Ceramic Trade from China to Basra and Back," 4.

since glazes: Mason and Tite, 56.

Roman empire: Hallett, "Imitation and Inspiration," 4.

Nobody has done: Wood and Tite, "Blue and White — the Early Years: Tang China and Abbasid Iraq Compared," courtesy of authors.

Abbasid cobalt blue pigments: Wood, "The Importance of the Gongxian Kilns in China's Ceramic History," slide 46.

30 *maybe Abbasid blue-and-white:* Hallett, "Pearl Cups Like the Moon," 77.

The ancient world's first bright blue: Christie, 3.

calcium copper silicate: Linton, 10–11.

pre-dynastic Egypt: Berke and Wiedemann, "The Chemistry and Fabrication of the Anthropogenic Pigments Chinese Blue and Purple in Ancient China," 95.

Nefertiti's crown: Berke, "Chemistry in Ancient Times: The Development of Blue and Purple Pigments," 2485.

Despite a three-millennium: Berke, 2486.

31 *David Whitehouse:* Wood and Priestman, "New Light on Chinese

Tang Dynasty and Iraqi Blue and White in the Ninth Century: The
Material from Siraf, Iran," 57.

ancient port city of Siraf: Wood and Priestman, 48.

1966 and 1973: Wood and Priestman, 47.

Priestman realized: Wood and Priestman, 53.

Imagine Siraf: Hsieh, "The Navigational Route of the Belitung
Wreck and the Late Tang Ceramic Trade," 142.

The poet al-Adzi: Hallett, "Pearl Cups Like the Moon," 79.

Siraf's tendrils: Wood and Priestman, 48.

33 *divers brought up:* Kremb.

34 *Smithsonian memos:* Taylor, "Smithsonian Sunken Treasure
Show Poses Ethics Questions."

35 *Sackler Gallery called off:* Pringle, "Smithsonian Scuppers Ship-
wreck Exhibit, Plans to Re-Excavate."

A 2010 survey: Sudaryadi, 1–3.

the cargo suggests: Miksic, "Chinese Ceramic Production and
Trade," 6.

"A whitish": Flecker, "A Ninth-Century AD Arab or Indian Ship-
wreck in Indonesia," 339.

CHAPTER 3: RAINBOWS

37 *Persian-, Syriac-, and Arabic-speaking:* Saliba, *Islamic Science and
the Making of the European Renaissance,* 65–66, 74–75.

Arab scholars: Saliba, 74.

38 *Tyrian purple:* Abel, "The History of Dyes and Pigments," 566.

colors could look different: Aristotle, *Meterologica,* Book III, part 4.

elemental, fundamental: Kuehni, "Development of the Idea of Sim-
ple Colors in the Sixteenth and Early Seventeenth Centuries," 92.

He chose seven: Kuehni, "Development of the Idea of Simple Col-
ors," 93.

a rough scale: Kuehni, "Development of the Idea of Simple Col-
ors," 92.

39 *natural phenomena:* Kirchner and Bagheri, "Color Theory in Me-
dieval Islamic Lapidaries: Nīshābūrī, Tūsī and Kāshānī," 2.

He swapped: Aristotle, *Meteorology,* Book III, part 2.

Pliny argued: Pliny, *Natural History,* Book XXXV, ch. 32.

40 *they tried to avoid:* Shapiro, "Artists' Colors and Newton's Col-
ors," 602.

desaturated: Kuehni and Schwarz, *Color Ordered: A Survey of Color Order Systems from Antiquity to Present,* 11.

Various Islamic factions: Watson, *Light: A Radiant History from Creation to the Quantum Age,* 43.

disliked the sound of barking: O'Connor and Robertson, "Abu Ali al-Hasan ibn al-Haytham."

Basra-born: Ansari, "Ibn al-Haytham's Scientific Method."

mathematician and civil engineer: Watson, 44.

41 *back to the caliph:* Sabra, "Ibn al-Haytham."

al-Haytham got sprung: Watson, 45.

He showed: Tbakhi and Amr, "Ibn Al-Haytham: Father of Modern Optics," 465–66.

light could bend: Longair, "Light and Colour," 66–67.

hurts to look: Watson, 46.

42 *al-Haytham realized:* Kirchner, "Color Theory and Color Order in Medieval Islam: A Review," 6.

ancient Greek science: Saliba, 239.

Robert Grosseteste: Crombie, *Robert Grosseteste and the Origins of Experimental Science, 1100–1700,* 44.

taught at Oxford: Boyer, "Robert Grosseteste on the Rainbow," 249.

the path traveled: Sparavigna, "On the Rainbow, a Robert Grosseteste's Treatise on Optics," 109.

This "refraction": Smithson et al., "All the Colours of the Rainbow," 540.

Grosseteste thought: Sparavigna, 110.

modern historians: Smithson et al., 540.

43 *Roger Bacon:* Crombie, 151.

nested cones: Crombie, 234–36.

more scientific conditions: Kuehni, "Development of the Idea of Simple Colors," 98.

secondary rainbows: Kirchner, 9.

watching the light: Topdemir, "Kamal Al-Din Al-Farisi's Explanation of the Rainbow," 80.

44 *Islamic tradition:* Kirchner, 13–14.

urine flasks: Crombie, 122.

same sequence: Kuehni and Schwarz, 33.

ultimate influencer: Lozier, "Red Ochre, Vermilion, and the Transatlantic Cosmetic Encounter," 124.

45 *physically healthy:* Sammern, "Red, White and Black: Colors of Beauty, Tints of Health and Cosmetic Materials in Early Modern English Art Writing," 402.

European women: Lozier, 124.

Indian indigo: Balaram, "Indian Indigo," 142–43.

get access: Balaram, 140.

46 Libro dell'arte: Cennini, *The Craftsman's Handbook.* See preface.

Craftsman's Handbook: Broecke, *Cennino Cennini's Il Libro dell'arte: A New English Translation and Commentary with Italian Transcription,* 6.

seven ways: Cennini, xxii.

terre verte: Grissom, "Green Earth," 141.

malachite: Feller and Bayard, "Terminology and Procedures Used in the Systematic Examination of Pigment Particles with the Polarizing Microscope," 288–89.

blues and yellows: Berrie, "Mining for Color: New Blues, Yellows, and Translucent Paint," 326; Cennini, 32 and 32, n. 1.

a lovely story: Broecke, 70–71.

didn't understand: Broecke, 9.

simulate volume: Barrett and Stulik, "An Integrated Approach for the Study of Painting Techniques," 7–8.

47 *in a chapter:* Broecke, 111.

one problem: Bomford, "The History of Colour in Art," 9.

Another artist: Bomford, 12.

48 *pigments in oil:* Bomford, 14–15.

49 *a tween:* Gleick, *Isaac Newton,* 16.

Isaac Newton: Iliffe, *Newton: A Very Short Introduction,* 11.

full of instructions: Shapiro, 609.

ink and paint: Newton, Pierpont Morgan Notebook.

knowledge was secret: Massing, "From Books of Secrets to Encyclopedias: Painting Techniques in France Between 1600 and 1800," 20.

Newton read Descartes: Shapiro, 614; Kuehni, "Development of the Idea of Simple Colors," 98.

his mother's house: Gleick, 33.

50 *Newton pressed on the eye:* Iliffe, 37.

 a "bodkin": Iliffe, 39.

 self-experimentation: Gleick, 61–62.

 Conjuring colors: Iliffe, 35.

 bunch of rich guys: McDougall-Waters et al., "Philosophical Transactions: 350 Years of Publishing at the Royal Society, 1665–2015," 7.

51 *single-windowed study:* Gleick, 81.

52 *"the spectrum":* Crombie, 275–76.

 Henry Oldenburg: McDougall-Waters et al., 7.

 Journal des Sçavans: Massing, 24.

 early edition: McDougall-Waters et al., 7.

 Philosophical Transactions: McDougall-Waters et al., 8.

 Oldenburg got wind: Gleick, 79–80.

 on the record: McDougall-Waters et al., 8.

53 *something of a confection:* Gleick, 82.

 Almost right away: Iliffe, 48.

 Newton bailed: Gleick, 162–63.

 colors could change: Mollon, "The Origins of Modern Color Science," 3.

54 *Newton's ordering was modern:* Shapiro, 619–20.

 the alchemists: Kuehni and Schwarz, 129.

 alchemical ideas: Iliffe, 6.

 included books on alchemy: Gleick, 67.

55 *colors weren't "primary":* Mollon, "Origins of Modern Color Science," 4.

 physicists and painters: Shapiro, 620.

 English tin: Newton, "To John Williams."

 their own tradition and ideas: Shapiro, 620.

56 *master-apprentice relationship:* Massing, 22.

 importance of textiles: Massing, 24.

 blown his own mind: Birren, *The Story of Color,* 73.

57 *Gregor's article:* Gregor, "Observations and Experiments on Manacanite, a Magnetic Sand Found in Cornwall," 40.

 Journal de Physique: Gregor, "On Manaccanite, a Species of Magnetic Sand Found in the Province of Cornwall and the Discovery of Titanium," 152.

 of perhaps fifty: Mabe, "The Growth and Number of Journals," 193.

rule against printing: Bristow and Cleevely, "Scientific Enquiry in Late Eighteenth Century Cornwall," 6.

"Ingelfinger Rule": Angell and Kassirer, "The Ingelfinger Rule Revisited," 1371.

58 *something that rankled*: Paris, *A Memoir of the Life and Scientific Labours of the Late Reverend William Gregor*, 21.

CHAPTER 4: THE LEAD WHITE OF COMMERCE

59 *painted interior*: Funderburg. "Paint Without Pain"; Pulsifer, *Notes for a History of Lead and an Inquiry into the Development of the Manufacture of White Lead and Lead Oxides*, 313.

first church in Boston: Pulsifer, 313–14.

Xenophon's Oikonomikos: Glazebrook, "Cosmetics and Sôphrosunê: Ischomachos' Wife in Xenophon's Oikonomikos," 237.

Saint Jerome: Saint Jerome, "Letter to Furia," Letter LIV.

60 *this dynamic*: Batchelor, *Chromophobia*, 23.

a contemporary sculpture: Brinkmann, "A History of Research and Scholarship on the Polychromy of Ancient Sculpture," 13.

way-pale faces: Lozier, "Red Ochre, Vermilion, and the Transatlantic Cosmetic Encounter," 125–26.

hair loss: Nriagu, *Lead and Lead Poisoning in Antiquity*, 25.

St. Stephen's Chapel: Pulsifer, 242–43.

Cennini mentions: Broecke, *Cennino Cennini's Il Libro dell'arte: A New English Translation and Commentary with Italian Transcription*, 84–86 and notes.

61 *ripples of light*: Berrie and Matthew, "Lead White from Venice: A Whiter Shade of Pale?," 297–98.

North American colonies: Stilgoe, *Common Landscape of America, 1580 to 1845*, 166.

Faber Birren: Birren, *The Story of Color*, 143.

You could get: Stilgoe, 166.

62 *Venice was still*: Pulsifer, 262–63.

shutters of green: Linton, *Ancient and Modern Colours, from the Earliest Periods to the Present Time: With Their Chemical and Artistical Properties*, 74–78.

"It was new": Stilgoe, 169.

Samuel Wetherill: Hussey, *From Merchants to "Colour Men": Five*

Generations of Samuel Wetherill's White Lead Business, 2–3; Pulsifer, 314–16.

Wetherill sold: Hussey, 4.

63 *it burned down:* Funderburg.

a new factory: Hussey, 7.

War of 1812: Funderburg.

lead deposit: Hussey, 46.

their own mine and smelter: Hussey, 8.

lead-based pigments: Fitzhugh, "Red Lead and Minium," 111.

Wetherill factory: Hussey, 23.

pig lead: Hussey, 79.

64 *1824 dissertation:* Hussey, 76–78.

"there yet lurks": Melville, *Moby-Dick,* 118.

king of terrors: Melville, 120.

65 *"The chalking of white lead":* Holley, *The Lead and Zinc Pigments,* 140.

ancient Roman: Waldron, "Lead Poisoning in the Ancient World," 394.

team of researchers: Hong et al., "Greenland Ice Evidence of Hemispheric Lead Pollution Two Millennia Ago by Greek and Roman Civilizations," 1841.

66 *Benjamin Franklin:* Benjamin Franklin, "To Benjamin Vaughan."

Lead's mode of toxicity: Needleman, "Lead Poisoning," 210–11.

French chemist: Kühn, "Zinc White," 170.

67 *Inhale too much:* Kühn, 175.

Pigments made: Halford, "Understanding Oil-Paint Brittleness," 38–39.

four times: Kühn, 170.

"Chinese white": Holley, 153.

LeClaire cheated: Holley, 152–53.

warmer and clearer: Kühn, 172.

American industrialists: Holley, 155.

68 *Zinc wasn't great:* Holley, 178.

iodine scarlet: Katz, "William Holman Hunt and the 'Pre-Raphaelite Technique,'" 159.

available pigments: Griffiths, "The Historical Development of Modern Colour and Constitution Theory," 21.

painters began experimenting: Carlyle, "Beyond a Collection of

Data: What We Can Learn from Documentary Sources on Artists' Materials and Techniques," 2.

undergirding "grounds": Fischer, *The Permanent Palette,* 63.

different versions: Van Gogh, "To Theo Van Gogh."

69 *50,000 tons:* Pulsifer, 291.

70,000 tons: Pulsifer, 334.

He enters a dark, meager: Drew, *Dickens' Journalism, Vol. IV: "The Uncommon Traveler" and Other Papers, 1859–1870,* 8.

70 *"'Tis the poor craythur":* Dickens, "A Small Star in the East," 258.

Thomas Oliver: "Obituary: Sir Thomas Oliver, LLD, DCL, MD, DSc, FRCP," 681; "Thomas Oliver, KT, MD Glasg., DCL Durh., FRCP."

71 *mostly women:* Holley, 143–44.

Oliver eventually lobbied: Oliver, "A Lecture on Lead Poisoning and the Race," 1096.

occupational safety: Warren, *Brush with Death: A Social History of Lead Poisoning,* 71.

Clifford Dyer Holley pish-poshes: Holley, 148.

white lead's toxicity: Toch, "White Lead," 30–31.

72 *a virtue:* Warren, 53.

"Dutch Boy": Warren, 46–47.

331,000 tons: Holley, 1.

Le Blon: Choulant, *History and Bibliography of Anatomic Illustration in Its Relation to Anatomic Science and the Graphic Arts,* 265.

first decade of the 1500s: Krivatsy, "Le Blon's Anatomical Color Engravings," 154.

73 *discovered around 1704:* Krivatsy, 155.

Le Blon distinguished: Le Blon, *Coloritto; or the Harmony of Colouring in Painting: Reduced to Mechanical Practice, Under Easy Precepts, and Infallible Rules; Together with Some Colour'd Figures, in Order to Render the Said Precepts and Rules Intelligible, Not Only to Painters, but Even to All Lovers of Painting,* 6.

74 *His reproduction-printing business:* Lowengard, *The Creation of Color in Eighteenth-Century Europe.*

75 *air-conditioning system:* Nagengast, "100 Years of Air Conditioning," 44–45.

few still exist: Krivatsy, 158.

Perhaps the most famous: Cockburn, *The Symptoms, Nature, Cause, and Cure of Gonorrhoea.*

depicted penis: Le Blon, "Anatomische Studie van de Penis."
a medical textbook: Choulant, 265.

76 *George Giros de Gentilly Palmer:* Lowengard, ch. 17.
himself the inventor: Walls, "The G. Palmer Story (Or, What It's Like, Sometimes, to Be a Scientist)," 78.
This pamphlet: Lowengard, ch. 17.
getting reflection and absorption wrong: Kuehni, "Talking About Color . . . Which George Palmer?," 2.

77 *After his book:* Kuehni, "Talking About Color," 3.
Joseph Huddart: Huddart, "XIV. An Account of Persons Who Could Not Distinguish Colours. By Mr. Joseph Huddart, in a Letter to the Rev. Joseph Priestley, LL.D F.R.S," 260–61.
Cumberland shoemaker: Huddart, 263.
atoms to chemistry: Michalovic, "John Dalton and the Scientific Method."
John Dalton admitted: Dalton, "Extraordinary Facts Relating to the Vision of Colours: With Observations," 5, no. 1 29–30.
silk threads: Cliff, "Dirty Green and the Anatomy of Colour."

78 *all "yellow":* Dalton, 31.
Dalton even: Dalton, 39.
vitreous humour: Hunt et al., "The Chemistry of John Dalton's Color Blindness," 984.
Thomas Young: Mollon, "Introduction: Thomas Young and the Trichromatic Theory of Colour Vision," xix.
Young realized: Mollon, "Introduction," xxiii.

79 *"undulations in a second":* Young, "The Bakerian Lecture: On the Theory of Light and Colours," 39.
if you know something's frequency: Mollon, "Introduction," xxvi.
Young had studied: Kuehni and Schwarz, *Color Ordered: A Survey of Color Order Systems from Antiquity to Present,* 129.
a lecture: Young, 16.
"the sensation": Young, 18.
"each principal colour": Young, 21.

80 *James Clerk Maxwell:* Kuehni and Schwarz, 130.
describe electromagnetism: Mahon, "How Maxwell's Equations Came to Light," 3.
spinning colored disks: Kuehni, "A Brief History of Disk Color Mixture," 116.

same methodology: Turner, *In the Eye's Mind: Vision and the Helmholtz-Hering Controversy,* 99.

Maxwell could produce: Turner, 100.

colorblind people: Turner, 102.

81 *a pattern:* Maxwell, "On the Theory of Compound Colours, and the Relations of the Colours of the Spectrum," 61.

"one of these is absent": Maxwell, 61.

a "dichromat": Maxwell, 78.

82 *specific groups of atoms:* Bradford, "Colour and Chemical Structure," 362.

simple functional groups: Griffiths, 22.

chromophores meant: Osborne, "A History of Colour Theory in Art, Design and Science," 507.

CHAPTER 5: WORLD'S FAIR

83 *Jules Verne stuff:* de Wit, "Building an Illusion: The Design of the World's Columbian Exposition," 46.

Committees assembled: Hines, *Burnham of Chicago: Architect and Planner,* 75–76.

84 *Europe was looking down:* de Wit, 43.

Daniel Burnham and John Root: "Burnham and Root."

For added oomph: Hines, 76.

85 *plan for the Exposition:* Hines, 77.

Root drew: Monroe, *John Wellborn Root: A Study of His Life and Work,* 249–50.

and a pink granite: Monroe, 253–54.

knew the value of fun: Rybczynski, *A Clearing in the Distance: Frederick Law Olmsted and America in the Nineteenth Century,* 398.

facades as rigorously unified: Christiansen, *City of Light: The Transformation of Paris,* 14.

The fair would be as ephemeral: Quoted in Hines, 78.

86 *"To Science will":* Monroe, 205.

In this protomodern: Weingarden, *Louis H. Sullivan and the Nineteenth-Century Poetics of Naturalized Architecture,* 122.

Root believed: Weingarden, "The Colors of Nature: Louis Sullivan's Architectural Polychromy and Nineteenth-Century Color Theory," 247.

Chicago polychromatism: Weingarden, "The Colors of Nature," 246.

aerosolized effluent: Weingarden, *Louis H. Sullivan,* 191.

87 *In January of 1891:* Monroe, 281.
On a chilly Saturday: Hines, 81.
Burnham spent the night: Hines, 82.

88 *uniform cornice height:* de Wit, 58.
facades of staff: Kamin, "Artifacts from 1893 World's Fair Found Beneath Obama Center Site, but Report Signals Construction Won't Be Blocked."
The fair was intended: de Wit, 58.
a literal instantiation: Meilke, *Twentieth Century Limited: Industrial Design in America, 1929–1935,* 136.
"We talked about": Moore, "Lessons of the Chicago World's Fair," 43.
A "sanitary movement": Harris and Helgertz, "Urban Sanitation and the Decline of Mortality," 207–8.

89 *Toiletry marketing:* Humphries, "Have We Hit Peak Whiteness?"
Even the Eiffel Tower: Weingarden, "The Colors of Nature," footnote on p. 255.
Olmsted wrote: Quoted in Rybczynski, 391.
The all-white color scheme: Rybczynski, 391–92.
A plan of the Exposition: de Wit, 55.

90 *Auditorium Building in Chicago:* Weingarden, *Louis H. Sullivan,* 285–86.
full-on revolution: Weingarden, "The Colors of Nature," 252.
And Sullivan had: Weingarden, *Louis H. Sullivan,* 284.
Galerie des Gobelins: "Royal Factory of Furniture to the Crown at the Gobelins Manufactory."

91 *Chevreul became his assistant:* Dijkstra, "How Chevreul (1786–1889) Based His Conclusions on His Analytical Results," 8.

92 *So Charles X:* Kuehni and Schwarz, *Color Ordered: A Survey of Color Order Systems from Antiquity to the Present,* 84.
brushed up against failure: Lowengard, *The Creation of Color in Eighteenth-Century Europe,* ch. 16.
Dyeing the textiles: Roque, "Chevreul's Colour Theory and Its Consequences for Artists," 2–3.
The colors were wrong: Roque, "Chevreul and Impressionism: A Reappraisal," 26.

"I saw the want of vigour": Viénot, "Michel-Eugène Chevreul: From Laws and Principles to the Production of Colour Plates," 5.

"not a problem": Roque, "Chevreul's Colour Theory," 4.

Young had: Kuehni and Schwarz, 130.

93 *That's because of an ability:* Mollon, "Introduction: Thomas Young and the Trichromatic Theory of Colour Vision," xxviii.

The eye or brain: Chevreul, 4.

Chevreul had actually: Roque, "Chevreul's Colour Theory," 8.

Since tapestry makers: Roque, "Chevreul and Impressionism," 27; Viénot, 11.

weaving is an art: Roque, "Chevreul's Colour Theory," 13.

The French Romantic: Roque, "Chevreul's Colour Theory," 14.

Camille Pissarro started: Roque, "Chevreul and Impressionism," 33–34.

94 *Claude Monet:* Roque, "Chevreul and Impressionism," 32–33.

drawing is "absolute": Roque, "Seurat and Color Theory," 47.

Impressionists largely abandoned: Bomford, "The History of Colour in Art," 24.

Paul Signac: Roque, "Chevreul's Colour Theory," 18.

essentially how halftone: Nassau, *The Physics and Chemistry of Color: The Fifteen Causes of Color,* 14.

95 *But Chevreul didn't:* Roque, "Chevreul and Impressionism," 30.

So fashion designers: Nicklas, "One Essential Thing to Learn Is Colour: Harmony, Science and Colour Theory in Mid-Nineteenth-Century Fashion Advice," 221.

English translations: Nicklas, 219, 244.

World's Columbian Exposition opened: Harris, "Memory and the White City," 10.

"object lessons": de Wit, 62.

96 *Sullivan's Transportation Building:* Weingarden, "The Colors of Nature," 254.

"not so much many": Weingarden, *Louis H. Sullivan,* 296.

His embrace: Harris, "Memory and the White City," 10–11.

Sullivan was telling people just that: Sullivan, "The Tall Office Building Artistically Considered," 406.

his 1922 autobiography: Sullivan, *The Autobiography of an Idea,* 316.

97 *"'Hustle' was"*: Sullivan, *The Autobiography of an Idea,* 319.

"departed joyously": Sullivan, *The Autobiography of an Idea,* 320–21.

kind words: Sullivan, *The Autobiography of an Idea,* 322.

"The damage wrought": Sullivan, *The Autobiography of an Idea,* 325.

Lewis Mumford blamed: Mumford, *Sticks and Stones: A Study of American Architecture and Civilization,* 57–58.

98 *archaeological excavations:* Brinkmann, "A History of Research and Scholarship on the Polychromy of Ancient Sculpture," 14.

The same École des Beaux-Arts: Brinkmann, 14–15.

Greeks also used: Brinkmann et al., "Ancient Paints and Painting Techniques," 86–97.

the term "polychromy": Brinkmann, 16.

just an artifact: Brinkmann et al., 110.

depicted the Parthenon: Haynes, "When the Parthenon Had Dazzling Colours."

99 *"I feel here"*: Porter and Mikellides, *Colour for Architecture,* 25.

article in Harper's: Sturgis, "Recent Discoveries of Painted Greek Sculpture," 538–39.

one in Chicago: Brinkmann, 19.

who'd rebuilt Paris: Birren, *The Story of Color,* 114.

Olmsted's Midway Plaisance: Domosh, "A 'Civilized' Commerce: Gender, 'Race,' and Empire at the 1893 Chicago Exposition," 184.

pop-up village: Reed, "The Black Presence at 'White City': African and African American Participation at the World's Columbian Exposition, Chicago, May 1, 1893–October 31, 1893."

100 *digital doppelganger lives on:* Snyder, "The World's Columbian Exposition of 1893."

101 *painters who recorded:* Lovell, "Picturing 'A City for a Single Summer': Paintings of the World's Columbian Exposition," 41.

other Impressionists: Hines, 74.

102 *price of artificial light:* Fouquet and Pearson, "The Long Run Demand for Lighting: Elasticities and Rebound Effects in Different Phases of Economic Development," 90.

open at night: Lovell, 43.

Edison and General Electric: Wilkes, "Edison, Westinghouse and Tesla: The History Behind The Current War."

103 *first city lights:* Jackle, *City Lights: Illuminating the American Night,* 73.

incandescence: Osborne, "A History of Colour Theory in Art, Design and Science," 520.

the Edison tech: Skinner, "Lighting the World's Columbian Exposition," 19.

the reddish side: Kendricken, "Why Hollywood Will Never Look the Same Again on Film: LEDs Hit the Streets of LA & NY."

Lights glowed: Lovell, 42–43.

The Ferris wheel: White and Igleheart, *The World's Columbian Exposition, Chicago, 1893,* 301, 306.

104 *the Rainbow City:* Blaszczyk, *The Color Revolution,* 192.

Theatrical performances: Eskilson, "Color and Consumption," 19.

"the great gizmo": Banham, "The Great Gizmo," 110.

Designers learned: Meilke, 110.

105 *"chromatic revolution":* "The New Age of Color," 22; Eskilson, 17.

CHAPTER 6: TITANIUM WHITE

107 *unhappy former DuPont engineers:* Wilber, "Stealing White."

108 *Cynthia Ho:* US v. Liew et al., transcript, vol. 2, 239.

in Christina's purse: US v. Liew et al., transcript, vol. 2, 248.

a long look: US v. Liew et al., transcript, vol. 1, 123.

109 *The bank revealed:* USA v. Walter Liew and Christina Liew, 9.

three years of probation: "Two Individuals and Company Found Guilty in Conspiracy to Sell Trade Secrets to Chinese Companies."

110 *Crell's Annalen:* Gregor, "Observations and Experiments on Manacanite, a Magnetic Sand Found in Cornwall," 40.

Spellings and translations: Thompson, *The History of Chemistry,* 208.

not totally clear: Russell, "The Rev. William Gregor (1761–1817), Discoverer of Titanium," 618.

Even Gregor admitted: Bristow and Cleeveley, "Scientific Enquiry in Late Eighteenth Century Cornwall," 8.

Martin Klaproth: Thompson, 206.

111 *whatever was in red schörl:* Thompson, 207.

"distinct, metallic substance": Klaproth, *Analytical Essays Towards Promoting the Chemical Knowledge of Material Substances*, 201.

Klaproth found out: Thompson, 208.

got a sample: Bristow and Cleevely, 7.

misspelled the name: Klaproth, 499.

Human muscle: Baskerville, "On the Universal Distribution of Titanium," 1100.

The best steel: FitzGerald, "Perkin Medal Award — Mr. A. J. Rossi and His Work," 139.

New Jersey's state geologist: FitzGerald and Rossi, "Rossi and Titanium," 205.

112 *estate brought in Rossi:* Rossi, "Perkin Medal Award — Address of Acceptance," 141–42.

consulting engineer: FitzGerald and Rossi, 205.

25 percent: Rossi, "Titaniferous Ores in the Blast-Furnace," 833.

Others had tried: Rossi, "Titaniferous Ores in the Blast-Furnace," 835.

Furnaces in Stockton-on-Tyne: Rossi, "Titaniferous Ores in the Blast-Furnace," 839–40.

113 *light, superstrong metal:* Smith, *From Monopoly to Competition: The Transformations of Alcoa, 1888–1986*, 2, 96; Kienle, "The Relation of the Chemical Industry of Niagara Falls to the Water Works," 498.

Silica and carbon: Richards, "Niagara as an Electrochemical Centre," 14.

114 *the force of water:* "The History of Power Development in Niagara."

the 1870s: "The History of Power Development in Niagara."

two hundred ninety megawatts: Richards, "Niagara as an Electrochemical Centre," 12. Assuming my math and conversion is correct.

"fancies which": Richards, "Niagara as an Electrochemical Centre," 11.

The community heard stories: FitzGerald, 138.

against having visitors: Richards, "The Metallurgy of the Rarer Metals," 29.

graphite-containing bricks: FitzGerald and Rossi, 206.

"wonder-working alloy": "Titanium, the Wonder-Working Alloy."

Rossi experimented: Barksdale, *Titanium: Its Occurrence, Chemistry, and Technology*, 355.

115 *tended toward yellow:* Laver, "Titanium Dioxide Whites," 297.
developed and patented: Barksdale, 356.
Rossi won the Perkin Medal: Rossi, "Perkin Medal Award — Address of Acceptance," 145.
they found out about Florida: "The History of The Titanium Division: Titanox Pigments Early History and Development," in Chowkwanyun et al., *Toxic Docs: Version 1.0*, 26.

116 *clean it all up:* Gerety, "Broken Promises," 45.
northeastern Florida: "The History of the Titanium Division," 26.
Trail Ridge: Force and Rich, "Geologic Evolution of Trail Ridge Eolian Heavy-Mineral Sand and Underlying Peat, Northern Florida," 2.

117 *a wetland:* Force and Rich, 2.

118 *a hundred miles:* Pirkle and Yoho, "The Heavy Mineral Ore Body of Trail Ridge, Florida," 18.
Eolian sand: Force and Rich, 14.
the wave zone: Van Gosen and Ellefsen, *Titanium Mineral Resources in Heavy-Mineral Sands in the Atlantic Coastal Plain of the Southeastern United States*, 3.
fine strata: Van Gosen, 6.
Some little bit: Jones, "Mineral Sands: An Overview of the Industry," 4–6.

121 *chromium:* Osborne, "A History of Colour Theory in Art, Design and Science," 517.

122 *Cadmium:* Fiedler and Bayard, "Cadmium Yellows, Oranges, and Reds," 67.
vividly colored wallpapers: Meier, "Death by Wallpaper: The Alluring Arsenic Colors That Poisoned the Victorian Age."
whole new gamut: de Keijzer, "Microchemical Analysis on Synthetic Organic Artists' Pigments Discovered in the Twentieth Century," 220.
But put matter: Diebold, *Application of Light Scattering to Coatings: A User's Guide*, 6.

123 *high refractive index:* Nassau, *The Physics and Chemistry of Color: The Fifteen Causes of Color*, 285.

124 *sulfuric acid:* de Keijzer, "A Brief Survey of the Synthetic Inorganic Artists' Pigments Discovered in the Twentieth Century," 14.
it chalked: Toch, "Titanium White," 50.

public recognition: Heaton, "The Production of Titanium Oxide and Its Use as a Paint Material," 553.

the global market: Zlinkoff and Barnard, "The Supreme Court and a Competitive Economy: 1946 Term Trademarks, Patents and Antitrust Laws," 934.

his death: "Dr. Auguste J. Rossi, Discoverer of Titanium and Consulting Chemist at Big North End Plant, Is Dead."

125 *Photons would reflect:* Stieg, "Opaque White Pigments in Coatings," 1256.

absorb and scatter: Brill and Vik, "Kubelka, Paul," 1.

"hiding power": Stieg, 1256.

Kubelka-Munk equations: Kubelka and Munk, "An Article on Optics of Paint Layers," 593.

Kubelka figured out: Haber and Kubelka, Production of Titanium Dioxide from Titanium Tetrachloride, 1,931,380.

129 Pine Trees: Hara, *White,* 38.

130 *the 1925 fair:* Meikle, *Twentieth Century Limited: Industrial Design in America, 1929–1935,* 21.

Century of Progress exposition: Eskilson, "Color and Consumption," 24.

During the closing ceremony: Meikle, 4.

131 *Taut hoped:* Düttmann et al., *Color in Townscape: Handbook in Six Parts for Architects, Designers and Contractors for City-Dwellers and Other Observant People,* 19–20.

Sure, by spring: Düttmann et al., 22–23.

keeping up with demand: Kurylko, "Model T Had Many Shades; Black Dried Fastest."

fast-drying lacquer: "Duco Paint."

monopolistic purchase: "Irenee du Pont Says He Rebuffed Pierre on Exclusive Buying Pact."

Ford came around: "Tech Q&A — Paint Charts."

spate of new products: Meilke, 77.

"Lifebuoy Soap": Eskilson, 26.

132 *titanium-based paints:* "Introducing 'Ti-Bar' and 'Ti-Cal.'"

Malevich primarily: Railing, "Malevich's Suprematist Palette —'Colour Is Light,'" 48.

its other colors: van Driel et al., "The White of the Twentieth Century: An Explorative Survey into Dutch Modern Art Collections," 1.

Over in Holland: Porter, *Architectural Color: A Design Guide to Using Color on Buildings,* 18–19.

Jean Arp's Shirt Front and Fork: de Keijzer, "The History of Modern Synthetic Inorganic and Organic Artists' Pigments," 44.

The Bauhaus thinker: Moholy-Nagy, *The New Vision: Fundamentals of Bauhaus Design, Painting, Sculpture, and Architecture,* note 4, loc. 3229.

133 *"One cannot deny":* Moholy-Nagy, loc. 1152.

"degree zero": Joseph, "White on White," 92.

"nothing" and "silence": Joseph, 107, n. 39.

"its big brother": Moholy-Nagy, loc. 1152.

134 *cups called* qeros: Kaplan et al., "The Qero Project: Conservation and Science Collaboration over Time," 17.

Ollantaytambo qeros: Kaplan et al., 11.

rubbery resin: Newman et al., "Mopa Mopa: Scientific Analysis and History of an Unusual South American Resin Used by the Inka and Artisans in Pasto, Colombia," 123.

gooey stuff: Kaplan et al., 12–13.

135 *most of the pigments:* Howe et al., "The Occurrence of a Titanium Dioxide/Silica White Pigment on Wooden Andean Qeros: A Cultural and Chronological Marker," 3.

white mineral sand: Howe et al., 3.

at the Giacomo deposit: Kaplan et al., 19.

Vinland Map: Towe, "The Vinland Map Ink Is NOT Medieval," 863.

136 *white on the qeros:* Kaplan et al., 19.

CHAPTER 7. COLOR WORDS

138 *Paul Kay:* Wald, "Why Red Means Red in Almost Every Language."

139 *ranging from Arabic:* Berlin and Kay, *Basic Color Terms: Their Universality and Evolution,* 7.

an array: Berlin and Kay, 5.

irreducible quanta: Berlin and Kay, 5.

some kind of order: Kuehni, "Development of the Idea of Simple Colors in the Sixteenth and Early Seventeenth Centuries," 92.

140 *"color temperature":* Kendricken, "Why Hollywood Will Never Look the Same Again on Film: LEDs Hit the Streets of LA & NY."

141 *famously pointed out:* Gladstone, *Studies on Homer and the Homeric Age: Three Volumes in One,* loc. 25778.
 Gladstone dismisses: Gladstone, note 150.
 translated as "purple": Gladstone, loc. 29959.
 "wine-dark sea": Gladstone, loc. 25998.
 it's a mess: Gladstone, loc. 25885.
 lack the language: Sassi, "Can We Hope to Understand How the Greeks Saw Their World?"
 lack the gene: Nassau, *The Physics and Chemistry of Color: The Fifteen Causes of Color,* 346.

142 *Tyrian purple:* Cooksey, "Tyrian Purple: 6,6'-Dibromoindigo and Related Compounds."
 ten thousand snails: Nassau, 132.
 relative of indigo: Nassau, 132.
 color of water: Nassau, 75–77.
 whitecaps and foam: Nassau, 28, 77.
 silk or velour: Sassi.
 Allen sent letters: Allen, *The Colour-Sense: Its Origin and Development — An Essay in Comparative Psychology,* 204–5.

143 *indigenous people:* Allen, 208.
 "Andaman Islanders": Allen, 212.
 absence of words: Allen, 220.
 Emily Wilson: Homer, *The Odyssey,* 135.
 red painted prows: Homer, 503.
 occasionally grayish: Homer, 243.
 sometimes whitening: Homer, 245.

144 *fire safety inspector:* Whorf, *Language, Thought, and Reality: Selected Writings of Benjamin Lee Whorf,* 3.
 hidden meanings: Whorf, *Language, Thought, and Reality,* 13.
 Whorf published: Whorf, *Language, Thought, and Reality,* 27.

145 *series of articles:* Whorf, "Science and Linguistics," 272.
 "No individual": Whorf, "Science and Linguistics," 274.
 this dictum: Levinson, Foreword, loc. 114.
 it's a doozy: Woodworth, "The Psychology of Light," 386–87.

146 *Those difficulties:* Kuehni, "The Early Development of the Munsell System," 20; Kuehni and Schwarz, *Color Ordered: A Survey of Color Order Systems from Antiquity to the Present,* 228.

"barycentric arch": Turner, *In the Eye's Mind: Vision and the Helmholtz-Hering Controversy*, 98–99.

Albert Munsell: Kuehni, "The Early Development of the Munsell System," 21–22.

saturation or pastel-ness: Kuehni, "The Early Development of the Munsell System," 24.

147 *three mappable coordinates*: Nickerson, "History of the Munsell Color System."

what they found: Berlin and Kay, 2–3.

148 *Allen had proposed*: Allen, 255.

They hypothesized: Berlin and Kay, 16.

abstract pseudometric: Wald.

149 *late 1970s*: "The World Color Survey."

hooked up with: Kay et al., *The World Color Survey*, 13.

stated mission: "Our History."

front for the CIA: "Ecuador Bans Controversial Linguistics Institute."

even more laborious: Kay et al., 13–14.

2,616 people: Lindsey and Brown, "World Color Survey Color Naming Reveals Universal Motifs and Their Within-Language Diversity," 19785.

didn't bear out: Kay et al., 3.

"perceptual landmarks": Kay et al., 23.

150 *new shade of blue*: Hume, *A Treatise of Human Nature*, 10.

an exception: Nelson, "Hume's Missing Shade of Blue Re-Viewed," 354.

151 *Old French*: Nelson, 187.

complement to red: Gage, "Colour and Culture," 177.

Greek has two: Regier and Kay, "Language, Thought, and Color: Whorf Was Half Right," 442.

in Russian: Berlin and Kay, 35.

short-wavelength, bluish-sensing ones: "Cones and Color Vision."

They're wired: Zeki et al., "The Constancy of Colored After-Images," 6.

lighter-colored irises: Schmidt et al., "Circuitry to Explain How the Relative Number of L and M Cones Shapes Color Experience," 9.

yellowish pulp: Loskutova et al., "Macular Pigment and Its Contribution to Vision," 1963.

152 *"categorical perception":* Kwok et al., "Learning New Color Names Produces Rapid Increase in Gray Matter in the Intact Adult Human Cortex," 6687.

distinguish better: Franklin et al., "Categorical Perception of Color Is Lateralized to the Right Hemisphere in Infants, but to the Left Hemisphere in Adults," 3221.

three square color: Winawer et al., "Russian Blues Reveal Effects of Language on Color Discrimination," 7781.

same test: Winawer et al., 7783.

154 *person to person:* Schmidt et al., "Circuitry to Explain," 18.

four-month-olds: Bornstein et al., "Color Vision and Hue Categorization in Young Human Infants," 115; Bornstein et al., "The Categories of Hue in Infancy," 202.

155 *colored lights:* Franklin and Davies, "New Evidence for Infant Colour Categories," 352.

strap in some babies: Franklin and Davies, 353.

Babies can distinguish among: Skelton et al., "Biological Origins of Color Categorization," 5547, 5549.

156 *new research project:* Gibson et al., "Color Naming Across Languages Reflects Color Use," 10785.

CHAPTER 8: THE DRESS

160 *took a picture:* Wallisch, "Illumination Assumptions Account for Individual Differences in the Perceptual Interpretation of a Profoundly Ambiguous Stimulus in the Color Domain: 'The Dress,'" 2.

Grace posted: Warzell, "2/26: How Two Llamas and a Dress Gave Us the Internet's Greatest Day." McNeill's original Tumblr post is gone, but you can see it here: https://web.archive.org/web/20151030053615/http://swiked.tumblr.com/post/112073818575/guys-please-help-me-is-this-dress-white-and.

161 *Holderness made a poll:* Holderness, "What Colors Are This Dress?"

163 *Young had realized:* Kuehni and Schwarz, *Color Ordered: A Survey of Color Order Systems from Antiquity to the Present,* 130.

color constancy: Mollon, "Introduction: Thomas Young and the Trichromatic Theory of Colour Vision," xxviii.

Surfaces are tricky: Shevell and Kingdom, "Color in Complex Scenes," 144.

I wrote a story: Rogers, "The Science of Why No One Agrees on the Color of This Dress."

165 *appear the same:* Morgenstern et al., "Properties of Artificial Networks Evolved to Contend with Natural Spectra," 10868.

levels of brightness: Turner, *In the Eye's Mind: Vision and Helmholtz-Hering Controversy,* 28.

colored after-images: Lotto et al., "Seeing in Colour," 263.

scientific preoccupation: Gage, "Colour and Culture," 177.

color constancy: Hurlbert, "Colour Constancy," R907.

166 *called it Retinex:* Land, "The Retinex Theory of Color Vision."

published a paper: Brainard et al., "Bayesian Model of Human Color Constancy," 1269.

168 *pick the best color:* Lafer-Sousa et al., "Striking Individual Differences in Color Perception Uncovered by 'the Dress' Photograph," S13.

combinations including: Mahroo et al., "Do Twins Share the Same Dress Code? Quantifying Relative Genetic and Environmental Contributions to Subjective Perceptions of 'the Dress' in a Classical Twin Study," 3.

Most picked: Lafer-Sousa et al., R545.

"Gold" is: Okazawa et al., "Categorical Properties of the Color Term 'GOLD,'" 3.

"brown" is really: Buck, "Brown," R536.

naturally night owls: Wallisch, 6.

169 *blown-up image:* Lafer-Sousa et al., R546.

clipped the dress: Lafer-Sousa et al., Figure S2.

fMRI tube: Schlaffke et al., "The Brain's Dress Code: How the Dress Allows to Decode the Neuronal Pathway of an Optical Illusion," 272.

170 *entire cortex:* Schlaffke et al., 272.

171 *lateral geniculate nucleus:* Wiesel and Hubel, "Spatial and Chromatic Interactions in the Lateral Geniculate Body of the Rhesus Monkey," 1123–24.

172 *core explainers:* Hurlbert.

CHAPTER 9: FAKE COLORS AND COLOR FAKES

175 *Harvard University commissioned:* Stenger et al., "The Making of Mark Rothko's Harvard Murals," 331.

176 *fields of color:* Osborne, "A History of Colour Theory in Art, Design and Science," 525.

six canvasses: Stenger et al., "The Making of Mark Rothko's Harvard Murals," 332–33.

skilled technician: Stenger et al., "The Making of Mark Rothko's Harvard Murals," 332.

animal glue: Stenger et al., "The Making of Mark Rothko's Harvard Murals," 334, 337.

aluminum to alizarin: Schweppe and Winter, "Madder and Alizarin," 109, 124.

tears and dents: Menand, "Watching Them Turn Off the Rothkos."

177 *faded even faster:* Kelleher, "The Harvard Color Detectives."

organic binder: Laver, "Titanium Dioxide Whites," 314.

People who saw: Stenger et al., "Conservation of a Room: A Treatment Proposal for Mark Rothko's Harvard Murals," 349–50.

179 *adding glaze now:* Stenger et al., "Conservation of a Room," 350–51.

worried about art critics: Garber, "How to Restore a Rothko (Without Ruining a Rothko)."

blue and white light: Lafontaine, "Seeing Through a Yellow Varnish: A Compensating Illumination System," 100.

181 *defocus the projectors:* Stenger et al., "Conservation of a Room," 355–56.

matte/gloss action: Stenger et al., "Conservation of a Room," 357.

182 *People liked:* Menand.

expressed disappointment: Menand.

paintings don't emit light: Stenger et al., "Conservation of a Room," 358.

183 *Sometimes the dots:* Babaei et al., "Color Contoning for 3D Printing," 8.

called it "contoning": Babaei et al., 5.

184 *deeply chromatic:* Babaei et al., 4.

switched tactics: Babaei et al., 6.

more inks: Shi et al., "Deep Multispectral Painting Reproduction via Multi-Layer, Custom-Ink Printing," 4.

185 *train the AI:* Shi et al., 4. And I have a picture.

187 *ink palette:* Shi et al., 10.

incorporating a varnish: Elkhuizen et al., "Reproducing Oil Paint Gloss in Print for the Purpose of Creating Reproductions of Old Masters," 4.

188 *exact same directions:* Shi et al., 1, 12.

CHAPTER 10: SCREENS

189 *brightest, whitest white:* Vukusic et al., "Brilliant Whiteness in Ultrathin Beetle Scales," 348.

190 *fine web:* Yip et al., "Brilliant Whiteness Surfaces from Electrospun Nanofiber Webs," 776–77.

191 *an 1888 letter:* Van Gogh, "To Emile Bernard."

light-dark dimension: Kingdom, "Lightness, Brightness and Transparency: A Quarter Century of New Ideas, Captivating Demonstrations and Unrelenting Controversy," 653.

"mother of all": Mollon, "Monge: The Verriest Lecture, Lyon, July 2005," 305.

sometimes define it: Bosten et al., "What Is White?," 3.

cerulean line: Bosten et al., 4.

bad placeholder: Bosten et al., 15.

black and darkness: Schmidt et al., "The Spectral Identity of Foveal Cones Is Preserved in Hue Perception," 1.

192 *black Egyptian kohl:* Linton, *Ancient and Modern Colours, from the Earliest Periods to the Present Time: With Their Chemical and Artistical Properties,* 31–33.

194 *a guy fell:* Cascone, "A Man Fell into Anish Kapoor's Installation of a Bottomless Pit at a Portugal Museum."

195 *Kapoor told* Artforum: Bronner, "Anish Kapoor."

198 *2021 Venice Biennale:* Cascone, "Anish Kapoor Will Unveil His First Vantablack Sculptures During the Venice Biennale, Dazzling Visitors with the 'Blackest' Black Ever Made."

200 *serious themes:* Osborne, "A History of Colour Theory in Art, Design and Science," 524–25.

transmit a color signal: Osborne, "A History of Colour Theory in Art, Design and Science," 525.

201 *Pointer white-balanced:* Pointer, "The Gamut of Real Surface Colours," 147–48.

"Pointer's Gamut": Jansen, "The Pointer's Gamut: The Coverage of Real Surface Colors by RGB Color Spaces and Wide Gamut Displays."

Nobel Prize: Nobel Prize, Press Release.

202 *flat-screen TV:* Luo et al., "Television's Quantum Dot Future," 30–31.

208 *parts of the brain:* Murphey et al., "Perception Matches Selectivity in the Human Anterior Color Center," 216.

210 *Crum can decouple:* Darcy et al., "Physiological Capture of Augmented Viewing States: Objective Measures of High-Dynamic-Range and Wide-Color-Gamut Viewing Experiences," 8.

211 *good indicator:* Linden, "The P300: Where in the Brain Is It Produced and What Does It Tell Us?," 563.

CONCLUSION

213 *The Bioptron:* "Bioptron: A Breakthrough in Light Healing!"

214 *any effect effects:* Bowens, "Evidence Based Review: Bioptron Light Therapy," 11–12; Monstrey et al., "A Conservative Approach for Deep Dermal Burn Wounds Using Polarised-Light Therapy," 426. (Beware, this is a study of human burns, with graphic photos.)

"just a hobby": Nathans, "The Evolution and Physiology of Human Color Vision: Insights from Molecular Genetic Studies of Visual Pigments," 304.

synthesized from coal tar: Osborne, "A History of Colour Theory in Art, Design and Science," 519.

the periodic table: Osborne, "A History of Colour Theory in Art, Design and Science," 517.

viral coverage: Cascone, "The Wild Blue Yonder: How the Accidental Discovery of an Eye-Popping New Color Changed a Chemist's Life."

contains no actual: de Baun, "Hello, Bluetiful! There's a New YInMn Blue-Inspired Crayon."

couldn't figure out a red: Schonbrun, "The Quest for the Next Billion-Dollar Color."

215 *cosmetics:* Christie, *Colour Chemistry,* 252.

nail polish: Morante and DiGiovanna, *Colorants Used in the Cosmetics Industry,* 11.

just leave out: Morante and DiGiovanna, 18.

216 *highly reactive:* Winkler, *Titanium Dioxide: Production, Properties, and Effective Usage,* 83.

National Lead Company: Fujishima et al., "TiO_2 Photocatalysis and Related Surface Phenomena," 516–17.

coatings and stabilizers: Völz et al., "The Chemical Nature of Chalking in the Presence of Titanium Dioxide Pigments," 169.

hydrogen and oxygen: Fujishima and Honda, "Electrochemical Photolysis of Water at a Semiconductor Electrode," 38.

217 *self-cleaning:* Paz et al., "Photooxidative Self-Cleaning Transparent Titanium Dioxide Films on Glass," 2847.

a little copper: Fujishima et al., 554.

Thousands of buildings in Japan: Fujishima et al., 565.

219 *reddish to brownish:* Xiao et al., "Characterising the Variations in Ethnic Skin Colours: A New Calibrated Data Base for Human Skin," 27.

called melanosomes: Wasmeier et al., "Melanosomes at a Glance," 3995.

220 *complex melanin patterns:* Xiao et al., "Bio-Inspired Structural Colors Produced via Self-Assembly of Synthetic Melanin Nanoparticles," 5454.

out of polystyrene: Meng et al., "Core–Shell Colloidal Particles with Dynamically Tunable Scattering Properties," 6293.

along different axes: Saranathan et al., "Structure and Optical Function of Amorphous Photonic Nanostructures from Avian Feather Barbs: A Comparative Small Angle X-Ray Scattering (SAXS) Analysis of 230 Bird Species," 2569.

223 *"All art":* Allen, *The Colour-Sense: Its Origin and Development—An Essay in Comparative Psychology,* 281.

BIBLIOGRAPHY

Abel, A. "The History of Dyes and Pigments." In *Colour Design: Theories and Applications*. 2nd ed. Edited by Janet Best. Cambridge: Elsevier, 2012, https://doi.org/10.1016/b978-0-08-101270-3.00024-2.

"*Aedes aegypti* — Factsheet for Experts." European Center for Disease Control, December 20, 2016. https://ecdc.europa.eu/en/disease-vectors/facts/mosquito-factsheets/aedes-aegypti. Accessed May 17, 2020.

Allen, Grant. *The Colour-Sense: Its Origin and Development — An Essay in Comparative Psychology*. Boston: Houghton, Osgood and Co., 1879.

Angell, Marcia, and Jerome P. Kassirer. "The Ingelfinger Rule Revisited." *New England Journal of Medicine* 325, no. 19 (November 7, 1991): 1371–73, https://doi.org/10.1056/NEJM199111073251910.

Ansari, Shaikh Mohammad Razaullah. "Ibn al-Haytham's Scientific Method." *UNESCO Courier*, https://en.unesco.org/courier/news-views-online/ibn-al-haytham-s-scientific-method. Accessed September 15, 2018.

Aristotle. *Meterologica*. Book III, http://classics.mit.edu/Aristotle/meterology.3.iii.html.

"Augustus and Peter Porter." *Niagara Falls Info*, https://www.niagarafallsinfo.com/niagara-falls-history/niagara-falls-power-development/the-history-of-power-development-in-niagara/augustus-and-peter-porter/. Accessed May 26, 2020.

"The Australian Rock Art Archive," The Bradshaw Foundation, http://www.bradshawfoundation.com/bradshaws/bradshaw_paintings.php. Accessed May 17, 2020.

Babaei, Vahid, Kiril Vidimče, Michael Foshey, Alexandre Kaspar, Piotr Di-

dyk, and Wojciech Matusik. "Color Contoning for 3D Printing." *ACM Transactions on Graphics (SIGGRAPH 2017)* 36, no. 4 (July 2017): 1–15, https://doi.org/10.1145/3083157.3092885.

Balaram, Padmini Tolat. "Indian Indigo." In *The Materiality of Color: The Production, Circulation, and Application of Dyes and Pigments, 1400–1800,* 139–54. Edited by Andrea Feeser, Maureen Daly Goggin, and Beth Fowkes Tobin. Abingdon: Routledge, 2016.

Banham, Reyner. "The Great Gizmo." In *Design by Choice,* 108–14. Edited by Peggy Sparke. London: Academy Editions, 1981.

Barksdale, Jelks. *Titanium: Its Occurrence, Chemistry, and Technology.* New York: Ronald Press Co., 1949.

Barrett, Sylvana, and Dusan Stulik. "An Integrated Approach for the Study of Painting Techniques." In *Historical Painting Techniques, Materials, and Studio Practice. Preprints of a Symposium, University of Leiden, the Netherlands. 26–29 June 1995,* 6–11. Edited by Arie Wallert, Erma Hermens and Marja Peek. Los Angeles: Getty Conservation Institute, 1995.

Baskerville, Charles. "On the Universal Distribution of Titanium." *Journal of the American Chemical Society* 21, no. 12 (December 1899): 1099–101, https://doi.org/10.1021/ja02062a006.

Batchelor, David. *Chromophobia.* London: Reaktion Books, 2000.

Bednarik, Robert G. "A Taphonomy of Palaeoart." *Antiquity* 68, no. 258 (March 26, 1994): 68–74, https://doi.org/10.1017/S0003598X00046202.

Benn, Charles. *China's Golden Age: Everyday Life in the Tang Dynasty.* Oxford: Oxford University Press, 2002.

Bentley-Condit, Vicki, and E. O. Smith. "Animal Tool Use: Current Definitions and an Updated Comprehensive Catalog." *Behaviour* 147, no. 2 (2010): 185–221, A1–A32, https://doi.org/10.1163/000579509X1251 2865686555.

Berke, Heinz. "Chemistry in Ancient Times: The Development of Blue and Purple Pigments." *Angewandte Chemie International Edition* 41, no. 14 (July 15, 2002): 2483–87, https://doi.org/10.1002/1521 -3773(20020715)41:14<2483::AID-ANIE2483>3.0.CO;2-U.

Berke, Heinz, and Hans G. Wiedemann. "The Chemistry and Fabrication of the Anthropogenic Pigments Chinese Blue and Purple in Ancient China." *East Asian Science, Technology, and Medicine* 17 (2000): 94–119.

Berlin, Brent, and Paul Kay. *Basic Color Terms: Their Universality and Evolution.* Palo Alto, CA: CSLI Publications, 1999.

Berrie, Barbara H. "Mining for Color: New Blues, Yellows, and Translu-

cent Paint." *Early Science and Medicine* 20, no. 4–6 (December 7, 2015): 308–34, https://doi.org/10.1163/15733823-02046p02.

Berrie, Barbara H., and Louisa Matthew. "Lead White from Venice: A Whiter Shade of Pale?" In *Studying Old Master Paintings: Technology and Practice: The National Gallery Technical Bulletin 30th Anniversary Conference Postprints,* 295–301. Edited by Marika Spring, Helen Howard, Jo Kirby, Joseph Padfield, Peggie David, Ashok Roy, and Ann Stephenson-Wright. Washington, DC: Archetype, 2011.

"Bioptron: A Breakthrough in Light Healing!" Bioptron.com, http://www.bioptron.com/How-it-Works/Bioptron-Light-Therapy.aspx. Accessed June 8, 2020.

Birren, Faber. *The Story of Color.* Westport, CT: Crimson Press, 1941.

Blaszczyk, Regina Lee. *The Color Revolution.* Cambridge, MA: MIT Press, 2012.

Boaretto, Elisabetta, Xiaohong Wu, Jiarong Yuan, Ofer Bar-Yosef, Vikki Chu, Yan Pan, Kexin Liu, et al. "Radiocarbon Dating of Charcoal and Bone Collagen Associated with Early Pottery at Yuchanyan Cave, Hunan Province, China." *Proceedings of the National Academy of Sciences* 106, no. 24 (June 16, 2009): 9595–600, https://doi.org/10.1073/pnas.0900539106.

Bomford, David. "The History of Colour in Art." In *Colour: Art and Science.* Edited by Trevor Lamb and Janine Bourriau. Cambridge: Cambridge University Press, 1995.

Bornstein, Marc H., William Kessen, and Sally Weiskopf. "The Categories of Hue in Infancy." *Science* 191, no. 4223 (January 16, 1976): 201–2, https://doi.org/10.1126/science.1246610.

——. "Color Vision and Hue Categorization in Young Human Infants." *Journal of Experimental Psychology: Human Perception and Performance* 2, no. 1 (1976): 115–29, https://doi.org/10.1037/0096-1523.2.1.115.

Bosten, J. M., R. D. Beer, and D. I. A. MacLeod. "What Is White?" *Journal of Vision* 15, no. 16 (December 7, 2015): 1–19, https://doi.org/10.1167/15.16.5.

Bowens, Amanda. "Evidence Based Review: Bioptron Light Therapy." New Zealand: Accident Compensation Corporation, 2006.

Boyer, Carl B. "Robert Grosseteste on the Rainbow." *Osiris* 11 (1954): 247–58.

Bradford, S. C. "Colour and Chemical Structure." *Science Progress in the Twentieth Century (1906–1916)* 10, no. 39 (1916): 361–68.

Brainard, David H., Philippe Longère, Peter B. Delahunt, William T. Free-

man, James M. Kraft, and Bel Xiao. "Bayesian Model of Human Color Constancy." *Journal of Vision* 6, no. 11 (November 1, 2006): 1267–81, https://doi.org/10.1167/6.11.10.

Brill, Michael H., and Michal Vik. "Kubelka, Paul." In *Encyclopedia of Color Science and Technology,* 188: 1–3. Edited by R. Luo. Berlin, Heidelberg: Springer Berlin Heidelberg, 2014, https://doi.org/10.1007/978-3-642-27851-8_300-1.

Brinkmann, Vinzenz. "A History of Research and Scholarship on the Polychromy of Ancient Sculpture." In *Gods in Color: Polychromy in the Ancient World,* 13–26. Edited by Vinzenz Brinkmann, Renée Dreyfus, and Ulrike Koch-Brinkmann. Munich: Fine Arts Museums of San Francisco — Legion of Honor and DelMonico Books — Prestel, 2017.

Brinkmann, Vinzenz, Ulrike Koch-Brinkmann, and Heinrich Piening. "Ancient Paints and Painting Techniques." In *Gods in Color: Polychromy in the Ancient World,* 86–97. Edited by Vinzenz Brinkmann, Renée Dreyfus, and Ulrike Koch-Brinkmann. Munich: Fine Arts Museums of San Francisco — Legion of Honor and DelMonico Books — Prestel, 2017.

Bristow, Colin M., and Ron J. Cleevely. "Scientific Enquiry in Late Eighteenth Century Cornwall and the Discovery of Titanium." In *The Osseointegration Book: From Calvarium to Calcaneus,* 1–11. Edited by Per-Ingvar Brånemark. Berlin: Quintessenz Verlags-GmbH, 2005.

Broecke, Lara. *Cennino Cennini's Il Libro dell'arte: A New English Translation and Commentary with Italian Transcription.* London: Archetype Publications, 2015.

Bronner, Julian Ellis. "Anish Kapoor." *Artforum.* April 3, 2015, https://www.artforum.com/words/id=51395.

Buck, Steven L. "Brown." *Current Biology* 25, no. 13 (June 2015): R536–37, https://doi.org/10.1016/j.cub.2015.05.029.

"Burnham and Root." *Encyclopedia of Chicago.* http://encyclopedia.chicagohistory.org/pages/2581.html. Downloaded May 22, 2020.

Carlyle, Leslie A. "Beyond a Collection of Data: What We Can Learn from Documentary Sources on Artists' Materials and Techniques." In *Historical Painting Techniques, Materials, and Studio Practice: Preprints of a Symposium, University of Leiden, the Netherlands, 26–29 June 1995,* 1–5. Edited by Arie Wallert, Erma Hermens, and Marja Peek. Los Angeles: Getty Conservation Institute, 1995.

Cascone, Sarah. "Anish Kapoor Will Unveil His First Vantablack Sculp-

tures During the Venice Biennale, Dazzling Visitors with the 'Blackest' Black Ever Made." *Artnet News,* March 12, 2020, https://news.artnet .com/exhibitions/anish-kapoor-first-vantablack-sculptures-venice -biennale-1801614. Accessed September 23, 2020.

——. "A Man Fell into Anish Kapoor's Installation of a Bottomless Pit at a Portugal Museum." *Artnet News,* August 20, 2018, https://www .theartnewspaper.com/news/man-hospitalised-after-falling-in-anish -kapoor-installation.

——. "The Wild Blue Yonder: How the Accidental Discovery of an Eye-Popping New Color Changed a Chemist's Life." *Artnet News,* June 19, 2017, https://news.artnet.com/art-world/yinmn-blue-to-be-sold -commercially-520433.

Cennini, Cennino D'Andrea. *The Craftsman's Handbook.* (*Il Libro dell'arte*). Translated by Daniel V. Thompson. New York: Dover Publications, 1960.

Chevreul, M. E. *The Laws of Contrast of Colour and Their Application to the Arts of Painting, Decoration of Buildings, Mosaic Work, Tapestry and Carpet Weaving . . .* Translated by John Spanton. London: Routledge, Warne, and Routledge, 1861.

Chittka, Lars, and Axel Brockmann. "Perception Space — The Final Frontier." *PLoS Biology* 3, no. 4 (April 12, 2005): 0564–68, https://doi.org/10 .1371/journal.pbio.0030137.

Choulant, Ludwig. *History and Bibliography of Anatomic Illustration in Its Relation to Anatomic Science and the Graphic Arts.* Translated by Mortimer Frank. Chicago: University of Chicago Press, 1917.

Chowkwanyun, Merlin, Gerald Markowitz, and David Rosner. "The History of the Titanium Division: Titanox Pigments Early History and Development." In *Toxic Docs: Version 1.0* [database], 26. New York: Columbia University and City University of New York, 2018, https://www .toxicdocs.org/d/byYKO4DZXJNog2LwgvkmN0Bz1.

Christiansen, Rupert. *City of Light: The Transformation of Paris.* New York: Basic Books, 2018.

Christie, Robert M. *Colour Chemistry.* 2nd ed. Cambridge: Royal Society of Chemistry, 2015.

Clarke, M., P. Frederickx, M. P. Colombini, A. Andreotti, J. Wouters, M. van Bommel, N. Eastaugh, V. Walsh, T. Chaplin, and R. Siddall. "Pompeii Purpurissum Pigment Problems." In *Eighth International Conference on Non-Destructive Investigations and Microanalysis for the Diag-*

nostics and Conservation of the Cultural and Environmental Heritage, 1–20. Lecce, Italy, 2005.

Cliff, Alice. "Dirty Green and the Anatomy of Colour." *Science and Industry Museum Blog,* September 6, 2016, https://blog.scienceandindu strymuseum.org.uk/john-dalton-colour/. Accessed February 24, 2019.

Cockburn, William. *The Symptoms, Nature, Cause, and Cure of Gonorrhoea.* 2nd ed. London: G. Straghan, 1715.

"Cones and Color Vision." In *Neuroscience.* 2nd ed. Edited by Dale Purves, George J. Augustine, David Fitzpatrick, Lawrence C. Katz, Anthony-Samuel LaMantia, James O. McNamara, and S. Mark Williams. Sunderland, MA: Sinauer Associates, 2001, https://www.ncbi.nlm.nih.gov/books/NBK11059.

Cooksey, Christopher. "Tyrian Purple: 6,6'-Dibromoindigo and Related Compounds." *Molecules* 6, no. 9 (August 31, 2001): 736–69, https://doi .org/10.3390/60900736.

Crombie, A. C. *Robert Grosseteste and the Origins of Experimental Science, 1100–1700.* Oxford: Oxford University Press, 1953.

Cuthill, Innes C., William L. Allen, Kevin Arbuckle, Barbara Caspers, George Chaplin, Mark E. Hauber, Geoffrey E. Hill, et al. "The Biology of Color." *Science* 357, no. 6350 (August 4, 2017): eaan0221, https://doi .org/10.1126/science.aan0221.

Dalton, John. "Extraordinary Facts Relating to the Vision of Colours: With Observations." *Memoirs of the Literary and Philosophical Society of Manchester* 5, no. 1 (1798): 28–45, https://doi.org/10.1037/11304-013.

Darcy, Dan, Evan Gitterman, Alex Brandmeyer, Scott Daly, and Poppy Crum. "Physiological Capture of Augmented Viewing States: Objective Measures of High-Dynamic-Range and Wide-Color-Gamut Viewing Experiences." *Electronic Imaging* 16 (2016): 1–9.

Darwin, Charles. Letter to AR Wallace, February 26, 1867. Darwin Correspondence Project, "Letter no. 5420," http://www.darwinproject.ac .uk/DCP-LETT-5420. Accessed September 3, 2018.

Dash, Mike. "The Demonization of Empress Wu." *Smithsonian,* August 10, 2012. https://www.smithsonianmag.com/history/the-demonization -of-empress-wu-20743091/. Accessed September 23, 2020.

de Baun, Katharine. "Hello, Bluetiful! There's a New YInMn Blue–Inspired Crayon." Oregon State University, September 15, 2017, http:// impact.oregonstate.edu/2017/09/bluetiful-crayola-names-new -yimmn-blue-inspired-crayon/.

de Keijzer, Matthijs. "A Brief Survey of the Synthetic Inorganic Artists' Pigments Discovered in the Twentieth Century." In *ICOM Committee for Conservation, Ninth Triennial Meeting, German Democratic Republic, 26–31 August 1990,* 214–18. Edited by Kristen Grimstad. Los Angeles: International Council of Museums Committee for Conservation, 1990.

———. "The History of Modern Synthetic Inorganic and Organic Artists' Pigments." In *Contributions to Conservation: Research in Conservation at the Netherlands Institute for Cultural Heritage (ICN Instituut Collectie Nederland),* 42–54. Edited by Jaap A. Mosk and Norman H. Tennent. London: James and James (Science Publishers), 2002.

———. "Microchemical Analysis on Synthetic Organic Artists' Pigments Discovered in the Twentieth Century." In *ICOM Committee for Conservation, 9th Triennial Meeting, German Democratic Republic, 26–31 August 1990,* 220–25. Edited by Kristen Grimstad. Los Angeles: International Council of Museums Committee for Conservation, 1990.

Delamare, François, and Bernard Guineau. *Colors: The Story of Dyes and Pigments.* Translated by Sophie Hawkes. New York: Harry N. Abrams, 2000.

d'Errico, Francesco, Christopher Henshilwood, Marian Vanhaeren, and Karen van Niekerk. "*Nassarius Kraussianus* Shell Beads from Blombos Cave: Evidence for Symbolic Behaviour in the Middle Stone Age." *Journal of Human Evolution* 48, no. 1 (January 2005): 3–24, https://doi.org/10.1016/j.jhevol.2004.09.002.

de Wit, Wim. "Building an Illusion: The Design of the World's Columbian Exposition." In *Grand Illusions: Chicago's World's Fair of 1893,* 41–98. Edited by Neil Harris, Wim de Wit, James Gilbert, and Robert W. Rydell. Chicago: Chicago Historical Society, 1993.

Dickens, Charles. "A Small Star in the East." In *The Uncommercial Traveller.* London: Chapman & Hall, 1905, http://www.gutenberg.org/files/914/914-h/914-h.htm#page258.

Diebold, Michael P. *Application of Light Scattering to Coatings: A User's Guide.* Cham, Switzerland: Springer, 2014.

Dijkstra, Albert J. "How Chevreul (1786–1889) Based His Conclusions on His Analytical Results." *Oléagineux, Corps Gras, Lipides* 16, no. 1 (January 15, 2009): 8–13, https://doi.org/10.1051/ocl.2009.0239.

Domosh, Mona. "A 'Civilized' Commerce: Gender, 'Race,' and Empire at the 1893 Chicago Exposition." *Cultural Geographies* 9 (2002): 181–201, https://doi.org/10.1191/1474474002eu242oa.

"Dr. Auguste J. Rossi, Discoverer of Titanium and Consulting Chemist at Big North End Plant, Is Dead." *Niagara Falls Gazette,* September 20, 1926.

Drew, John. *Dickens' Journalism, Vol. IV: "The Uncommon Traveler" and Other Papers, 1859–1870.* JM Dent/Orion Publishing Group, 2000. Reprinted in Dickens Journal Online, http://www.djo.org.uk/media/downloads/articles/5649_New%20Uncommercial%20Samples_%20A%20Small%20Star%20in%20the%20East%20[xxxi].pdf.

"Duco Paint," DuPont Heritage, https://web.archive.org/web/20081230211716/http://heritage.dupont.com:80/touchpoints/tp_1923/depth.shtml. Accessed May 28, 2020.

Düttmann, Martina, Friedrich Schmuck, and Johannes Uhl, eds. *Color in Townscape: Handbook in Six Parts for Architects, Designers and Contractors for City-Dwellers and Other Observant People.* Translated by John William Gabriel. London: The Architectural Press, 1981.

"Ecuador Bans Controversial Linguistics Institute," *Washington Post,* May 29, 1981.

Elkhuizen, Willemijn S., Boris a. J. Lenseigne, Teun Baar, Wim Verhofstad, Erik Tempelman, Jo M. P. Geraedts, and Joris Dik. "Reproducing Oil Paint Gloss in Print for the Purpose of Creating Reproductions of Old Masters." In *Proceedings of SPIE 9398, Measuring, Modeling, and Reproducing Material Appearance 2015-IS&T Electronic Imaging.* Edited by Maria V. Ortiz Segovia, Philipp Urban, and Francisco H. Imai. 9398:93980W, 2015, https://doi.org/10.1117/12.2082918.

Eskilson, Stephen. "Color and Consumption." *Design Issues* 18, no. 2 (April 2002): 17–29, https://doi.org/10.1162/074793602317355756.

Feller, Robert L., and Michael Bayard. "Terminology and Procedures Used in the Systematic Examination of Pigment Particles with the Polarizing Microscope." In *Artists' Pigments: A Handbook of Their History and Characteristics.* Vol. 1, 285–98. Edited by Robert L. Feller. Washington, DC: National Gallery of Art, 1986.

Fiedler, Inge, and Michael A. Bayard. "Cadmium Yellows, Oranges, and Reds." *Artists' Pigments: A Handbook of Their History and Characteristics.* Vol. 1, 65–108. Edited by Robert L. Feller. Washington, DC: National Gallery of Art, 1986.

Fischer, Martin. *The Permanent Palette.* Mountain Lake Park, MD: National Publishing Society, 1930.

FitzGerald, Francis A. J. "Perkin Medal Award — Mr. A. J. Rossi and His Work." *Journal of Industrial & Engineering Chemistry* 10, no. 2 (February 1918): 138–40.

FitzGerald, Francis A. J., and Auguste J. Rossi. "Rossi and Titanium." *The Mining Magazine,* April 1918, 205–7.

Fitzhugh, Elisabeth West. "Red Lead and Minium." In *Artists' Pigments: A Handbook of Their History and Characteristics.* Vol. 1, 109–140. Edited by Robert L. Feller. Washington, DC: National Gallery of Art, 1986.

Flecker, Michael. "A Ninth-Century Arab or Indian Shipwreck in Indonesian Waters." *International Journal of Nautical Archaeology* 29, no. 2 (2000): 199–217, https://doi.org/10.1006/ijna.2000.0316.

——. "A Ninth-Century AD Arab or Indian Shipwreck in Indonesia: First Evidence for Direct Trade with China." *World Archaeology* 32, no. 3 (2001): 335–54, https://doi.org/10.1080/0043824012004866.

——. "A Ninth-Century Arab or Indian Shipwreck in Indonesian Waters: Addendum." *International Journal of Nautical Archaeology* 37, no. 2 (September 2008): 384–86, https://doi.org/10.1111/j.1095-9270.2008.00193.x.

Force, Eric R., and Frederick J. Rich. "Geologic Evolution of Trail Ridge Eolian Heavy-Mineral Sand and Underlying Peat, Northern Florida." United States Geological Survey. Vol. 1499. Washington, DC, 1989.

Fouquet, Roger, and Peter J. G. Pearson. "The Long Run Demand for Lighting: Elasticities and Rebound Effects in Different Phases of Economic Development." *Economics of Energy & Environmental Policy* 1, no. 1 (January 1, 2012): 83–100, https://doi.org/10.5547/2160-5890.1.1.8.

Franklin, Anna, and Ian R. L. Davies. "New Evidence for Infant Colour Categories." *British Journal of Developmental Psychology* 22, no. 3 (September 2004): 349–77, https://doi.org/10.1348/0261510041552738.

Franklin, Anna, G. V. Drivonikou, L. Bevis, Ian R. L. Davies, P. Kay, and T. Regier. "Categorical Perception of Color Is Lateralized to the Right Hemisphere in Infants, but to the Left Hemisphere in Adults." *Proceedings of the National Academy of Sciences* 105, no. 9 (March 4, 2008): 3221–25, https://doi.org/10.1073/pnas.0712286105.

Franklin, Benjamin. "To Benjamin Vaughan." July 31, 1786. The Papers of Benjamin Franklin, http://franklinpapers.org/yale?vol=44&page=238&ssn=001-71-0028. Accessed December 31, 2018.

Fujishima, Akira, and Kenichi Honda. "Electrochemical Photolysis of

Water at a Semiconductor Electrode." *Nature* 238, no. 5358 (July 1972): 37–38, https://doi.org/10.1038/238037a0.

Fujishima, Akira, Xintong Zhang, and Donald A. Tryk. "TiO_2 Photocatalysis and Related Surface Phenomena." *Surface Science Reports* 63, no. 12 (December 15, 2008): 515–82, https://doi.org/10.1016/j.surfrep.2008 .10.001.

Funderburg, Anne Cooper. "Paint Without Pain." *Invention and Technology* 17, no. 4 (Spring 2002): 48–56, https://www.inventionandtech .com/content/paint-without-pain-0. Accessed October 4, 2020.

Gage, John. "Colour and Culture." In *Colour: Art and Science*. Edited by Trevor Lamb and Janine Bourriau. Cambridge: Cambridge University Press, 1995.

Garber, Megan. "How to Restore a Rothko (Without Ruining a Rothko)." *Atlantic*, May 28, 2014, https://www.theatlantic.com/technology/ archive/2014/05/how-to-restore-a-rothko-without-ruining-a-rothko/ 371769/.

Gerety, Rowan Moore. "Broken Promises." *Scientific American*, July 2019, 43–49.

Gettens, Rutherford J., Hermann Kühn, and W. T. Chase. "Lead White." In *Artists' Pigments: A Handbook of Their History and Characteristics*. Vol. 2, 67–82. Edited by Ashok Roy. Washington, DC: National Gallery of Art, 1993, https://doi.org/10.2307/1506614.

Gibson, Edward, Richard Futrell, Julian Jara-Ettinger, Kyle Mahowald, Leon Bergen, Sivalogeswaran Ratnasingam, Mitchell Gibson, Steven T. Piantadosi, and Bevil R. Conway. "Color Naming Across Languages Reflects Color Use." *Proceedings of the National Academy of Sciences* 114, no. 40 (October 3, 2017): 10785–90, https://doi.org/10.1073/pnas .1619666114.

Gladstone, William E. *Studies on Homer and the Homeric Age: Three Volumes in One*. Oxford: Owlfoot Press, 2016. Kindle.

Glazebrook, Allison. "Cosmetics and Sôphrosunê: Ischomachos' Wife in Xenophon's Oikonomikos." *Classical World* 102, no. 3 (2009): 233–48, https://www.jstor.org/stable/40599847.

Gleick, James. *Isaac Newton*. New York: Vintage Books, 2004.

Goldsmith, Timothy H. "What Birds See." *Scientific American*, July 2006, 68–71, https://doi.org/10.1038/scientificamerican0706-68.

Gregor, William. "Observations and Experiments on Manacanite, a Mag-

netic Sand Found in Cornwall." *Chemische Annalen für die Freunde der Naturlehre, Arzneygelahrtheit, Haushaltungskunst und Manufakturen* 15 (1791): 40–54, 103–19.

——. "On Manaccanite, a Species of Magnetic Sand Found in the Province of Cornwall." *Journal de Physique* 39 (July 1791): 152–60.

Griffiths, J. "The Historical Development of Modern Colour and Constitution Theory." *Review of Progress in Coloration and Related Topics* 14, no. 1 (October 23, 1984): 21–32, https://doi.org/10.1111/j.1478-4408.1984.tb00041.x.

Grissom, Carol A. "Green Earth." In *Artists' Pigments: A Handbook of Their History and Characteristics.* Vol. 1, 141–68. Edited by Robert L. Feller. Washington, DC: National Gallery of Art, 1986.

Guy, John. "Rare and Strange Goods: International Trade in Ninth-Century Asia." In *Shipwrecked: Tang Treasures and Monsoon Winds,* 19–33. Edited by Regina Krahl, John Guy, J. Keith Wilson, and Julian Raby. Washington, DC: Arthur M. Sacker Gallery, Smithsonian Institution, 2010.

Haber, Hermann, and Paul Kubelka. Production of Titanium Dioxide from Titanium Tetrachloride. 1,931,380. USA: United States Patent Office, issued 1931.

Halford, Bethany. "Understanding Oil-Paint Brittleness." *Chemical and Engineering News* 89, no. 34 (August 22, 2011): 38–39, http://pubs.acs.org/cen/science/89/8936scic7.html.

Hallett, Jessica. "Imitation and Inspiration: The Ceramic Trade from China to Basra and Back." In *UNESCO Maritime Silk Roads Expedition,* 1–6. Goa: UNESCO, 1990, http://docplayer.net/28549561-Imitation-and-inspiration-the-ceramic-trade-from-china-to-basra-and-back-jessica-hallett-1-oxford-university.html. Accessed September 26, 2020.

——. "Pearl Cups Like the Moon: The Abbasid Reception of Chinese Ceramics." In *Shipwrecked: Tang Treasures and Monsoon Winds,* 75–84. Edited by Regina Krahl, John Guy, J. Keith Wilson, and Julian Raby. Washington, DC: Arthur M. Sackler Gallery, Smithsonian Institution, 2010.

Hara, Kenya. *White.* Zurich, Switzerland: Lars Müller Publishers, 2009.

Harris, Bernard, and Jonas Helgertz. "Urban Sanitation and the Decline of Mortality." *History of the Family* 24, no. 2 (April 3, 2019): 207–26, https://doi.org/10.1080/1081602X.2019.1605923.

Harris, Neil. "Memory and the White City." In *Grand Illusions: Chicago's*

World's Fair of 1893, 1–40. Edited by Neil Harris, Wim de Wit, James Gilbert, and Robert W. Rydell. Chicago: Chicago Historical Society, 1993.

Haynes, Natalie. "When the Parthenon Had Dazzling Colours." BBC.com, January 22, 2018, http://www.bbc.com/culture/story/20180119-when-the-parthenon-had-dazzling-colours.

Heaton, Noel. "The Production of Titanium Oxide and Its Use as a Paint Material." *Journal of the Royal Society of Arts* 70, no. 3632 (1922): 552–65.

Helwig, Kate. "Iron Oxide Pigments: Natural and Synthetic." In *Artists' Pigments: A Handbook of Their History and Characteristics*. Vol. 4, 39–109. Washington, DC: National Gallery of Art, 2007.

Henderson, Richard. "The Purple Membrane from Halobacterium Halobium." *Annual Review of Biophysics and Bioengineering* 6, no. 1 (June 1977): 87–109, https://doi.org/10.1146/annurev.bb.06.060177.000511.

Henshilwood, Christopher S., F. D'Errico, K. L. van Niekerk, Y. Coquinot, Z. Jacobs, S.-E. Lauritzen, M. Menu, and R. Garcia-Moreno. "A 100,000-Year-Old Ochre-Processing Workshop at Blombos Cave, South Africa." *Science* 334, no. 6053 (2011): 219–22, https://doi.org/10.1126/science.1211535.

Henshilwood, Christopher S., Francesco d'Errico, and Ian Watts. "Engraved Ochres from the Middle Stone Age Levels at Blombos Cave, South Africa." *Journal of Human Evolution* 57, no. 1 (2009): 27–47, http://dx.doi.org/10.1016/j.jhevol.2009.01.005.

Hines, Thomas S. *Burnham of Chicago: Architect and Planner.* New York: Oxford University Press, 1974.

"The History of Power Development in Niagara," *Niagara Falls Info*, https://www.niagarafallsinfo.com/niagara-falls-history/niagara-falls-power-development/the-history-of-power-development-in-niagara/. Accessed May 26, 2020.

Hodgskiss, Tammy, and Lyn Wadley. "How People Used Ochre at Rose Cottage Cave, South Africa: Sixty Thousand Years of Evidence from the Middle Stone Age." *PLoS ONE* 12, no. 4 (2017): 1–24, https://doi.org/10.1371/journal.pone.0176317.

Holderness, Cates. "What Colors Are This Dress?" *BuzzFeed*, February 26, 2015, https://www.buzzfeed.com/catesish/help-am-i-going-insane-its-definitely-blue. Accessed September 22, 2020.

Holley, Clifford Dyer. *The Lead and Zinc Pigments*. New York: John Wiley & Sons, 1909.

Homer. *The Odyssey*. Translated by Emily Wilson. New York: W. W. Norton & Co., 2018.

Hong, Sungmin, J.-P. Candelone, Clair C. Patterson, and Claude F. Boutron. "Greenland Ice Evidence of Hemispheric Lead Pollution Two Millennia Ago by Greek and Roman Civilizations." *Science* 265, no. 5180 (September 23, 1994): 1841–43, https://doi.org/10.1126/science.265.5180.1841.

Hovers, Erella, Shimon Ilani, Ofer Bar-Yosef, and Bernard Vandermeersch. "An Early Case of Color Symbolism." *Current Anthropology* 44, no. 4 (August 2003): 491–522, https://doi.org/10.1086/375869.

Howe, Ellen, Emily Kaplan, Richard Newman, James H. Frantz, Ellen Pearlstein, Judith Levinson, and Odile Madden. "The Occurrence of a Titanium Dioxide/Silica White Pigment on Wooden Andean Qeros: A Cultural and Chronological Marker." *Heritage Science* 6, no. 41 (December 1, 2018): 1–12, https://doi.org/10.1186/s40494-018-0207-0.

Hsieh, Ming-liang. "The Navigational Route of the Belitung Wreck and the Late Tang Ceramic Trade." In *Shipwrecked: Tang Treasures and Monsoon Winds,* 136–43. Edited by Regina Krahl, John Guy, J. Keith Wilson, and Julian Raby. Washington, DC: Arthur M. Sackler Gallery, Smithsonian Institution, 2010.

Huddart, Joseph. "XIV. An Account of Persons Who Could Not Distinguish Colours. By Mr. Joseph Huddart, in a Letter to the Rev. Joseph Priestley, LL.D F.R.S." *Philosophical Transactions of the Royal Society of London* 67 (January 1777): 260–65, https://doi.org/10.1098/rstl.1777.0015.

Hume, David. *A Treatise of Human Nature*. Oxford: Clarendon Press, 1739. Kindle.

Humphries, Courtney. "Have We Hit Peak Whiteness?" *Nautilus*, July 30, 2015, http://nautil.us/issue/26/color/have-we-hit-peak-whiteness.

Hunt, David M., Kanwaljit S. Dulai, James K. Bowmaker, and John D. Mollon. "The Chemistry of John Dalton's Color Blindness." *Science* 267, no. 5200 (February 17, 1995): 984–88, https://doi.org/10.1126/science.7863342.

Hurlbert, Anya C. "Colour Constancy." *Current Biology* 17, no. 21 (November 2007): R906–7, https://doi.org/10.1016/j.cub.2007.08.022.

Hussey, Miriam. *From Merchants to "Colour Men": Five Generations of Samuel Wetherill's White Lead Business.* Research Studies XXXIX, Industrial Research Department, Wharton School of Finance and Commerce. Philadelphia: University of Pennsylvania Press, 1956.

Iliffe, Rob. *Newton: A Very Short Introduction.* Oxford: Oxford University Press, 2007.

"Introducing 'Ti-Bar' and 'Ti-Cal,'" *DuPont Magazine,* November 1935.

"Irenee du Pont Says He Rebuffed Pierre on Exclusive Buying Pact," *New York Times,* February 25, 1953.

Jackle, John A. *City Lights: Illuminating the American Night.* Baltimore: Johns Hopkins University Press, 2001.

Jansen, Kid. "The Pointer's Gamut: The Coverage of Real Surface Colors by RGB Color Spaces and Wide Gamut Displays." *TFT Central,* February 19, 2014, http://www.tftcentral.co.uk/articles/pointers_gamut.htm.

Jones, Greg. "Mineral Sands: An Overview of the Industry." Iluka Resources, 2009.

Joseph, Branden W. "White on White." *Critical Inquiry* 27, no. 1 (2000): 90–121.

Judson, Sheldon. "Paleolithic Paint." *Science* 130, no. 3377 (September 18, 1959): 708. https://doi.org/10.1126/science.130.3377.708.

Kamin, Blair. "Artifacts from 1893 World's Fair Found Beneath Obama Center Site, but Report Signals Construction Won't Be Blocked." *Chicago Tribune.* March 25, 2018. http://www.chicagotribune.com/news/columnists/kamin/ct-met-obama-center-artifacts-kamin-0325-story.html.

Kaplan, Emily, Ellen Howe, Ellen Pearlstein, and Judith Levinson. "The Qero Project: Conservation and Science Collaboration over Time." In *RATS/OSG Joint Session, 40th Annual Meeting of the American Institute for Conservation of Historic and Artistic Works.* Albuquerque, NM, 2012.

Katz, Melissa R. "William Holman Hunt and the 'Pre-Raphaelite Technique.'" In *Historical Painting Techniques, Materials, and Studio Practice: Preprints of a Symposium, University of Leiden, the Netherlands, 26–29 June 1995,* 158–65. Edited by Arie Wallert, Erma Hermens, and Marja Peek. Los Angeles: Getty Conservation Institute, 1995.

Kay, Paul, Brent Berlin, Luisa Maffi, William R. Merrifield, and Richard Cool. *The World Color Survey.* Palo Alto, CA: Center for the Study of Language and Information Publications, 2009.

Kelleher, Katy. "The Harvard Color Detectives." *Paris Review,* July 12, 2018, https://www.theparisreview.org/blog/2018/07/12/the-harvard-color-detectives/.

Kendricken, Dave. "Why Hollywood Will Never Look the Same Again on Film: LEDs Hit the Streets of LA & NY." *No Film School,* February 1, 2014, http://nofilmschool.com/2014/02/why-hollywood-will-never-look-the-same-again-on-film-leds-in-la-ny.

Kerr, Rose, and Nigel Wood. *Science and Civilization in China.* Volume 5 of *Chemistry and Chemical Technology, Part XII: Ceramic Technology.* Edited by Rose Kerr and Joseph Needham. Cambridge: Cambridge University Press, 2004.

Kiang, Nancy Y., Janet Siefert Govindjee, and Robert E. Blankenship. "Spectral Signatures of Photosynthesis. I. Review of Earth Organisms." *Astrobiology* 7, no. 1 (February 2007): 222–51. http://www.liebertpub.com/doi/10.1089/ast.2006.0105.

Kienle, John A. "The Relation of the Chemical Industry of Niagara Falls to the Water Works." *Journal of the American Water Works Association* 6, no. 3 (1919): 496–517.

Kingdom, Frederick A. A. "Lightness, Brightness and Transparency: A Quarter Century of New Ideas, Captivating Demonstrations and Unrelenting Controversy." *Vision Research* 51, no. 7 (2011): 652–73, https://doi.org/10.1016/j.visres.2010.09.012.

Kirchner, Eric. "Color Theory and Color Order in Medieval Islam: A Review." *Color Research and Application* 40, no. 1 (2015): 5–16, https://doi.org/10.1002/col.21861.

Kirchner, Eric, and Mohammad Bagheri. "Color Theory in Medieval Islamic Lapidaries: Nīshābūrī, Tūsī and Kāshānī." *Centaurus* 55, no. 1 (2013): 1–19, https://doi.org/10.1111/1600-0498.12000.

Klaproth, Martin Henry. *Analytical Essays Towards Promoting the Chemical Knowledge of Material Substances.* London: Cadell and Davies, 1801.

Krahl, Regina. "Chinese Ceramics in the Late Tang Dynasty." In *Shipwrecked: Tang Treasures and Monsoon Winds,* 44–73. Edited by Regina Krahl, John Guy, J. Keith Wilson, and Julian Raby. Washington, DC: Arthur M. Sackler Gallery, Smithsonian Institution, 2010.

———. "White Wares of Northern China." In *Shipwrecked: Tang Treasures and Monsoon Winds,* 202–8. Edited by Regina Krahl, John Guy, J. Keith

Wilson, and Julian Raby. Washington, DC: Arthur M. Sackler Gallery, Smithsonian Institution, 2010.

Krahl, Regina, John Guy, J. Keith Wilson, and Julian Raby, eds. *Ship-wrecked: Tang Treasures and Monsoon Winds.* Washington, DC: Arthur M. Sacker Gallery, Smithsonian Institution, 2010.

——. "Green Wares of Southern China." In *Shipwrecked: Tang Treasures and Monsoon Winds,* 185–200. Edited by Regina Krahl, John Guy, J. Keith Wilson, and Julian Raby. Washington, DC: Arthur M. Sackler Gallery, Smithsonian Institution, 2010.

Kremb, Jürgen. "Find on the Black Rock." *Der Spiegel,* April 22, 2004, http://www.spiegel.de/spiegel/print/d-30285777.html (translated via Google Translate). Accessed December 9, 2018.

Krivatsy, Peter. "Le Blon's Anatomical Color Engravings." *Journal of the History of Medicine and Allied Sciences* 23, no. 2 (April 1968): 153–58, https://doi.org/10.1093/jhmas/XXIII.2.153.

Kubelka, Paul, and Franz Munk. "An Article on Optics of Paint Layers." *Zeitschrift fur Technische Physik* 12 (August 1931): 593–601.

Kuehni, Rolf G. "A Brief History of Disk Color Mixture." *Color Research and Application* 35, no. 2 (2010): 110–21, https://doi.org/10.1002/col.20566.

——. "Development of the Idea of Simple Colors in the Sixteenth and Early Seventeenth Centuries." *Color Research and Application* 32, no. 2 (2007): 92–99, https://doi.org/10.1002/col.20296.

——. "The Early Development of the Munsell System." *Color Research & Application* 27, no. 1 (February 2002): 20–27, https://doi.org/10.1002/col.10002.

——. "Talking About Color . . . Which George Palmer?" *Color Research & Application* 34, no. 1 (February 2009): 2–5, https://doi.org/10.1002/col.20462.

Kuehni, Rolf G., and Andreas Schwarz. *Color Ordered: A Survey of Color Order Systems from Antiquity to the Present.* Oxford: Oxford University Press, 2008.

Kühn, Hermann. "Zinc White." In *Artists' Pigments: A Handbook of Their History and Characteristics.* Vol. 1, 169–86. Edited by Robert L. Feller. Washington, DC: National Gallery of Art, 1986, https://doi.org/10.2307/1506614.

Kurylko, Diana T. "Model T Had Many Shades; Black Dried Fastest." *Au-*

tomotive News, June 16, 2003, https://www.autonews.com/article/20030616/SUB/306160713/model-t-had-many-shades-black-dried-fastest. Accessed September 26, 2020.

Kwok, Veronica, Zhendong Niu, Paul Kay, Ke Zhou, Lei Mo, Zhen Jin, Kwok-Fai So, and Li Hai Tan. "Learning New Color Names Produces Rapid Increase in Gray Matter in the Intact Adult Human Cortex." *Proceedings of the National Academy of Sciences* 108, no. 16 (April 19, 2011): 6686–88, https://doi.org/10.1073/pnas.1103217108.

Lafer-Sousa, Rosa, Katherine L. Hermann, and Bevil R. Conway. "Striking Individual Differences in Color Perception Uncovered by 'the Dress' Photograph." *Current Biology* 25, no. 13 (2015): R545–46, https://doi.org/10.1016/j.cub.2015.04.053.

Lafontaine, Raymond H. "Seeing Through a Yellow Varnish: A Compensating Illumination System." *Studies in Conservation* 31, no. 3 (August 19, 1986): 97–102, https://doi.org/10.1179/sic.1986.31.3.97.

Lambert, Meg. "Belitung Shipwreck." *Trafficking Culture*, August 8, 2012, http://traffickingculture.org/encyclopedia/case-studies/biletung-shipwreck/. Downloaded May 21, 2017.

Land, Edwin H. "The Retinex Theory of Color Vision." *Scientific American*, December 1977, https://doi.org/10.1038/scientificamerican1277-108.

Laver, Marilyn. "Titanium Dioxide Whites." In *Artists' Pigments: A Handbook of Their History and Characteristics*. Vol. 3, 295–355. Edited by Elizabeth West Fitzhugh. Washington, DC: National Gallery of Art, 1997, https://doi.org/10.2307/1506614.

Le Blon, Jacob Christof. "Anatomische Studie van de Penis," c. 1721, Rijksmuseum, https://artsandculture.google.com/asset/anatomische-studie-van-de-penis/swFuQGgtj180uA.

———. *Coloritto; or the Harmony of Colouring in Painting: Reduced to Mechanical Practice, Under Easy Precepts, and Infallible Rules; Together with Some Colour'd Figures, in Order to Render the Said Precepts and Rules Intelligible, Not Only to Painters, but Even to All Lovers of Painting*. London, 1725.

Levinson, Stephen C. Foreword to *Language, Thought, and Reality: Selected Writings of Benjamin Lee Whorf*. 2nd ed. By Benjamin Lee Whorf. Edited by John B. Carroll, Stephen C. Levinson, and Penny Lee. Cambridge, MA: MIT Press, 2012, Kindle.

Lewis, Mark Edward. *China's Cosmopolitan Empire: The Tang Dynasty.* Cambridge, MA: Belknap Press of Harvard University Press, 2009.

Li, Zhiyan. "Ceramics of the Sui, Tang, and Five Dynasties." In *Chinese Ceramics: From the Paleolithic Period Through the Qing Dynasty,* 197–264. Edited by Zhiyan Li, Virginia L. Bower, and He Li. New Haven, CT: Yale University Press, 2010.

Li, Zhiyan, Virginia L. Bower, and He Li, eds. *Chinese Ceramics: From the Paleolithic Period Through the Qing Dynasty.* New Haven, CT: Yale University Press, 2010.

Linden, David E. J. "The P300: Where in the Brain Is It Produced and What Does It Tell Us?" *Neuroscientist* 11, no. 6 (December 29, 2005): 563–76, https://doi.org/10.1177/1073858405280524.

Lindsey, Delwin T., and Angela M. Brown. "World Color Survey Color Naming Reveals Universal Motifs and Their Within-Language Diversity." *Proceedings of the National Academy of Sciences* 106, no. 47 (2009): 19785–90, https://doi.org/10.1073/pnas.0910981106.

Linton, William. *Ancient and Modern Colours, from the Earliest Periods to the Present Time: With Their Chemical and Artistical Properties.* London: Longman, Brown, Green, and Longman, 1852.

Longair, Malcolm. "Light and Colour." In *Colour: Art and Science,* 65–102. Edited by Trevor Lamb and Janine Bourriau. Cambridge: Cambridge University Press, 1995.

Loskutova, Ekaterina, John Nolan, Alan Howard, and Stephen Beatty. "Macular Pigment and Its Contribution to Vision." *Nutrients* 5, no. 6 (May 29, 2013): 1962–69, https://doi.org/10.3390/nu5061962.

Lotto, R. Beau, Richard Clarke, David Corney, and Dale Purves. "Seeing in Colour." *Optics & Laser Technology* 43, no. 2 (March 2011): 261–69, https://doi.org/10.1016/j.optlastec.2010.02.006.

Lovell, Margaretta M. "Picturing 'A City for a Single Summer': Paintings of the World's Columbian Exposition." *Art Bulletin* 78, no. 1 (1996): 40–55, https://doi.org/10.2307/3046156.

Lowengard, Sarah. *The Creation of Color in Eighteenth-Century Europe.* New York: Columbia University Press, 2006, http://www.gutenberg-e.org/lowengard/.

Lozier, Jean-François. "Red Ochre, Vermilion, and the Transatlantic Cosmetic Encounter." In *The Materiality of Color: The Production, Circulation, and Application of Dyes and Pigments, 1400–1800.* Edited by An-

drea Feeser, Maureen Daly Goggin, and Beth Fowkes Tobin. Abingdon: Routledge, 2016.

Luo, Zhongsheng, Jesse Manders, and Jeff Yurek. "Television's Quantum Dot Future." *IEEE Spectrum* 55, no. 3 (March 2018): 28–33, 52–53.

Lynch, David, and William Livingston. *Color and Light in Nature.* 2nd ed. Cambridge: Cambridge University Press, 2001.

Mabe, Michael. "The Growth and Number of Journals." *Serials: The Journal for the Serials Community* 16, no. 2 (2003): 191–97, https://doi.org/ http://doi.org/10.1629/16191.

Mahon, Basil. "How Maxwell's Equations Came to Light." *Nature Photonics* 9, no. 1 (January 1, 2015): 2–4, https://doi.org/10.1038/nphoton.2014 .306.

Mahroo, Omar A., Katie M. Williams, Ibtesham T. Hossain, Ekaterina Yonova-Doing, Diana Kozareva, Ammar Yusuf, Ibrahim Sheriff, Mohamed Oomerjee, Talha Soorma, and Christopher J. Hammond. "Do Twins Share the Same Dress Code? Quantifying Relative Genetic and Environmental Contributions to Subjective Perceptions of 'the Dress' in a Classical Twin Study." *Journal of Vision* 17, no. 1 (January 27, 2017): 1–17, https://doi.org/10.1167/17.1.29.

Marshall, Justin, and Kentaro Arikawa. "Unconventional Colour Vision." *Current Biology* 24, no. 24 (December 2014): R1150–54, https://doi.org/ 10.1016/j.cub.2014.10.025.

Mason, R. B., and M. S. Tite. "The Beginnings of Tin-Opacification of Pottery Glazes." *Archaeometry* 39, no. 1 (February 1997): 41–58, https://doi .org/10.1111/j.1475-4754.1997.tb00789.x.

Massing, Ann. "From Books of Secrets to Encyclopedias: Painting Techniques in France Between 1600 and 1800." In *Historical Painting Techniques, Materials, and Studio Practice: Preprints of a Symposium, University of Leiden, the Netherlands, 26–29 June 1995,* 20–39. Edited by Arie Wallert, Erma Hermens, and Marja Peek. Los Angeles: Getty Conservation Institute, 1995.

Maxwell, J. Clerk. "On the Theory of Compound Colours, and the Relations of the Colours of the Spectrum." *Philosophical Transactions of the Royal Society of London* 150 (1860): 57–84, https://doi.org/10.1098/rstl .1860.0005.

McDougall-Waters, Julie, Noah Moxham, and Aileen Fyfe. "Philosophical Transactions: 350 Years of Publishing at the Royal Society 1665–2015." Royal Society, 2015.

Meier, Allison. "Death by Wallpaper: The Alluring Arsenic Colors That Poisoned the Victorian Age." *Hyperallergic,* October 31, 2016, https://hyperallergic.com/329747/death-by-wallpaper-alluring-arsenic-colors-poisoned-the-victorian-age/. Accessed May 26, 2020.

Meilke, Jeffrey M. *Twentieth Century Limited: Industrial Design in America, 1929–1935.* 2nd ed. Philadelphia: Temple University Press, 2001.

Melville, Herman. *Moby-Dick.* Mineola, NY: Dover Thrift, 2011.

Menand, Louis. "Watching Them Turn Off the Rothkos." *New Yorker,* April 1, 2015, https://www.newyorker.com/culture/cultural-comment/watching-them-turn-off-the-rothkos.

Meng, Guangnan, Vinothan N. Manoharan, and Adeline Perro. "Core–Shell Colloidal Particles with Dynamically Tunable Scattering Properties." *Soft Matter* 13, no. 37 (2017): 6293–96, https://doi.org/10.1039/C7SM01740E.

Michalovic, Mark. "John Dalton and the Scientific Method." *Distillations,* Spring 2008, https://www.sciencehistory.org/distillations/magazine/john-dalton-and-the-scientific-method.

"Middle Stone Age Tools," Smithsonian Museum of Natural History, http://humanorigins.si.edu/evidence/behavior/stone-tools/middle-stone-age-tools. Last modified May 14, 2020; accessed May 16, 2020.

Miksic, John. "Chinese Ceramic Production and Trade." In *Oxford Research Encyclopedia of Asian History,* Vol. 1, 1–34. Oxford: Oxford University Press, June 28, 2017, https://doi.org/10.1093/acrefore/9780190277727.013.218.

Moholy-Nagy, László. *The New Vision: Fundamentals of Bauhaus Design, Painting, Sculpture, and Architecture.* 4th ed. Translated by Daphne M. Hoffmann, 1947. Mineola, NY: Dover Publications, 2005. Kindle.

Mollon, John D. "Introduction: Thomas Young and the Trichromatic Theory of Colour Vision." In *Normal and Defective Colour Vision,* xix–xxxiii. Edited by J. D. Mollon, J. Pokorny, and K. Knoblauch. Oxford: Oxford University Press, 2003.

——. "Monge: The Verriest Lecture, Lyon, July 2005." *Visual Neuroscience* 23, no. 3–4 (May 6, 2006): 297–309, https://doi.org/10.1017/S0952523806233479.

——. "The Origins of Modern Color Science." In *The Science of Color,* 1–37. Edited by Steven K. Shevell. Oxford: Elsevier Publishing, 2003.

Monroe, Harriet. *John Wellborn Root: A Study of His Life and Work*. Boston: Houghton, Mifflin & Company, 1896.

Monstrey, Stan J., H. Hoeksema, H. Saelens, K. Depuydt, Moustapha Hamdi, Koenread Van Landuyt, and Phillip N. Blondeel. "A Conservative Approach for Deep Dermal Burn Wounds Using Polarised-Light Therapy." *British Journal of Plastic Surgery* 55, no. 5 (2002): 420–26, https://doi.org/10.1054/bjps.2002.3860.

Moore, Charles. "Lessons of the Chicago World's Fair: An Interview with the Late Daniel H. Burnham." *Archictectural Record* 33, no. 6 (June 1913): 35–44.

Morante, Nick, and James DiGiovanna. *Colorants Used in the Cosmetics Industry*. Society of Cosmetic Chemists Monograph Series No. 9. New York: Society of Cosmetic Chemists, 2006.

Morgenstern, Yaniv, Mohammad Rostami, and Dale Purves. "Properties of Artificial Networks Evolved to Contend with Natural Spectra." *Proceedings of the National Academy of Sciences* 111, no. S3 (July 22, 2014): 10868–72, https://doi.org/10.1073/pnas.1402669111.

Mumford, Lewis. *Sticks and Stones: A Study of American Architecture and Civilization*. 2nd ed. New York: Dover Publications, 1955.

Murphey, Dona K., Daniel Yoshor, and Michael S. Beauchamp. "Perception Matches Selectivity in the Human Anterior Color Center." *Current Biology* 18, no. 3 (February 2008): 216–20, https://doi.org/10.1016/j.cub.2008.01.013.

Nagel, Thomas. "What Is It Like to Be a Bat?" *Philosophical Review* 83, no. 4 (October 1974): 435, https://doi.org/10.2307/2183914.

Nagengast, Bernard. "100 Years of Air Conditioning." *ASHRAE Journal* 44, no. 6 (2002): 44–46.

Nassau, Kurt. *The Physics and Chemistry of Color: The Fifteen Causes of Color*. 2nd ed. New York: John Wiley & Sons, 2001.

Nathans, Jeremy. "The Evolution and Physiology of Human Color Vision: Insights from Molecular Genetic Studies of Visual Pigments." *Neuron* 24 (1999): 299–312, https://doi.org/10.1016/S0896-62730080845-4.

Needleman, Herbert. "Lead Poisoning." *Annual Review of Medicine* 55, no. 1 (February 2004): 209–22, https://doi.org/10.1146/annurev.med.55.091902.103653.

Nelson, John O. "Hume's Missing Shade of Blue Re-Viewed." *Hume Studies* 15, no. 2 (November 1989): 352–64.

"The New Age of Color." *Saturday Evening Post,* January 21, 1928, 22.

Newman, Richard, Emily Kaplan, and Michele Derrick. "Mopa Mopa: Scientific Analysis and History of an Unusual South American Resin Used by the Inka and Artisans in Pasto, Colombia." *Journal of the American Institute for Conservation* 54, no. 3 (August 7, 2015): 123–48, https://doi.org/10.1179/1945233015Y.0000000005.

Newton, Isaac. Pierpont Morgan Notebook. Published online October 2003, http://www.newtonproject.ox.ac.uk/view/texts/normalized/NATP00001.

———. "To John Williams." September 3, 1705. Mint 19/III.578-82, National Archives, Kew, Richmond, Surrey, UK, http://www.newtonproject.ox.ac.uk/view/texts/normalized/MINT00694.

Nickerson, Dorothy. "History of the Munsell Color System." *Color Engineering* 7, no. 5 (1969): 45, https://doi.org/10.1111/j.1520-6378.1976.tb00017.x.

Nicklas, Charlotte. "One Essential Thing to Learn Is Colour: Harmony, Science and Colour Theory in Mid-Nineteenth-Century Fashion Advice." *Journal of Design History* 27, no. 3 (2014): 218–36, https://doi.org/10.1093/jdh/ept030.

Nobel Prize. Press Release. NobelPrize.org. Nobel Media AB 2020. June 7, 2020, https://www.nobelprize.org/prizes/physics/2014/press-release/.

Nriagu, Jerome. *Lead and Lead Poisoning in Antiquity.* New York: John Wiley & Sons, 1983.

"Obituary: Sir Thomas Oliver, LLD, DCL, MD, DSc, FRCP." *BMJ* 1, no. 4247 (May 30, 1942): 681–82, https://doi.org/10.1136/bmj.1.4247.681-a.

O'Connor, J. J., and E. F. Robertson. "Abu Ali al-Hasan ibn al-Haytham." MacTutor History of Mathematics Archive, http://www-history.mcs.st-andrews.ac.uk/Biographies/Al-Haytham.html. Updated November 1999; accessed June 1, 2020.

Oftadeh, Ramin, Miguel Perez-Viloria, Juan C. Villa-Camacho, Ashkan Vaziri, and Ara Nazarian. "Biomechanics and Mechanobiology of Trabecular Bone: A Review." *Journal of Biomechanical Engineering* 137, no. 1 (January 1, 2015): 1–15, https://doi.org/10.1115/1.4029176.

Okano, Toshiyuki, Toru Yoshizawa, and Yoshitaka Fukada. "Pinopsin Is a Chicken Pineal Photoreceptive Molecule." *Nature* 372, no. 6501 (November 1994): 94–97, https://doi.org/10.1038/372094a0.

Okazawa, Gouki, Kowa Koida, and Hidehiko Komatsu. "Categorical Properties of the Color Term 'GOLD.'" *Journal of Vision* 11, no. 8 (2011): 1–19, https://doi.org/10.1167/11.8.4.Introduction.

Oliver, Thomas. "A Lecture on Lead Poisoning and the Race." *British Medical Journal* 1, no. 2628 (1911): 1096–98.

Osborne, Roy. "A History of Colour Theory in Art, Design and Science." In *Colour Design: Theories and Applications,* 507–27. 2nd ed. Edited by Janet Best. Duxford, UK: Elsevier, 2017.

———. *Books on Colour, 1495–2015.* Raleigh, NC: Lulu Enterprises, 2015.

"Our History." SIL, https://www.sil.org/about/history. Accessed June 6, 2020.

Paris, John Ayrton. *A Memoir of the Life and Scientific Labours of the Late Reverend William Gregor.* London: William Phillips, George Yard, 1818.

Patterson, Tony. "The 1,200-Year-Old Sunken Treasure That Revealed an Undiscovered China." *Independent,* April 14, 2004, https://www.independent.co.uk/news/world/asia/the-1200-year-old-sunken-treasure-that-revealed-an-undiscovered-china-559906.html. Accessed December 9, 2018.

Patton, Phil. "Off the Chart," AIGA. March 18, 2008, https://www.aiga.org/off-the-chart#authorbio. Accessed May 28, 2020.

Paz, Y., Z. Luo, L. Rabenberg, and A. Heller. "Photooxidative Self-Cleaning Transparent Titanium Dioxide Films on Glass." *Journal of Materials Research* 10, no. 11 (November 3, 1995): 2842–48, https://doi.org/10.1557/JMR.1995.2842.

Petru, Simona. "Red, Black or White? The Dawn of Colour Symbolism." *Documenta Praehistorica* 33 (2006): 203–8, https://doi.org/10.4312/dp.33.18.

Pettigrew, Jack, Chloe Callistemon, Astrid Weiler, Anna Gorbushina, Wolfgang Krumbein, and Reto Weiler. "Living Pigments in Australian Bradshaw Rock Art." *Antiquity* 84, no. 326 (2010), http://antiquity.ac.uk/projgall/pettigrew326/.

Pichaud, Franck, Adriana D. Briscoe, and Claude Desplan. "Evolution of Color Vision." *Current Opinion in Neurobiology* 9, no. 5 (October 1999): 622–27, https://doi.org/10.1016/S0959-43889900014-8.

Pirkle, E. C., and W. H. Yoho. "The Heavy Mineral Ore Body of Trail Ridge, Florida." *Economic Geology* 65, no. 1 (1970): 17–30, https://doi.org/10.2113/gsecongeo.65.1.17.

Pliny. *Natural History,* http://www.perseus.tufts.edu/hopper/text?doc=Perseus%3atext%3a1999.02.0137.

Pointer, M. R. "The Gamut of Real Surface Colours." *Color Research & Application* 5, no. 3 (1980): 145–55, https://doi.org/10.1002/col.5080050308.

Porter, Tom. *Architectural Color: A Design Guide to Using Color on Buildings.* New York: Whitney Library of Design, 1982.

Porter, Tom, and Byron Mikellides. *Colour for Architecture.* London: Studio Vista, 1976.

Pringle, Heather. "Smithsonian Scuppers Shipwreck Exhibit, Plans to Re-Excavate." *Science,* December 16, 2011, https://www.sciencemag.org/news/2011/12/smithsonian-scuppers-shipwreck-exhibit-plans-re-excavate. Accessed December 10, 2018.

Pulsifer, William H. *Notes for a History of Lead and an Inquiry into the Development of the Manufacture of White Lead and Lead Oxides.* New York: D. Van Nostrand, 1888.

Railing, Patricia. "Malevich's Suprematist Palette — 'Colour Is Light.'" *In-CoRM International Chamber of Russian Modernism Journal* 2, spring–autumn (2011): 47–57.

Reed, Christopher Robert. "The Black Presence at 'White City': African and African American Participation at the World's Columbian Exposition, Chicago, May 1, 1893–October 31, 1893." World's Columbian Exposition Website, 1999, http://columbus.iit.edu/reed2.html.

Regier, Terry, and Paul Kay. "Language, Thought, and Color: Whorf Was Half Right." *Trends in Cognitive Sciences* 13, no. 10 (October 2009): 439–46, https://doi.org/10.1016/j.tics.2009.07.001.

Richards, Joseph William. "The Metallurgy of the Rarer Metals." *Metallurgical and Chemical Engineering* 15, no. 1 (1916): 26–31.

———. "Niagara as an Electrochemical Centre." *Electrochemical Industry* 1, no. 1 (1902): 11–23.

Rifkin, Riaan F. "Ethnographic and Experimental Perspectives on the Efficacy of Ochre as a Mosquito Repellent." *South African Archaeological Bulletin* 70, no. 201 (2015): 64–75.

"Robert Rauschenberg. *White Painting.* 1951," Robert Rauschenberg: Among Friends audio tour, Museum of Modern Art, https://www.moma.org/audio/playlist/40/639.

Roebroeks, Wil, Mark J. Sier, Trine Kellberg Nielsen, Dimitri De Loecker, Josep Maria Parés, Charles. E. S. Arps, and Herman. J. Mücher. "Use of

Red Ochre by Early Neandertals." *Proceedings of the National Academy of Sciences* 109, no. 6 (2012): 1889–94.

Rogers, Adam. *Proof: The Science of Booze.* Boston: Houghton Mifflin Harcourt, 2014.

———. "The Science of Why No One Agrees on the Color of This Dress." *Wired,* February 26, 2015, https://www.wired.com/2015/02/science-one-agrees-color-dress/.

Roque, Georges. "Chevreul and Impressionism: A Reappraisal." *Art Bulletin* 78, no. 1 (March 1996): 26–39.

———. "Chevreul's Colour Theory and Its Consequences for Artists." Colour Group Great Britain, 2011.

———. "Seurat and Color Theory." In *Seurat Re-Viewed,* 43–64. Edited by Paul Smith. Philadelphia: Penn State University Press, 2010.

Rossi, Auguste J. "Perkin Medal Award — Address of Acceptance." *Journal of Industrial & Engineering Chemistry* 10, no. 2 (1918): 141–45.

———. "Titaniferous Ores in the Blast-Furnace." *Transactions of the American Institute of Mining Engineers* 21 (1893): 832–67.

"Royal Factory of Furniture to the Crown at the Gobelins Manufactory," *The J. Paul Getty Museum,* http://www.getty.edu/art/collection/artists/1188/royal-factory-of-furniture-to-the-crown-at-the-gobelins-manufactory-french-founded-1662-present/.

Russell, Arthur. "The Rev. William Gregor (1761–1817), Discoverer of Titanium." *Mineralogical Magazine and Journal of the Mineralogical Society* 30, no. 229 (June 14, 1955): 617–24, https://doi.org/10.1180/minmag.1955.030.229.01.

Rybczynski, Witold. *A Clearing in the Distance: Frederick Law Olmsted and America in the Nineteenth Century.* New York: Simon and Schuster, 1999.

Sabra, Abdelhamid I. "Ibn al-Haytham." *Harvard Magazine,* September–October 2003, https://harvardmagazine.com/2003/09/ibn-al-haytham-html. Accessed September 15, 2018.

Saint Jerome. "Letter to Furia." Letter LIV, The Letters of St. Jerome. *Nicene and Post-Nicene Fathers.* Series II, Vol. VI: The Principal Works of St. Jerome, http://www.tertullian.org/fathers2/NPNF2-06/Npnf2-06-03.htm#P2160_530357.

Saliba, George. *Islamic Science and the Making of the European Renaissance.* Cambridge, MA: MIT Press, 2007.

Sammern, Romana. "Red, White and Black: Colors of Beauty, Tints of

Health and Cosmetic Materials in Early Modern English Art Writing." *Early Science and Medicine* 20, no. 4–6 (December 7, 2015): 397–427, https://doi.org/10.1163/15733823-02046p05.

Saranathan, Vinodkumar, Jason D. Forster, Heeso Noh, Seng-Fatt Liew, Simon G. J. Mochrie, Hui Cao, Eric R. Dufresne, and Richard O. Prum. "Structure and Optical Function of Amorphous Photonic Nanostructures from Avian Feather Barbs: A Comparative Small Angle X-Ray Scattering (SAXS) Analysis of 230 Bird Species." *Journal of the Royal Society Interface* 9, no. 75 (October 7, 2012): 2563–80, https://doi.org/10.1098/rsif.2012.0191.

Sassi, Maria Michela. "Can We Hope to Understand How the Greeks Saw Their World?" *Aeon*, July 31, 2017, https://aeon.co/essays/can-we-hope-to-understand-how-the-greeks-saw-their-world. Accessed May 12, 2018.

Schafer, Edward H. "The Early History of Lead Pigments and Cosmetics in China." *T'oung Pao* 44, no. 1 (January 1, 1956): 413–38, https://doi.org/10.1163/156853256X00135.

Schlaffke, Lara, Anne Golisch, Lauren M. Haag, Melanie Lenz, Stefanie Heba, Silke Lissek, Tobias Schmidt-Wilcke, Ulf T. Eysel, and Martin Tegenthoff. "The Brain's Dress Code: How the Dress Allows to Decode the Neuronal Pathway of an Optical Illusion." *Cortex* 73 (December 2015): 271–75, https://doi.org/10.1016/j.cortex.2015.08.017.

Schmidt, Brian P., Alexandra E. Boehm, Katharina G. Foote, and Austin Roorda. "The Spectral Identity of Foveal Cones Is Preserved in Hue Perception." *Journal of Vision* 18, no. 11 (October 29, 2018): 1–18, https://doi.org/10.1167/18.11.19.

Schmidt, Brian P., Phanith Touch, Maureen Neitz, and Jay Neitz. "Circuitry to Explain How the Relative Number of L and M Cones Shapes Color Experience." *Journal of Vision* 16, no. 8 (2016): 1–17, https://doi.org/10.1167/16.8.18.

Schonbrun, Zach. "The Quest for the Next Billion-Dollar Color." *BloombergBusinessweek*, April 18, 2018, https://www.bloomberg.com/features/2018-quest-for-billion-dollar-red/.

Schweppe, Helmut, and John Winter. "Madder and Alizarin." In *Artists' Pigments: A Handbook of Their History and Characteristics.* Vol. 3, 109–42. Edited by Elizabeth West Fitzhugh. Washington, DC: National Gallery of Art, 1997.

Sensabaugh, David Ake. Foreword to *Chinese Ceramics: From the Paleo-*

lithic Period Through the Qing Dynasty, xiv–xv. Edited by Zhiyan Li, Virginia L. Bower, and He Li. New Haven, CT: Yale University Press, 2010.

Shail, Robin K., and Brian E. Leveridge. "The Rhenohercynian Passive Margin of SW England: Development, Inversion and Extensional Reactivation." *Comptes Rendus Geoscience* 341, no. 2–3 (February 2009): 140–55, https://doi.org/10.1016/j.crte.2008.11.002.

Shapiro, Alan E. "Artists' Colors and Newton's Colors." *Isis* 85, no. 4 (1994): 600–630.

Sherman, D. M., R. G. Burns, and V. M. Burns. "Spectral Characteristics of the Iron Oxides with Application to the Martian Bright Region Mineralogy." *Journal of Geophysical Research* 87 no. B12 (1982): 10169–80, https://doi.org/10.1029/JB087iB12p10169.

Shevell, Steven K., and Frederick A. A. Kingdom. "Color in Complex Scenes." *Annual Review of Psychology* 59, no. 1 (January 2008): 143–66, https://doi.org/10.1146/annurev.psych.59.103006.093619.

Shi, Liang, Vahid Babaei, Changil Kim, Michael Foshey, Yuanming Hu, Pitchaya Sitthi-amorn, Szymon Rusinkiewicz, and Wojciech Matusik. "Deep Multispectral Painting Reproduction via Multi-Layer, Custom-Ink Printing." *ACM Transactions on Graphics SIGGRAPH 2018* 37, no. 6 (November 2018): 1–15, https://doi.org/10.1145/3272127.3275057.

Siddall, Ruth. "Mineral Pigments in Archaeology: Their Analysis and the Range of Available Materials." *Minerals* 8, no. 5 (May 8, 2018): 201–36, https://doi.org/10.3390/min8050201.

———. "Not a Day Without a Line Drawn: Pigments and Painting Techniques of Roman Artists." *InFocus Magazine: Proceedings of the Royal Microscopical Society* 2 (2006): 18–23.

Skelton, Alice E., Gemma Catchpole, Joshua T. Abbott, Jenny M. Bosten, and Anna Franklin. "Biological Origins of Color Categorization." *Proceedings of the National Academy of Sciences* 114, no. 21 (May 23, 2017): 5545–50, https://doi.org/10.1073/pnas.1612881114.

Skinner, Charles E. "Lighting the World's Colombian Exposition." *Western Pennsylvania History* 17, no. 1 (March 1934): 13–22, https://journals.psu.edu/wph/article/view/1666.

Smith, George David. *From Monopoly to Competition: The Transformations of Alcoa, 1888–1986*. Cambridge: Cambridge University Press, 2003.

Smithson, Hannah E., Giles E. M. Gasper, and Tom C. B. McLeish. "All

the Colours of the Rainbow." *Nature Physics* 10, no. 8 (August 31, 2014): 540–42, https://doi.org/10.1038/nphys3052.

Snyder, Lisa. "The World's Columbian Exposition of 1893." Urban Simulation Team, https://web.archive.org/web/20191027034508/http://www.ust.ucla.edu/ustweb/Projects/columbian_expo.htm.

Sparavigna, Amelia Carolina. "On the Rainbow, a Robert Grosseteste's Treatise on Optics." *International Journal of Sciences* 2, no. 9 (2013): 108–13, https://doi.org/10.18483/ijSci.296.

Spudich, John L. "The Multitalented Microbial Sensory Rhodopsins." *Trends in Microbiology* 14, no. 11 (2006): 480–87, https://doi.org/10.1016/j.tim.2006.09.005.

Spudich, John L., and Roberto A. Bogomolni. "Mechanism of Colour Discrimination by a Bacterial Sensory Rhodopsin." *Nature* 312, no. 5994 (December 1984): 509–13, https://doi.org/10.1038/312509a0.

——. "Sensory Rhodopsins of Halobacteria," *Annual Review of Biophysics and Biophysical Chemistry* 17, no. 1 (June 1988): 193–215, https://doi.org/10.1146/annurev.bb.17.060188.001205.

Stavenga, Doekele G., and Kentaro Arikawa. "Evolution of Color and Vision of Butterflies." *Arthropod Structure & Development* 35, no. 4 (December 2006): 307–18, https://doi.org/10.1016/j.asd.2006.08.011.

Stenger, Jens, Narayan Khandekar, Ramesh Raskar, Santiago Cuellar, Ankit Mohan, and Rudolf Gschwind. "Conservation of a Room: A Treatment Proposal for Mark Rothko's Harvard Murals." *Studies in Conservation* 61, no. 6 (November 15, 2016): 348–61, https://doi.org/10.1179/2047058415Y.0000000010.

Stenger, Jens, Narayan Khandekar, Annie Wilker, Katya Kallsen, P. Daniel, and Katherine Eremin. "The Making of Mark Rothko's Harvard Murals." *Studies in Conservation* 61, no. 6 (2016): 331–47, https://doi.org/10.1179/2047058415Y.0000000009.

Stieg, Fred B. "Opaque White Pigments in Coatings." In *Applied Polymer Science*, 1249–69. 2nd ed. Edited by R. W. Tess and G. W. Poehlein. Washington, DC: American Chemical Society, 1985.

Stilgoe, John. *Common Landscape of America, 1580 to 1845*. New Haven, CT: Yale University Press, 1982.

Stoeckenius, Walther. "The Purple Membrane of Salt-Loving Bacteria." *Scientific American*, June 1976, 38–46.

Sturgis, Russell. "Recent Discoveries of Painted Greek Sculpture." *Harper's New Monthly* 81 (1890): 538–50.

Sudaryadi, Agus. "The Belitung Wreck Site After Commercial Salvage in 1998." In *Asia-Pacific Regional Conference on Underwater Cultural Heritage Proceedings,* 1–11, 2011.

Sudo, Yuki, and John L. Spudich. "Three Strategically Placed Hydrogen-Bonding Residues Convert a Proton Pump into a Sensory Receptor." *Proceedings of the National Academy of Sciences* 103, no. 44 (October 31, 2006): 16129–34, https://doi.org/10.1073/pnas.0607467103.

Sullivan, Louis H. *The Autobiography of an Idea.* New York: Press of the American Institute of Architects, 1922.

———. "The Tall Office Building Artistically Considered." *Lippincott's Magazine,* March 1896, 403–9.

Taylor, Kate. "Smithsonian Sunken Treasure Show Poses Ethics Questions." *New York Times,* April 24, 2011, https://www.nytimes.com/2011/04/25/arts/design/smithsonian-sunken-treasure-show-poses-ethics-questions.html downloaded 12/10/18. Evernote.

Tbakhi, Abdelghani, and Samir S. Amr. "Ibn Al-Haytham: Father of Modern Optics." *Annals of Saudi Medicine* 27, no. 6 (November–December, 2007): 464–87, https://doi.org/10.5144/0256-4947.2007.464.

"Tech Q&A — Paint Charts." 1928 Fordor, Model A Ford Club of America, https://www.mafca.com/tqa_paint_charts.html. Accessed May 28, 2020.

"Thomas Oliver, KT, MD Glasg., DCL Durh., FRCP." *Lancet* 239, no. 6196 (May 30, 1942): 665–66.

Thompson, Thomas. *The History of Chemistry.* Vol. 2. London: Henry Colburn and Richard Bentley, 1831.

"Titanium, the Wonder-Working Alloy." Advertisement in *Factory: The Magazine of Management,* January 1912, 59.

Toch, Maximilian. "Titanium White." *The Chemistry and Technology of Paints.* 3rd ed. New York: D. Van Nostrand Company, 1925.

———. "White Lead." In *The Chemistry and Technology of Paints.* 2nd ed. New York: D. Van Nostrand Company, 1916.

Topdemir, Hüseyin Gazi. "Kamal Al-Din Al-Farisi's Explanation of the Rainbow." *Humanity & Social Sciences Journal* 2, no. 1 (2007): 75–85.

Towe, Kenneth M. "The Vinland Map Ink Is NOT Medieval." *Analytical Chemistry* 76, no. 3 (February 2004): 863–65, https://doi.org/10.1021/ac0354488.

Turner, R. Steven. *In the Eye's Mind: Vision and the Helmholtz-Hering Controversy.* Princeton, NJ: Princeton University Press, 1994.

"Two Individuals and Company Found Guilty in Conspiracy to Sell Trade Secrets to Chinese Companies." US Attorney press release. March 5, 2014, https://www.fbi.gov/sanfrancisco/press-releases/2014/two-individuals-and-company-found-guilty-in-conspiracy-to-sell-trade-secrets-to-chinese-companies.

United States Geological Survey. 2013. *Titanium and Titanium Dioxide. Mineral Commodity Summaries.* February 2019, 174–75, https://minerals.usgs.gov/minerals/pubs/commodity/titanium/mcs-2019-titan.pdf

US v. Liew et al. Northern District of California, CR 11-00573 JSW. Transcript, vol. 1.

USA v. Walter Liew and Christina Liew. Northern District of California 11-cr-00573 JSW. Affidavit of Special Agent Cynthia Ho, July 27, 2011.

van Driel, B. A., K. J. van den Berg, J. Gerretzen, and J. Dik. "The White of the Twentieth Century: An Explorative Survey into Dutch Modern Art Collections." *Heritage Science* 6, no. 1 (December 29, 2018): 1–15, https://doi.org/10.1186/s40494-018-0183-4.

Van Gogh, Vincent. "To Emile Bernard." On or about June 7, 1888. *Vincent Van Gogh: The Letters.* 622. Br. 1990: 625. CL: B6, http://vangoghletters.org/vg/letters/let622/letter.html.

———. "To Theo Van Gogh." On or about June 25, 1888. *Vincent Van Gogh: The Letters.* 631. Br. 1990: 640. CL: 504, http://vangoghletters.org/vg/letters/let631/letter.html.

Van Gosen, Bradley S., and Karl J. Ellefsen. *Titanium Mineral Resources in Heavy-Mineral Sands in the Atlantic Coastal Plain of the Southeastern United States.* Scientific Investigations Report 2018-5045. US Geological Survey. 2018.

Vermeesch, Pieter. "A Second Look at the Geologic Map of China: The 'Sloss Approach.'" *International Geology Review* 45, no. 2 (February 14, 2003): 119–32, https://doi.org/10.2747/0020-6814.45.2.119.

Viénot, Françoise. "Michel-Eugène Chevreul: From Laws and Principles to the Production of Colour Plates." *Color Research & Application* 27, no. 1 (February 2002): 4–14, https://doi.org/10.1002/col.10000.

Völz, Hans G., Guenther Kaempf, Hans Georg Fitzky, and Aloys Klaeren. "The Chemical Nature of Chalking in the Presence of Titanium Dioxide Pigments." In *Photodegradation and Photostabilization of Coatings,* 163–82. Edited by S. Peter Pappas and F. H. Winslow. Washington, DC: American Chemical Society, 1981.

Vukusic, Pete, Benny Hallam, and Joe Noyes. "Brilliant Whiteness in Ultrathin Beetle Scales." *Science* 315, no. 5810 (2007): 348, https://doi.org/10.1126/science.1134666.

Wadley, Lyn. "Compound-Adhesive Manufacture as a Behavioral Proxy for Complex Cognition in the Middle Stone Age." *Current Anthropology* 51, no. S1 (2010): S111–19, https://doi.org/10.1086/649836.

Wadley, Lyn, Tammy Hodgskiss, and Michael Grant. "Implications for Complex Cognition from the Hafting of Tools with Compound Adhesives in the Middle Stone Age, South Africa." *Proceedings of the National Academy of Sciences* 106, no. 24 (2009): 9590–94, https://doi.org/10.1073/pnas.0900957106.

Wald, Chelsea. "Why Red Means Red in Almost Every Language." *Nautilus,* July 23, 2015, http://nautil.us/issue/26/color/why-red-means-red-in-almost-every-language. Accessed May 12, 2018.

Waldron, H. A. "Lead Poisoning in the Ancient World." *Medical History* 17, no. 4 (October 16, 1973): 391–99, https://doi.org/10.1017/S0025727300019013.

Wallisch, Pascal. "Illumination Assumptions Account for Individual Differences in the Perceptual Interpretation of a Profoundly Ambiguous Stimulus in the Color Domain: 'The Dress.'" *Journal of Vision* 17, no. 4 (June 12, 2017): 1–14, https://doi.org/10.1167/17.4.5.

Walls, Gordon L. "The G. Palmer Story Or, What It's Like, Sometimes, to Be a Scientist." *Journal of the History of Medicine and Allied Sciences* 11, no. 1 (1956): 66–96.

Warren, Christian. *Brush with Death: A Social History of Lead Poisoning.* Baltimore: Johns Hopkins University Press, 2000.

Warzell, Charlie. "2/26: How Two Llamas and a Dress Gave Us the Internet's Greatest Day." *BuzzFeed,* February 26, 2016, https://www.buzzfeed.com/charliewarzel/226-how-two-runaway-llamas-and-a-dress-gave-us-the-internets.

Wasmeier, Christina, Alistair N. Hume, Giulia Bolasco, and Miguel C. Seabra. "Melanosomes at a Glance." *Journal of Cell Science* 121, no. 24 (December 15, 2008): 3995–99, https://doi.org/10.1242/jcs.040667.

Watson, Bruce. *Light: A Radiant History from Creation to the Quantum Age.* New York: Bloomsbury, 2016.

Watts, Ian. "Red Ochre, Body Painting, and Language: Interpreting the Blombos Ochre." In *The Cradle of Language,* 62–97. Edited by Rudolf Botha and Chris Knight. Oxford: Oxford University Press, 2009.

Weingarden, Lauren S. "The Colors of Nature: Louis Sullivan's Architectural Polychromy and Nineteenth-Century Color Theory." *Winterthur Portfolio* 20, no. 4 (1985): 243–60.

———. *Louis H. Sullivan and the Nineteenth-Century Poetics of Naturalized Architecture.* London: Routledge, 2016.

White, Trumbull, and William Igleheart. *The World's Columbian Exposition, Chicago, 1893.* Boston: John K. Hastings, 1893.

Whorf, Benjamin Lee. *Language, Thought, and Reality: Selected Writings of Benjamin Lee Whorf.* 2nd ed. Edited by John B. Carroll, Stephen C. Levinson, and Penny Lee Cambridge: MIT Press, 2012.

Wiesel, Torsten N., and David H. Hubel. "Spatial and Chromatic Interactions in the Lateral Geniculate Body of the Rhesus Monkey." *Journal of Neurophysiology* 29, no. 6 (November 1966): 1115–56, https://doi.org/10.1152/jn.1966.29.6.1115.

Wilber, Del Quentin. "Stealing White." *Bloomberg Businessweek.* February 4, 2016, http://www.bloomberg.com/features/2016-stealing-dupont-white/.

Wilkes, Jonny. "Edison, Westinghouse and Tesla: The History Behind the Current War." *BBC History Revealed.* March 2019, https://www.historyextra.com/period/victorian/edison-westinghouse-tesla-real-history-behind-the-current-war-film/.

Winawer, Jonathan, Nathan Witthoft, M. C. Frank, L. Wu, A. R. Wade, and L. Boroditsky. "Russian Blues Reveal Effects of Language on Color Discrimination." *Proceedings of the National Academy of Sciences* 104, no. 19 (2007): 7780–85, https://doi.org/10.1073/pnas.0701644104.

Winkler, Jochen. *Titanium Dioxide: Production, Properties, and Effective Usage.* Hanover, Germany: Vincentz Network, 2013.

Wood, Nigel. *Chinese Glazes: Their Origins, Chemistry, and Recreation* Philadelphia: University of Pennsylvania Press, 1999. London: A&C Black, 2011.

———. "The Importance of the Gongxian Kilns in China's Ceramic History." Presentation at the Palace Museum, Beijing. October 23, 2018.

Wood, Nigel, and Seth Priestman. "New Light on Chinese Tang Dynasty and Iraqi Blue and White in the Ninth Century: The Material from Siraf, Iran." *Bulletin of Chinese Ceramic Art and Archaeology,* no. 7 (2016): 47–60.

Wood, Nigel, and Mike Tite. "Blue and White — the Early Years: Tang China and Abbasid Iraq Compared." In *Transfer: The Influence of China*

on *World Ceramics Colloquies on Art and Archaeology in Asia No. 24,* 21–45. Edited by Stacey Person. London: School of Oriental and African Studies, University of London, 2009.

Woodworth, R. S. "The Psychology of Light." *Scientific American Supplement,* no. 1876 (December 1911): 386–87.

"The World Color Survey," http://www1.icsi.berkeley.edu/wcs/. Accessed June 6, 2020.

Xiao, K., J. M. Yates, F. Zardawi, S. Sueeprasan, N. Liao, L. Gill, C. Li, and S. Wuerger. "Characterising the Variations in Ethnic Skin Colours: A New Calibrated Data Base for Human Skin." *Skin Research and Technology* 23, no. 1 (February 2017): 21–29, https://doi.org/10.1111/srt.12295.

Xiao, Ming, Yiwen Li, Michael C. Allen, Dimitri D. Deheyn, Xiujun Yue, Jiuzhou Zhao, Nathan C. Gianneschi, Matthew D. Shawkey, and Ali Dhinojwala. "Bio-Inspired Structural Colors Produced via Self-Assembly of Synthetic Melanin Nanoparticles." *ACS Nano* 9, no. 5 (May 26, 2015): 5454–60, https://doi.org/10.1021/acsnano.5b01298.

Yang, Liu. "Tang Dynasty Changsha Ceramics." In *Shipwrecked: Tang Treasures and Monsoon Winds,* 144–59. Edited by Regina Krahl, John Guy, J. Keith Wilson, and Julian Raby. Washington, DC: Arthur M. Sacker Gallery, Smithsonian Institution, 2010.

Yanyi, Guo. "Raw Materials for Making Porcelain and the Characteristics of Porcelain Wares in North and South China in Ancient Times." *Archaeometry* 29, no. 1 (February 1987): 3–19, https://doi.org/10.1111/j.1475-4754.1987.tb00393.x.

Yip, Joanne, Sun-Pui Ng, and K.-H. Wong. "Brilliant Whiteness Surfaces from Electrospun Nanofiber Webs." *Textile Research Journal* 79, no. 9 (2013): 771–79, https://doi.org/10.1177/0040517509102797.

Yoh, Kanazawa. "The Export and Trade of Chinese Ceramics: An Overview of the History and Scholarship to Date." In *Chinese Ceramics: From the Paleolithic Period Through the Qing Dynasty,* 534–63. Edited by Zhiyan Li, Virginia L. Bower, and He Li. New Haven, CT: Yale University Press, 2010.

Young, Thomas. "The Bakerian Lecture: On the Theory of Light and Colours." *Philosophical Transactions of the Royal Society of London* 92 (1802): 12–48, https://doi.org/10.1098/rstl.1802.0004.

Yu, Lu. *The Classic of Tea: Origins and Rituals.* Translated by Francis Ross Carpenter. Hopewell, NH: Ecco Press, 1974.

Zeki, Semir, Samuel Cheadle, Joshua Pepper, and Dimitris Mylonas. "The

Constancy of Colored After-Images." *Frontiers in Human Neuroscience* 11, no. 229 (May 10, 2017): 1–8, https://doi.org/10.3389/fnhum.2017.00229.

Zlinkoff, Sergei S., and Robert C. Barnard. "The Supreme Court and a Competitive Economy: 1946 Term Trademarks, Patents and Antitrust Laws." *Columbia Law Review* 47, no. 6 (September 1947): 914–52, https://doi.org/10.2307/1118242.

INDEX